SYMPTOMS OF CULTURE

SYMPTOMS
OF CULTURE

MARJORIE GARBER

Routledge
New York

Published in 1998 by
Routledge
29 West 35th Street
New York, NY 10001

Library of Congress Cataloging-in-Publication Data

Garber, Marjorie B.
 Symptoms of culture / Marjorie Garber.
 p. cm.
 Includes bibliographical references and index.
 ISBN 0-415-91859-6 (hbk.: acid-free paper).
 1. Civilization, Modern—1950– 2. Popular culture—History—20th century.
 3. Symbolism in literature. I. Title.
 CB430.G37 1998
 306'.09'04—dc21 97-40995
 CIP

For Bill Germano

Fleat Heraclitus an rideat Democritus? in attempting to speak of these Symptoms, shall I laugh with *Democritus* or weep with *Heraclitus?* they are so ridiculous and absurd on the one side, so lamentable and tragical on the other.

 —Robert Burton, *The Anatomy of Melancholy*

Contents

Acknowledgments

It is a pleasure to acknowledge the generous assistance of a number of friends and colleagues: Margaret Ferguson, David Simpson, Andrew Parker, Christina Carlson, Ted Gideonse, Toby Kasper, Paul Franklin, Carla Mazzio, David Hillman, Jeffrey Masten, Douglas Trevor, Patrick O'Malley, Jeffrey Reiser, Liz Campbell, Chinnie Ding, Brian Martin, David Horn, Lesley Lundeen, Ken Sherman, Benjamin Tiven, T. J. Mancini, Diane Gibbons, members of the Renaissance Colloquium, students in my course on Cultural Studies, and colleagues at the Harvard Center for Literary and Cultural Studies.

To Rachel Tiven I am especially grateful for her generous and tireless work locating permissions, indexing, and readying the manuscript for the press. Barbara Akiba gave unstintingly of her time and effort in assisting this process. Rebecca Walkowitz offered important support and advice throughout. Barbara Johnson was, as always, my most challenging and most inspiring reader. To all these friends, with whom it is a joy to work, my warmest thanks for making the writing and presentation of these essays a collaborative process that gives a daily beauty to this profession at its best.

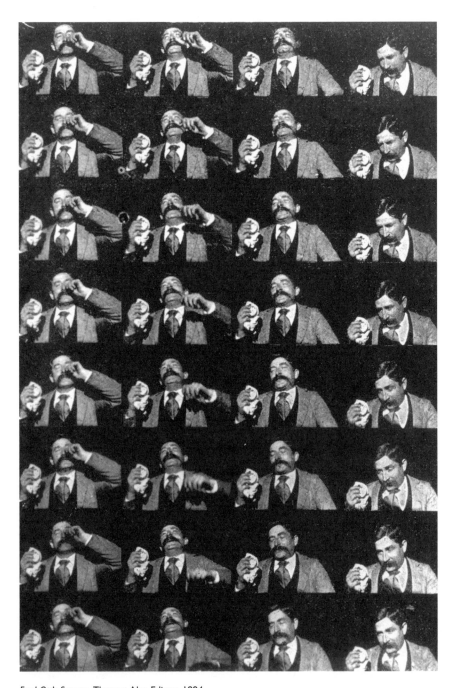

Fred Ott's Sneeze, Thomas Alva Edison, 1894.

Symptoms of Culture:
An Introduction

I'm not a doctor, but I play one on TV.
—advertising pitch by Robert Young,
star of *Marcus Welby, M.D.*

Playing doctor has long been a symptom of culture. But in the phrase "symptom of culture," is culture the patient, the doctor, or the disease?

The favored word among doctors and medical writers today is not "symptom" but "syndrome": Battered Woman Syndrome, Carpal Tunnel Syndrome, Dry Eye Syndrome, False Memory Syndrome, Fetal Alcohol Syndrome, Immunological Deficiency Syndrome, Battered Child Syndrome, Failure to Thrive Syndrome, Sudden Infant Death Syndrome, Munchausen-by-Proxy Syndrome, Peter Pan Syndrome. The Flight Safety Foundation reports that blood-clotting during long airplane flights, known medically as deep venous thrombosis, is also called "economy-class syndrome." As the heterogeneity of this list will suggest, a "syndrome," or concurrence of several symptoms, may be physiological, social, cultural or political.

In the scientific journal *Neurology*, two Swiss neuroscientists reported dozens of cases of "gourmand syndrome," a passion for fine food, developed by patients who had suffered significant damage to a particular region of the brain. After a brain hemorrhage, stroke, tumor, or injury, these patients began to crave "good tasty food served in a nice restaurant." They were not binge eaters or bulimics, nor were they sufferers from pica, an obsession with consuming a single food (or non-food) item. Rather, these individuals, previously indifferent to the meals they

ate, became deeply interested in the nature and quality of their food. One patient, a successful political journalist, suffered a hemorrhage to the right side of his brain, and became interested only in eating—or talking about—good food. When he returned to work, he became a food writer. "These people are not abnormally hungry," observed one of the scientists, "they are craving for a better state of being."[1]

What is the difference between a symptom and a syndrome? "Syndrome" seems often to mark the space of the inexplicable in scientific or empirical terms. A woman is being beaten. Children die, suddenly, in their cribs. "Syndrome" describes a problem, a set of symptoms. It is a word of context and interrelationship—precisely what we might think of as "cultural." A syndrome is a symptom in the public sphere.

Thus, for example, a 1997 congressional hearing on the nationwide spread of aggression behind the wheel produced a description of "a syndrome called 'road rage,'" whose symptoms include tailgating, weaving from lane to lane, horn-honking, speeding, failing to yield, flashing headlights, and the making of suggestive or obscene hand and facial gestures. This complex of dangerous and anti-social behaviors is now regarded as "a national personality disorder."[2]

Whether "craving for a better state of being" or exhibiting a "national personality disorder," sufferers from modern and postmodern syndromes like the two just described may not even know that they are suffering. Although the scientists who diagnosed "gourmand syndrome" were careful to distinguish it from "gourmet" taste, which they apparently regarded as an aspect of art or connoisseurship rather than of pathology, they were equally determined to insist that "gourmand syndrome" was not gluttony by another name. And responses to the concept of "road rage" in the letters section of the daily papers made it clear that some commentators viewed tailgating and honking as deviant behavior rather than social angst. Behind the sociologists' and psychotherapists' language they could sense an exculpatory legal maneuver analogous to the notorious Twinkie defense.

Culture itself, it is now presumably needless to say, is another of those artifacts of culture that has become symptomatic of current-day desires, fears, and fantasies. Above all, perhaps, fantasies of control. The syndrome is a category of naming, not a category of analysis like the symptom, or a category of allegorization like the symbol. To name is to control, or to assert control, even over that which we cannot fully

explain or understand. We could say, then, that the very concept of the syndrome becomes a symptom of culture.

But what is a symptom? And how can a culture have symptoms?

In our everyday lives, we use the word to talk about fever, the sniffles, a painful gait, or more darkly in referring to disturbing behaviors— chronic insomnia, violent temper, an obsession with body image. It might be supposed that the word symptom itself began as a medical term and became more broadly and metaphorically applied, over time, to other realms of inquiry, but in fact this is not the case. Symptoms were from the beginning broadly defined cultural indicators; it is symptomatic of our own desire to classify, categorize, and limit, that we should think of them in a more restricted pathological sense.

Deriving originally from Greek words for occurrence, phenomenon, chance, and accident, something that happens or literally "falls together," the symptom developed simultaneously as a medical and as a cultural term. That invaluable timeline of connotation, the *Oxford English Dictionary*, marks some of its variant meanings: Ben Jonson, a poet and playwright working within a patronage culture, could write about "symptoms of aspiring" (1611), philosopher and political economist Adam Smith about a "symptom of great national wealth" (1776), the historian Macaulay about "symptoms of discontent" (1855), the novelist Sir Walter Scott about the "symptoms" of a character's "approach" (1831).

Even medical writings in earlier centuries tended toward the "philosophical" rather than just the strictly "clinical," which is to say that they often pointed toward mental as well as physiological symptoms. "Fear, sorrow, suspicion, bashfulness," and "other dread symptoms of body and mind" were, for Robert Burton, clear indications of melancholia. In any case a symptom was an occasion for interpretation, a sign, not just a thing in itself. So a symptom is a kind of code, a way in which a body—or a culture—signals something that lies beneath or within. For the human psyche, a symptom is precisely that: a coded or ciphered message, a withheld narrative performed by the body.

"The mercury sank in the mouth of the dying day," wrote W.H. Auden in a poem marking the death of William Butler Yeats.

The provinces of his body revolted,
The squares of his mind were empty,
Silence invaded the suburbs,
The current of his feeling failed; he became his admirers.[3]

Here is a cultural event recorded, precisely, as a symptom: the dying Yeats, a poet and public man, is imagined through an anatomy of body and space, a diagnostic streetmap of feeling: "for him it was his last afternoon as himself,/An afternoon of nurses and rumours. . . . Now he is scattered among a hundred cities":

O all the instruments agree
The day of his death was a dark cold day.

For Auden there is both a sympathy and a disjunction between the dying poet's symptoms and the physical world's response. The poet's wittily mercurial image is also an instrument of pathos: the thermometer records at once the decline in the weather, the patient, and the linked conditions of poetry and history. "Far from his illness. . . . The death of the poet was kept from his poems."

Jane Austen's novels are full of characters trying to read each other's symptoms: symptoms of love, of pain, of regret. When an importunate suitor leaves the vicinity of Mansfield Park, "Edmund did not discern any symptoms of regret" on the part of his cousin Fanny Price.[4] "I can remember no symptom of affection on either side," says Elizabeth Bennet about the elopement of her sister Lydia with the seductive and profligate Wickham.[5] "Her look and manner were open, cheerful and engaging as ever, but without any symptom of peculiar regard," Darcy writes to Elizabeth, explaining why he thought Jane Bennet wasn't in love with Bingley.[6] At the home of Lady Catherine De Bourgh, Elizabeth keeps a close eye on Darcy and Miss De Bourgh, to whom he is said to be engaged, but "Neither at that moment nor at any other could she discern any symptom of love."[7] We might notice all these negative results: detectives of emotion in Austen's novels often seek such "symptoms" and fail to find them.

The symptom acts; it *acts out.* A blush, a stammer, a headache, a cough. Are these signs of love? of desire? of fear? of *repressed* or *unconscious* desire? Freud and psychoanalysts who follow him call the symptom a "compromise formation"—in other words, a sign of inner

conflict, a symbol of conflicting desires. "I want to/but I am forbidden to"; "I desire it/but I fear the consequences."

The desire cries out in its symptom, says the psychoanalyst. Freud's patient Dora's "wish" (or what her analyst wishes for her to wish?) is bodied forth in her fin-de-siècle onset of muteness. So also in the muteness induced by "shell-shock" in a soldier in Pat Barker's recent novel *Regeneration,* set during World War I. The symptom is a "return of the repressed"—a way of "saying" what the patient cannot or does not consciously wish to say. Shell-shock for men, hysteria for women: the *gendering* of these conditions is a cultural symptom.

Symptoms, then, are ways of speaking. And the analysis of symptoms is a reading practice. Jacques Lacan made the link between symptom and language explicit in one of his most famous utterances: "the symptom resolves itself entirely in an analysis of language, because the symptom is itself structured like a language."[8] "Enjoy your symptom!" enjoins the latter-day Lacanian theorist Slavoj Žižek, using the word "symptom" precisely in a wider, cultural, sense.[9]

The story of Oedipus, so central to the paradigms of psychoanalysis, is the story of a cultural symptom, as much as it is the story of a symptomatic culture. "Self-mutilation following the discovery of unwitting incest" would be a sad but minor sidebar in a newspaper or newsmagazine today—and it would, needless to say, entirely miss the point of *Oedipus the King.*

One noteworthy and worrisome symptom of culture has been the tendency, in recent years and from certain quarters, to devalue associational and metonymic structures in favor of "empirical evidence." In the case of Oedipus we might hypothetically explore the statistical occurrence of dysfunctional families within a) "real" Theban households of the period, or b) classical tragedy. How many royal babies were exposed on hillsides? What were the social and economic pressures compelling the remarriage of widows? If this sounds farcical, it is only because we segregate "great" literature, which is acknowledged to have "universal" and even "mythic" meaning, from the ordinary run of things that are, in fact, susceptible to quantification, stratification, poll, and questionnaire.

Ours is an era that distrusts language, that fears figures of speech, and especially what could be called figures of thinking—ideas and associations that beget ideas, that link to other links in culture rather than in hypertext, ideas that are regarded as dangerous because they are not

end-stopped. Ideas that lead us to the brink of consciousness and of
control. The dominance of the quantitative and the empirical, as con-
trasted with the overdetermined, the counterintuitive, and the qualita-
tive, seems to imply that the only things worth knowing are the things
that can be counted. The opposition between so-called "hard" and so-
called "soft" subjects (often construed as the tension between the nat-
ural or "social" sciences and the humanities, or even between history
and literary criticism) is itself one of the most striking symptoms of our
time. Our culture likes numbers, statistics, "facts." As if a fact were
somehow the end of the story rather than the beginning.

The tyranny of the empirical blinds us to the real interest of the par-
ticular, which is not its representativeness but rather its singularity. It
seems to me that our cultural understanding has become impoverished
through this dominant focus on quantification, and that that impover-
ishment needs to be addressed through the extension to culture of
reading strategies that are perhaps most fully developed in the field of
literary studies.

This is not to say, however, that the concept of the "symptom" should
be confused with the familiar literary concept of the "symbol." In a
famous observation, Samuel Taylor Coleridge argued for the impor-
tance of the symbol based upon its power to universalize. "The symbol
is characterized by the translucence of the special in the individual, or
of the general in the special, or of the universal in the general; above
all, by the translucence of the eternal through and in the temporal."[10]
It is the argument of this book that the symptom, and especially, as
adumbrated here, the symptom of culture, essentially reverses this dic-
tum, finding in the specificity and oddity of the particular a clue to *fan-
tasies* of the universal, the general, the eternal—all of which, as I will
suggest, are made possible by the omission or suppression of context.

Let me offer an example of this difference between "symbol" and
"symptom."

South Carolina is the only remaining state that flies the Confederate
flag over its Capitol. To some citizens it represents the state's Southern
heritage, to others it is a sign of racism, latent or overt. The public
display of the battle flag on state grounds is a tradition that dates back,
not to the Civil War, as some might suppose, but rather to 1962, when
the Stars and Bars was hoisted in defiance of the civil rights movement.
But opposition to change has become a major political issue. When
the state's governor, the great-great-great grandson of a Confederate

soldier, suggested moving the flag from the Capitol itself to a Confederate memorial on Capitol grounds he was roundly attacked. Klansmen and clergymen converged on state property and preempted other discussion.

White supporters of the symbols of the old South often base their arguments on claims of heritage, not race. Historian Charles Reagan Wilson, of the University of Mississippi, noted that "to cut that tie with the symbols, with the genealogy," is for many white Southerners "a kind of cultural death." And a South Carolina state senator asserted that removal of the flag and of the Confederate monuments that can be found in almost every Southern courthouse square would lead to "cultural genocide."[11] Cultural death; cultural genocide. These are themselves cultural symptoms.

In the case of the Confederate flag, a letter written to raise funds for the keep-the-flag battle in South Carolina warned that "the day may come when the children of South Carolina will be taught to be ashamed of their history and their heritage." "Heritage" is another one of those terms that claims centrality by a tacit exclusion. "When they talk about Southern heritage or Southern culture in that context," said William Ferris, an anthropologist, "what they really mean is white heritage or culture. They exclude the black experience and essentially render it invisible." Or, as the director of the Southeast office of the N.A.A.C.P. put it, "The question is, Whose heritage are you celebrating?"[12]

Heritage, like *greatness* and *gentility*—two other concepts put under pressure in some of the essays that follow—is, in fact, a self-proclaimed norm that becomes, when it is named, a symptom.

One of the most striking symptoms of culture in our time has been the phenomenon of the so-called "culture wars," a conflict that might be located precisely in the clash between the timeless, ahistorical, universalizing, decontextualizing function of the "symbol" and the historically contingent, specific, and overdetermined function of the "symptom." Literature is often thought of as treacherous territory if and as its "meaning" shifts over time, with new generations of readers, new cultural contexts. Literature as "symbol" is expected to proclaim "timeless, universal truths"; literature as "symptom" is embedded in particular historical preoccupations and conflicts, both in its own time and in ours. We eagerly allow our sciences (and even our social sciences) to find new "truths," to perform the equivalent of a computer's editing function, search-and-replace. But with the humanities, or what in French are called the

"human sciences," we are more intolerant of change, more possessive and nostalgic. Like a child returning home from an extended absence to find his or her bedroom full of new paint and furniture, many a modern critic will express dismay rather than pleasure that the "classics" can receive new interpretations, some quite different from the old ones.

"The wholeness of the human problem," wrote a celebrated author to the dean of an academic institution in his former country, "permits nobody, today less than ever, to separate the intellectual and artistic from the political and social, and to isolate himself within the ivory tower of the 'cultural' proper."[13] The author delivering this dignified reproof was Thomas Mann, writing from voluntary exile; the institution was the Philosophical Faculty of Bonn University; the occasion was his name being removed from the roll of Honorary Doctors; the year was 1937. More than a half-century later, in the rhetorical skirmishes rather self-importantly dubbed "culture wars," the "cultural" *is* very often "the political and social" rather than the "intellectual and artistic."

In today's "culture wars" whole categories of analysis crucial to cultural studies, from race to identity politics to queer theory, are often described as intrinsically inimical to aesthetic judgment and literary merit. But this is so only if merit and value are tied to decontextualization, historical forgetting, and erasure of the conflicting forces that go into the production and reception of literary and cultural works.

One criterion for the "greatness" of a "great work" lies in the range of scholarly and critical interpretations it can inspire and sustain. Yet each generation of readers seems to the previous generation to have attacked—rather than confirmed—the greatness of the work by asking new questions or violating old pieties. Consider the case of Shakespeare, the classic of classics. Traditional Shakespeareans in the early part of this century resisted the newfangled New Criticism and its tracing of verbal images, and stuck to philology's focus on the history of words and their derivations. But the study of animal imagery, for example, to cite a staple of fifties and sixties Shakespeare criticism, did not ruin *King Lear* for subsequent readers (now once more interested in problems of textual transmission and historical detail), any more than contemporary New Historicism's interest in colonial exploration has ruined *The Tempest*, or effaced New Critical readings of that play as a fable of art and the playwright's domain.

Those who inveigh against mixing high art with popular culture would do well to remember that Shakespeare himself began as popular

culture, not as the icon of high art he has become today. Plays in the late 16th century were not "works" to be published in folio form. Most of Shakespeare's plays were printed in quartos, the instant books of their day; Sir Thomas Bodley, the founder of Oxford's Bodleian Library, refused to have such "playbooks" in his collection because they would discredit the value of the whole. It was only in the 18th century that the myth of "Shakespeare," and of the Shakespeare text, began to be invented. Shakespeare in this sense is an 18th-century author. Or a 20th-century author, again breaching the boundaries of "high" and "low," "popular" and "learned," "culture" and "cultural studies." Increasingly, Shakespeare has become a common cultural language, a kind of secular Bible. Shakespeare, in short, is a process as well as a monument. A culture, we might say, as well as a literature.

I have introduced a set of terms from psychoanalysis, and specifically from the writings of Sigmund Freud, not because I am proposing to psychoanalyze cultural figures or "culture" itself, but because Freud provides an exemplary model of reading. I am speaking here of the Freud of *The Interpretation of Dreams*, not so much of the later Freud, who actively and directly engaged in cultural analysis in works like "Why War?," *Civilization and Its Discontents,* and *Totem and Taboo.* These latter works have a certain power of generalization that has recommended them to scholars of history and culture. But it is to Freud's earlier work on dream analysis, I want to suggest, that we should look for a theory of the symptom, and specifically, in my sense, the "symptom of culture." For in this mode of analysis we find an emphasis on intuitive connections, connecting seemingly unconnected, often wildly disparate things. Beneath the surface of conscious, rational thought lies not only the intuitive, but the counterintuitive. Precisely because it does not presuppose causes, intentions, and motivations, such a reading practice allows for a multiplicity of associations and linkages.

I do not propose to diagnose culture as if it were an illness of which we could be cured, but to read culture as if it were structured like a dream, a network of representations that encodes wishes and fears, projections and identifications, all of whose elements are overdetermined and contingent. In an analysis of one of his own dreams, the "Dream of the Botanical Monograph," Freud finds himself remembering that his conversation with a friend had been interrupted by a man called *Gärtner* [Gardener] and that he "thought his wife looked *blooming.* And

even as I write these words I recall that one of my patients, who bore the charming name of *Flora*, was for a time the pivot of our discussion. These must have been the intermediate links," he suggests, between his dream and his waking thoughts.

"I am prepared to find this explanation attacked on the ground of its being arbitrary or artificial," he offers, boldly. "What, it may be asked, would have happened if Professor Gärtner and his wife with her blooming looks had not come up to us or if the patient we were talking about had been called Anna instead of Flora? The answer is simple. If these chains of thought had been absent others would no doubt have been selected. It is easy enough to construct such chains, as is shown by the puns and riddles that people make every day for their entertainment. The realm of jokes knows no boundaries."[14]

Freud compares a dream to "a picture-puzzle, a rebus," containing elements as disparate as letters of the alphabet, headless human figures, houses, and boats. "Now I might be misled into raising objections and declaring that the picture as a whole and its component parts are nonsensical," he explains. "But obviously we can only form a proper judgement of the rebus if we put aside criticisms such as these of the whole composition and its parts and if, instead, we try to replace each separate element by a syllable or word that can be represented by that element in some way or other. The words which are put together in this way are no longer nonsensical but may form a poetical phrase of the greatest beauty and significance."[15]

The word "rebus" comes into English from *res,* the Latin word for things. A rebus is a riddle made up of things. The elements in the rebus are the symptoms. Freud's description of the dream as rebus is a good analogy for the interpretative model employed in the essays in this volume, which follow the itinerary of cultural signs from football to Jell-O to "Shakespeare" and "greatness," reading the picture-puzzle of their recurrence in diverse and often bafflingly inappropriate contexts. My method is metonymic, in that it pursues associations and contiguities rather than identities and essences; ideas do not "stand for" or "symbolize" something in culture but rather evoke, imply, glance at fields of connotation.

Just as what Freud calls the "Dream Work" turns the day's residues into coded messages from the latent dream thoughts, so too what might be called "Culture Work" involves a pattern of condensation, displacement, representation-by-the-opposite, and secondary revision, of the

residues of what is given to us by history and culture. For example, the mechanism of condensation might be illustrated by the fact that all-male Christian rallies have recently been held in major sports arenas, thus bringing together religion and sport in such a way as to reveal something about potent forces in American culture. The mechanism of displacement might in turn be illustrated by the outlawing of the wearing of yarmulkes on the basketball court, a form of anti-Semitism disguised as a concern for safety. Cultural meanings, in other words, are not so much determined as *overdetermined*, produced by multiple associative paths fortuitously converging on the same points.

To illustrate this, let me turn to a literary text that builds into its plot at a crucial moment a word game that strikingly combines overdetermination with contingency. The work I have in mind is A.S. Byatt's 1992 novella "Morpho Eugenia," and the remarkable film made from it, Philip Haas's *Angels and Insects*.

The aptly named William Adamson, a naturalist at the time of Darwin, is a guest in the great house of Sir Harald Alabaster and his aristocratic family, who pride themselves on their breeding. William, whose entomological interests are shared by Sir Harald, had been doing field work in the Amazon, and all his possessions, including his notes, have been lost in a shipwreck. Sir Harald's daughter, the even-more-aptly named Eugenia Alabaster (preternaturally *white* and *well-bred*) is involved in an incestuous love affair with her brother Edgar, and she marries the innocent William in part as a cover for her illicit relationship. While *all* the Alabaster children, including the children of incest, are extremely white, as their surname implies, no one seems to regard the name itself as in any way unusual or indicative. The plot turns not on these overdetermined and comic names but on an anagram orchestrated by Matty Crompton, William's naturalist collaborator (and ultimate partner).

The role of word games comes to the fore at a crucial moment in the plot, when, summoned back to the house by a mysterious message, William Adamson walks in on his wife and her brother-lover, belatedly discovering their incestuous secret. Inwardly distracted, angry, and betrayed, William is enlisted by Miss Crompton to play a game of Anagrams with various other members of the household. To him the descent from erotic high drama to the banality of ordinary life seems complete. "The game consisted of making words out of alphabet cards. . . . Everyone had nine letters, and could give any complete word

they could make secretly to anyone else, who must change at least one letter, and pass it on." He plays automatically, until he finds himself holding the letters to make the extremely appropriate word INSECT, a word he passes on to Matty Crompton, who has shared his interest in the local ant colonies.

Matty glances at the word, quickly rearranges the cards, and hands it back, so that William finds himself staring at the word INCEST, "lying innocently in his hand. He shuffled the evidence hastily, looked up, and met the dark intelligent eyes."[16]

In Philip Haas's film version the costumes establish metaphorical relation between women and insects. This is true not only of Eugenia herself, who bears the same name as a rare butterfly ("Morpho Eugenia," the punning insect of the title) but of practically everyone else, though—needless to say—no one appears to take cognizance of the fact. I remember with particular pleasure an outrageous yellow-and-black outfit that said "bee" as loudly as if the word were spelled out in letters. Lady Alabaster, grotesquely fat, has the appearance, and the energy, of a white slug. The metonymic presence of an ant colony completes the language lesson.

INSECT/INCEST is an instance of the verbal uncanny. There is no "reason" why the words should be equivalent. That they are, that they become so, is both brilliant and odd, brilliant, indeed, in part because odd. If the pun is so often denigrated as "the lowest form of humor" that may be because it is indeed sublogical, counterintuitive, yoking meanings by violence together. But therein lies its intepretative power. An anagram is a kind of visual pun, a rebus in letters.

As I will suggest in one of the essays in this volume, the mechanisms of cultural meaning often function disturbingly like a puzzle in James Joyce's *Ulysses*, the comic itinerary of the character "MacIntosh," who is not a character at all but is born of a misheard description of a man *in* a Macintosh, a British word for "raincoat." Similarly, in A.A. Milne's *The House at Pooh Corner*, Christopher Robin's misspelling of "Back Soon" as "Backson" on the notice he pins to his door (GON OUT, BACKSON, BISY BACKSON) sends Owl and Rabbit on a fruitless search for a Spotted or Herbaceous Backson in the forest. In just the same way—but this time with an inter-cultural misapprehension—Sherlock Holmes's unimaginative rival, Inspector Lestrade, misreading the German word *Rache* as a truncated version of a woman's name, searches in vain for the elusive Rachel. It is my contention that cultural symptoms are often

shaped in a similar, though less comic, manner, that the frenetic pursuit of something called "Un-American Activities," for example, takes on a life of its own precisely through the mechanisms of "naming names."

In E.B. White's children's classic, *Charlotte's Web*, which I discuss in the first chapter, the value of Wilbur the Pig is enhanced by the savvy spin doctor, Charlotte the Spider, through carefully chosen decontextualized messages woven into her web. Catching sight of the first message, the farmer Homer Zuckerman tells his wife:

> "We have received a sign. . . . Right spank in the middle of the web were the words, 'Some Pig.' A miracle has happened and a sign has occurred on earth, right on our farm, and we have no ordinary pig."
>
> "Well," said Mrs. Zuckerman, "it seems to me you're a little off. It seems to me we have no ordinary *spider*."
>
> "Oh, no," said Zuckerman. "It's the pig that's unusual. It says so, right here in the middle of the web."[17]

"It says so on the web. . . ." How much more resonant the voice of this locus of authority is today than even E.B. White could have predicted. In the information age, the messages on the Web (and on the Macintosh!) bring the forces of decontextualization even more universally to bear on the cultural text. In this book I often address the question of decontextualization, sometimes to recontextualize (as when I trace the strange cultural meanings of Jell-O that overdetermine its role as clue in the trial of Ethel and Julius Rosenberg) and sometimes to examine the cultural effects of decontextualization itself (quotations from Shakespeare out of context in a Senate hearing, the lack of scholarly apparatus included in the Great Books).

Symbol. Symptom. Syndrome. The essays that follow will identify and analyze a set of symptoms that may themselves add up to a syndrome. Certainly they are as heterogeneous as many nosological charts. Christian evangelism (for men only) in a football stadium. Prayer sessions in the locker room. A sneeze. A faked orgasm. The Lincoln bedroom. Genteel anti-Semitism and the question of Madeleine Albright's family origins. The Jell-O box used as evidence in the trial and conviction of Julius and Ethel Rosenberg. U.S. Senators quoting—and misquoting—Shakespeare. Shakespeare himself, or "Shakespeare" itself —the phenonemon of what might be called "the Shakespeare effect":

the penchant, in a society that increasingly distrusts intellectuals, artists, and academics, for invoking Shakespeare as often as the Bible as the disembodied arbiter of timeless moral and social truths. The shifting political, religious, and racial stakes in the battle over "evolution." The obsession of film-producers, sports promoters, and headline writers with Roman numerals.

There is a sense in which all of these symptoms might be regarded as symptoms of "culture" in quotation marks, symptoms of culture-making, cultural publicity and cultural analysis, rather than of one culture or another. They are cultural practices and cultural signs, evidence of the way we produce "culture" as something to be read. As such, they become the province of the literary analyst and the common reader of everyday life.

Part I

American Dreams

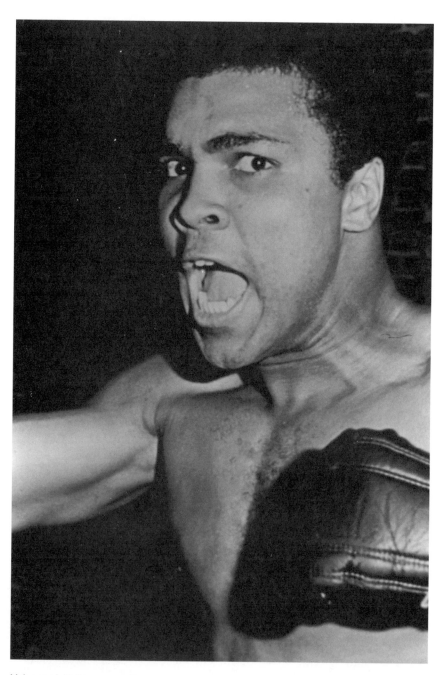

Muhammad Ali: "the greatest."

I

Greatness

It is natural to believe in great men.
—Ralph Waldo Emerson, "Uses of Great Men"

The "Great Wall of China" is, some modern scholars suggest, neither great nor a wall. It is a patchwork of sections, only about a third of which are presently standing. It was not built more than 2,000 years ago, despite what guidebooks claim. It did not halt a Mongol invasion. It can't be seen from the moon. "Let us beware of the myth of the Great Wall," cautioned Arthur N. Waldron, who has studied the place of the wall in Chinese history.[1] But Chinese leaders since Mao Zedong have made the wall a national icon, and foreign tourists arrive by the busload. "They've turned the Great Wall into a tourist attraction," complained a visitor from the Philippines. "You can't take a picture that doesn't include someone else taking a picture." But this aspect of the wall's celebrity was not inimical to its cultural power. "You get a sense of history, of greatness," explained the visitor. "You realize why they call it the Great Wall—because it is great, in size, in power. It's so impressive a structure that even the crass commercialization doesn't stop you from feeling its greatness."

Not only does the commercialization not "stop you" from feeling greatness. It may in fact inspire exactly those feelings, feelings that are, in the world of tourism and celebrity, an aspect of what scholars call imitative or mimetic desire. The greatness of a site is directly proportional

to the number of other viewers who consider it great. The tourist is always, in a sense, taking pictures of another tourist taking pictures.

"Greatness" as a term is today both an inflated and a deflated currency, shading over into categories of notoriety, transcendence, and some version of the postmodern fifteen minutes of fame. The modern cultural fantasy about heroes and greatness is a symptom of desire and loss: a desire for identifiable and objective standards, and a nostalgia for hierarchy, whether of rank or merit.

Sometimes today "greatness"—so often linked, in our national rhetoric, with "America"—functions rhetorically as pure boiler-plate (the politician's statutory "this is a great country") while at other times it seems to be its own, tautologous, ground of self-evident truth. To give one trivial but telling example: the announcement of the U.S. Post Office's plan to issue an Elvis Presley commemorative stamp—thus officially declaring Elvis dead, as well as transcendent—was greeted with pleasure by a 72-year-old Vermont woman who had written the Postmaster General almost every week since the King's death, pushing for an Elvis commemorative. "I can't imagine anybody more deserving to be put on a stamp than my Elvis," she told the *New York Times*. "I'm not one of those who believes he's not dead. He's dead, unfortunately. He was a great man, a great American. I knew that the first time I laid eyes on him in that black leather suit."[2]

Bear in mind that "great" in English once meant "fat." Or thick, or coarse, or bulky—take your pick. It was an aspect of physical size, not of moral weight. The "Great Bed of Ware" in Elizabethan England was 10 feet 11 inches (3.33 metres) square. It was not the bed of a "great man," but rather a convenient lodging for several itinerant travelers. Nor, when applied to persons, did "greatness" necessarily imply quality or merit. Shakespeare has more than one joke on this: Shakespearean characters called "Pompey" tend in fact to present themselves as targets for comic undercutting because of their pretensions to greatness. An amateur actor in the bumbling "Pageant of the Nine Worthies" presented before the court in *Love's Labour's Lost* announces, "I Pompey am, Pompey, surnam'd the Big—" and is quickly corrected by a condescending lord: "The Great." Later he acknowledges, with a modesty that would better become his noble audience, "I made a little fault in 'Great.'"[3] A pimp named Pompey in *Measure for Measure* is surnamed "Bum," and his judicial interrogator quips disgustedly that "your bum is the greatest thing about you; so that, in the beastliest sense, you are Pompey the Great."[4]

But "great" also meant "powerful." A "great man" was a mover-and-shaker, a political force, nobly born and to be reckoned with. "Madness in great ones must not unwatched go," declares the politic Claudius about the dangerously unpredictable Hamlet.[5] Hamlet himself, in a phrase that has attracted scholarly attention for its knotted syntax, seeks to find some common ground between the moral or ethical realm and the demands of power politics, observing admiringly of his rival Fortinbras that "Rightly to be great/Is not to stir without great argument" (i.e., strong motivation), "But greatly to find quarrel in a straw/When honour's at the stake."[6] By this reasoning, one can be wrongly as well as rightly great. Significantly, the Shakespearean locus classicus of the concept of greatness is put into the mouth of a social climber rather than a "great man." "Some are born great, some achieve greatness, and some have greatness thrust upon 'em."[7] The words are in fact already a bromide when the pompous Malvolio finds and reads them: he picks up a letter counterfeited in the handwriting of his noble employer, the Lady Olivia, and imagines that they have direct and unambiguous pertinence to him.

The sense in which "greatness" here means high birth rather than merit is underscored by the counterfeit letter's preceding line, "In my stars I am above thee, but be not afraid of greatness." Yet only the second half of the line is commonly remembered in modern citations of this famous phrase, so that, as with so many other Shakespearean phrases taken out of context, the "some are born great" passage is frequently used by 20th-century pundits to mean pretty much the opposite of what the original context implies. As yet another Shakespearean clown will remark of an impostor pretending to be a courtier, "A great man, I'll warrant; I know by the picking on's teeth."[8]

Tooth-picking, warfare, and "marrying up" may be three infallible marks of greatness, not only for the Renaissance but for our own day. But the cultural role of "greatness" has shifted a little in these democratic days. Jane Austen's Mr. Darcy in *Pride and Prejudice* is regarded as "so great a man"[9] not because he is brilliant or accomplished but because he has inherited a large estate. "Perhaps he may be a little whimsical in his civilities," worries Elizabeth Bennet's city uncle, who is doubtful about whether to trust Darcy's invitation to fish on his estate. "Your great men often are."[10] In the same novel the unlikeable but high-born Lady Catherine de Bourgh and her sickly daughter are regarded with awe by the new knight, Sir William Lucas, who "was stationed in the doorway, in earnest contemplation of the greatness

before him, and constantly bowing" whenever they deigned to look his way.[11]

With the separation from the old world of rank and status, where inherited titles conferred "greatness," came a new ideology of the natural aristocrat, the aristocrat of the mind. A sermon preached before the King of England in 1698 raised the question of *Great Men's Advantages and Obligations to Religion*, where "great men" refers to social rank. But *Great Men are God's Gift*—the title of a memorial discourse on the death of Daniel Webster in 1852—offers a different notion of "greatness." The phrase was much on America's mind. When Ralph Waldo Emerson wrote that "It is natural to believe in great men"[12] he meant men like Plato, Goethe, Napoleon, and, indeed, Shakespeare. Their greatness consists, as we will see, in the greatness of their books, or in their presumed exemplary status as models of decorum and achievement.

Emerson's own example in cataloguing "great men" has been followed in the twentieth century with varying success. Today one can consult volumes on *Great Men of Science, Great Men of American Popular Song, Great Men of Derbyshire, Great Men of Michigan, Great Men Who Have Added to the Enlightenment of Mankind Through Endowed Professorships at the University of Chicago, Short Sayings of Great Men*, and, my favorite, an instructive fictionalization for children, *Great Men's Sons: Who They Were, What They Did, and How They Turned Out*. There are also of course, in our enlightened century, lists of great women: *Great Women of the Bible, Of Antiquity, Of Faith, Of Medicine, Of India*, and *Of the Press*, as well as *Great Women Mystery Writers, Great Women Athletes*, and *Great Women Superheroes*. On library bookshelves F.R. Leavis's *Great Books and a Liberal Education* jostles for space with *Great Books as Life Teachers: Studies of Character Real and Ideal*, and the *Great Book of Couscous*.

In short, by the latter half of the 20th century "great" as a term had become an empty colloquial affirmation cognate with other debased terms like "fantastic," "terrific," and "awesome," which have likewise lost their original specificity in fantasy, terror, and awe. "Baby, you're the greatest," declares Jackie Gleason's character Ralph Kramden, enfolding his long-suffering wife in his arms at the end of practically every episode of "The Honeymooners." Alice's "greatness" consists in tolerating her husband's foibles. But "great" has also become a category of popular celebrity, a headline and a cultural diagnosis. "I am the greatest," announced pugilist and poet Muhammad Ali after a boxing match, crowning himself for our age as definitively as did Napoleon for his.

In what follows I will be analyzing the mechanisms for producing greatness in a number of different contexts, from a children's story to a presidential campaign, from the politics of our so-called national pastime to the politics of the so-called Great Books. But let me begin by establishing a couple of quick benchmarks, fairly straightforward instances in which "greatness" is produced as a spectral effect, with consequences that are political, ideological, and cultural, while appearing, to some eyes at least, to be none of these.

In L. Frank Baum's *The Wizard of Oz*, the wonderful wizard, appearing variously to Dorothy and her friends as an enormous head without a body, a lovely lady, a terrible beast, and a ball of fire, introduces himself: "I am Oz the Great and Terrible."[13] Oz is a nice instance of Lacan's "*sujet supposé savoir,*" the one who is supposed to know—and of course he turns out (perhaps like Lacan's all-knowing psychoanalyst) to be a humbug and a ventriloquist. "Pay no attention to that man behind the curtain," blusters the voice of Oz in the MGM film, when Dorothy's familiar, the little dog Toto, tugs away the hangings to disclose a frightened little man pulling levers behind the scenes. (Here we could footnote, were we so inclined, another dictum from Lacan: "the phallus can play its role only when veiled.")[14] The film (1939) is more cynical than the book (1900) on the question of "greatness"; the Wizard's main speech, written for W.C. Fields, who declined the part, has him handing out a diploma in place of the Scarecrow's wished-for brains, a plaque in place of the Tin Woodman's heart, and a medal in place of the Lion's courage. Significantly, what are today in politics called "character issues" (brains, courage, heart) are thus here explicitly fetishized and commodified, displayed as assumable attributes of the surface.

Another twentieth-century text in which the fantasy of greatness is enacted as pure theater, pure representation based on no original, is Genet's *The Balcony*. In that play the phallic reference, muted in *The Wizard of Oz*, is displayed in all its mimetic glory. Published in the same year as Lacan's essay "The Signification of the Phallus" (1958), Genet's play could easily bear that title. It takes place in a brothel in which clients pay to enact their erotic fantasies dressed as pillars of society's institutions: the Judge, the Bishop, the General.

The Chief of Police, also known as the Hero, is disconsolate because no one has yet asked to impersonate him, to play his part, that of the Chief of Police, in a sexual studio of fantasy. To enhance his appeal he

is advised to appear in the form of "a gigantic phallus, a prick of great stature." This will enable him, he thinks, to "symbolize the nation." Let this fantasmatic giant phallus, like the giant disembodied head of the Great Oz, stand as a clear example of the representation of greatness, what I am calling here the politics of mimesis. The Police Chief's companions, the Judge and the Bishop, are dumbfounded:

> THE JUDGE: A phallus? Of great stature? You mean—enormous?
> THE CHIEF OF POLICE: Of my stature.
> THE JUDGE: But that'll be very difficult to bring off.
> THE CHIEF OF POLICE: Not so very. What with new techniques in the rubber industry, remarkable things can be worked out.
> THE BISHOP (*after reflection*): . . . to be sure, the idea is a bold one. . . . it would be a formidable figure-head, and if you were to transmit yourself in that guise to posterity. . . .
> THE CHIEF OF POLICE (*gently*): Would you like to see the model?

This scheme, in fact, never does quite come off. The fantasy of the Hero unveiled as a phallic figure-head is revised in practice, as the revolutionary Roger does choose to impersonate the Hero, but mimetically, as Chief of Police, dressed in his clothes, even wearing his toupee. Like the other pretenders in the brothel, Roger wears the traditional footwear of ancient tragedy, cothurni about twenty inches high, so that he towers over the "real" Hero and the others onstage. The Police Chief is ecstatic—"So I've made it?," he asks, and declares "Gentlemen, I belong to the Nomenclature."[15]

But Roger (the impersonator) in turn mistakes the role for the real: "I've a right," he says, "to lead the character I've chosen to the very limit of his destiny . . . of merging his destiny with mine." Dramatically he takes out a knife and, according to Genet's stage direction, "makes the gesture of castrating himself." After which the Chief of Police, ostentatiously feeling his own balls, heaves a sigh of relief: "Mine are here. So which of us is washed up? He or I? Though my image be castrated in every brothel in the world, I remain intact. . . . An image of me will be perpetuated in secret, Mutilated? (*he shrugs his shoulders*). Yet a low Mass will be said to my glory. . . . Did you see? Did you see me? There, just before, larger than large, stronger than strong, deader than dead?"[16]

This is the apotheosis of the Hero, performed in a place called the Mausoleum Studio, since the dissemination of the Hero's image—as we

have already seen with Elvis— is coterminus with his death: "The truth [is] that you're dead, or rather that you don't stop dying and that your image, like your name, reverberates to infinity."[17] Such is the reality of the brothel, the place of greatness as mimesis. "Judges, generals, bishops, chamberlains, rebels," says the Madame of the House to her customers in the play's closing lines, "I'm going to prepare my costumes and studios for tomorrow. . . . You must now go home, where everything—you can be quite sure—will be falser than here."[18]

You must now go *home*, where everything—you can be quite sure— will be falser than here. The instruction, the desire, or the necessity to go home again, to quit the fantasy world of "greatness," is another move that links Dorothy's adventures in Oz, and her longing for Kansas, with the world inside—and outside—Genet's theatrical brothel. "Make-believe" is a term that unites these fantasy worlds. "It's make-believe that these gentlemen want," says the brothel madam, and Oz meekly confesses that he has only been "making believe."

> "Making believe!" cried Dorothy. "Are you not a great Wizard?"
> "Hush, my dear," he said, "don't speak so loud, or you will be overheard—and I should be ruined. I'm supposed to be a Great Wizard."
> "And aren't you?" she asked.
> "Not a bit of it, my dear; I'm just a common man."

Or, as the Scarecrow points out, to Oz's evident pleasure, and with a manifest gesture in the direction of P.T. Barnum, a "humbug."[19] That this is what greatness *is*—that greatness is not only not distinguishable from make-believe and from humbug, but is in fact necessarily dependent upon them, is the somewhat tendentious starting point of this essay.

Dorothy wants—or thinks she wants—to go home to Aunty Em, to return from the technicolor splendors of Oz to the sepia "reality" of Kansas. The customers in Genet's brothel are sent home to a "real" world that is a pale copy of their fantasies. I want now to point out that the uncanniness of the return home, the simultaneity, in Freud's by-now familiar argument, of the *heimlich* and the *unheimlich*, the home-like and the uncanny, "something familiar and old-established . . . that has been estranged by the process of repression," is persistently literalized in contemporary American culture through the figure of baseball, another fantasy world or *field of dreams*, in which "greatness" is figured as

the capacity to control the return home, through the agency of the "home run."

A good and rather unexpected example of this appears in the 1991 film *Hook*, made by America's own Oz figure, Steven Spielberg, as a rewriting of *Peter Pan* for our time. For me, Spielberg's film lost all the magic of the original, not incidentally because of the "normalization" of Pan in the figure of a childish middle-aged male actor, Robin Williams, rather than a woman cross-dressed as the eternal boy. (Though, of course, Williams did his cross-dressing in another film, *Mrs. Doubtfire*, where he played the Nanny, not the child.) But in a crucial moment in *Hook*, when Peter's son Jack has been captured, Hook attempts to seduce his affections by replaying a scene in which the "real" father, Peter Banning/Robin Williams, failed his son by not showing up at a baseball game. The son struck out; the team lost. Captain Hook restages the baseball game in Neverland, with Jack as the hero, and posts his pirate minions in the crowd with placards. Each pirate holds a card with a letter, and the sequence is intended to spell out the slogan, "Home Run, Jack." But the pirates, being British rather than American, are unfamiliar with the terminology of the game, and get their terms confused. Instead of "Home Run, Jack," the hortatory message that greets the batter at the plate is the subliminal one that surfaces: "Run Home, Jack." Run Home, Jack. A great deal of the film turns on the question of which place *is* home; "I *am* home," the son will defiantly tell his father, flushed with the pleasure of the ball game, and the home run, in Neverland.

In the 1989 movie *Field of Dreams*, the protagonist's unconscious desire to recuperate his relationship with his dead father is accomplished through the mediation of the father's own baseball hero, Shoeless Joe Jackson, the star player unfairly disgraced, debarred from heroism, greatness, and professional baseball itself by the Black Sox scandal of 1919. Building his baseball field in the middle of an Iowa cornfield ("Toto, I think we're not in Kansas anymore") he too restages an American drama of greatness: Shoeless Joe and the Black Sox get to play baseball again, reversing the ban placed on them by the baseball commissioner, and the dead father returns as a young man in baseball uniform to play catch with his (now-grown) son. (It is of some small interest that the ghostly baseball players, returning to the boundary of the cornfield into which they disappear each evening after the game, jokingly call out to the living spectators in a famous phrase from *The Wizard of Oz*, "I'm melting, I'm melting"—the last words of the wicked witch.)

Furthermore, this configuration of the baseball commissioner, the banned and disgraced hero, and the fantasy of return ("Run Home, Jack") is not, of course, only a story of the distant past. For the story itself subsequently returned, in the controversy between Cincinnati Reds baseball star Pete Rose, banned from professional baseball for allegedly betting on games, and the Commissioner who banned him, the late A. Bartlett Giamatti. The confrontation between the two men was dramatic, based and grounded (so to speak) in notions of greatness and of mimesis. Could a man be a sports hero, especially for children, when he violated baseball's cardinal rules? Terms like "authenticity," "idealism," and "integrity" were, said Giamatti, at stake, so that it was necessary for Rose to be "banished" from baseball forever. The tough, eloquent stance Giamatti took on the Rose case "elevated" him, wrote James Reston Jr., "to heroic stature in America. By banishing a sport hero, he became a moral hero to the nation."[20]

Seven days after Giamatti's dramatic announcement he himself was dead, of a heart attack. When the news of his death reached the denizens of a Cincinnati sports bar, flashed over the television screen, Rose fans broke out in a chorus from the *Wizard of Oz*: "Ding, dong, the witch is dead, the wicked, wicked, witch is dead...."[21] (We may notice the gender implications and complications here; as Giamatti is demonized he is also feminized.) But subsequently, the issue of Rose's banishment from baseball was revived, specifically with regard to the question of "greatness." Should Pete Rose be forever banned, not only from baseball, but also from its Hall of Fame? *New York Times* sports columnist Dave Anderson, among others, thought not: the "best interests of baseball," he wrote, citing Giamatti's own phrase, would be served by Rose's election to the Hall of Fame.[22]

Bart Giamatti is described on the jacket blurb of his baseball book *Take Time for Paradise* as "a Renaissance scholar and former President of Yale University and of the National League." (That this can be offered not as a zeugma but as a simple compound tells its own, fascinatingly American, story.) "When A. Bartlett Giamatti died," wrote *U.S. News and World Report* in a quotation given prominent place on the front cover of the paperback edition, "baseball lost more than a Commissioner. It lost an expositor. A philosopher. A poet. A high priest. Giamatti plays all of those positions with distinction in *Take Time for Paradise*." Notice, if you will, the nice crossover phrase "plays all of those positions." Giamatti is both philosopher and utility infielder. And, since his book is published

posthumously, he is also, and very effectively, its immanent and ghostly figure of pathos.

Take Time for Paradise begins with a quotation from Shakespeare's Prince Hal ("If all the world were playing holidays, to sport would be as tedious as to work") which is all the more striking for its relevance to the concept of "banishment" in the *Henry IV* plays (and in *Richard II*). It ends with Aristotle on mimesis, cited, purposefully, in the chatty style of present-tense baseball talk, "the tone and style of our national narrative,"[23] a style, says Giamatti, "almost Biblical in its continuity and its instinct for typology":

> So . . . I'm standing in the lobby of the Marriott in St. Louis in October of '87 and I see this crowd, so happy with itself, all talking baseball . . . working at the fine points the way players in the big leagues do, and it comes to me slowly, around noon, that this, *this,* is what Aristotle must have meant by the imitation of an action.

This (*this*) is the end of Giamatti's book. *Politics* for him—glossed both from Aristotle's *Politics* and etymologically from its roots in *polis,* "is the art of making choices and finding agreements in public,"[24] and baseball "mirrors the conditions of freedom for Americans that Americans ever guard and aspire to, so that "to know baseball is to aspire to the condition of freedom, individually, and as a people."[25] In Giamatti's reading of baseball not only Aristotle but Western culture is itself confirmed in its centrality: "Before American games are American, they are Western."[26] It is, I think, thus highly significant that Giamatti should choose to frame this humanist argument in a selective reading of the concept of *home.*

The crux of Giamatti's argument centers around nostalgia, around the *nostos,* the classical figure of return, and its relationship to "home plate, the center of all the universes, the *omphalos,* the navel of the world." "In baseball," he writes, citing the description of this "curious pentagram" from *The Official Baseball Rules,* "everyone wants to arrive at the same place, which is where they start."[27] And "everyone" is a version of the classical hero. "Home is the goal—rarely glimpsed, never attained—of all the heroes descended from Odysseus."[28] "As the heroes of romance beginning with Odysseus know, . . . to attempt to go home is to go the long way around, to stray and separate in the hope of finding completeness in reunion."[29]

Giamatti dramatizes his analogy with the empathic energy of identification. "Often the effort fails, the hunger is unsatisfied as the catcher bars fulfillment, as the umpire-father is too strong in his denial, as the impossibility of going home again is reenacted."[30] "Or if the attempt . . . works, then the reunion and all it means is total—the runner is a returned hero."[31] "Baseball is a Romance epic . . . finally told by the audience . . . the Romance Epic of homecoming America sings to itself."[32]

And what is *home*? "*Home*," says Giamatti, "is an English word virtually impossible to translate into other tongues. No translation catches the associations, the mixture of memory and longing, the sense of security and autonomy and accessibility, the aroma of inclusiveness, of freedom from wariness, that cling to the word *home*. . . . *Home* is a concept, not a place; it is a state of mind where self-definition starts; it is origins—the mix of time and place and smell and weather wherein one first realizes one is an original, perhaps *like* others, especially those one loves, but discrete, distinct, not to be copied. Home is where one first learned to be separate and it remains in the mind as the place where reunion, if it were ever to occur, would happen."[33] And for Giamatti home is the space of baseball, and middle-America—the Marriott in St. Louis—and of "the Greeks." "Ancient," he says, "means Greek, for us."[34]

Home, in short, is *Homer*, a name that has become in baseball parlance both a noun and a verb, signifying the ultimate achievement, the fulfillment of desire. To homer—to hit a homer—is to be a hero, to go home again.

Bart Giamatti was the founder of Yale's great books course on the Western tradition from Homer to Brecht and the author of a study of the earthly paradise in the Renaissance epic. He was a premier and eloquent defender of the concept of "humanism" in literary studies, and an explicit champion both of the traditional literary canon and—as these quotations will have demonstrated—the capacity of "great literature" to inform and shape "human life."

The ideology of "greatness"—an ideology that claims, precisely, to transcend ideological concerns and to locate the timeless and enduring, the fit candidates, though few, for a Hall of Fame, whether in sports or in arts and letters—is, in fact, frequently secured with reference to a philology of origins. Yet a specific examination of the relationship of philology to the politics of mimesis yields, as well, some interesting complications.

Consider the case of Erich Auerbach's landmark study, *Mimesis: The*

Representation of Reality in Western Literature, a study that takes as its start-ing point a sustained meditation on the concept of Homer and "home." "Readers of the *Odyssey*," the book begins, without preamble, "will remember the . . . touching scene in book 19, when Odysseus has at last come home." But where is "home" for Erich Auerbach?

A distinguished professor of romance philology who concluded his career as Sterling Professor at Yale, Auerbach was a Jewish refugee from Nazi persecution who was born in Berlin. Discharged from his position at Marburg University by the Nazi government, he emigrated to Turkey, where he taught at the Turkish State University, until his move to the United States in 1947. His celebrated book, *Mimesis*, was written in Istanbul in the period between May 1942 and April 1945. It was pub-lished in Berne, Switzerland, in 1946, and translated into English for the Bolligen Series, published by Princeton University Press, in 1953. The politics of *Mimesis* were thus, at least in part, a politics of exile—and a politics of *nostos* and nostalgia. "Home" was the Western tradition, and the *translatio studii.*

In his Epilogue to *Mimesis*, Auerbach is at pains to point out that "the book was written during the war and at Istanbul, where the libraries are not well equipped for European studies." Thus, he explains, his book necessarily lacks footnotes, and may also assert something that "modern research has disproved or modified."[35] Yet, he remarks, "it is quite pos-sible that the book owes its existence to just this lack of a rich and spe-cialized library. If it had been possible for me to acquaint myself with all the work that has been done on so many subjects, I might never have reached the point of writing."

This last sentiment—that reading criticism and scholarship may sometimes impede the creative process—will doubtless be familiar to all graduate students embarking on the writing of a Ph.D. thesis. Yet, as we will see in a moment, it is also strikingly similar to a certain tactical enhancement of "great literature" and "greatness" in general through the evacuation of historical context. I want to suggest that the absence of a critical apparatus in a book on the evolution of the great tradition in Western letters is something more, or less, than an accident of his-torical contingency. Auerbach's research opportunities were limited by his circumstances; his choice of topic was not. The scholar who would later write that "our philological home is the earth; it can no longer be the nation,"[36] sustained his argument through a selection of texts that he alleges were "chosen at random, on the basis of accidental

acquaintance and personal preference."[37] Out of this came a book which claimed, and has been taken, to set forth "the representation of reality in Western literature."

Edward Said has noted that Auerbach's alienation and "displacement" in Istanbul offers a good example of the way in which *not* being "at home" or "in place" with respect to a culture and its policing authority can enable, as well as impede, literary and cultural analysis.[38] But what for Erich Auerbach was a wartime necessity became, for a group of U.S.–based scholars in the same period, a democratic principle of pedagogy.

Let us now move, profiting from Giamatti's and Auerbach's speculations on home and Homer, to a consideration of the specific kind of "greatness" embodied in the concept of the Great Books, the cultural heroes of our time for pundits from Allan Bloom to Harold Bloom. To study "Greats" at Oxford and Cambridge is to read the ancient classics; for this generation of Americans, however, the greats have been updated—slightly.

In search of some wisdom on this topic—of what makes the great books great—I decided to consult the experts: specifically, the editors of the Encyclopedia Britannica Great Books Series, more accurately described as the *Great Books of the Western World,* first collected and published in 1952 in a Founders' Edition under the editorship of Robert Maynard Hutchins and Mortimer J. Adler.

Hutchins's prefatory volume, entitled *The Great Conversation,* makes it clear that, at least in 1952, "There [was] not much doubt about which [were] the most important voices in the Great Conversation."[39] "The discussions of the Board revealed few differences of opinion about the overwhelming majority of the books in the list," which went from Homer to Freud. "The set" wrote Hutchins, "is almost self-selected, in the sense that one book leads to another, amplifying, modifying, or contradicting it."[40] *The Great Conversation,* as Adler and his board conceived it, at the time of the election of President Eisenhower, was, it is not surprising to note, exclusively considered as taking place between European and American men, men who were no long living at the time they were enshrined in the hard covers of "greatness." The explicit politics of the edition was, nonetheless, aggressively democratic: no "scholarly apparatus" was included in the set, since the editors believed that "Great books contain their own aids to reading; that is one reason why they are great. Since we hold"—writes Hutchins—"that these works are

Introductory Volumes:
1. The Great Conversation
2. The Great Ideas I
3. The Great Ideas II

4. HOMER
5. AESCHYLUS SOPHOCLES EURIPIDES ARISTOPHANES
6. HERODOTUS THUCYDIDES
7. PLATO
8. ARISTOTLE I
9. ARISTOTLE II
10. HIPPOCRATES GALEN
11. EUCLID ARCHIMEDES APOLLONIUS NICOMACHUS

12. LUCRETIUS EPICTETUS MARCUS AURELIUS
13. VIRGIL
14. PLUTARCH
15. TACITUS
16. PTOLEMY COPERNICUS KEPLER
17. PLOTINUS
18. AUGUSTINE
19. THOMAS AQUINAS I
20. THOMAS AQUINAS II
21. DANTE
22. CHAUCER
23. MACHIAVELLI HOBBES
24. RABELAIS
25. MONTAIGNE
26. SHAKESPEARE I
27. SHAKESPEARE II

28. GILBERT GALILEO HARVEY
29. CERVANTES
30. FRANCIS BACON
31. DESCARTES SPINOZA
32. MILTON
33. PASCAL
34. NEWTON HUYGENS
35. LOCKE BERKELEY HUME
36. SWIFT STERNE
37. FIELDING
38. MONTESQUIEU ROUSSEAU
39. ADAM SMITH
40. GIBBON I

41. GIBBON II
42. KANT
43. AMERICAN STATE PAPERS THE FEDERALIST J. S. MILL
44. BOSWELL
45. LAVOISIER FOURIER FARADAY
46. HEGEL
47. GOETHE
48. MELVILLE
49. DARWIN
50. MARX ENGELS
51. TOLSTOY
52. DOSTOEVSKY
53. WILLIAM JAMES
54. FREUD

Opening endpapers to *The Great Books of the Western World.*

ANGEL
ANIMAL
ARISTOCRACY
ART
ASTRONOMY
BEAUTY
BEING
CAUSE
CHANCE
CHANGE
CITIZEN
CONSTITUTION
COURAGE
CUSTOM AND CONVENTION
DEFINITION
DEMOCRACY
DESIRE
DIALECTIC
DUTY
EDUCATION
ELEMENT
EMOTION
ETERNITY
EVOLUTION
EXPERIENCE

FAMILY
FATE
FORM
GOD
GOOD AND EVIL
GOVERNMENT
HABIT
HAPPINESS
HISTORY
HONOR
HYPOTHESIS
IDEA
IMMORTALITY
INDUCTION
INFINITY
JUDGMENT
JUSTICE
KNOWLEDGE
LABOR
LANGUAGE
LAW
LIBERTY
LIFE AND DEATH
LOGIC
LOVE
MAN
MATHEMATICS

MATTER
MECHANICS
MEDICINE
MEMORY AND IMAGINATION
METAPHYSICS
MIND
MONARCHY
NATURE
NECESSITY AND CONTINGENCY
OLIGARCHY
ONE AND MANY
OPINION
OPPOSITION
PHILOSOPHY
PHYSICS
PLEASURE AND PAIN
POETRY
PRINCIPLE
PROGRESS
PROPHECY
PRUDENCE
PUNISHMENT
QUALITY
QUANTITY
REASONING

RELATION
RELIGION
REVOLUTION
RHETORIC
SAME AND OTHER
SCIENCE
SENSE
SIGN AND SYMBOL
SIN
SLAVERY
SOUL
SPACE
STATE
TEMPERANCE
THEOLOGY
TIME
TRUTH
TYRANNY
UNIVERSAL AND PARTICULAR
VIRTUE AND VICE
WAR AND PEACE
WEALTH
WILL
WISDOM
WORLD

Closing endpapers to *The Great Books of the Western World.*

intelligible to the ordinary man, we see no reason to interpose our-
selves or anybody else between the author and the reader."

The assumption here was one of enlightened "objectivity": given a
handsomely produced, uniformly bound set of volumes vetted for
"greatness," the reader—unreflectively gendered male, an inevitable
commonplace of the times—would be able, the editors thought, with
the help of a curious kind of two-volume outline called the *Syntopticon*,
"which began as an index and then turned into a means of helping the
reader find paths through the books," to "find what great men have had
to say about the greatest issues and what is being said about these issues
today." A chief obstacle to this process, apparently, was what Hutchins
called, in a phrase later to be echoed by the likes of Bill Bennett and
Lynne Cheney, "the vicious specialization of scholarship." With the help
of this completely objective and apolitical edition "the ordinary
reader," we are assured, will be able to break through the obfuscating
barrier of "philology, metaphysics, and history," the "cult of scholar-
ship" that forms a barrier between him and the great authors. For
example, despite the huge "apparatus" of commentary surrounding
The Divine Comedy (an apparatus the "ordinary reader" has "heard of"
but "never used"), the purchaser and reader of the Great Books will be
"surprised to find that he understands Dante without it."

The end-papers of the *Great Books of the Western World,* uniform
throughout the 54 volumes, are themselves a treasure trove of informa-
tion. The first pair of end-papers, in the front of each volume, lists the
product being sold, and bought: "The Great Books of the Western
World" and the three introductory volumes that frame them, *The Great
Conversation, The Great Ideas I,* and *The Great Ideas II.* But what *are* the
Great Ideas? In case we are in any doubt, the editors conveniently list
them for us in the second set of end-papers, the ones that close the
book. Remember that this is an objective, non-political list, assembled
by editors who "believe that the reduction of the citizen to an object of
propaganda, private and public, is one of the greatest dangers to
democracy,"[41] and that "until lately" (again, 1952) "there never was very
much doubt in anybody's mind about which the masterpieces were.
They were the books that had endured and that the common voice of
mankind called the finest creations, in writing, of the Western mind."

The Great Ideas, the preoccupations of the great authors who wrote
the Great Books and participate in the ongoing Great Conversation in
which the ordinary citizen is encouraged to think he should also take

part—these Great Ideas are listed in the second set of end-papers in
alphabetical order, from Angel to World. I will restrict myself to two
comments about them, one of which will be quite self-evident, the
other, perhaps, less so.

You will notice that in the course of this list, which includes ideas like
Citizen, Constitution, Courage, Democracy, and Education, there ap-
pear, occasionally, words with a more disquieting ring: "evil," "pain,"
"contingency," "other," and the great cornerstone of individualism, and
therefore of humanist hero-making, "death."

But all of these words are tamed and contained—and here we should
indeed think of Cold War containment theory—by being presented as
part of a dyad. Angel, Animal, and Aristocracy stand alone; but Good
and Evil, Life and Death, Necessity and Contingency, One and Many,
Pleasure and Pain, Same and Other, Virtue and Vice, Universal and
Particular are tethered together like the horses of the charioteer. It is
perhaps too much to say that cutting free each of the dark twins in this
dyad would produce an entirely different profile of "great ideas" and
great books; but it is *not* too much to say that the last forty-odd years of
literary and cultural theory have explored, precisely, the dangerous
complacencies of these binarisms, the politics of their masquerade as
opposites rather than figures for one another, the master-slave relation
that informs them.

My second observation about "The Great Ideas" is one that addresses
the question of packaging. On one page of this list the ideas run alpha-
betically from Angel to Mathematics, and on the other they run from
Matter to World. In each case the list fills up the entire page, with one
decorative squiggle at the beginning, and one at the end. Angel to
Mathematics, Matter to World. It is of some small interest, however, that
the two series volumes that contain the Great Ideas, the *Syntopticon*
Volumes I and II, choose slightly different moments to begin and end.
Volume I ends not with Mathematics but with Love; Volume II thus
starts with Man.

Volume I: Angel to Love; Volume II: Man to World. You'll have to
admit this gives a somewhat different spin to the alphabetical iconogra-
phy of greatness. Matter and Mathematics are worthy enough cate-
gories in themselves, but seem somehow so material, lacking the
humanist grandeur of Love and Man. Nor is this an accident of division
based upon the length of the individual articles. Angel to Love, Chap-
ters 1 to 50, the contents of volume one, covers 750 pages; Chapters 51

to 102, Man to World, in the second volume, covers 809 pages. It seems reasonable to think that an editorial decision has been taken—and a perfectly appropriate one, given the presumptions of the Great Books project. The titles of the prefatory volumes will be an icon of the whole.

The very trope usually ascribed to deconstructors, and to a deconstructive playfulness, the trope of chiasmus, is here quietly employed to anchor the ideology of the series; the relationship of "Man" to "Love" (*not* the relationship of "Matter" to "Mathematics") will serve as a fulcrum, a micro-relation mediating the macro-relation of "Angel" to "World." Readers of Tillyard's *Elizabethan World Picture* and Lovejoy's *Great Chain of Being* will here recognize a familiar structure. But what I find so scandalous about this whole enterprise is its blithe claim that the absence of a scholarly apparatus is *preferable* because, apparently, *non-ideological.*

I quote again from Hutchins's Preface: "We believe that the reduction of the citizen to an object of propaganda, private and public, is one of the greatest dangers to democracy. . . . The reiteration of slogans, the distortion of the news, the great storm of propaganda that beats upon the citizen twenty-four hours a day all his life long mean either that democracy must fall a prey to the loudest and most persistent propagandists or that the people must save themselves by strengthening their minds so that they can appraise the issues for themselves."[42] And again, "The Advisory Board recommended that no scholarly apparatus should be included in the set. No 'introductions' giving the Editors' views of the authors should appear. The books should speak for themselves, and the reader should decide for himself."[43] Angel to Love; Man to World.

I want now to turn to another crucial text of the same year, 1952, a work not included in Hutchins and Adler's Great Books series, but one that I myself consider a foundational mid-century American text for the making of the hero—and the theorization of fame and greatness—through an effectively placed, media-wise sound-bite: the book is E.B. White's *Charlotte's Web.*

You will recall that in White's tale Wilbur, the innocent, unworldly pig, is threatened by a "plot"[44] to turn him into smoked bacon and ham. "There's a regular conspiracy around here to kill you at Christmastime," an old sheep tells him, complacently. "Everybody is in on the plot"—the farmer, the hired hand, and, unkindest cut of all, the allegorically named John Arable, whose daughter Fern was Wilbur's first foster-mother, and who is himself now—according to the old

sheep—about to arrive, shotgun in hand, to slaughter Wilbur the pig in time for the holidays.

As we shall see, Wilbur's story is a classic fable of nature and culture, or of the transition from the Imaginary to the Symbolic. The dyadic, prefallen, and pre-oedipal world inhabited by Wilbur and Fern Arable, in which the infant Wilbur is fed with a bottle like a human baby and wheeled about in a baby carriage, is disrupted by farmer Arable's decision that "Wilbur is not a baby any longer and he has got to be sold." The purchaser, a near-neighbor and relation, is John Arable's brother-in-law, Homer Zuckerman.

Nature and Homer were, he found, the same, says Pope of the poet of the *Georgics*, but for Wilbur the move down the road from *Arable's* farm to that of his brother-in-law *Homer*, is precisely a move from nature to culture.

With the threat of impending death, Wilbur is translated into a far more dangerous—but also potentially more heroic—world of language: a world, in fact, in which philology does produce a politics of mimesis. For it is in Uncle Homer's barn that he meets Charlotte the spider, whose instincts for publicity—and understanding of the way signification follows the sign—will be his salvation. Charlotte has a plan.

"Some Pig!" she writes neatly, in block letters, in the middle of her web, to be discovered in the morning by the hired hand. "Some Pig!" The word spreads quickly.

"Edith, something has happened," farmer Zuckerman reports to his wife "in a weak voice." "I think you had best be told that we have a very unusual pig."

> A look of complete bewilderment came over Mrs. Zuckerman's face. "Homer Zuckerman, what in the world are you talking about?" she said.
>
> "This is a very serious thing, Edith," he replied. "Our pig is completely out of the ordinary."
>
> "What's unusual about the pig?" asked Mrs. Zuckerman....
>
> "Well, I don't really know yet," said Mr. Zuckerman. "But we have received a sign.... [R]ight spang in the middle of the web were the words, 'Some Pig.' ... A miracle has happened and a sign has occurred here on earth, right on our farm, and we have no ordinary pig."
>
> "Well," said Mrs. Zuckerman, "it seems to me you're a little off. It seems to me we have no ordinary *spider*."
>
> "Oh, no," said Zuckerman. "It's the pig that's unusual. It says so, right there in the middle of the web."[45]

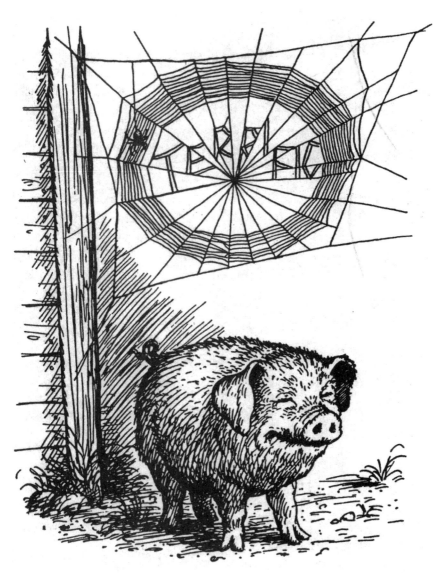

Wilbur the pig in E.B. White's *Charlotte's Web*, illustrations by Garth Williams.

Such is the power of publicity. "Some Pig" is, of course superbly cho-
sen as an epithet of praise, since it could mean anything, and shortly
does. "You know," muses Mr. Zuckerman this time in "an important
voice," "I've thought all along that that pig of ours was an extra good
one. He's a solid pig. That pig is as solid as they come."[46] "He's quite a
pig," says Lurvy the hired hand. "I've always noticed that pig." "He's as
smooth as they come. He's some pig." In days, the rumor has spread
through the county and "everybody knew that the Zuckermans had a
wondrous pig."

Philology enters the story explicitly through the quest for new signs,
new slogans, since "Some Pig!," though a good, all-purpose characteri-
zation, soon begins to seem stale, and other suggestions are sought
from the barnyard animals. What should appear next written in the
web? "Pig supreme" is rejected as too culinary in association—"It
sounds like a rich dessert," says Charlotte—but "terrific" will do, even
though Wilbur protests that he's *not* terrific. "That doesn't make a par-
ticle of difference," replies Charlotte, "Not a particle. People believe
almost anything they see in print. Does anybody here know how to spell
'terrific'?"

But the chief agent of philological instrumentality is the barn's resi-
dent research assistant, Templeton the Rat, whose nocturnal foraging
in the local dump produces scraps of paper, advertisements torn from
old magazines, that will provide Charlotte with something to copy. Not
every piece of research pays off. "Crunchy" (from a magazine ad) and
"Pre-Shrunk" (from a shirt label) are both discarded as inappropriate
to a discourse of fame and transcendence. "Crunchy," says Charlotte, is
"just the wrong idea. Couldn't be worse. . . . We must advertise Wilbur's
noble qualities, not his tastiness." But a package of soap flakes in the
woodshed produces a winner: "With New Radiant Action."

> "What does it mean?" asked Charlotte, who had never used any soap
> flakes in her life.
> "How should I know?" said Templeton. "You asked for words and I
> brought them. I suppose the next thing you'll want me to fetch is a dic-
> tionary."

Together they contemplate the soap ad, and then they send for Wilbur
and put him through his paces. This is the mimesis test. "Run around!"
commanded Charlotte, "I want to see you in action, to see if you are

radiant." After a series of gallops, jumps, and back-flips, the brain trust of the spider and the rat decide that, if Wilbur is not exactly radiant, he's close enough.

"Actually," said Wilbur, "I *feel* radiant." "Do you?" said Charlotte, looking at him with affection, "Well, you're a good little pig, and radiant you shall be. I'm in this thing pretty deep now—I might as well go the limit."[47]

In sequence, then, the web declares Wilbur to be "Some Pig!," "Terrific," "Radiant," and finally, "Humble," a word Templeton finds on a scrap of folded newspaper, and which Charlotte glosses for him: "'Humble' has two meanings. It means 'not proud' and it means 'near the ground.' That's Wilbur all over. He's not proud and he's near the ground."

Charlotte the spider, indeed, is the book's learned philologist, the erudite definer of terms like "gullible," "sedentary," "untenable," and "versatile," a scholar whose Latin is as good as her English. She describes her egg sac as her *magnum opus*, explaining to Wilbur, whose Latin is weak, that a magnum opus is a great work. (Neither Wilbur nor Charlotte seem to speak Pig-Latin, the obvious lingua franca for the great conversation in the barnyard.) And as this concept of a great work implies, Charlotte is also, ultimately, the book's figure of humanist aesthetic pathos, a self-described writer for whom "Humble" is "the last word I shall ever write," whose own death displaces Wilbur's and preserves him as a hero, as "Zuckerman's Famous Pig."

We noted a moment ago that the name of Wilbur's new owner, Homer Zuckerman, introduced into this little fable a tonic note of culture and, indeed, of both the Great Books and the paternal Law. That this Homeric nomination is not entirely trivial—that I am not entirely wasting your time with these onamastic skirmishes—may be discerned by considering again the identity of the media agent in Wilbur's story, the resourceful Charlotte, a spider with a magic web.

For Charlotte, this uncanny precursor of the modern "spin-doctor," the media-manipulator for political figures, is also, classically, a Penelope, weaving and unweaving her web, creating headlines that guarantee Wilbur not only his fifteen minutes of fame but also his life.

"The dissimulation of the woven texture can in any case take centuries to undo its web; a web that envelops a web, undoing the web for centuries." This is Derrida at the beginning of "Plato's Pharmacy," an

essay that also begins with philological explorations, with the multiple meanings of *histos*, which means at once *mast, loom, woven cloth,* and *spider's web.* Both mast and loom; that is, both the story of Odysseus (bound to the mast, hearing the Sirens) and the story of Penelope (weaving and unweaving her web).[48] (Is it an accident that this is also the design of Auerbach's *Mimesis*—from "Odysseus' Scar" to Mrs. Ramsay's "Brown Stocking"? A coincidence, certainly; but perhaps not altogether an accident.)

Recall, if you will, the completely disregarded observation of Mrs. Zuckerman, on hearing the news of the miraculous web, that what they had was "no ordinary *spider*," not, as her husband claimed, "no ordinary pig." Oh no, he assured her; the spider was quite ordinary, a common gray spider. It was the pig who was remarkable, terrific, radiant. It said so quite clearly in the web. The text is indeed dissimulated behind the self-evidence of its message.

> Ever since the spider had befriended him, [Wilbur] had done his best to live up to his reputation. When Charlotte's web said SOME PIG, Wilbur had tried hard to look like some pig. When Charlotte's web said TERRIFIC, Wilbur had tried to look terrific. And now that the web said RADIANT, he did everything possible to make himself glow.
> It is not easy to look radiant, but Wilbur threw himself into it with a will.[49]

"Ladeez and gentlemen," blared the loud speaker at the County Fair, "we now present Mr. Homer L. Zuckerman's distinguished pig. The fame of this unique animal has spread to the far corners of the earth. . . ." "In the words of the spider's web, ladies and gentlemen, this is some pig." "This magnificent animal," continued the loudspeaker, "is truly terrific." "Note the general radiance of this animal! Then remember the day when the word 'radiant' appeared clearly on the web. Whence came this mysterious writing? Not from the spider, we can rest assured of that. Spiders are very clever at weaving their webs, but needless to say spiders cannot write."[50]

Now, if Charlotte is a humanist, she is also a feminist. Wilbur naively but unerringly recognizes the physical stigmata of feminism, as described in the popular magazines of today. "You have awfully hairy legs," he says to her soon after they meet.[51] Feminist theologian Mary Daly has claimed Charlotte as a fellow Spinster, tracing her ancestry from Arachne and the Spider Woman of Navaho myth, and lamenting the

apparent role of the mythic female spider, however powerful, as merely the accomplice and the public relations agent of the male hero's fame.

Daly's chief target here, and one worth attacking, is Joseph Campbell, the arch-archetypalist who is also the source for her account of the Spider Woman myth. "Spider Woman with her web can control the movements of the Sun," writes Campbell. "The hero who has come under the protection of the Cosmic Mother cannot be harmed."[52] Mary Daly would prefer a more female-affirmative fable. "Is Wilbur worth it?" she asks. And "what if the aided pig had been Wilma or Wilhelmina?"[53] For her, Spinsters, taking their cue from "the complex and fascinating web of the spider," can spin ideas about such interconnected symbols as the maze, the labyrinth, the spiral, the hole as mystic center . . . to weave and unweave, dis-covering hidden threads of connectedness."[54]

Reference to the figure of the female spider (who weaves and un-weaves; who mates and kills) appears over and over again, symptomati-cally, in stories of the making of cultural heroes, from Freud's essay on "Femininity" to *The Wizard of Oz* to Darwin to *Goodbye, Mr. Chips*. Despite Joseph Campbell, it is clear that the spider's transgressive and sexual-ized power, and, indeed, her relationship to the psychoanalytic figure of the phallic woman, renders her potentially threatening as well as nurtu-rant. The cultural permutations of the Spider Woman myth in the twen-tieth century have been manifold, from individual erotic power (the vamp of German expressionism and film noir) to communal social heal-ing (the AIDS quilt). Shakespeareans will recognize the uncanny and ambivalent power of magic in the web, and of the spider in the cup. In Genet's *Balcony,* the powerful fantasmatic Queen, who never appears, is described as "embroidering and not embroidering," "embroidering an invisible" (and an "interminable") "handkerchief." In Manuel Puig's novel *The Kiss of the Spider-Woman*, the "spider woman" is a powerful, transgendered storyteller, an imprisoned gay man who sometimes calls himself a woman, and who "embroiders" (the word is literally used) the movie plots which are his own version of Penelope's web.

But my point here is that Charlotte's web, like the prisoner Molina's, frames the sign: produces an object of desire, Wilbur, who seems to stand free of all the apparatus that produces him, like the Wizard of Oz, like the apparently free-standing Great Books that are, similarly, show-cased as self-evidently great, decontextualized and made into icons. Wilbur—TERRIFIC, RADIANT, AND HUMBLE—emerges as some-thing like the ideal political candidate, with only invisible strings attached.

Wilbur himself, we might note, makes one vain attempt to spin a web, to become himself the self-sufficient spider-artist (albeit with string attached), under Charlotte's indulgent direction, climbing to the top of a manure pile with a string tied to his tail. "You can't spin a web, Wilbur," counseled Charlotte after this sorry adventure, "and I advise you to put the idea out of your mind. You lack two things needed for spinning a web.... You lack a set of spinnerets, and you lack know-how." Here again nature and culture, or biology and destiny, are linked together. Pigs, it seems, can't fly.

Or can they?

For a generation brought up on *Charlotte's Web*—for my generation—the intuition that Wilbur resembled a political candidate, and, in a way, the ideal political candidate, was literalized in one glorious gesture by Jerry Rubin and the Yippies. At the Democratic National Convention in Chicago in 1968 the Yippies—the Youth International Party—nominated a pig for president, with the campaign pledge "They nominate a president and he eats the people, We nominate a president and the people eat him."[55] Perhaps significantly, in the context of the rhetoric of nostalgia and the politics of mimesis, this pig had a classical name: "Pigasus." Who says that pigs can't fly? ("The time has come, The Walrus said /To talk of many things,/Of shoes—and ships—and sealing wax—/And cabbages and kings,/And why the sea is boiling hot,/And whether pigs have wings.")

The tangled web of philology and mimesis was actualized in the media-conscious sixties through a metonymic figure, that of the "network," an electronic web. As in all those old movies and newsreels, in which the concentric circles of radio signals were seen to spread out across the country in a widening ripple effect, the spin-doctors of media culture dissimulated their messages.

"*We have to be very clear on this point,*" wrote Richard Nixon's speech-writer Raymond Price, "*that the response is to the image, not the man. . . .* It's not what's *there* that counts; it's what's projected." "Carrying it one step further," Price continued, "it's not what *he* projects but rather what the voter receives. It's not the man we have to change, but rather the *received impression.* And this impression often depends more on the medium and its use than it does on the candidate himself."[56]

As we have just seen in the case of Wilbur.

To us this is no longer a surprise. The use of advertising in political campaigns is by now a commonplace; the *Boston Globe,* for example, cur-

rently features a regular column called "Advertising Watch" in which
campaign commercials are described, named (each has a title, like that
of a short subject or a feature film) and analyzed for truth and political
effectiveness. The work of Michael Rogin, among others, has described
"Ronald Reagan, the Movie" as a commodified, empty fiction. But there
was a time when political advertising, and the involvement of ad men in
political campaigns, was not only surprising but transgressive—and, if
you were an ad man, both exciting and lucrative.

Journalist Joe McGinniss himself became a "nonfiction star of the
first rank"—according to the bio-blurb on his book—when he wrote
The Selling of the President, the book that exposed to the general reading
public "the marketing of political candidates as if they were consumer
products," "selling Hubert Humphrey to America like so much tooth-
paste or detergent."[57] Or, again, remembering the radiant Wilbur, like
soap flakes. McGinniss chronicled in fascinated—and fascinating—
detail the machinations of men like Raymond Price, Roger Ailes,
Leonard Garment, and Frank Shakespeare in the packaging of Richard
Nixon. (For me there is a certain pleasure even in the accident of these
names: Price, Garment, Shakespeare, the very allegorical structure of
hero-making.)

The element of "Some Pig" in the Nixon success story is consider-
able; the back-room boys' work on Nixon's "personality problems," on
his "lack of humor," on his need to concoct some "memorable phrases
to use in wrapping up certain points,"[58] and so on. Sound bites are very
much at issue, as are their visual counterparts, "photo opportunities." At
the end of a staged television panel discussion—one of a number sched-
uled coast to coast throughout the campaign—"the audience charged
from the bleachers, as instructed. They swarmed around Richard Nixon
so that the last thing the viewer at home saw was Nixon in the middle of
this big crowd of people, who all thought he was great."[59]

Once again, as with the words in Charlotte's web, as with Angel to
Love and Man to World, let us focus on the framing of the sign.

Advertising executive Harry Treleaven, a mastermind of Nixon's first
successful campaign, submitted a passionate memo explaining "Why
Richard Nixon Should Utilize Magazine Advertising in the State of New
Hampshire Primary." "This writer believes firmly that the chances of
overcoming Richard Nixon's cold image and the chances of *making* him
loved and *making* him glamorous via commercial exposure on television
(where admittedly he has not been at his best) are far less than the

chances of *making* him loved and *making* him glamorous via saturation exposure of artfully conceived and produced four-color, full-page (or double spread) magazine advertisements. . . . Are women going to vote for a Richard Nixon they currently believe to be cold, unloving, un-glamorous? No. . . . But rich, warm advertising in a woman's own medium, the service magazine, next to her cake mixes and her lipstick advertisements will go a long way, I believe, toward making Mr. Nixon acceptable to female viewers. . . . Warm, human, four-color magazine illustrations depicting Dick Nixon the family man, perhaps even sur-rounded by his beautiful family, will allow the women of America, and, initially, the women of New Hampshire, to identify with him, and his home life. . . . This warm visual image . . . will sell his qualifications to voters who can study the advertisement leisurely in their home."[60] Here is that American "home" again, full of "warm, human, four-color . . . illustrations." Run home Dick. (Even real estate agents now sell "homes" rather than "houses"—at least in ads targeted to the middle-class "homeowner." This too, I think, is part of the contemporary rhetoric of nostalgia.)

"It's not what's there that counts, it's what's projected," wrote Raymond Price about candidate Nixon. This is a pronouncement strik-ingly similar to a remark by rock star George Michael: "It's not some-thing extra that makes a superstar," opined Michael, "it's something missing."

For me the question is really not one of elegiac loss, but of the politi-cal uses of nostalgia. Are great books most in need of being called "great" when their link with the culture is most tenuous? Has political life as we commonly understand it—from Wilbur to Nixon to Reagan and Bush and Clinton—become an arena in which what is *imitated* is mimesis? (Bush pretending that he buys his socks at JC Penneys in an attempt to stimulate the economy? Reagan "remembering" wartime events that he saw, or acted, in Hollywood B-pictures? Bill Clinton gain-ing political momentum from a photograph of him as a young boy shaking the hand of JFK, as if the ghost of the slain president were lit-erally "electing" or choosing his successor?) Is "greatness" largely or entirely an effect—and if so, what kind of effect? A stage effect, a psy-choanalytic effect—or an effect of nostalgia? It's not something extra, but something missing.

What is at issue is overcompensation, and an anxious fantasy of wholeness. As with Oz the Great and Terrible; as with Genet's Chief of

Police and his fantasy of the giant phallus. Mortimer Adler, updating his list of "Great Books, Past and Present" in 1988 lists 36 new white male authors who published between 1900 and 1945, and an additional 18 authors—also all male and all white—for the period 1945 to the present. But he is worried about his capacity to see clearly: "Could it be that my nineteenth-century mentality . . . blind[s] me to the merit of work that represents the artistic and intellectual culture of the last forty or so years?"[61] Adler's concern is that he may fail to identify some of the great works; but he is entirely convinced, not only that they are there to be found, but that "greatness" can be pinpointed, however tautologous the test. "If we say that a good book is a book that is worth reading carefully once, and that a better book than that—a great book—is one that is worth reading carefully a second or third time, then the greatest books are those worth reading over and over again—endlessly." And, he implies, we can make a list.

Wilbur, Oz, the Great Books, the Great Tradition. Greatness is an effect of decontextualization, of the decontextualizing of the sign—and of a fantasy of control, a fantasy of the *sujet supposé savoir*, of a powerful agency, divine or other. "If you build it, he will come." "A miracle has happened and a sign has occurred here on earth, right on our farm, and we have no ordinary pig." Someone knows; someone—someone *else*—is in control. The political logic of this is as disturbing as its psychology. It's a lesson that has not been lost on contemporary political "spinmeisters" from Reagan's Peggy Noonan to Bush's Lee Atwater to Clinton's technocratic masters of the Web.

"Good" books, like "competent" politicians, are in our inflated culture somehow not good enough. From the canon debate to the political arena, "greatness" has become an increasingly problematic standard. If we have greatness thrust upon us in either sphere, we should recognize it as an ideological category, a redundancy effect, a "recognition factor," as the pundits say. It seems clear that anxieties about greatness in literature are closely tied to anxieties about national, political, and cultural greatness, and that the more anxious the government, the more pressure is placed upon the humanities to textualize and naturalize the category of the "great." This is no reason to discard such a category entirely, even if it were possible to do so. But it is a good reason to be wary, and to pay some attention to that man behind the curtain—or, if anyone tries to sell you one, to be cautious about lionizing "some pig"— however terrific, radiant, and humble—in a poke.

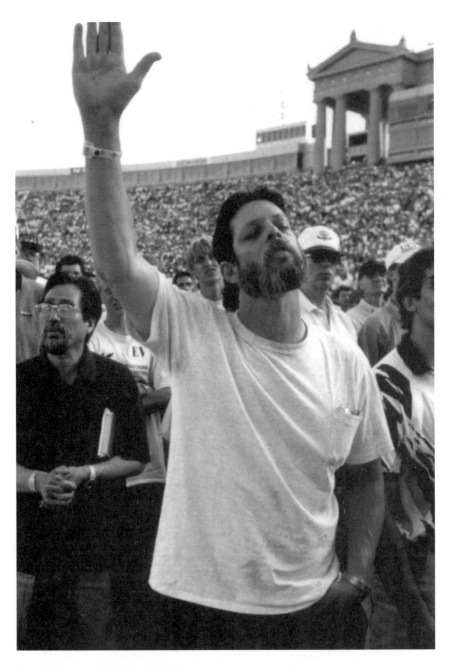

Promise Keepers rally, Soldier Field, Chicago.

II

Two-Point Conversion

Hail Mary. A last-second pass, usually thrown toward several receivers in an area near or across the goal line in the hope (and with a prayer) that one of them will catch it.

— *The Pro Football Fan's Companion*

I

The emblem of St. Lawrence, one of the most famous of Christian martyrs, is the gridiron. Little did this early deacon of Rome know how pertinent that symbol would become in the last decade of the 20th century, when football, its coaches, players, and stadiums have become major purveyors of public prayer. But these days the contest is not between the Christians and the lions. Instead the Christians *are* the Lions—and the Bears, and the Panthers, and the Jaguars, and the Saints. And—as we will see—the patriots.

Viewers tuning in at the end of the football playoff games in January 1997, might be pardoned for thinking they had inadvertently pushed the wrong button and wound up on Reverend Jerry Falwell's Christian television station. First, a Jacksonville Jaguars quarterback informed a sideline reporter that God was responsible for the Jags' victory. How did he account for his Cinderella team's success? "Thanks be to God," he said, "There's a bunch of guys on this team that really love the Lord." Then the New England Patriots' Keith Byars, on another network, began his postgame recap with "Thanks be to God from whom all blessings flow" before himself flowing seamlessly, as if it were not a change of

45

subject, into a detailed analysis of passes, tackles, and punts. Not to be outdone, Patriots' owner Bob Kraft came out as a Jew, confiding genially to a television interviewer that coach Bill Parcells had told him he had "something Kraft would appreciate" in his pocket. Turned out it was a 'chai, the Hebrew letter that means "life," a pendant given Parcells by a friend from New Jersey, and which he had kept pocketed during the Patriots' lopsided 28–3 victory over the Pittsburgh Steelers. Kraft appreciated the gesture, he said—even though the charm was upside down.

A photograph of a benignly bemused Parcells holding his 'chai in one vast hand was featured on the sports page of the *Boston Globe*, which described the "Hebrew 'chai' symbol" as one of Parcells's many "superstitions," noting that baseball player Wade Boggs, formerly of the Red Sox and now of the hated Yankees, draws a "chai" symbol "with his bat in the dirt prior to every at bat." (It is perhaps unnecessary to note that Boggs, like Parcells, is not Jewish.)[1]

Although I reveled, briefly, in this moment of ecumenical team spirit (what might be called "'chai society"), I was struck by the term "superstition." I wondered whether, if a Jewish professional ballplayer like Hank Greenberg or Sandy Koufax had—against all probability—drawn a cross in the dirt with his bat each time he stepped up to the plate Red Barber would have called it a "superstition." Certainly the word "superstition" is not routinely spoken by television sportscasters on those occasions when I have glimpsed a baseball player, often wearing a cross around his neck, make the sign of the cross before stepping into the batter's box.

As for Parcells, when asked whether (in view of the active discussion of religious faith on the part of players on both teams) he thought God would favor one side or the other, he replied judiciously: "No disrespect to anyone, but it usually works better when the players are good and fast."[2]

But the players' piety has attracted more attention than the coach's realism. "God has certainly played an important role on this football team," announced quarterback Mark Brunell to a reporter. "There's a lot of guys on this team who love Jesus. That's what's been exciting to me: to get to know these guys and play with them, but more importantly, to just get the chance to develop the friendship and closeness that you don't see in a lot of football teams right now."[3]

"I think there's probably 10 or 15 very committed guys on this foot-

ball team who love God and I firmly believe that's the reason for our success this year."

"God has had His hand on this football team, and the Bible says that He's looking around for people who are going to give glory to him and who are going to give Him credit. And this football team is doing that, and I think that's the reason for our success this year." (Note: the following weekend they lost to the New England Patriots.)[4]

Of course, the Jaguars are far from the only ostentatiously devout squad in the league. Members of the Fellowship of Christian Athletes are active in professional, as well as in high school and after-school, sports programs. The other successful 1996 NFL expansion team, the Carolina Panthers, was praised by hometown fans in Charlotte, North Carolina: "This is the Bible Belt, and we've got a praying team," said a waitress at a soul food restaurant near the stadium. Fundamentalist preacher Joseph R. Chambers viewed the Panthers as an affirmation of "conservative values" by "a conservative city that loves the churches on every corner."[5]

The Green Bay Packers' Reggie White has been an ordained minister since his college days at the University of Tennessee. During his years in the National Football League he moved from team to team on what is sometimes referred to as the Reggie White Traveling Ministry before settling with the Packers. "This guy," said a teammate, "is like God in pads. He's the most revered athlete I've ever been around."[6] Some critics took issue with his religious fervor when he declared that God had ordained the Packers' NFC championship victory because that was the role He had cast for them, but in general the media and the fans have shared his teammates' respect. "He rapidly converts the doubters," one sportswriter observed. No one, so far as I know, quoted Psalm 37, "I have seen the wicked in great power, and flourishing like a green bay tree" (Ps. 37:36).

On the eve of Super Bowl XXXI White requested air-time during the postgame ceremonies to say a public prayer before the assembled crowd, and perhaps on national television—if the Packers won. Asked about the precedent of giving a microphone to someone to espouse his private views, White professed surprise: "A lot of people ask me questions about football and religion," he said. "I don't see the problem. Most of you guys [sportswriters and media critics], when we get down in the end zone and pray or get together and pray on the field, you have a

real problem when it comes to that."[7] Other members of the Packers' God squad framed their desire for public prayer in terms of rights. "I think it's our right," said receiver Don Beebe. "That's our field. We play football on that field."

The NFL director of communications remarked that if anyone else also wanted to say a prayer to the crowd from the platform after the game there was not much the league could do about it, but another league official expressed concern that football fans might find themselves unwittingly and unwillingly listening to a televised sermon.[8] Is this a First Amendment issue? Or is the public to be protected from intrusive, perhaps even coercive, prayer?

After Green Bay's Super Bowl victory, jubilant fans displayed banners of coach Mike Holmgren, quarterback Brett Favre, star player (and minister) Reggie White, and legendary former coach Vince Lombardi, labeled, respectively, "the father, the son, the holy and the ghost." "It's a spiritual thing for me," said one woman who had waited hours (with 60,000 others of the faithful) at bitter cold Lambeau Field for the Packers' return. "This is God's team."[9]

The present trend for highly visible postgame prayer huddles in the NFL began with a December 1990 game between the New York Giants and the San Francisco 49ers at Candlestick Park. "Guys from both teams just wanted to make a statement," said 49ers tight end—and evangelical Christian—Brent Jones, who led a group of kneeling players at midfield. The game, which was televised on "Monday Night Football," set a trend in public piety. It's worth noting that the National Football League first opposed the idea, citing a league rule against opposing players "fraternizing" on the field, but an NFL official reversed the ruling after contemplating "the public relations fiasco that would follow a crackdown on prayer." Former 49er Bubba Paris, now an ordained minister and Bible teacher, noted that "you find more Christians on teams with more black players."[10] By "Christians" here, Paris, and many others, mean "evangelical" or "Pentecostal" or "born-again" Christians, who are often more comfortable with public demonstrations of faith than are mainline Protestants or Roman Catholics.

Indeed, Christianity and sports have long been regarded in certain parts of the United States as not only compatible but boon companions. It's no accident that the Super Bowl is played on a Sunday.

"Your Son is our quarterback and You are our coach," intoned the Catholic Archbishop of Miami before a Dolphins football game in the seventies. "We sometimes get blitzed by heavy sorrows or red-dogged by

Satan," announced the Archbishop, to the irreverent pleasure of a staff member for the *National Catholic Reporter.* "Teach us to run the right patterns in our life so that we will truly make a touchdown one day through the heavenly gates, as the angels and saints cheer us on from the sidelines."[11] Opinions differ as to which position is the most appropriate for the Heavenly Superstar.

If Jesus played football,
he'd be an end.

begins a poem by Bill Heyen

After his shower, he'd appear to us
to pose with us for pictures by his side.[12]

Or, as the country music song has it, "Drop Kick Me Jesus Through the Goal Posts of Life."

Some have suggested that He plays other sports. Baseball star Brett Butler testified, "I believe that if Jesus Christ was a baseball player he'd go in hard to break up the double play and then pick up the guy and say, 'I love you.'"[13]

The Christian sports connection is not exclusively high- or low-church, Catholic or Protestant. The football stadium at Notre Dame is presided over by a huge library mural known as "Touchdown Jesus." In the chapel of the University of the South in Sewanee, Tennessee, is a stained glass window displaying a figure in the vestments of an Episcopal bishop, holding a football in one hand and the Book of Common Prayer in the other. At his feet is a baseball, and a baseball bat is propped against the frame.[14] The Episcopal Cathedral of St. John the Divine contains a sports bay, dedicated in 1928 to such worldly athletes as Hobey Baker, Walter Camp, and Christy Mathewson, which mingles these football and baseball heroes with biblical scenes like Jacob wrestling with the angel.[15]

It is in the evangelical churches and movements, however, that sports and religion have been most directly linked in this century, through the rise of what is now quite frankly described as "sports evangelism." So-called "muscular Christianity," of the sort touted by baseball player-turned-evangelist Billy Sunday, loudly refuted the idea that Jesus was a weakling, a man of sorrows, a loser. "I press toward the mark for the prize of the high calling of God in Christ Jesus" (Philippians 3:14) has

been described as the verse that has become "the keystone of muscular Christianity."[16] Athletic skill was a kind of Christian witness, while cheering crowds blended their enthusiasm for sports and—and as—religion.

Christian evangelists in the early and middle part of the century deliberately made use of sporting events and sports celebrities to attract crowds, and especially to win over young men to the cause. The athlete and preacher Gil Dodds ran six laps around the assembled faithful to kick off Billy Graham's revival movement in 1947. Graham himself underscored the disturbing and by now virtually inevitable association of sports, religion, and patriotism, remarking during the Vietnam War that "People who are carrying the Viet Cong flag around the country are not athletes. If our people would spend more time in gymnasiums and on playing fields, we'd be a better nation!"[17]

Today members of the Fellowship of Christian Athletes bear witness to their faith at sporting events and clinics—sometimes to the dismay of the parents of Little Leaguers inadvertently made to attend a religious rally. It's part of what Frank Deford called "sportianity," in a *Sports Illustrated* article rather pointedly called "Endorsing Jesus."[18]

"Athletics," declared evangelist and educator Oral Roberts, "is part of our Christian witness.... Nearly every man in America reads the sports pages, and a Christian school cannot ignore these people. Sports are becoming the No.1 interest of people in America." Sports evangelism, in fact, is a booming business these days. An article suitably titled "From Muscular Christians to Jocks for Jesus" published in *Christian Century* in 1992 noted that "the press and public have struggled to make sense of the increasing number of elite athletes who proclaim their faith in Jesus."[19] Robert Higgs's *God in the Stadium* reported on the Annual Sports Outreach America conference on sports evangelism. For 1995 Super Bowl Sunday, Higgs reports, the Sports Outreach program distributed a twelve-minute video of religous testimony offered by NFL players, which was "shown on huge screens set up in churches for this purpose and for presentation of the game."[20] It doesn't take much to see that "sports evangelism" on television is a version of televangelism, and indeed, as Higgs points out, conservative ministers like Falwell, Roberts, and Pat Robertson are vociferous sports boosters, following in the evangelical footsteps of Billy Sunday and Billy Graham.

This has led to some lively exchanges between church and state, or, at least, between religion and law. Irritated at the theatrical display that had become common practice among players who scored touchdowns, the National Collegiate Athletic Association tried, in 1995, to enforce a

"no-gloating" rule prohibiting self-congratulatory victory demonstrations in the end zone. But it soon found itself on the receiving end of a lawsuit from the Rev. Jerry Falwell's Liberty University, whose team customarily knelt in gratitude to thank God for enabling them to score. Liberty's evangelical Christians sued on the grounds that the prohibition violated the 1964 Civil Right Act and was a form of religious discrimination. The NCAA, fearing that it would be targeted as an enemy of gridiron prayer, revised its ruling to allow players to pray if they did so discreetly: "Players may pray or cross themselves without drawing attention to themselves," wrote Vince Dooley, chairman of the NCAA Football Rules Committee, in a memo to coaches. "It is also permissible for them to kneel momentarily at the conclusion of a play, if in the judgment of the official the act is spontaneous and not in the nature of a pose."[21] How this distinction would be regulated in church, much less on the football field, was never explained.

As Wendy Kaminer suggests, "Secularists are often wrongly accused of trying to purge religious ideas from public discourse. We simply want to deny them public sponsorship." But "new Christian advocacy groups, modeled after advocacy groups on the left, are increasingly portraying practicing Christians as citizens oppressed by secularism and are seeking judicial protection. The American Center for Law and Justice (ACLJ) founded by Pat Robertson, is one of the leaders in this movement, borrowing not only most of the acronym but the tactics of the American Civil Liberties Union in a fight for religious 'rights.'"[22]

It's not clear how the public (or, for that matter, sports officialdom) would have responded had Reggie White's or Mark Brunell's evangelical energies been put at the service of a different faith—say, Islam. Some small indication might be found in the NBA's suspension of pro basketball player Mahmoud Abdul-Rauf, who had refused to stand during the national anthem. Abdul-Rauf, a member of the Denver Nuggets' team, claimed that paying homage to anything but God was idolatry, and that the American flag was a symbol of oppression. While he was supported by the American Civil Liberties Union and the NBA players' union, some veterans groups called his behavior treasonous.[23] The dispute was resolved when Rauf decided to stand and pray silently during the playing of the anthem, but the entire matter made Muslim groups, members of the fastest-growing religion in the US (some 5 million strong), nervous about public perception.

Star status may make a difference. Houston Rockets' star Hakim Olajuwon's Muslim religion requires him to pray five times a day—a

schedule that is willingly accommodated by his coach and fans. When
the city of Houston staged a victory parade for its NBA champs in 1994,
500,000 people waited in the heat of a Texas June for Olajuwon to
arrive from his daily devotions. "We're all aware of his prayer schedule
this year," said a spokesperson for the Mayor a year later, when the
parade was planned around the star center's needs.

But Olajuwon differs from Abdul-Rauf in another way: he hasn't
linked his own Muslim faith to a critique of the U.S. and its symbols.
The designation "America's team," borne proudly in football by the
Tom Landry-led Dallas Cowboys and then claimed by the 1996 Green
Bay Packers, seemed to blend patriotism with religion, and, specifically,
with Christianity.

When columnist Rick Reilly complained in *Sports Illustrated* about the
intrusiveness—and coerciveness—of public praying during and after
pro football games, his critique of "50-yard-line religious sales pitches"
was answered in *Commonweal*, a journal edited by Roman Catholic lay
people.

"Once upon a time people who thought as Reilly does were content
to confine their arguments to cases of coercion in the strict, juridical
sense," wrote R. Bruce Douglass, an assistant professor of government
at Georgetown, in *Commonweal*. The issue used to be whether public
money was used to underwrite the exercise of religion, but now "public
expressions of piety" by individuals were under attack. "Just who is it,"
asked Douglass, "that is being intolerant to whom?"[24]

Reilly had argued that "imposing one's beliefs on a captive audience
is wrong, irreligious, even" and suggested that the National Football
League ought to outlaw public displays of prayer by players in the hud-
dle or the locker room. At the very least, he thought, television should
refuse to broadcast them. As things stood, stadiums full of fans, and mil-
lions more watching at home, were subjected to the spectacle of public
prayer whether they liked it or not. "It would be just as inappropriate,"
he said, "for Jewish players to conduct services at the far hash mark or
for Muslim players to place prayer rugs under a goalpost and face
Mecca." He also had harsh words for players who prayed for results, like
the New York Giants team that knelt and prayed as an opposing kicker
tried for a last-second field goal. "Is praying for somebody to blow it
very Christian?"[25] Reilly asked.

But in a set of moves very like the self-justifications of economic
Social Darwinism, not only are gridiron victories ascribed to God, they

are taken as evidence that the winners are somehow particularly virtuous, or devout, or Christian. The 1997 Super Bowl Pre-Game Show clinched this point by showing a clip from Kenneth Branagh's film version of Shakespeare's *Henry V* in which the young king rallies his forces, "we few, we happy few, we band of brothers." Later he will exult in victory: "Take it, God,/For it is none but thine." Though Fox TV didn't show this latter moment, the implied parallels were clear—and disturbing. Despite the fact that Grantland Rice's famous rhyme declared that

> When the One Great Scorer comes to write against your name—
> He marks—not that you won or lost—but how you played the game[26]

cynical sports journalists are increasingly confronted with public declarations of decisions by the Divine Referee. "This was Jesus Christ working through my players," declared the new coach of the University of Oklahoma football team to ABC–TV after they beat archrival Texas in overtime. "What role did God play—or not play—in the eight Oklahoma losses this season?" wondered a writer who identified himself "not as an atheist journalist, but as a Bible-reading Christian."[27]

At the same time, evangelical Christianity's receptiveness to the repentant sinner has allowed drug- and sex-abusing athletes to proclaim, publicly, their reformation. At the end of Dallas Cowboys receiver Michael Irvin's five-game suspension for pleading no contest to cocaine possession, he marched to the end zone, knelt, and prayed. No sportswriter present could recall any previous occasion on which Irvin had engaged in public prayer. This is the evangelical obverse of Catch–22; the more errant the sinner, the greater God's victory in winning him over. But if theatricalized displays like step-strutting are banned as unsportsmanlike, what is the place of ostentatious prayer? When the private becomes public, becomes uniform, becomes customary, has a line been crossed? And what kind of line? A goal line? or a foul line?

Another Super Bowl video staple, the clever commercial, spoke directly to this question, when it pictured a locker room full of players being prayed with, or prayed at, first by the coach, and then by a politically correct sequence of multicultural clerics, each in distinctive garb. As the praying droned on and the players yawned, they reached for a snack to keep them awake. The sponsor was Snickers, the candy bar. This may be the only way in which snickering at religious display is permitted to a public audience today.

"It seems a feeble pluralism that cannot encompass a bit of postgame prayer," observed *New York Times* "Beliefs" columnist Peter Steinfels, reporting on the "delicate and slightly unsettling moment" when television cameras in the locker room of new NBA champions the Chicago Bulls caught the victors holding hands and reciting the Lord's Prayer.[28] Where the intrusive glance of the camera has sometimes had to tilt away to avoid disclosing the physical nakedness of the athlete, the camera in the Bulls' locker room offered a glimpse of another kind of intimacy. Was this a kind of voyeurism? Or a kind of exhibitionism?

These are questions to which we shall want to return.

II

At public universities and schools where taxpayers' funds are used, the issue of locker room prayer has attracted some critical attention. The former coach of the University of Colorado football team, Bill McCartney, was accused of giving priority in hiring, recruiting, and playing time to athletes who shared his Christian faith.[29] The American Civil Liberties Union argued that injecting religion into a state-sponsored program violated the constitutional mandate for government neutrality. The worst-case scenario is the succinctly named "no pray/no play" rule. In 1994, students at Memphis State University alleged that the coaches were "attempting to convert the student-athletes to Christianity, to be saved, to be part of the Born-Again movement," and that if they failed to attend coach Ray Dempsey's mandatory prayer meetings they would not get to play. As an attorney in the case observed, financial constraints often limit the student-athlete's capacity to protest: "It is clear that personnel on athletic scholarships are not going to complain."[30] "No pray/no play" is clearly a violation of First Amendment rights. But what about peer pressure and the emotional prestige of the coach?

Coaches often function in loco parentis for athletes, occupying what one observer called, nicely, "the fatherly/motherly position."[31] (I think the observer in question may have meant "fatherly for young men" and "motherly for young women," but the conflation of the two seems entirely appropriate.) The coach is omniscient, omnipotent, nurturing, law-giving, and punishing, the male version of the phallic mother. Who would displease such a figure, the true parent, the chosen leader, the fulfillment and apotheosis of the family romance?

A high school football coach in Florence, Arizona resigned because

the principal sent him a memo saying "there should be no prayer at any school organized events." Coach Tom Shoemake said he had prayed with his teams before and after games for 20 years.[32]

And then there is peer pressure, the emphasis on being a "team player." While an athlete is technically free to leave the locker room during a team prayer, the social costs are so high that the exercise of this "freedom" is unlikely. Much of the case law that exists deals with high school and elementary school team prayer, in situations that, by the fact of the relative youth of the students, are often held to be more coercive. Though the argument that *televised* prayer is coercive to the at-home viewers has also been persuasively made.

In a Texas case (Doe v. Duncanville Independent School District), the court, Jane Doe, and her father John Doe protested the mandatory prayers conducted by the coach of a girls' basketball team at practice and at the end of games. (The visual image conjured by the court's words is striking: "the girls on their hands and knees with the coach standing over them, heads bowed," as they recited the Lord's Prayer in the center of the court.) Such prayers had been recited at basketball games for over 20 years when the suit was brought. Prayers were also regularly said at pep rallies, at awards ceremonies, before all home football games, and when teams boarded buses for away games. When Jane Doe elected not to participate in the team prayer, her coach made her stand outside the prayer circle. Other students asked her "Aren't you a Christian?"; a spectator at a game shouted "Well, why isn't she praying? Isn't she a Christian?"; and her history teacher called her "a little atheist." The Does sued.

The Court of Appeals held up a lower court's ruling enjoining the school district's employees from leading, encouraging, promoting, or participating in prayer "with or among students during curriculum or extracurricular activities, including before, during and after school related sporting events." Furthermore, noting the "pervasive nature of past school prayer," the school district was instructed to advise students, in writing, that "under the First Amendment of the United States Constitution, prayer and religious activities initiated and promoted by school officials are unconstitutional, and that students have a constitutional right not to participate in such activities." The claim that prayer accomplished the purpose of stirring up "school spirit" was not held to be persuasively secular.

We may notice that the plaintiff in Doe is female. It is not clear

whether she was, in fact, "a little atheist" as her history teacher suggest-
ed. "Atheist" seems to function here as the "natural" or inevitable oppo-
site to "Christian." It's tempting to remember W.S. Gilbert's mocking
verse from *Iolanthe*: "every boy and every gal/That's born into the world
alive/Is either a little Liberal,/Or else a little Conservative!" Since
"Doe" is a pseudonym that defies religious or ethnic stereotyping, it's
also not possible to detect, immediately, whether Jane Doe was Jewish
or Muslim, a Buddhist or a Jain. In other team prayer cases, however,
the religious identifications of the plaintiffs are more manifest. In two
particularly indicative instances, they are Jewish.

Max Berlin was a senior at Crestview High School in Okaloosa County,
Florida, and a member of the football team. His sister Tammy was a
sophomore at the same school. Through their parents, the Berlins
sought an injunction to prevent the school from offering an invocation,
through the public address system, before each home football game.
They also filed a motion to prevent the football coaches from leading
their teams in prayer before or after the game.

 The invocation specifically asked for "sportsmanlike spirit" among
players and spectators and for blessings on the players "for we are all
winners through Jesus Christ, our Lord." Such an invocation had been
offered at Crestview High and other schools in the area for more than
thirty years, and the Superintendent of Schools acknowledged to the
court that the invocation was, in the court's words, "in keeping with the
customs, expectations, and religious traditions of the vast majority of
the residents of Okaloosa County, who are Christians" (1988 WL. 85937
[N.D. Fla.]). He also suggested in a public statement that opposition to
the invocation was an opposition to "wholesome values." Mrs. Berlin
testified that what was offensive to her in the invocation was the refer-
ence to Jesus Christ, and that she had felt an animosity from the crowd
when she remained seated during the invocation. Tammy Berlin testi-
fied that when she walked around rather than standing for the invoca-
tion she was treated as an outsider.

 After noting that the school district had instructed its football
coaches not to pray with their teams before or after games, and not to
encourage others to do so (thus rendering part of the motion moot),
the judge denied the motion for a preliminary injunction. The invoca-
tion could continue, for the time being; the team prayer had to stop.

 The Berlins' suit was based upon a sense of their own minority status

as Jews, and the ways in which the "customs, expectations, and religious traditions of the vast majority of the residents of Okaloosa County, who are Christians" could all-too-easily slide over into a definition of "wholesome values" that seemed to exclude Jews from wholesomeness (and, indeed, from good "values"). The high school football field became an outdoor church, and Tammy Berlin, like Jane Doe, seemed to be regarded as a little atheist—or worse—because she did not observe its protocols. In another case that turned on religion and sports, however, the entire team was Jewish—and *its* "customs, expectations, and religious traditions" were resisted, and in fact briefly outlawed, by the "secular" regulating agency.

A class action on behalf of male members of the Orthodox Jewish faith was brought against the Illinois High School Association, to which all the public schools and almost all the private schools in the state belonged. At issue was the Association's rule, newly passed, that prohibited, for safety reasons, the wearing of yarmulkes when playing basketball.

This was, to me, a completely fascinating case. The plaintiffs were two private Jewish secondary schools, whose teams routinely wore yarmulkes attached with bobby-pins. Orthodox Jewish men cover their heads at all times (except when unconscious, under water, or in imminent danger of loss of life) as a sign of respect to God. One of the teams had been part of the association for three years, the other for eight, and during this time players had worn yarmulkes on the court without incident, until 1981, when a problem arose. That year the Association refused to let them play in the championship elimination tournament, held in a prestigious and high-profile location (the University of Illinois basketball fieldhouse) unless they took off their yarmulkes.

The basketball rule book instructed referees to prevent players from wearing any equipment which might cause harm to another player, like forearm guards, plastic or metal braces, headwear, and jewelry. Barrettes made of soft material were legal, as were two-inch wide headbands. The Jewish high schools sought, and the judge granted, an injunction that would allow them to play in the tournament, since the Court pointed out, not only that there were First Amendment considerations, but also that "no rational distinction appeared to exist between a soft barrette attached to the hair with bobby pins or clips and a yarmulke similarly attached."[33]

After the court entered its preliminary injunction order, and while

the action remained pending, the National Federation of State High School Associations, of which the Illinois group is a member, sent out a questionnaire to basketball coaches and officials in 44 states, including Illinois, asking, among other things, whether they approved of the rule permitting soft barrettes. Over 10,000 responses were received. 8,766 said that the rule was satisfactory, 1,476 that it was not. Nevertheless, in April 1981 the Federation changed its rule. The chairman of the Basketball Rules Committee claimed that it was difficult for officials to distinguish between "hard" barrettes and "soft" barrettes, and that therefore *all* barrettes should be barred.

The court was neither persuaded nor amused. It noted that there was no information presented about injuries that had occurred as the result of wearing either soft barrettes or yarmulkes. "It taxes credulity," wrote District Judge Shadur, "that the change in the rule was not at least in part responsive to the pendency of this litigation." Furthermore, the judge noted, "Under any possible interpretation, for safety and all like purposes a yarmulke is the functional equivalent (although not of course the religious equivalent) of a soft barrette, not a hard barrette."[34]

There were other disturbing developments. When the results of the questionnaire were submitted, a "typographical error" (the quotation marks are Judge Shadur's) altered the number of "yes" votes approving soft barrettes from 8,766 to 1,766, an "error" that was only caught when the Court's law clerk asked for a copy of the actual document, the "only one not so delivered by IHSA counsel." Describing the behavior of the Federation's Basketball Rules Committee as "clearly disingenuous," the judge observed dryly that "Obviously a six-to-one vote from more than 10,000 knowledgeable basketball coaches and officials in favor of retaining the rule permitting soft barrettes (functionally equivalent to yarmulkes in all respects as to safety) has a devastating effect on the 'compelling necessity' of a new rule to serve IHSA's stated purpose of prohibiting yarmulkes to assure safety."

Nor was this the end of the matter. As the judge quite emphatically went on to note, "it is most troublesome to encounter what appears to be a pretextual basis for the adoption of the current rule."[35]

The claim of those who pushed for a rule change was safety. Slips and falls, the judge agreed, are common to the game of basketball, as are minor injuries. But in fact the Federation did not have on record a single instance of a slip, fall, or injury resulting from either "a yarmulke having come loose and fallen on a basketball court" or "a bobby pin or clip" having fallen. Indeed, in testimony that covered more than 1,300

interscholastic games and many more that were non-interscholastic, no one had ever mentioned a single instance of slippage or injury "from either yarmulkes or their associated bobby pins or clips." Though yarmulkes had fallen onto the basketball court an average of one or two times a game, they had always been promptly picked up.

And, persevered the judge, other things do fall to the basketball court during play, like players' eyeglasses, whether or not they are secured by elastic bands. Likewise, the judge continued, "foreign objects such as paper and coins are unfortunately thrown by fans onto the basketball court from time to time during basketball games, and paper is from time to time left on the court as a result of the incomplete cleaning up of paper detached from pompons left by cheerleaders." All of these would be fully as hazardous as a fallen yarmulke. But "IHSA rules do not prohibit persons wearing glasses from playing IHSA interscholastic basketball. Nor do IHSA rules ban attendance at games or cheerleader participation during games." No, indeed: the Illinois group that sponsors the state tournament, the Elite Eight, at the basketball fieldhouse of the University of Illinois, does not ban eyeglass-wearers or cheerleaders or fans. But it did—or it wished to—ban the wearing of yarmulkes. For *safety* reasons. Whose safety is being threatened here—and by whom?

Thus, to summarize: during the course of the litigation IHSA changed its view from "yes" to "no" on soft barrettes (and thus on yarmulkes), despite the total absence of any demonstrated safety hazard and the presence of an overwhelming six-to-one vote. It claimed "compelling interests" when none—apparently—existed, as sufficient reason to override the First Amendment rights of the players who covered their heads for reasons of religious faith. Moreover, the Court had "real questions as to the total candor" of those involved in changing the rules in the middle of the legal game. "IHSA's argument involves an impermissible sleight of hand: It falsely equates basketball safety with prohibiting yarmulkes," declared the ruling. "In basketball terms IHSA loses by too many points to making keeping score worthwhile."[36]

With this final slam-dunk the judge blew the whistle on the IHSA. At least on the yarmulke question. But it may be worth noting that this same organization, the Illinois High School Association, has been adamant in its support of football prayer. "The IHSA doesn't have a rule against prayer on the field and shouldn't and never will," said the executive director in November 1996. It's "as appropriate as jumping up and down and yelling 'We're No.1' and cheering." But precisely who

is it who comes out number one in this kind of religious demonstration? Ecumenicism? or "Christianity"? Who is to be the judge of what is "appropriate" in the realm of religious cheerleading?

III

Sigmund Freud's "Group Psychology and the Analysis of the Ego" sets forth his general sense that "libidinal ties" link group members, especially in "artificial" (by which he means organized and regulated) groups; his chief examples, in an essay published in 1921, are the Church and the Army, both pertinent models for today's professionalized and proselytizing sports teams, whether they are literally pros or just part of a highly developed and well-funded "amateur" sports program.

> It is to be noticed that in these two artificial groups each individual is bound by libidinal ties on the one hand to the leader (Christ, the Commander-in-chief) and on the other hand to members of the group. How the two ties are related to each other, whether they are of the same kind and the same value, and how they are to be described psychologically—these questions must be reserved for subsequent enquiry.[37]

While it would not be especially helpful to "apply" this Freudian analysis uncritically to, say, the Jacksonville Jaguars or the Green Bay Packers, it is worth noting that "leader" and "group" ties are terms perfectly appropriate to the relationship of the team to its coach, captains, and God, on the one hand, and to itself ("team spirit") on the other. (We might recall professional football player Rich Griffiths's testimony, "I don't do it for Coach Coughlin or for anyone else. I do it for a superior person.")

Robert Higgs notes that "in its early days football was viewed as a substitute for war and as a training ground for war," citing as the three "staunchest promoters of the football-war metaphor" West Pointer (and first NCAA President) Palmer Pierce, Douglas MacArthur, and Teddy Roosevelt. "If athletes are soldiers of sorts," remarks Higgs, "then the effort of the FCA [Fellowship of Christian Athletes] and other proselytizing groups has been to make them Christian soldiers."[38] Today's vocal and demonstrative Christian Athletes thus combine the two "artificial groups" that seemed to Freud the most obvious examples of his "group psychology."

What Freud calls, in a wonderful phrase, "the narcissism of minor

differences" accounts for the enmity that once made the Yankees and the Dodgers such bitter rivals:

> Of two neighboring towns each is the other's most jealous rival; every little canton looks down upon the others with contempt. Closely related races keep one another at arm's length; the South German cannot endure the North German, the Englishman casts every kind of aspersion upon the Scot, the Spaniard despises the Portuguese. We are no longer astonished that greater differences should lead to an almost insuperable repugnance, such as the Gallic people feel for the German, the Aryan for the Semite, the white races for the coloured.

Within groups, however, the opposite occurs:

> But when a group is formed the whole of this intolerance vanishes, temporarily or permanently, within the group. So long as a group formation persists or so far as it extends, individuals in the group behave as though they were uniform, tolerate the peculiarities of the other members, equate themselves with them, and have no feeling of aversion towards them. Such a limitation of narcissism can, according to our theoretical views, only be produced by one factor, a libidinal tie with other people.

And what about "team spirit"? Here Freud, again tendentiously, writes of the "desexualized, sublimated homosexual love for other men, which springs from work in common." For mankind as a whole, as for the individual,

> love alone acts as the civilizing factor in the sense that it brings a change from egoism to altruism. This is true both of sexual love for women, with all the obligations which it involves of not harming the things that are dear to women, and also of desexualized, sublimated homosexual love for other men, which springs from work in common.[39]

In other words, men in groups, to use Lionel Tiger's famous phrase, come to love one another, in the process turning their egoism into altruism. Diana Fuss has commented trenchantly on the effort Freud expends to keep the two kinds of love ("sexual" and "desexualized") apart. His view turns on the question of "identification," the "earliest expression of an emotional tie with another person," distinguishing

between wanting to *be* and wanting to *have* another person. (Unsurprisingly, Freud's early example is that of the boy who takes his father as his ideal; his later example is the "tie with the leader." For both "father" and "leader" here we may, for our purposes, read "coach" or "captain.") The "mutual tie between members of a group" takes the form, says Freud, of an identification based upon some perceived common quality—a quality which is *not* based upon erotic feelings. "Freud's theory of identification," argues Fuss, "appears as a theoretical *defense* against any eventuality of a nonsublimated homosexual love as the basis of a homosocial group formation. By extracting identification from desire, insisting that a subject cannot identify with another person and desire that person at the same time, Freud is able to conceptualize homosexuality and homosociality as absolutely distinct categories."[40] For Fuss, the supposed distinctness of these categories—like the distinctness of supposed desire and identification—is itself a symptom of their tendency to become both confused and undecidable.

Yet what is most fascinating about Freud's own argument, as Fuss notes, is his observation that what he calls "homosexual love" is "far more compatible with group ties" than is heterosexual love, "even when it takes the shape of uninhibited sexual impulses." He himself calls this "a remarkable fact, the explanation of which might carry us far."[41]

"That the locker room can be an erotic environment is undeniable," observes former sports writer Brian Pronger in *The Arena of Masculinity*, a book about sports and homosexuality.[42] Can the eros of physical sexuality and the eros of religious faith be compared? Or identified? "Men who love football love men," says Mariah Burton Nelson in *The Stronger Women Get, the More Men Love Football.*

On- and off-court physical contact between celebrated "straight" male athletes—like the "customary smooching" between best friends Isiah Thomas and Magic Johnson noted by *Sports Illustrated* (June 27, 1988) under the photo caption "Kiss and Make Up"—has been used, through an elementary paradoxical logic, to shore up the *heterosexuality* of men's sports, analogous to the ostentatious wearing of earrings and necklaces that might be deemed, on less monumental males, overt signs of gay identity and display. It takes a "real man"—which is to say, a heterosexual man—to wear all this expensive jewelry in public. By touching and indeed crossing the line between stereotypical "gay" and stereotypical "straight" costume and practice, male athletes affirm their

manliness. As Lionel Tiger noted in 1969, "Men such as war heroes, politicians, sports heroes, who have established themselves as virile, may indulge in public tenderness more easily than persons in less evidently virile occupations, such as poetry, teaching, hairdressing, etc."[43]

Mariah Burton Nelson comments on a photograph of three Texas high school football players, in full football regalia, backs to the camera, holding hands. "Were these same young men to hold hands in a different setting—on a city street, say, or on a beach, without their football uniforms—they would be thought to be gay. They might be taunted by other men—football players, perhaps. Yet in this picture, their hand-holding projects a solemn, unified sort of group power."[44] "Together," she concludes, "they fall in love—with power, with masculinity. They also fall in love with each other."

What's love got to do with it?

"Language has carried out an entirely justifiable piece of unification in creating the word 'love' with its numerous uses," writes Sigmund Freud. "In its origin, function, and relation to sexual love, the 'Eros' of the philosopher Plato coincides exactly with the love-force, the libido of psychoanalysis." Indeed, says Freud, "when the apostle Paul, in his famous epistle to the Corinthians, praises love above all else, he certainly understands it in this same 'wider' sense."[45]

Recall here Nelson's description of team-bonding: "a solemn, unified sort of group power"; "together, they fall in love." Respected folklorist Alan Dundes wrote some years ago what he characterized as "a psychoanalytic consideration of American football" in which he pointed out that language like "end" ("tight end," "split end"), "penetration," "go through a hole," etc., was a kind of "folk speech" that suggested "ritual homosexuality." "I have no doubt," said Dundes, "that a good many football players and fans will be skeptical (to say the least)." Even a gay player like David Kopay declined to agree that being about to hold hands in the huddle and "pat each other on the ass" was an overt sign of homosexuality. But Dundes stuck to his argument: "The unequivocal sexual symbolism of the game, as plainly evidenced in folk speech, coupled with the fact that all of the participants are male, makes it difficult to draw any other conclusion."[46]

Easy for him to say. For the average fan, player, or coach, what is difficult is to draw *this* conclusion, or even to entertain the possibility of a subliminal (homo)erotics of male sport. And what is even more difficult is explaining the difference between a cultural practice and a

sexual identity. No one—or virtually no one—claims that football play-
ers are, as a class, subliminally or overtly gay. Or that they are drawn to
football because it affords them an opportunity to pat each others' bot-
toms or put their hands (expecting the ball) between each others' legs.
Reading America's passion for football as a cultural symptom does not
threaten anyone's identity, sexuality, future, or faith. Or does it?

<div align="center">IV</div>

Spectatorship in sport, like film spectatorship, has certain mirroring
and compromising effects. Laura Mulvey's famous formulation about
the "determining male gaze" in cinema, "woman as image, man as
bearer of the look," becomes interestingly complicated when the look-
ers and the looked-at—in and out of what has been dubbed the "looker
room"—are male. More than thirty years ago televised sports was char-
acterized by one shrewd observer as "Male Soap Opera."[47] Sociologist
Lionel Tiger offered an evolutionary view: "Perhaps we can regard sport
spectatorship as a phenomenon bearing the same relation to hunting
and male bonding as love stories do to reproductive drives and mate
selection."[48] The need to keep identification apart from desire—to
insist that you want to *be* Brett Favre and not *have* Brett Favre—produces
all-male spectatorship in a very curious space: the displacement of the
permission to desire onto a nominally desexualized erotic object—Jesus
or God—which legitimizes and sacralizes (which is to say, heterosexual-
izes) male-male love. By the emotional logic of this position, so long as
someone else is doing it "wrong," you can be sure you are doing it right. A
group of "insiders" depends for its cohesiveness on identifying certain
"outsiders," who are either to be permanently excluded for their own
good (like women) or, if they meet certain standards, to be converted
from error to truth. And in this latter category—the category of the
potential convert—we find the usual suspects: homosexuals and Jews.
Gay men love other men the "wrong" way. This gives other men permis-
sion to love each other—in a way that they can secure as different.

When a Coach Coughlin or a Coach Landry (or, indeed, a "God in
pads" like Reggie White) leads a team in prayer, the term "love" circu-
lates freely in the huddle. And the idea that God (or Jesus) is the real
captain, or quarterback, the Landrys and Coughlins and Whites merely
apostles, is familiar, as we have seen, from the way they think and speak.

Coach Bill McCartney, late of the University of Colorado, took this erotics of football from the locker room to the bleachers, with remarkable—and disquieting—effect.

Since 1990, an all-male, all-Christian organization called the Promise Keepers, founded by Coach McCartney, has been holding its rallies in stadiums across the country. Linked to other right-wing groups espousing causes from the teaching of creationism in the schools to the denunciation of abortion and homosexuality, supported by evangelical and politically conservative ministers Jerry Falwell and Pat Robertson, the Promise Keepers gets much of its emotional mileage out of the pep-rally scenario of coach and fans. *New York Times* columnist Frank Rich, formerly assigned to the paper's theater beat, accurately gauged the level, and nature, of PK's appeal when he made a field trip to New York's Shea Stadium, home of the hapless Mets. There he found "some 35,000 standing, waving guys shouted their love to Jesus at a decibel level unknown even in Shea's occasional brushes with a pennant race. During a marathon rally of sermonizing, singing and praying, the men also repeatedly sobbed and hugged each other—or, more joyously, slapped high-fives while repeating the chant, "Thank God I'm a man!"[49] The Promise Keepers Rich met were, he thought, "more motivated by a Robert Bly-esque hunger to overcome macho inhibitions and reconnect with God than by any desire to enlist in a political army. But an army PK most certainly is. Its preachers sound more like generals and hard-charging motivational cheerleaders than clergy. Every music cue, crowd maneuver and sales pitch for PK paraphernalia is integrated into the show with a split-second precision that suggests a Radio City religious pageant staged by George Patton." In the Promise Keepers, Freud's two characteristic groups, the Army and the Church, come together.

Other media observers have seen the atmosphere at PK rallies as "equal parts religious revival, inspirational pep talk and spiritual support group."[50] "As a man," said one of the nearly 50,000 who attended a session at the Thunderdome in St. Petersburg, Florida, "you get trained for your job, you get trained for athletics. But who trains you to be a Christian man?"[51] Roaming among book exhibits that feature works like *What Makes a Man* and *Strategies to a Successful Marriage,* as well as copies of Promise Keepers' own magazine, *New Man,* sporting T-shirts that declared (in a faint echo of muscular Christianity's defensiveness) "Real Men Love Jesus," the audience (congregation? fans?) testified to

the pleasure of meeting in all-male groups. "In our church, there are more women than men," reported one Florida man. "To see this, it's awesome."

For some Americans, and other world citizens too, the Promise Keepers only became visible on the national scene in October 1997 when they held a rally on the Washington Mall. But the movement began in Boulder, Colorado, with a conference of 4,200 Christian men in the university's football stadium. Upon this rock—or boulder—McCartney built his church. The following year there were 22,000; the year after that, 50,000. Founder Bill McCartney quit his $350,000 job as Colorado's football coach and went into the Promise Keeping business full time. He called the movement an opportunity for men to "walk in Christian masculinity." The Promise Keepers went national (72,000 men in the Silverdome in Pontiac, Michigan; 52,000 at RFK stadium in Washington, D.C.; 13 cities in the Summer and Fall of 1995) and planned expansion overseas. Participants, who paid $55 apiece for the privilege of attending, bought Promise Keepers books, tapes, T-shirts, caps, did "stadium waves," sang, prayed, held hands, and embraced.[52]

This fellowship of men, who often embrace one another and speak in a rhetoric of love, is part of a movement that is, officially, anti-gay. Any gay men who show up are candidates for double conversion—to born-again Christianity and to heterosexuality—with counselors on hand to assist in making the change. Coach McCartney, whose movement is dedicated to "uniting men through vital relationships to become godly influences in their world," drew administrative and student ire when he was at the University of Colorado for publicly denouncing homosexuality as "an abomination of almighty God" and for endorsing Colorado's proposed amendment that would have barred laws protecting homosexuals from discrimination. The University's President, the ACLU, student groups, and Representative Pat Schroeder all deplored McCartney's use of his university role for political and ideological ends: the conservative group called Colorado for Family Values had listed him as a board member, and identified him as Colorado's football coach. A student leader commented that McCartney was "spreading gay hatred and bigotry and gay bashing at an institution of higher education," and asked rhetorically, "You tell me if that is good Christian values and what we should be teaching at a university."

One might think that Coach McCartney's departure from coaching was hastened by the restrictions the state University placed on his role.

But he himself claims that he founded the movement—and turned away from coaching—because he suddenly realized that his wife was unhappy. Although he tells this story at every rally, with his wife by his side (sometimes he kisses her onstage to punctuate his story), he doesn't usually report that his unmarried daughter "gave birth to two children, both fathered by players on McCartney's teams." (Since McCartney had, when at the University of Colorado, criticized homosexuals as people who do not reproduce and want equality with people who do, it is perhaps possible to see this family "expansion team" as consistent with, rather than a violation of, his own beliefs.)

It's fascinating to imagine what the church and the media's response might be to stadiums full of *women*, 50,000 strong, chanting in concert and declaring themselves dedicated to social change. "Mass hysteria" is the phrase that comes to mind. One has only to think of all that file footage on women and girls weeping and screaming at the sight of the Beatles—or, for that matter, the young Frank Sinatra. One of Freud's examples of "group psychology" is in fact "the troop of women and girls, all of them in love in an enthusiastically sentimental way, who crowd round a singer or a pianist after his performance. It would certainly be easy for each of them to be jealous of the rest; but, in the face of their numbers and the consequent impossibility of their reaching the aim of their love, they renounce it, and, instead of pulling out one another's hair, they act as a united group, do homage to the hero of the occasion with their common actions, and would probably be glad to have a share of *his* flowing locks. Originally rivals, they have succeeded in identifying themselves with one another by means of a similar love for the same object."[53] When a woman's version of the Million Man March was organized it attracted relatively few participants—and almost no media attention. Was this because the event was so decorous, with so little in the way of "acting out"?[54] Would anyone take a group of 50,000 sobbing, praying, and embracing women seriously as a sign of moral progress? Or would they be regarded as symptoms of cultural crisis, of *lack* of moral strength and emotional self-control?

And if you find this scenario hard to imagine, try replacing the 50,000 singing and chanting heterosexual men with 50,000 gay men. "We're number one" in this context would surely be taken as a sign of group narcissism, as a decadent conspiracy, and as a desperate plot against the moral fiber of the nation. Even if they prayed. And especially if they embraced each other.

V

Ruminating on the pecularities of "normality" in human sexual life, Sigmund Freud had, on one memorable occasion, rather witty recourse to the figure of conversion. "In general," he remarked, "to undertake to convert a fully developed homosexual into a heterosexual does not offer much more prospect of success than the reverse, except that for good practical purposes the latter is never attempted."[55] For Freud the Jew, the concept of conversion—forced conversion—was, we can presume, already heavily freighted. "The conversion of the Jews" was a long-term project for Christianity, a project so proverbially formidable that the poet Andrew Marvell could equate it with eternity ("And you should, if you please, refuse/Till the conversion of the Jews"), so ideologically desirable and hotly contested that it formed a central tenet of Protestant Evangelism in England from the time of the French Revolution to the end of the 19th century. "In the vocabulary of a Christian," wrote Lewis Way, a member of the London Society for Promoting Christianity amongst the Jews, in 1831, "conversion does not stand opposed to *toleration* but to *persecution*."[56] In the vocabulary of football, conversion is a way of scoring points: the "extra point" earned by a kick after a touchdown, or the "two-point conversion" scored by running or passing. Modern-day evangelicals, from the Promise Keepers to the more mainline Protestant denominations, have their own kind of two-point conversion: point one, the conversion of the homosexuals; point two, the conversion of the Jews.

When the 14,000 delegates to the Southern Baptist Convention met in New Orleans in June 1996 they affirmed their support for a major campaign to convert American Jews to Christianity. (Delegates called on the same occasion for a boycott of Disney because of its alleged pro-gay stance in producing the TV series "Ellen" and allowing benefits for same-sex partners of Disneyland employees. Both points of the "two-point conversion" were thus expressly on the agenda.)[57] Lawyer Leonard Garment wrote eloquently in the *New York Times* that the resolution was "the latest in a centuries-old line of conversion efforts whose history is so distasteful as to make the Baptists' action profoundly offensive." "In the simple conversionist view," Garment explains in a tone that is carefully, passionately, dispassionate, "Christianity is the natural, necessary culmination of Jewish history. It makes Judaism unnecessary and obsolete. The persistence of Jews who choose to remain Jews poses

a challenge to this idea of inevitability. Thus, the argument goes, intensive conversion efforts must be made." Moreover, he noted, the Baptists' mission is specifically targeted at Jews. Their resolution "does not declare that the growing Muslim population in the United States is in special need of spiritual improvement. Only the Jews merit this honor."[58] That persistent and defining evangelical activity, the conversion of the Jews, long regarded as the millenarian missionary moment, was, it seemed, once again at hand.

The evangelism resolution itself had an oddly defensive-aggressive tone, demonstrating perhaps that, as the sports truism goes, the best defense is a good offense. "There has been an organized effort on the part of some either to deny that Jewish people need to come to their Messiah, Jesus, to be saved; or to claim, for whatever reason, that Christians have neither right nor obligation to proclaim the gospel to the Jewish people," it declared. This latest mission to the Jews was thus somehow both anti-conspiracy ("an *organized* effort *on the part of some*") and a matter of civil rights (refuting the "claim, *for whatever reason,* that Christians *have neither right nor obligation* to proclaim the gospel to the Jewish people"). What might appear to Jews intrusive and unwelcome spiritual bullying is summarily redefined as a courageous act of conscience. In this latest confrontation between Christians and lions it was the Lion of Judah who was subject to attack.

We might note that the rise of "muscular Christianity" took place at about the same time as the physician Max Nordau's call, in Germany, for the appearance of a "new Muscle Jew." Sports were part of the regimen recommended by turn-of-the-century Zionists for rebuilding the bodies and spirits of Jews worn down by ghetto life. German-Jewish gymnastic competitions and Nordau's invitation to the playing fields of Berlin and Vienna were part of a systematic plan for incorporating healthy minds and bodies and overcoming the perceived divide between "muscle Jews and nerve Jews"[59]—a view held both by political and by medical commentators. ("They have been little inducted, during their pilgrimages, into the public games of the countries in which they have been located," wrote a sympathetic American observer in 1882 in a book called *Diseases of Modern Life.*)[60] Thus the Jewish Olympic athlete was perceived as something of an anomaly.

But the key distinction here, of course, is that modern Judaism is emphatically not a missionary or evangelical religion. As anyone knows who has contemplated becoming a Jew, the rabbis ordain a period of

intensive study, and in general converts are discouraged unless they can prove a sustained and informed interest in the faith. "I don't want to speculate why Jews don't evangelize," said a Southern Baptist spokesman, "but if your religion is so great, why aren't you on the street evangelizing?"[61] This perceived "exclusiveness" has been held (like so much) against the Jewish religion from time to time. "Unlike that of proselytizing religions," writes James Carroll, "the Jewish ethic boils down to the injunction: Let other people be other people." Carroll, a columnist and essayist, suggests that Jews have been so hated in history "because they have refused to make an absolute of group identity, thereby calling into question, by their very existence, the rigid intolerance of groups that do exactly that."[62] What is completely out of the question, in any case, is the idea of a football field full of persons "called" to Judaism, or a sudden onset of faith. Jewish athletes may be heroes, loners, or role models—but they are not, by the very nature of the Jewish faith, agents of conversion.

We noticed in our discussion of Freud's "Group Psychology" that the narcissism of small differences made neighbors into rivals, and that "the libidinal constitution of groups," as he put it, the (carefully desexualized and spiritualized) "love" that is often expressed by team members for one another, is a way of overcoming rivalry, of turning "egoism" into "altruism"—or at least into points on the board. "We're number one" is, when you stop to think about it, a slightly paradoxical chant, numerically speaking. "Identification" produces group identity, which produces "love."

What makes a group a group, though, or a team a team, turns out to be as much rivalry or aggression as love. As Freud remarks with deceptive matter-of-factness in *Civilization and Its Discontents*, "It is always possible to bind together a considerable number of people in love, so long as there are other people left over to receive the manifestations of their aggressiveness." (Are you listening, sports fans?)

"In this respect," he continues, with equal urbanity, "the Jewish people, scattered everywhere, have rendered most useful services to the civilizations of the countries that have been their hosts; but unfortunately all the massacres of the Jews in the Middle Ages did not suffice to make that period more peaceful and secure for their Christian fellows. When once the Apostle Paul had posited universal love between men as the foundation of his Christian community, extreme intolerance on the part of Christendom towards those who remained outside it became the inevitable consequence."[63]

Let us return then, briefly, to the Promise Keepers.

What are the promises the Promise Keepers promise to keep?

With Robert Frost's refrain ("I have promises to keep, And miles to go before I sleep") and J.L. Austin's speech-act theory in mind, I had blandly (and as it turned it, blindly) assumed that a promise was a kind of ethical, and indeed largely secular, declaration or assurance, made by one person to another. I had imagined that all these men in football stadiums, who wept and shouted that they had been bad husbands and bad fathers were promising to reform their conduct toward their (absent) wives and children. And so they may, in part, be doing. But *promise* is also a religious term. The rainbow, I was taught as a child, was God's promise to humankind that there would never be another Flood. And America, I was also taught, was the Land of Promise, to which my (as it happens, Jewish) ancestors came to find freedom and opportunity.

In today's majoritarian religious parlance, however, it seems that *promise* is a word with what has become an increasingly specific Christian meaning. "The word *promise* in the New Testament" says Cruden's concordance to the Bible, "is often taken for those promises that God made to Abraham and the other patriarchs of sending the Messiah. It is in this sense that the apostle Paul commonly uses the word *promise*." Jesus, in short, is the promise. Romans 4:13: "For the promise, that he should be the heir of the world, was not to Abraham, or to his seed, through the law, but through the righteousness of faith." Galatians 3:16: "Now to Abraham and his seed were the promises made. He saith not, And to seeds, as of many; but as of one. And to thy seed, which is Christ." Promise=eternal life though Jesus Christ.

Now, this understanding of the "promise" as not—despite what one might at first think—an equal-opportunity opportunity, so to speak, but rather a specifically *Christian* notion, brings with it a number of potentially dangerous side effects. Look what happens, for example, to the question, not only of the Promised Land (the state of Israel, the place of the Messiah) but also of the Land of Promise (the United States of America). It becomes, as Pat Robertson, Mississippi Governor Kirk Fordice, and others have been all-too-quick to claim, a "Christian nation."[64] One of the fastest growing movements in the U.S. today is the extreme right-wing cluster of organizations known as "Christian patriots," a Christian Identity group whose commitment is to Jesus Christ as savior, to the promise of salvation, and to the idea that Christianity alone can offer eternal life. "The *end* of Christian patriotism," writes sociologist James Aho, "is the preservation of 'Christian values' and

'Americanism,' as the patriots understand them."[65] And if we understand "promise" as *code* for Christianity, and even, especially, messianic and evangelical Christianity, then the promise of the Promise Keepers can be understood as an appropriation, and a naturalization, of born-again Christianity as the American experience.

This is one reason why Jacques Derrida describes Francis Fukuyama's book *The End of History and the Last Man* as a "neo-evangelistic" gospel, preaching the "good news." ("We have become so accustomed by now to expect that the future will contain bad news with respect to the health and security of decent, democratic political practices that we have problems recognizing *good news* when it comes. And yet, the *good news* has come.")[66] Here is Derrida's swift and devastating analysis:

> If one takes into account the fact that Fukuyama associates a certain Jewish discourse of the Promised Land with the powerlessness of economic materialism or of the rationalism of natural science; and if one takes into account that elsewhere he treats as an almost negligible exception the fact that what he with equanimity calls "the Islamic world" does not enter into the "general consensus" that, he says, seems to be taking shape around "liberal democracy"[p.211], one can form at least an hypothesis about which angle Fukuyama chooses to privilege in the eschatological triangle. The model of the liberal State to which he explicitly lays claim is not only that of Hegel, the Hegel of the struggle for recognition, it is that of a Hegel who privileges the "Christian vision."[67]

In other words, "The end of History is essentially a Christian eschatology," the imagination of postwar America and the European Community as a "Christian State."

It may be of more than passing interest that the place where the Southern Baptist Convention gathered in New Orleans to adopt their "Resolution on Jewish Evangelism" was the Louisiana Superdome, home of the New Orleans Saints. In a cordoned-off third of the stadium, slated in a few months to play host to Super Bowl XXXI, the assembled faithful heard their newly elected President urge them to "Step up to the plate and be the people of God He expects us to be."[68] (On another occasion, one of the leaders of the Southern Baptists' mission to the Jews predicted that in the End Days of the world "It'll be the bottom of the ninth, and the Jews will be batting clean-up for Christ.")[69] The Superdome is a football, not a baseball, field, but the month was

June, after all, and God (as we have already seen) is, in evangelist-speak, the Utility Infielder to end all utility infielders, a team player—and team leader—in all organized sports. ("We're scoring baskets for Jesus," declared the emcee of a Promise Keeper's event in Colorado's Folsom Stadium, another football venue.)[70] And, I want to suggest, it is neither an accident nor a mere matter of convenience that this act of spiritual cheerleading emanated from a football stadium.

What does it mean to claim that the Dallas Cowboys—or now, the Green Bay Packers—are "America's Team"? Is part of what makes "America's Team" American the fact that the players and coaches are overtly, manifestly, even ostentatiously Christian? The oppositional, ecstatic, and zealous nature of sports spectatorship and sports fandom ("Kill the ump"; "throw the bums out") raises the temperature of the crowd even as it lowers the level of nuance and subtlety. The twin phenomena—of exhibitionistic, often televised moments of prayer by players and coaches, and of the religious faithful convened for evangelical purpose in football stadiums around the country, exhorted to action by coaches who are now ministers, or ministers who are now coaches—reflect each other with uncanny and disturbing symmetry. Winning, it may turn out, converting points for "our" team, the chosen team, the team that *deserves* to win, is once again the "only thing" that counts.

The football rulebook contains a number of sounding phrases that mark infractions on the field, from "out of bounds" to "unsportsmanlike conduct" to "palpably unfair acts," like a player coming off the bench to tackle the ball carrier. "Encroachment," defensive or offensive holding, illegal motion, and falling or "piling on" are other sins of the gridiron, as is "prolonged, excessive, premeditated celebration."[71] Once upon a time, before the modern era of illuminated stadiums and luxury boxes it was also possible for a game to be "called on account of darkness." The high visibility of evangelical and salvific Christianity in sports, and its close ties with a competitive rhetoric of patriotism and Americanism, suggest that this may be the moment to call for a time out on proclamations of holiness in the huddle—time to rethink the troubling implications of public prayer on the field and organized team prayers in the locker room.

Celeste Holm and Gregory Peck in *Gentleman's Agreement.*

III

Gentility

We all expect a gentle answer, Jew!
—Shakespeare, *The Merchant of Venice*

I

Epistle to the Gentiles

"Gentile" is a word one hardly ever hears any more, except when the epistles of St. Paul are read out in church. While it is not in the same league as other proscribed racial and religious slurs, the g-word, as we might call it, seems both quaint and somehow offensive. What does it mean? Here are both the lower-case and upper-case definitions from a dictionary in common use, the appropriately named *American Heritage*.

> **gentile,** *adj.* 1. Of or pertaining to the gens or to the tribal society based on it. 2. Of or relating to Gentiles. 3. *Grammar.* Of or pertaining to a noun or adjective designating a nation, place, or people: *"American" and "Italian" are gentile nouns.*

> **Gentile.** 1. Anyone who is not of the Jewish faith or is of a non-Jewish religion. 2. A Christian as distinguished from a Jew. 3. A pagan or heathen. [Middle English *gentil, gentyle,* from Late Latin *gentiles,* pagans, heathens, from *gentilis,* pagan, from Latin, of the same clan, from *gens,* clan.]

So "Gentile" with a capital G means "non-Jewish," a word I heard frequently in my own (Jewish) household when I was growing up—and a

word which, even then, struck me as curiously out-of-kilter with what
I took to be the prevailing demographic facts of American life. *Most*
people, it seemed, were non-Jewish. Were all these people to be denom-
inated as "Gentiles"? Only, it seemed, to my Jewish relations and school-
mates and my elegant New York grandmother, who in her seventies
scoured the *Times* obituaries to see if any Jews had died that day.

Like "White," "Gentile" seemed a marked word for a conventionally
unmarked term. So the publication in 1942 of an anthology called *Jews
in a Gentile World* (significantly subtitled *The Problem of Anti-Semitism*)
seems, in retrospect, both optimistic and naive. Written before Ameri-
cans had full knowledge of the Nazi death camps and Hitler's "final
solution," these essays by sociologists, anthropologists, and psycholo-
gists addressed anti-Semitism from a social science point of view deter-
mined to "give an *objective* portrait of Jews in their relationships with the
Gentile world."[1] The approach is resolutely ameliorist and behaviorist,
a matter of conduct and mutual understanding rather than of un-
imaginable evil or of genocide. Thus, for example, Harvard sociologist
Talcott Parsons detailed, in a way intended to be dispassionate, the ten-
sions between Jews and Gentiles. A few examples may suffice to suggest
something of Parsons's thoughtful but "balanced" tone; he sees, pretty
clearly, that there are failures on both sides:

"The Jews are a group who, as individuals, are in active economic
competition with Gentiles," he writes, and "The 'chosen people' idea
held by the Jews is undoubtedly another source of friction. Gentiles usu-
ally resent the arrogance of the claim that a group who are in a sense
'guests' of their country claim a higher status than the 'host' people,"
and again, "The main consequence of [the] widespread psychological
insecurity among Jews are the closely related tendencies to oversensi-
tiveness to criticism, on the one hand, and 'abnormal' aggressiveness
and self-assertion, on the other. . . . Gentiles in contact with them often
get irritated and, being themselves insecure, are often ready to accuse
the whole group as sharing what they think obnoxious qualities. Since
many Jews are typical 'intellectuals' they are unaware of the extent to
which they offend the non-rational sentiments of others."[2]

Parsons finds the tensions between Jews and Gentiles genuinely
"deplorable" but he is convinced that "it is unlikely that a movement
involving anti-Semitism on a scale comparable to that in National
Socialist Germany will develop in the United States . . . in spite of the
fact that most of the basic elements inherent in National Socialism are

present in this country."[3] A post-Holocaust perspective alters significantly the parameters of "anti-Semitism" as a social or sociological fact of life. But for Parsons at this time, significantly, the Jew was a *symbol* and anti-Semitism was a *symptom.*

"It has been argued," he writes, "that the most important source of virulent anti-Semitism is probably the projection on the Jew, as a symbol, of free-floating aggression, springing from insecurities and social disorganization. . . ."

> The situation may be compared to that of a psychiatrist in treating a patient. The psychiatrist resorts neither to admonishment to "be reasonable" nor to coercive measures, for he knows that this will do no good. . . . Mere indignant repression of an evil is the treatment of symptoms, not of the disease.

But what is Parsons's remedy? To late 20th-century eyes, it has itself some of the same symptoms of the disease it seeks to eradicate, for Parsons urges patience and toleration on the part of the Jews—it is they who must "be reasonable" since the anti-Semites will not.

> Generally speaking, any policy which tends to make Jews as Jews more conspicuous, and particularly those Jews who are at the same time vulnerable symbols in other respects, would tend to be an invitation to anti-Semitic reaction. Thus indiscriminate attack on every form of existent discrimination, regardless of anything but the immediate effectiveness of the means, is not likely to achieve the actual elimination of anti-Semitism, but on the contrary to intensify the reactions it attempts to stop.

Jews should avoid being "conspicuous," especially if they are "vulnerable symbols in other respects"—presumably, because they embody those "obnoxious characteristics" distasteful to Gentile society. Like present-day gays and lesbians—to whose situation, in comparison with the Jews of the forties, we will want to return—these Jews are urged to be inconspicuous, to moderate their extreme characteristics, to play along with what Parsons identifies as the "psychopathology" of "anti-Semitically inclined Gentiles," their "tendency to project upon others the moral responsibilities for one's own shortcomings,"[4] so that they—the Gentiles—will feel better about themselves, and thus about Jews.

We might compare Parsons's irenic (and ironic) faith in the inevi-

tability of social progress with the later views of Slavoj Žižek, a Slovenian theorist of the "symptom" whose own writing is symptomatically obsessed with the interruptive figure of the "Jew." "Society is not prevented from achieving its full identity because of Jews," writes Žižek, "it is prevented by its own antagonistic nature, by its own immanent blockage, and it 'projects' this internal negativity into the figure of the 'Jew.' In other words, what is excluded from the Symbolic (from the frame of the corporatist socio-symbolic order) returns in the Real as a paranoid construction of the 'Jew.'"[5] Like Talcott Parsons, Žižek sees "the Jew" as a projection of fantasies and fears. And like Parsons, he sees that the ideology of anti-Semitism is likely to prevail even against individual counterexamples of "good" Jews, Jews who can pass, those whom Parsons characterizes as "the more successful among the Jews, who are usually those who have become more or less assimilated and thus share many of the values of the Gentile society."[6] Thus Žižek speculates rhetorically, what if an anti-Semite should happen to know a Jew (perhaps his neighbor) who contradicts every stereotype the anti-Semite holds dear? Will he abandon his "beliefs"? Certainly not, says Žižek, for this is exactly the power of ideology. "His answer would be to turn this gap, this discrepancy itself, into an argument for anti-Semitism: 'You see how dangerous they really are? It is difficult to recognize their real nature. They hide it behind the mask of everyday appearance—and it is exactly this hiding of one's real nature, this duplicity, that is a basic feature of the Jewish nature.' An ideology really succeeds when even the facts which might at first sight contradict it start to function as arguments in its favor."[7]

In the pages that follow I will explore this double-bind of assimilation, anti-Semitism and Jewish "passing" by juxtaposing two striking examples of cultural overdetermination. The first is Laura Z. Hobson's 1946 novel, *Gentleman's Agreement*, which startled readers with its novel premise: a Christian masquerades as a Jew to test the boundaries of anti-Semitism among the "nice" people, what sociologist Melvin A. Tumin would later characterize as "the so-called 'gentle people of prejudice,' the polite bigots—those who would hardly, if ever, insult a Jew to his face or discriminate against him openly and candidly."[8] My second example, drawn from "life" rather than from "art," is the fascinating story of Madeleine K. Albright, U.S. diplomat and Secretary of State, who discovered, belatedly, that her Catholic parents had converted from Judaism when they left a Europe menaced by the Nazis, and that

she herself had therefore been born a Jew. These two rather atypical narratives of "passing" invite some reflections on the specific paranoia around anti-Semitism and the visibility and invisibility of Jewishness produced in and by the Hollywood of the forties, and, in a different way, by the race discourse of the nineties, in which the ghost of the concept of a "Jewish race" threatens, oddly, to return. At stake throughout these investigations, as I hope will become clear, is the way in which anti-Semitism itself has become a scapegoat in the latter part of the 20th century, drawing critiques from both the "left" and the "right." Finally, I will take brief note of the provocative and problematic analogy, already hinted at above, between homosexuality and Jewishness, to see how "gentility" affects and inhibits issues of identification, performance, and cultural pride.

The modern word "gentle" comes from the same root as "gentile," and initially meant well-behaved *because* "well-born." The barbed invitation of the Duke in *The Merchant of Venice* that I have used as an epigraph to this essay, "we all expect a gentle answer, Jew" sets up the paradox of the Jew-Gentile dynamic, the necessity and impossibility of passing, the recurring impasse that confronts "the Jew" in culture, suavely invited to translate himself out of existence. I begin this next section, however, with a citation from a more recent observer of cultural prejudice, an insider rather than an outsider: the muppet, Kermit the Frog: "It's not easy bein' green."

II
It's Not Easy Bein' Green

In the closing pages of Hobson's novel, *Gentleman's Agreement,* reporter Schuyler Green, known as Phil to his family, comes out to his secretary as a Christian. He has been writing an essay called "I Was Jewish for Eight Weeks" for the liberal magazine *Smith's Weekly,* and in the process he has learned a few things, first-hand, about "antisemitism."[9]

Some of those things he has learned, in fact, from his secretary, Miss Wales. Born Estelle Walovsky, she had changed her name to Elaine Wales in order to get a job. In fact, the experiment Phil Green wants eagerly to try, sending identically phrased letters to firms and hotels in the names of Schuyler Green and Phil Green (seeking, in the latter case, reservations "for myself and my cousin, Capt. Joseph Greenberg") has already been tried by Miss Wales. "Yes to the Greens and no to the

Greenbergs" had, in her case, translated into no job for Miss Walovsky, and a good job offer for Miss Wales. The employer in question? *Smith's Weekly.*

Sobered by this evidence that anti-Semitism is indeed not inconsistent with self-styled "liberal" crusading, Phil Green blows the whistle on *Smith's Weekly*'s personnel manager. "Is it just by chance," asks the magazine's editor sardonically, dressing down his resentful employee, "that we haven't one secretary named Finkelstein or Cohen? In the city of New York? . . . Come off it, Jordan."[10]

But Phil's grand gesture earns only Miss Wales's censure. She worries that, if *Smith's Weekly* now begins to advertise, as its liberal editor insists, that "Religion is a matter of indifference to this office" (the 1940s version of "Harvard is an equal opportunity employer"), there will be an immediate backlash. "If they just get one wrong one in, it'll come out of *us.*" If "just *one* of the objectionable ones" is hired, the "O.K. Jews," the "'white' Jews,"[11] the ones who can pass, will suffer.

And what are the "objectionable qualities" to which Miss Wales objects? Loudness, "too much rouge," and troublemaking. When Phil remonstrates that "they don't hire *any* girls that are loud and vulgar, What makes you think that they'll suddenly start?" Miss Wales thinks he's simply being obtuse. And when he calls her on her use of the word "kike" (as powerful a red flag in the 1940s as the word "nigger" is today), she is astonished. Since she's Jewish, she feels that she has a clear right to use the objectionable word, even to describe her own behavior ("if I'm about to do something, and I know I shouldn't, sort of in my head I'll say, 'Oh, don't be such a kike'"). That this too is "anti-semitism," that she herself could be an anti-Semite, as he says to her, seems to Miss Wales absurd, a categorical impossibility. She's Jewish. She's just not—in the phrase used as the title of an art exhibit mounted by the Jewish Museum in New York—"Too Jewish."[12]

So when Schuyler Green, having experienced the full gamut of 1940s genteel anti-Semitism —the doctor who remarks carelessly that a specialist called Abrahams is "not given to overcharging and running visits out, the way some do"; the reservations clerk at a "restricted" hotel who suddenly has no rooms available, despite the existence of a prior reservation; the reporter who observes that "of course" Phil would be "for Roosevelt"; the girlfriend who, intending to be comforting, tells Phil's son that the neighborhood boys who called him "dirty Jew" and "kike" were just making a "mistake," since he's not any more Jewish than she

is—when Schuyler Green, educated in ways he had not expected by his undercover assignment, finishes his manuscript and gives it to Miss Wales to type, he has almost forgotten that the gimmick, what the book calls the "angle," of his passing as a Jew has the power to disconcert her. But it does.

"You're a Christian, Mr. Green!" she exclaims, "surprise, reproof, embarrassment" all coloring her reply. "And I never suspected it." As Phil now clearly sees, this reaction, which assumes "that there *is* something different between Jews and Christians," reconfirms not only the dynamics of this particular binary opposition (so vital in the 1940s, so dated-seeming in the multicultural and multiethnic 1990s when many of the liberal Jews of the forties, today's "white Jews," are the mainstays of neo-conservative magazines), but also the inevitable insidious hierarchy of the binary structure itself. Christian/Jew, like white/black and male/female and straight/gay, functions in Miss Wales's world as a rank order of value. "Threaded through her ordinary surprise was astonished disbelief that anyone could voluntarily abandon that glory!"[13]

"You're a Christian, Mr. Green!" "And I never suspected it." Suspicion, that crucial tool for sussing out "suspects" and subversives, here attaches to a *majority* category and signally fails to detect it.

"Christianity" in the urban America of the forties is unmarked, unreadable, despite the crucial stigmata, the crucial symptoms, that are as plain as the (un-hooked) nose on his face.

When Laura Hobson first proposed the project that became *Gentleman's Agreement,* her editor at Simon & Schuster was dubious: "I don't think you have the necessary objectivity," said Lee Wright. "You are writing about a man who pretends to be a Jew in order to find out what they go through. But you who are writing this book are a Jew. How can you put yourself in his place?" And again, "You will be be accused of artificiality and special pleading, and you may do more harm than good. It is a great theme, but I think it has to be written by your hero, a liberal Christian man."[14] Wright thought a woman should not try to make a man her central character, but more at issue were the questions of identification and credibility. Publisher Dick Simon had similar doubts: "I think that if you write this book . . . readers will not believe that a gentile would pose as a Jew." The reverse-twist here is noteworthy: where it is hard to believe that a gentile would willingly pose as a Jew, it is even harder, say the editors, to imagine that a Jewish woman could put

herself in the place of a Christian man. Hobson is thus herself accused of trying to pass, just as her "hero" Phil Green does, and with some of the same caveats that Phil's fiancée Kathy, rather self-servingly, offers to him. Simon (himself a Jew) thought her "good intentions" would "come to naught," and that the whole experience would be "heartbreaking" for her. He discouraged her from attempting the book.

"Look, I'm the same guy I've been all along," explains Phil "gently" to his secretary, Miss Wales. "Same face, nose, tweed suit, voice, everything. Only the word 'Christian' is different. Someday you'll believe me about people being people instead of words and labels."[15]

What is especially striking about this little dialogue, however, is that Phil had already rehearsed it in his mind, but from the other side, as a "Jew" rather than a "Christian," at the time that he broke the news of his story's angle to Kathy. "I'm going to tell everybody I'm Jewish," he said to her, and saw "some veil of a thing" in her eyes. "Jewish? But you're not, Phil, are you?" And then, sensing his hesitation, "I know perfectly well you're not Jewish and I wouldn't care if you were."

It was at this point, quite early in the novel, that he imagined to himself what would happen if he said to her, "I really am Jewish."

> He'd be the same guy, the same face, the same voice, manner, tweed suit, same eyes, nose, body, but the word "Jewish" would have been said and he'd be different in her mind.

There would be, as he puts it, "a something to 'not-care'" about.[16]

"Same face, nose, tweed suit, voice, everything." When the word "Jewish" follows this list, words like "face," "nose," "voice," and the particular design and pattern of that "tweed suit" are inflected in one way; you can almost see Kathy's re-evaluation of his features, tonalities, and sartorial taste. When the word "Christian" follows, as in Green's conversation with Miss Wales, we get the Pinocchio effect in reverse: the nose shrinks back to WASP proportions, the voice (one of the most traditional ways of stigmatizing the "too Jewish" speaker)[17] softens and flattens, the suit becomes more conservative in both pattern and cut.

"Same face, nose, tweed suit, voice, everything." In the 1947 Academy Award winning film version of *Gentleman's Agreement* (Oscar for Best Picture), directed by Elia Kazan (Oscar for Best Director) with a screenplay by Moss Hart, this conversation between Phil Green (Gregory Peck) and Miss Wales (June Havoc) in which he comes out as

Christian was excerpted in the movie trailer, the come-on to audiences, inviting them to see a film whose topic is described in the trailer as "taboo," and which is in fact *so* taboo that the word "anti-Semitism" is never actually mentioned in the trailer. *This* was the scene that the producers and marketers apparently thought would engage the imagination of viewers.

But in the film the wording of Phil Green's speech is slightly changed, "fleshed out," so to speak, so that it resembles, even more closely, the most famous Jewish coming-out speech of all time.

Here is Gregory Peck in the film version of *Gentleman's Agreement*:

> Look at me, Miss Wales. . . . Same face, same eyes, same nose, same suit, same everything. Here, take my hand, feel it. Same flesh as yours, isn't it? No different today than it was yesterday. . . .

And here—of course—is Shakespeare's Shylock:

> I am a Jew.
> Hath not a Jew eyes? Hath not a Jew hands, organs,
> dimensions, senses, affections, passions; fed with
> the same food, hurt with the same weapons, subject
> to the same diseases, heal'd by the same means,
> warm'd and cool'd by the same winter and summer,
> as a Christian is? . . .
>
> *Merch.* 3.1.58–64

"Same flesh as yours." Peck's (or rather, screenwriter Moss Hart's) word "flesh" does not appear in this speech in either Hobson's novel or Shakespeare's play, but it is, needless to say, *the* ultimate signifying word of *The Merchant of Venice,* which turns on the demand for a pound of flesh.

Hobson's Phil Green, seized with the brilliance of his "angle," had checked over his personal attributes in the mirror: "tall, lanky; sure, so was Dave, so were a hell of a lot of guys who were Jewish. He had no accent or mannerisms that were Jewish—neither did lots of Jews, and antisemitism was hitting at them just the same. His nose was straight—so was Dave's, so were a lot of other guys'. He had dark eyes, dark hair, a kind of sensitive look—."[18] This tall, straight-nosed, accentless man without any "mannerisms that were Jewish" (query: are there "mannerisms that are Christian"?) is the fantasmatic assimilated American Jew—

no wonder Gregory Peck can impersonate one without difficulty.

For Gregory Peck, the WASP to end all WASPS, to intone that word "flesh," having earlier stared at his reflection in the mirror and willfully misrecognized himself as John Garfield, who plays his war buddy Dave Goldman ("dark hair, same as Dave; dark eyes, same as Dave . . . "), is to reposition Shylock as the American Everyman, only Jewish incidentally and by historical accident, but much more importantly and transcendently "human." Jewishness is a contingent and secondary characteristic, something that "shouldn't" matter and "shouldn't" get in the way.

John Garfield himself appears in the film in double ethnic drag. Born Julius Garfinkle, he changed his name to John Garfield—following the assimilation/obliteration tactics of the Hollywood studio system—and was subsequently cast as Hobson's paragon of quiet Jewish heroism, Captain Dave Goldman, war hero. At the beginning of his career, arriving in Hollywood in 1938 fresh from the left-wing Group Theatre in New York, Garfield had called himself "Jules Garfield." When studio head Jack Warner told him it didn't "sound American" ("What kind of a name is Garfield, anyway?") the young actor explained that it was the name of an American president. So they worked on changing his *first* name. Warner suggested James—the name of the President—and Garfield/Garfinkle asked whether he'd name an actor "Abraham Lincoln." Certainly not, came the reply: "Abe" would sound too Jewish.[19] So Julius Garfinkle became John Garfield, and a major Hollywood star.

The phenomenon of a Jew adopting a Christian-sounding name to make it in movies, and then playing the part of an admirable, morally upright, sentimentally idealized Jew in a film about anti-Semitism (in effect, the Sidney Poitier of Jewishness) is rather like the boy actor-playing-a-female-character-playing-a-"boy" structure of Shakespeare's cross-dressing comedies. The audience is invited to look both at and through the character, and its sense of irony or fitness will depend to a certain extent on whether its members "know" that John Garfield is Julius Garfinkle—or rather, that he *was* Julius Garfinkle until his baptism-by-Hollywood. A good father and a good fighter, the Dave Goldman of the novel is a man with a "short, stubby nose" and "red blond" stubble who nonetheless looked like a Jew. "It was there somewhere. In the indented arcs of the nostrils? In the turn of the lips? In the quiet eyes? It was such a damn strong good face."[20] ("Nostrility" was one of the stereotypical terms applied to the Jewish nose by pseudo-scientists, some of them

Jewish, from the middle to the end of the 19th century.)[21] Dave
Goldman—despite the fact that Schuyler Green sees him as a kind of
twin—is "readable" as Jewish. What about John Garfield?

Garfield's liberal politics, which led to his blacklisting in the early
fifties, were taken to *confirm* the secretive and (therefore?) potentially
seditious tendencies that were represented by his change of name.
"There are even Jews who suggest that all Jews should be forced to
change their names" wrote Jean-Paul Sartre in 1946, in his philosophi-
cal polemic, *Anti-Semite and Jew.*[22] Compounding the irony, it was Jack
Warner (son of a devoutly religious Polish-Jewish immigrant), the very
man who had in effect officiated at Garfield's re-naming ceremony,
who was the first Jewish studio executive to "name names" before the
House Un-American Activities Committee when it went hunting for
Communists in the Spring and Fall of 1947—the very year, lest we for-
get, in which *Gentleman's Agreement* won the Oscar for Best Picture.
(Award-winning Director Kazan was also one of those who elected, a few
years later, to name names before the Committee, earning for himself
the right to make movies uninterruptedly without government interfer-
ence throughout this troubling time, and with it the lifelong ambiva-
lence of Hollywood—but that's another story.)[23]

On November 24, 1947, Representative John E. Rankin of Mississippi,
a leading figure on the Un-American Activities Committee and "the out-
standing anti-Semite in Congress,"[24] rose to denounce a petition signed
by several members of a Hollywood group calling itself the Committee
for the First Amendment, a committee formed by such screen luminar-
ies as Frank Sinatra, Judy Garland, Kirk Douglas, Katherine Hepburn,
John Garfield, Edward G. Robinson, Groucho Marx, and Lauren Bacall
to protest impingements on the right of free association. Many of the
Committee's members were Jewish; others were not. Rankin spoke in
support of the contempt citations proposed by the House to punish ten
"uncooperative witnesses" who declined to name names to HUAC. He
read off the names of the signatories to the CFA petition:

> "One of the names is June Havoc. We found out from the motion-picture
> almanac that her real name is June Hovick.
>
> "Another one was Danny Kaye, and we found out that his real name
> was David Daniel Kaminsky. . . .
>
> "Another one is Eddie Cantor, whose real name is Edward Iskowitz.
>
> "There is one who calls himself Edward Robinson. His real name is
> Emmanuel Goldenberg.

"There is another one here who calls himself Melvyn Douglas, whose real name is Melvyn Hesselberg."[25]

The "real names" of these famous actors—a veritable Who's Who of the entertainment industry in the 1940s—were, implied the Congressman, dissimulated, faked, falsified, and hidden. He himself—or his diligent, loyal, and patriotic staff—had had to ferret them out. From the motion-picture almanac.

"So long as there is anti-Semitism," Sartre believed, "assimilation cannot be realized. . . . No democracy can seek the integration of the Jews at such a cost."[26] "Under the kind of censorship this inquisition threatens," observed Ring Lardner, Jr., one of the Jewish screenwriters under investigation by the committee, "A leading man wouldn't even be able to blurt out the words 'I love you' unless he had first secured a notarized affadavit proving he was a pure, white Protestant gentile of old Confederate stock."[27]

Notice that one of the first names named (and held up to public scrutiny) by Congressman Rankin is that of June Havoc, who plays the Jewish secretary Elaine Wales/Estelle Walovsky in the film version of *Gentleman's Agreement.* So Havoc, like Garfield, plays a multiple, infolded role in the film, cast as a Jewish woman who changed her name and quietly passed as Gentile to get and keep a job in the media industry. As the movie trailer notes sonorously and without any hint of double meaning (or excessive concern for syntactical agreement) "in selecting the cast, the roles were filled with special care."

Phil Green's article for *Smith's Weekly* describes him as an Episcopalian, brought up by Episcopalians whose parents, in turn, were Episcopalians.[28] His father was a liberal who gave every penny of the interest on his "fortune" to "something he believed in":

> Before 1917, he'd sent it to an organization for the defense of political prisoners in Russia; when the Ku Klux Klan was raging in the early twenties, he'd sent it to a group fighting it; when the Civil Liberties Union came into being he'd mailed his little checks there.[29]

In other words the elder Green would have been a prime target for the House Un-American Activities Committee—as author Hobson is perfectly well aware.

But let us return to the other reverse twist of *Gentleman's Agreement,*

the fact that the Shylock-like moment of self-revelation and exposure, the appeal to pathos and recognition, ultimately occurs at the moment when Phil Green outs himself as a *Christian*.

We might regard this minoritizing move as a distinctly Hollywood touch. The film's producer Darryl Zanuck, a Protestant from Wahoo, Nebraska, who was nevertheless closely associated in the public mind with the "Jewish" entertainment industry, once remarked to an associate on the unsuspected depth of anti-Semitism in America, reporting "without a trace of irony" the difficulty he and his wife encountered when they tried to register at a resort hotel: "It took me two hours to convince them that I wasn't a Jew."[30] (David O. Selznick's wife Irene, the daughter of Louis B. Mayer, remarked about the combative Zanuck, "Thank God he's gentile; otherwise he'd give Jews a bad name.")[31] It was in Zanuck's film version of Hobson's novel that the crusading gentile Schuyler Green makes a special trip to the "restricted" Flume Inn in the White Mountains of New Hampshire to convince them that he *is* a Jew (or rather, as the manager so delicately puts it, that he "follow[s] the Hebrew religion").

"Restricted" had become, by the forties, so familiar a shorthand term that its meaning and implication were clear. (In a famous comic scene in *Auntie Mame*, the ultraliberal Mame, who discovers with delight that some Jewish friends from New York are bidding on a piece of property in Connecticut near her nephew's future in-laws, is informed by the gauche and scandalized WASPs that their town of Mountebank is "restricted.")[32] But the fuller legal designation, "restrictive covenant," embodies a further irony. In property law, a restrictive (or protective) covenant is one that is intended to preserve or enhance real property values by the maintenance of certain standards; such covenants were regularly used to keep out Jews, blacks, and other minorities, until the U.S. Supreme Court outlawed the practice. But "covenant," of course, is also a religious term, employed by both Jews and Christians to mark the particularity of their engagement with God.[33] Restrictive covenants in civil law, then, when utilized to exclude Jews from owning property in certain places (like the Darien, Connecticut, of *Gentleman's Agreement*), preempt the concept of "covenant" to turn it against Jews and to protect the "chosenness" of Christians.

We might, then, think of the peculiarly ambivalent pathos of the Christian unmasked as not-a-Jew as a typical Hollywood twist, were it not that the possibility of such a "revelation," the "dog bites man" of religio-

ethnic news stories, has been trotted out in connection with one of the more compelling cultural identity tales of the day: the story of Secretary of State Madeleine K. Albright's recently disclosed Jewish heritage. More than one person wondered aloud what would have happened if the revelations had been reversed—if what Madeleine Albright had learned, whether from a Mayor or a cousin or the *Washington Post,* had been that she was not Jewish, but Christian. Would this revelation have aroused "suspicion" about a wish for secrecy, about prior knowledge? Why is Judaism a (guilty) secret, and Christian identity an unquestioned, and unquestionable, given? As one reader wrote to the *New York Times,* "If the situation were reversed—that a prominent Jewish person learned of a Christian background—would that be a 'thunderbolt'?"[34]

"You're a Christian, Mr. Green!"

III
Diplomatic Immunity

A "diplomat" (back-formation from the French adjective *diplomatique,* diplomatic: "connected with the documents that regulate international relations") is a creature of agreements, some written, some unwritten and perhaps even unspoken. Indeed diplomacy, the art of conducting international relations, could be said to be the ultimate kind of "Gentleman's Agreement" ("an agreement guaranteed only by the honor of the participants").[35]

Arguably, the American Secretary of State at the end of the 20th century is the diplomat of diplomats, especially, perhaps, when this particular, and particularly skilled, diplomat comes to the cabinet direct from the crucial and delicate post of Ambassador to the United Nations.

But what happens when this diplomat of diplomats is revealed to be, or identified as being, not a "gentleman" but a woman? In fact, a "Jewish" woman. Even if she is a practicing Episcopalian?

Easy: she loses her immunity.

Madeleine Korbel Albright's father was himself a diplomat, as many news sources stressed. He fled first the Fascists, and then, in the late forties, the Communists. "This family were probably fairly secular Jews to begin with, and the father, a diplomat and very bright man, saw what was coming and probably thought it best to protect the family and was baptized," suggested Zbigniew Brzezinski, former National Security Advisor to President Jimmy Carter. "And then not to create an identity

issue for the children, he probably kept going."[36] Brzezinski, who had
been Albright's thesis adviser and hired her to do Congressional liaison
work at the White House, was dismissive of speculations about her prior
knowledge, regarding them as products of New World provincialism;
Americans, he said, "have a very naive view of the symbiosis and inter-
penetration between Jewish and non-Jewish populations in Central
Europe" before World War II. But whether provincial, naive, or—as oth-
ers would suggest—guilt-ridden, the views of Americans, and preemi-
nently of American Jews of European descent, were not themselves kept
secret.

In February 1997, about a week after *Washington Post* reporter
Michael Dobbs broke the news that Albright's parents were Czech Jews
who had converted to Catholicism, novelist Anne Bernays wrote feel-
ingly to the *New York Times*:

> I have tried without success to put a positive spin on the report about
> Madeleine K. Albright's reaction to the big news about her family.
> It's clear that despite her public denial, she knew for some time that
> her antecedents were Jewish. The only possible interpretation of this
> secrecy is that she doesn't like being a Jew. I'm sure I'm not alone in
> reacting with pity for her trepidation and shame for her lack of ethnic
> pride.[37]

Other letters to the editor on the same day took equally strong positions
on the issue, from "what business is it of ours to deliver reproaches? . . .
this is essentially a private matter, one that has no bearing on Ms.
Albright's qualifications as Secretary of State" to "A leader without the
curiosity or courage to embrace her own history offers a saddened
prospect." Words like "denial" and "willful eras[ure]" recurred like
unburied ghosts of the past, and the strong tone of Bernays's "only pos-
sible interpretation," "secrecy," and "shame" rang out in letter after let-
ter. There was also "fabrication"—and the assertion that a "drive for
professional advancement" had motivated the obliteration of an incon-
venient personal past.[38]

In an interview Albright recalled that her parents talked with her
"about getting ready for various holidays, for Easter and Christmas"[39]
but, the reporter intervened, "those memories of childhood Easters
were fabricated later to try to keep her own sense of identity whole."
And Albright herself used terms like "gap," "story," and "duality" to

describe the narrative progress of her belated enlightenment. "I had a story, and there were no gaps in that story, and as a child, if there are no gaps, you don't ask questions," she reflected. "It is that duality I will have to live with for the rest of my life."[40]

"Madeleine Albright must have known," declared the opening sentence, indeed, the entire opening paragraph, of an Editorial Notebook piece by Philip Taubman in the *New York Times*.[41] "She didn't want to know from Jewish," remarked a Democratic loyalist to columnist Frank Rich, deliberately choosing to speak for effect in the demotic patois of the first-generation Jewish immigrant.[42] This was the Yinglish language Albright presumably had never known, never heard, from her parents, themselves central European immigrants to America. "Who knew?"—to cite another Yiddishism—that she was "really" Jewish? In retrospect it seemed so clear.

What did she know and when did she know it? This accusatory question, so familiar to Watergate groupies of the 1970s ("What did the President know and when did he know it?") resurfaced in the Albright affair—or, as Taubman called it, The Albright Syndrome, or, as Rich called it, "The Albright Question," as a pervasive epistemology of suspicion.

> If letters sent in recent years by the Mayor of her father's hometown in the Czech Republic reached her, why did she fail to respond to the detailed accounts they provided about her family's Jewish background?
>
> Running beneath these questions is the suspicion that she did know, or made a conscious effort not to know, because she did not want to be seen as a Jew in a world still uncomfortable with Jews. "We may never know how much Ms. Albright knew. . . ." wrote Taubman. "Maybe she didn't want to know," an expert on trauma and Holocaust survivors told the *Washington Post*. "I don't find that so inconceivable."[43]

What did she know and when did she know it? "Suspicion" was the word, all right. "What bothers me is that some sort of cover-up or anti-Semitism might be imputed to her," said her friend and Wellesley classmate Emily MacFarquar, whose name before marriage was Emily Cohen. "That's the hidden question, and it's better to say it. But if there was any cover-up, it was by her parents, whom I knew very well, and it was for the most benign of reasons. A lot of families closed down on this horror and tried to block it out." As for speculation about whether the Korbel family

was Jewish, it appears that there had been some at the time: "It's presumed that refugees from Nazis are Jews until proven otherwise."

The complexities of the fifties moment are well recalled by MacFarquar, who, as a Jewish undergraduate was assigned a Jewish roommate, while down the hall Madeleine Korbel, a Catholic, shared a room with another Catholic. Between their two double rooms, on the same hallway, was a single room occupied by a black woman.[44] I'm sure this was regarded as a "liberal" arrangement, and that it was meant to make everyone "comfortable," as, perhaps, it did. Jewishness—and Catholicism—were hardly hidden in this system, but rather indexed for all to see. (Were the white Protestants all in another wing?)

It is easy to forget, in these days of race- and gender-based affirmative action, that religious identity was a crucial and often limiting factor in admission to many elite colleges and universities earlier in this century. In 1945, the Secretary of Yale University wrote to one of the university's lawyers about the difficulty of counting the "final" percentage of Jews in each entering class: "A number of Hebrews record themselves among the Protestants, chiefly as Episcopalians, and some don't reply at all."[45] What the Chair of the Yale College Admissions Committee called "the Jewish problem" thus led to a formalization of restrictions, since, as he noted in his 1944–45 annual report "the proportion of Jews" with high scholastic qualifications had "increased and remains too large for comfort."[46]

At Harvard, President A. Lawrence Lowell, a former vice-president of the Immigration Restriction League, urged the adoption of a quota on Jews, ironically (but not unusually) arguing that anti-Semitism would diminish if colleges limited the proportion of Jewish students. The subsequent publicity debacle led to a public outcry in 1922, a state-sponsored investigation of discrimination practices, and an official retraction in the following year, after which the admissions policy, and the management of numbers, went underground.

From the twenties onward, a policy of "restriction of numbers by the exclusion of low class Jews and their like"[47] had been under discussion by the Yale Corporation, The materials of this discussion are, rather ominously in view of subsequent historical events, collected in a folder labeled "Jewish Problem" in the collected papers of Yale President James R. Angell. The official Yale designation was not "quota" but the somewhat more genteel phase "Limitation of Numbers"—a phrase itself not entirely devoid of disquieting resonance. In the same period,

Columbia College, according to its dean, was able to limit the number of Jews through psychological testing, reducing the percentage from 40 to 20: "Most Jews," he wrote, in response to a query from Yale, "especially those of the more objectionable type, have not had the home experiences which enable them to pass these tests as successfully as the average native American boy." Jewishness was often rhetorically described in this way, as antagonistic to Americanness and therefore invidious to the spirit of the elite colleges and universities. Questions about religious affiliation were standard on college application forms until the late forties, when four significant reports (issued by President Truman's Commission on Higher Education, the New York State Commission on the Need for a State University, the American Council on Education, and the Connecticut State Inter-Racial Commission) strongly suggested that Jews had more difficulty being admitted to the colleges of their choice than did gentiles.[48] In the wake of this negative publicity, many Northern schools dropped application questions about religion and race. As Dan Oren reports, a request for the candidate's "Mother's maiden name," for example, had been included in application forms "precisely in order to determine the applicant's religio-racial background."[49]

With this historical context in mind, some commentators regarded the story of Madeleine Albright as far from unusual. Scholar Deborah Lipstadt, a Professor of Jewish Studies who writes on the complex response of America and American Jews to the Holocaust, noted that that during the 1950s, when the young Madeleine Korbel was a student at Wellesley, it was not "convenient to be Jewish."[50] Frank Rich adds that the postwar period was "the time for heavy-duty assimilation, for name changes and nose jobs and reform synagogues that bordered on the Episcopalian." Her case, he suggests shrewdly, "wouldn't resonate so loudly if it didn't awaken guilty memories in so many American homes" —memories of an assimilation so complete that it erased, or seemed to erase, all traces of Jewish identity. As the Jewish humorist and philosopher Harry Golden once remarked, "the first Jewish President will be an Episcopalian."[51]

One letter to the *New York Times* suggested that "in those days the prestigious Eastern colleges seemed to be more concerned with elegance and success than with self-awareness, courage, and acting on conviction."

During that period there were still quotas on Jews at nearly all elite colleges, and the "best" social clubs virtually excluded Jews.[52]

It is not surprising in this setting that many American Jews on those campuses, not only a Czech-born Roman Catholic of Jewish descent like Madeleine Korbel, would seek to hide their roots. In the case of the Americans, the denial was conscious; in the instance of Madeleine Korbel, it may well have been unconscious.[53]

But can one "hide" what one does not know? The "unconscious denial," as many others sought to point out, was manifested by incuriosity: not a failure to tell, but a failure to ask. How could this be regarded as "denial"—or, to use a commonplace of therapy-speak, as being "*in* denial"? ("I had a story, and there were no gaps in that story, and as a child, if there are no gaps, you don't ask questions.")

The "secret" of Albright's "Jewish identity" (but in what sense was she a Jew, she who had been brought up a Catholic and converted to Episcopalianism?) was both symptomatically seized upon, and symptomatically disavowed.

"Was she really honor-bound to become, in her late 50's, all of a sudden, a Jew?" asked Louis Begley in yet another Op-Ed piece (the *New York Times* could not get enough of this story). A further spate of letters debated this and related questions of heritage and faith. "Secretary of State Albright is an American Christian by citizenship, upbringing, and conviction," wrote one. "Her forebears came from another culture, like most Americans. By suggesting that admitting her Jewish ancestry would change her identity, Mr. Begley tacitly accepts the racial stigma that has tragically accompanied Jews throughout their history."[54]

A column in *Moment*, which calls itself "the Jewish magazine for the '90s," posed the question all its readers wanted to ask: "Is Madeleine Albright Jewish?" "The knee-jerk reaction of most Jews," wrote Lawrence Shiffman, a professor of Hebrew and Judaic Studies at NYU, "is that Albright is certainly a Jew, assuming that her mother's mother was herself born to a Jewish mother." Since Albright had no control over her religious identity as a child, she was in Jewish law what is called a *tinok she-nishbah*, literally "an infant that was captured" (and raised among non-Jews). This was a situation unfortunately not unprecedented in the long history of Judaism, and it had therefore been extensively considered by Jewish law. From ancient Rome to the Spanish Inquisition, forcible conversions, including the conversions of

unknowing children, were no obstacle to reclaiming Jewish identity. And since they themselves did not know that they were Jewish, "The hidden children of the Holocaust, including Madeleine Albright," would require no conversion if they wished to return to Judaism. Even if Albright did not return to Judaism, in fact, there was a possibility that she would be recognized under Israel's Law of Return, since she had a Jewish grandparent. This, though, was a ruling that would have to be made by the Israeli courts.[55]

After the revelation of Albright's parents' history, the *New York Times* editorial page asserted that her "strong record of support for democracy and human rights" was sufficient evidence that her views would not "be influenced by her Jewish heritage." To imply that they might be was, said the paper, "offensive." But at least one reader found this apologetic disclaimer itself an offense.[56]

Whether the question was a public or a private one was also a hot topic for disputation. Albright and the State Department said it was private: "This is a personal issue for her and her family. It is not a political issue. It is not a foreign policy issue." But in fact the Arab press had made it a public issue long *before* the revelations in the *Washington Post*. Some Arab newspapers had decried her as a Jew, a Zionist, an Israeli-sympathizer and (in consequence) an Arab-hater long before Dobbs's article was published in the *Washington Post*. (They also said, equally symptomatically, that she was a frustrated old maid whom President Clinton had promised a husband if she got rid of Boutros Boutros-Ghali, an Egyptian, then Secretary General of the United Nations.)[57] When Albright was nominated as Secretary of State, the Saudi-owned international Arabic daily *Al Hayat* described her not as President Clinton's choice but rather as "the choice of the Jewish lobby in America, just as William Cohen is at the Department of Defense."[58] (Cohen, whose father was Jewish, was brought up as a member of the Unitarian-Universalist Church.) "It becomes very difficult to find one position in the Clinton administration that is not held by a Jew," said *Al Hayat*. An "otherwise pro-U.S.-leaning academic in Saudi Arabia" called her "that horrible, macarena-loving woman," and declared that "Madeleine Albright is no friend of the Arabs." Editorial cartoons identified her with Golda Meier, and showed her holding an Israeli flag and dressed in six-pointed Jewish stars. The Syrian Ambassador to the United States said Albright would have to work hard to overcome her negative image among Arabs. Albright herself, explaining one of the reasons she discounted some of the letters she received, characterized the authors as

"Serbians who hated my guts and said I was a whore and I was Jewish; I figured that was invective."[59]

"Until the nineteenth century," wrote Jean-Paul Sartre, "the Jews, like women, were in a state of tutelage; thus their contribution to political and social life, like that of women, is of recent date."[60] As Michael Walzer points out in a thoughtful preface to the second edition of *Anti-Semite and Jew*, Sartre's "ignorance of Judaism was willful and programmatic," as was his lack of understanding of Jewish history. He is writing about France, and from a Marxist/Existentialist perspective. Though he brilliantly describes the interpersonal construction of personal identities he does not imagine a Jewishness, or a Jewish identity, of the kind that has emerged fifty years after the writing of his provocative and important essay.

Sartre's famous—or notorious—description of "authentic" and "inauthentic" Jews, the one active, affirming a Jewish identity, the other merely reactive, seeking "avenues of escape" through cosmopolitan irony and rationalism, is effectively qualified by Walzer, who noted that although "Jews are more likely today than they were in 1944 to respond 'authentically' to their encounter with anti-Semitism—that is, to affirm the value of their history and culture," they often do so with reference to "what many Jews today would call inauthenticity, though it is not clear that Sartre would recognize it as such: that is, *the effort to base Jewish identity on the Holocaust experience.*"[61]

Sartre had predicted that intermarriage and assimilation would follow upon the lessening of anti-Semitic pressure. But side by side with these incentives to invisibility and passing have come new imperatives for visibility: "the institutional strength of diaspora Jewish communities, the rise of Jewish studies in universities throughout the Western world, the revival of religious interest (if not religious faith), and a transnational solidarity that extends across the diaspora as well as binding diaspora Jews to Israel."[62]

It is in this contradictory terrain between assimilation and diasporic consciousness that Madeleine Albright's "Jewishness" emerged as a contestatory site for questions of both authenticity and identity. "I have never been secretive about anything in my life," Albright told Frank Rich after she read his column,[63] but the secret was not hers to keep—or to disclose. "The effort to base Jewish identity on the Holocaust experience" was a powerful engine deployed by her critics and investigators: she was a Jew *because* her grandparents had perished in the camps. And as myopic as Sartre's statement about the novelty of Jews

and women in public life may seem to us today from the vantage point of a (non-French) European and American history, there seems little question that Albright's femaleness, taken together with her "Jewishness," constituted a political and social problem. After all, she had married. Like her Wellesley classmate and friend, Emily MacFarquar, who reminded interviewers that she was "Emily Cohen MacFarquar," Madeleine Korbel Albright had taken a gentile husband and a gentile surname. Her Jewishness needed to be retrieved for her, made visible. And there was, if she chose to think about it, this other reminder from Sartre, about the Jew who aspires to a certain position in public life: "how sharply must he feel the vanity of honors and of fortune, when the greatest success will never gain him entrance into that society which considers itself the 'real' one. As a cabinet minister, he will be a Jewish cabinet minister, at once an 'Excellency' and an untouchable."[64]

IV
Passports

Shortly after her confirmation by the Senate Madeleine Albright went on her first official trip outside Washington. The newspapers were full of the "revelations," as they continued to insist upon calling them, that "her family was Jewish." The pressure of state affairs was considerable— there was trouble in the Middle East and in Russia—but Albright headed, deliberately, not overseas but to Houston, Texas, where she chose, as her first stop, the local passport office. There she took up a stand behind a bulletproof window and herself renewed the passport of a startled member of the public.[65]

The symbolism of the passport was greater, perhaps, than even she had intended. Researcher Kenneth Jacobson sought out people who "had struggled with their Jewishness during the Nazi period," hoping that "the accounts they would give of their lives might provide a new perspective on the nature of identity."

There were those who assumed a non-Jewish persona in an attempt to foil the Nazis, and those who revealed or insisted upon a Jewish connection even when it put them at peril. There were those who, turning their backs on the majority society, converted to Judaism once the Third Reich had fallen, and those who tried to loosen their ties to a Jewish past by taking a new name, becoming Christian, or simply getting lost in the crowd. There were those of mixed parentage.... Finally, there were those who

had Jewishness thrust upon them—who had been totally unaware of their Jewish background before being threatened because of it, or had known of it, but wanted no part of it; or had acknowledged it, but had viewed themselves for religious reasons as Christians rather than Jews; or were first confronted with it, and with the implications for their own lives and those of their families, once the persecution was at an end.[66]

All over Europe, says Jacobson, he found Jews who had achieved a "seamless assimilation" into the dominant Christian culture. For many of these people "being Christians, or at least not being visible Jews, was looked at as a ticket to full participation in society."[67]

What is the difference between a ticket and a passport? A ticket is a piece of paper that obtains, for its holder, admission to an event, or use of a service. It lets you in. A passport is a government document that certifies identity and citizenship, permitting travel across borders and boundaries. It says who you are; it lets you across or through.

In his conversations with members of what he calls this "exceptional minority," Jacobson explores the whole question of a "choice" of identity. His interview subjects were, in a variety of ways, "in the position of having to choose between a Jewish or a non-Jewish identity or to find a way of making the two coexist." We might recall Albright's own statement about coming to terms with her parents' religious past: "It is that duality I will have to live with for the rest of my life."

A duality, however, is not the same as a deceit. Clearly some of Albright's most vociferous detractors among both Jews and non-Jews thought she was trying to get away with something, trying to pass. "She didn't want to know from Jewish." Was passing her passport to a career in public life?

For some political and cultural observers today the concept of Jewish "passing" may seem passé. American Jews today are generally regarded as white, well-educated, and well-off—the very antithesis of the underclass. Why should they have to "pass" since they already inhabit the precincts of privilege? Yet this is a view that flouts history.

"For years Jews have also been 'passing,'" declare the authors of a book called *The Einstein Syndrome*. "Often a change of name and nose will do the trick. Even so, only a small minority of Jews prove to be willing and able to pass the WASP test."[68] "Jewish names are typically Jewish," they observe, "and frankly, we doubt if any Christians have changed their names."[69]

"Passing" is a word most frequently used at present in connection

with race, gender, or sexuality: individuals in history and characters in fiction are said to pass, or to have passed, as white, as straight, or as men (or women). Thus, for example, a recent collection of essays on "passing and the fictions of identity" associates passing directly with "the discourse of *racial* difference" and "by extension" to "other elements of an individual's presumed 'natural' or 'essential' identity, including class, ethnicity, and sexuality, as well as gender."[70]

While Jewishness has at one time or another been linked with *all* of these variables it is virtually absent from this essay collection, appearing only once and then only as a foil: The author of *Black Like Me* was struck in the postwar forties by the similarity between U.S. white supremacist notions and "Aryan supremacy as practiced to genocidal effect against Jews in Europe."[71] There is no sense in this account that "Aryan supremacy" was given substantial credibility in the *United States* at this same time—or, indeed, that it is still present more than fifty years later. "Race" is regarded here as an "essential" characteristic—one you can't escape, "can't help," can't change.

"Have the Jews a Racial Identity?"[72] asked a scholarly article written by an American anthropologist in the early forties describing, in terms he would later characterize as a matter of "zoological taxonomy,"[73] "the cast of countenance which is commonly labeled "Jewish": "a relatively wide head and narrow face, with a slanting axis to the ears; a narrow lower jaw; a narrow interocular distance; and a considerable nose length, with convexity of profile and tip depression," together with a set of "non-inheritable traits, culturally acquired, and including characteristic postures, facial expressions, and vocal habits."

"There is no evidence," retorted another anthropologist in the same volume, "for the existence of a distinctive Jewish blood or 'race,' nor has there ever been a group of family lines of Jews that could be called a 'race.' The Jewish leader who speaks about 'our race' is talking unadulterated nonsense. When he or she accedes to such a notion, or uses such words, there is an admission in effect that the racial nonsense uttered by the bitterest enemies of the Jewish people is likewise biologic truth.

"It is no longer necessary," he continued with some force, "to reiterate the puerile claim of a common 'racial' characteristic in order to take significant pride in participating in a rich historic and religious heritage. Therefore it is correct to affirm the continuity of a Jewish religion, a Jewish community of peoples, a continuity of cultural forms, and other nonbiologic entities. It is on a completely different level of

analysis to point out that linguistically and biologically the Jewish peoples have often changed into forms indistinguishable from the Gentile people around them."[74] The second of these two authors was Jewish; the first was not.

Like the recent trend claiming an immutable "biological" basis for homosexuality, the old arguments for a "Jewish race" seemed to turn, in part, on issues of heritage, kinship, mannerism, and visibility. Was Jewish identity a choice, or an inescapable fact of life? Imposed from within or from without? Is Judaism a "natural," "essential," or racial identity? And if not, what are the implications for a discourse of Jewish passing? As 19th- and early 20th-century science made all too clear, Jewishness has sometimes been very "visible" indeed as a "racial" category with marked physical and social characteristics—and not only in the eyes of manifest bigots. But its visibility has been spectral—the visibility of the ghost.

V
The Jew as Ghost

When Phil Green's son Tommy in *Gentleman's Agreement* asks his father whether they're Jewish, as a playmate has asserted, Phil providentially remembers a film they have recently seen, Danny Kaye's *Wonder Man* (1945), in which a "dead brother's ghost" gets into his twin's body and makes him dance and sing and talk like him." The serious, bookworm brother Edwin Dingle is forced to take the place of his gregarious entertainer sibling Buzzy (Buster) Bellew when the latter is killed. This is the "grown-up game" Phil describes to Tommy.

"You mean you're not Jewish but just as if you had a twin brother's ghost in *you*, like the movie, and *that* one is Jewish?" Tommy, his interest piqued, wants to get "in on the game," but Phil tells him it "isn't a game a little boy would know how to play right," and that, in fact, he shouldn't tell anyone it's a game. To the inquisitive friend who has posed the question in the first place, Tommy is therefore instructed to say that Phil is "partly Jewish." Tommy gets the point: "But not say it's the ghost part!"

The image of the Jew-as-ghost, his own (and Europe's) spectral double, is one of the most commonplace in literature, whether deployed in a way that intends itself to be pro- or anti-Semitic. Jean-Paul Sartre's *Anti-Semite and Jew* describes "the Jew" as "assuming a phantom person-

ality, at once strange and familiar, that haunts him and which is nothing but himself—himself as others see him."[75] "The life of each [Jew] is haunted by the lives of others," writes Sartre, and again, "such, then, is this haunted man, condemned to make his choice of himself on the basis of false problems and in a false situation." And who has put "the Jew" in this position, according to Sartre? The non-Jew. The Frenchman. Sartre himself. "It is our eyes that reflect to him the unacceptable image that he wishes to dissimulate. It is our words and gestures—*all* our words and *all* our gestures—our anti-Semitism, but equally our condescending liberalism—that have poisoned him." The twin of the Jew is the anti-Semite; in fact, "it is the anti-Semite that creates the Jew."

Jacques Derrida's self-described "hauntology," *Specters of Marx*, evokes the ghost of the unnamed Jew-as-ghost through the spectrality of a 19th-century Marxism, and a 20th-century Communism, that are feared to be always-already ready to return. "It is supposed to be a past specter. It was only a specter, an illusion, a phantasm, a ghost."[76] And yet it returns, for this is the "logic of the ghost," a logic that resists the binary of actuality and ideality, presence and non-presence, interposing between them, or rather disrupting them, with the fantastic, the ghostly, the synthetic, the prosthetic. But what has this to do with the Jew, and with the Jew-in-diplomacy? Precisely the fact that it is in the Middle East today, "since the end of the Second World War, in particular since the founding of the State of Israel," that "the most archaic and the most modern spectral forces" are mobilized and put to the test. Forces, that is, of the nation-state, international law, "tele-techne-medio-economic and scientifico-military forces." In this new and old familiar battleground ("the war for the 'appropriation of Jerusalem' is today the world war"), it is Marxism that must be made "to analyze the new articulation of techno-economic causalities and of religious ghosts."

But if the Jew/non-Jew reading of *Wonder Man* is a plausible one, at least as a home-grown teaching device through which Phil Green can instruct his son, there is also another way of reading this lighthearted end-of-war film about a man and his double. For Danny Kaye, as we have already seen, is himself a Hollywood Jew with a double name and a double life. And the two brothers, Edwin, the timid "genius" in wire-rimmed glasses who is most at home in the library, and Buzzy, the ebullient comic who is most at home on the stage, are *both* fantasmatic avatars of the 20th-century Jew in culture. It may be noteworthy that as the spirit of Buzzy enters the body of Edwin (in a move that anticipates

and closely resembles Whoopi Goldberg's physical embodiment of Patrick Swayze in the 1990 movie *Ghost*), this double creature becomes a literal man of the world, performing a mock-solo as a Russian singer. Edwin, trapped in doublet and hose, false beard and false moustache, improvises his way through an Italian opera, and has a number of comic exchanges with a German-American delicatessen owner named Schmidt. The domestication of the foreign—a hallmark of Kaye's comic nonsense songs—becomes, in this cinematic trifle about death, rebirth, and ubiquity, a plausible allegory about the Jew as supplement—simultaneously addition and substitute[77]—inside and outside the worlds of New York, and Hollywood, and the cultural imaginary.

And one more thing: What is the name of the "game" that Phil is playing, the game that he will later explain to Tommy can't be played if everyone knows it's a game? "What's this game called, Dad?" Tommy asks, and his father remembers that "this was a matter of childhood protocol. . . . Everything had to have a name, a label."

"'Identification,' I guess," Phil said."[78]

Identification, not identity. "Identification names not only the history of the subject but the subject in history," suggests Diana Fuss. "It is precisely identity that becomes problematic in and through the work of identification."[79]

"Funny thing," Phil Green had reflected earlier to his mother, "the way I felt so man-to-man with Miss Wales. . . . Asking her right out how she felt, as if we both were really on the inside. I keep forgetting it's just an act."
She looked at him thoughtfully. "I suppose that's what's called 'Identification.'"[80]

"Man-to-man" is a wonderful touch. Gender is reconfigured in this moment of intimacy, as Phil makes Miss Wales his own twin. "As if we both were really on the inside," like Edwin and Buzzy. "I keep forgetting it's just an act."

Since "identification" is a psychoanalytic practice as much, or more, as a social one, it is in fact not a surprise that Madeleine Albright, Czech-born, newly "identified" as "Jewish" (from the outside if not the inside, by the media and the mayor if not by her own identificatory

election), the empowered female diplomat who told the (Communist) Cubans that their airborne ambush was "not *cojones* but cowardice," should function as the revenant, the ghost that always returns.

VI
Hobson's Choice

Hobson's choice. An apparent freedom of choice with no real alternative. [after Thomas *Hobson* (died 1631), English liveryman, who required his customers to take the next available horse rather than give them a choice.] —*American Heritage Dictionary*

"Nobody ever speaks of 'gentilery,'" Laura Hobson had noted in a memorandum to herself written in the early sixties. "The connotations of Christianity are different, the opposite number of Judaism." Assimilation, she thought, had become "*the dirtiest 12-letter word in the language,*" since "Many liberal Jews who are all for the Negro's integration into the culture of the U.S. will think 'coward' or 'traitor' about the Jew who is integrated." She found herself preoccupied with thoughts about "Jews who converted," and about "the implied accusation that to be assimilated is somehow a treason to Jewishness or 'Jewry,'" the "group-word" she found so offensively specific, so un-like the impossible majoritarian, unmarked term "gentilery."[81]

Hobson's eighth novel, *Over and Above,* published in 1979, explores some of these tensions around Jewish identity and assimilation for three generations of American women. The novel ends with a dialogue between the pro-Israel, anti-terrorist mother and her pro-Palestinian, pro-terrorist daughter, in which the daughter asks "How long do you stay Jewish anyway?. . . Do I have to keep saying I'm a Jew forever?" and the mother replies, "You don't, Julie. But I do."[82]

But the question of assimilation—and its edgier, more politically and ethically tinged sibling, passing—had been on her mind throughout the seventies, and this return to the question of *Jewish* identity might be regarded, in part, as a safe swerve away from an even more disturbing identity crisis. For in 1958 Hobson had received a letter from her son Christopher announcing that he was a homosexual. *Consenting Adult,* the novel she wrote seventeen years later about a mother's response to

her son's coming out as gay, would estrange her from Chris for years. Hobson, a lifelong liberal who had written an angry piece for the *New York Times* about the uncomical comedy of Archie Bunker's casual racial bigotry,[83] understood perfectly well that her anger at Archie was a version of what might be called "bunker mentality"—a displacement of her distress about Chris and her commitment to work through her own crisis by writing about it.

To what extent did she see an analogy between homophobia and anti-Semitism? And to what extent was such an analogy viable?

In 1982, invited to contribute a piece to *Perspectives,* a magazine published by the United States Commission on Civil Rights, Hobson decided to speculate on what if anything she would have to change if she were writing *Gentleman's Agreement* then, rather than when it appeared in the forties.

> What if Phil were black or Puerto Rican or Mexican-American and trying to rent or buy a house in certain neighborhoods? What about his getting into those good medical schools or renting an apartment or finding a job if he was known to be gay, and refusing to remain a closet gay?
>
> Alas, if I were writing that book this very minute, and merely changed the word Jew to black or Puerto Rican or gay or Mexican-American, I could leave most of its scenes intact. . . .[84]

The word "gay" is introduced in this sequence between "Puerto Rican" and "Mexican-American," tucked in, with seeming casualness, in the midst of a series cataloguing racial minorities. It is as if *gay* as a term needs still to be closeted for her. She is uncomfortable with it, but determined to say the word—the obverse of her irritation with Archie Bunker for his spewing of "Hebe, spade, spic, coon, Polack." In this fantasy version of *Gentleman's Agreement: The Sequel,* Phil Green is a gay man who, like her son, refuses to remain a closet gay.

What makes *Gentleman's Agreement* seem so much a period piece is the sense that for some of its characters Jewishness was regarded as something to hide, for prudential or practical reasons. "Why Mr. Green, you're a Christian!" marks a writer's tour de force. There is no similar moment of pseudo-revelation in *Consenting Adult,* no moment when it turns out that the supposed gay man is only gay in masquerade: "Why, Mr. Green, you're straight!" Instead *Consenting Adult* tries to

come to terms with a different kind of "gentlemen's agreement"—an agreement between men from which women (and mothers) are ultimately excluded.

Assimilation, passing, all the familiar and contestatory terms dealing with Jewishness in society return for Hobson, as for the mother character, Tessa, not in the space of liberal politics but in the space of gentility. And it is not a comfortable, or perhaps even a tenable, space. The specificity of the son's desire to be independent of toleration—to be not a "problem" but a free agent, "transforming" his own life through "changed consciousness and political struggle"—is a specificity that Hobson finds comfortable in Judaism but not in gay identity.

"Our disagreement was very deep," Christopher Hobson reflected, years after the fact. "She felt that her experience of coming to terms with her son's sexuality, transmuted into fiction, would help countless parents and their children who were in a similar situation. More than that, she saw her book as a plea for enlightenment and tolerance, as all her important work was. I could sympathize with her aims, but I felt she should not write the book at all. I was disturbed by the amount of detail the manuscript drew from my own life—as I suppose many authors' relatives have been. More fundamentally, I felt, rightly or wrongly, that to focus as the book did on the parents' reactions and conflicts inevitably gave some ground to the idea that homosexuality itself was a problem, that it was undesirable, even if accepted in the end. And reading the finished book, I felt that that idea of gay *liberation*—of gay people themselves transforming their own lives through changed consciousness and political struggle, the idea that gayness is not just to be accepted, but is good and beautiful in itself—I felt this was absent. Yet that idea was at the core of my own life and work in the early 1970s, and today."[85]

The radical daughter's question from *Over and Above*, "Do I have to keep saying I'm a Jew forever?," and the liberal mother's reply, "You don't. . . . But I do,"[86] are here transmuted into an exchange about outness and the pride of visibility. It is the mother who now wants the question to go away, the child who now wants to assert his identificatory difference to the world. In that shift of position, from minority to majority, Laura Hobson finds her own discomfort. The difficulty Hobson has in doing what ventriloquists call "throwing the voice" is the problem of assimilation transposed to the realm of fiction-writing.

At the end of *Consenting Adult*, Tessa congratulates herself on her acceptance of her son and his lover: "Then I am a consenting adult

too."[87] As it happens, the son's lover, like the son, is a Jewish doctor, so the limits of Tessa's liberalism need not be tested too much. But it is easy to be dismissive of other peoples' boundaries, and that is not really the question here. Rather, it is a matter of the return of the repressed once again. Tessa, like Laura Hobson, opts for a version of "Hobson's Choice," an apparent freedom of choice with no real alternative, the equivalent of "no choice." But choosing "Hobson's Choice"—choosing to deal with the horse nearest the door—*is* a kind of choice after all.

Mathew Harrison Brady's triumphant entry into "heavenly Hillsboro." From *Inherit the Wind* (1960).

IV

Cinema Scopes:
Evolution, Media, and the Law

Hear no evil, see no evil, speak no evil.
—Legend of the "Three Wise Monkeys"
carved over the door of the
Sacred Stable in Nikko, Japan

The "world's most famous court trial" attracted media attention and
headlines from around the globe. Radio and print journalists, photog-
raphers and movie cameramen swelled the crowd and provided eco-
nomic benefits to the community, since they needed hotel rooms, food
services, and sundries. Potential jurors vied with one another for a cov-
eted place on the panel, and hence in the spotlight. Many testified that,
despite all the publicity, they knew nothing about the affair that could
prejudice them.[1] Movie cameras cranked, and electronic hook-ups
flashed the news from the courtroom. "My gavel," the judge announced
with pride, "will be heard around the world."[2] This was a trial that
would be tried in the media, as many noted, with some witnesses and
testimony denied to the jury yet heard and read by national audiences
seemingly insatiable in their appetite for trial-related news.[3] The date
was 1925, and the place was Dayton, Tennessee.

The "Scopes Trial"—or the "Bible-Evolution" trial—or the "Monkey
Trial,"—was one of a number of high-profile 20th-century courtroom
events that have each in turn been dubbed the trial of the century:

others include the Lindbergh kidnapping trial, the Nuremberg war crimes tribunal, the Patty Hearst trial, the Leopold and Loeb trial, and the trial of O.J. Simpson. What made the trial of John Thomas Scopes the "world's most famous court trial"[4] (to quote the title of the published trial transcript) was in part the publicity and media attention that surrounded it: like Daniel Boorstin's famously tautologous definition of a "celebrity," a person well known for being well known, the Scopes trial gained its visibility from the very intensity of media coverage, and, quite specifically, from the convergence of radio, movie camera, still photography, print reporting, and commercial advertising that directed international attention upon a small town in Tennessee.

In the 1990s, there have been striking signs of renewed interest both in the trial and in the issues. A revival of *Inherit the Wind* starring George C. Scott and Charles Durning was mounted on Broadway by Tony Randall's National Actors Theatre. A symposium at Tennessee's Vanderbilt University explored "Religion and Public Life Seventy Years After the Scopes Trial."[5] Politician Pat Buchanan magnanimously informed reporter Sam Donaldson, "Sam, you may believe you're descended from monkeys.... I think you're a creature of God."[6] And the legislature of the state of Tennessee considered a bill allowing school boards to dismiss teachers who present evolution as a fact rather than a theory, giving more support for creationism, now also called "intelligent design." The bill, perhaps unsurprisingly, became known as the "Monkey Bill."[7]

What is the scope of "Scopes" in our time? In considering the ways in which this peculiar confluence of religion, science, public education, and law seems to recur and repeat itself in 20th-century American public life, I want to look at three moments in the trial's reception, three ways in which the "monkey trial" might be regarded as a primal scene: 1925, the date of the actual court case, *Tennessee v. Scopes*; 1960, the date of the Stanley Kramer film, *Inherit the Wind*, based on the Broadway hit play of 1955; and the mid-1990s, when for a variety of reasons "the Scopes trial," Darwinism, and evolution returned to public attention and concern.

The observations that follow will be divided into three parts: "Hear No Evil," "See No Evil," and "Speak No Evil." In this motto of the "Three Wise Monkeys," meaning seems to fluctuate between antithetical poles: an injunction to avoid *evil*, or an injunction to avoid *knowledge*. But as the ensuing cultural narrative will suggest (and, indeed, as

readings of the first book of Genesis by Milton and others have repeatedly shown), it is not always possible, feasible, or even desirable, to tell the two apart.

I

Hear No Evil: The Media Trial, Radio, and Translation

> People, this is no circus. There are no monkeys up here. Let us have order.
> —Officer Kelso Rice, bailiff of the court
> in *Tennessee v. Scopes*

> If an army of monkeys were strumming on typewriters they *might* write all the books in the British Museum.
> —Sir Arthur Stanley Eddington,
> *The Nature of the Physical World* (1928)

It was "the first great media trial in American history," and "the first trial broadcast nationwide by the new medium of radio," so that "every word could be hung upon by all those Americans blest with a crystal set, static permitting."[8] "We are told," preened William Jennings Bryan in his last court speech, "that more words have been sent across the ocean by cable to Europe and Australia about this trial than has ever been sent by cable in regard to anything else happening in the United States."[9]

The paradox of publicity for the Scopes trial was that the message of "modernism" was so desperately and determinedly not to be heard. The more Bryan boomed and boasted, the more radio transmitters were set up in the courtroom, the more eager was Tennessee not to send forth a new message about the modern theory of evolution. "You're not supposed to say God on the radio." "You're not supposed to say Hell, either," admonish characters in *Inherit the Wind*.

In this trial, as in some others we could name, notoriety produces "greatness": the World's Greatest Court Trial, while it had in fact an enduring impact upon the law, had if possible an even greater immediate effect in the cultural imaginary, because the trial was itself the production site of its own publicity, the occasion for media display. As much

as the nascent film industry was represented, the key media innovations for this trial were the radio and the overseas cable. Hearing, rather than seeing, was principally at issue. And this was perfectly appropriate, since the question being asked was whether there were some ideas too dangerous for Tennessee's (and America's) children to hear.

The trial had begun as a "test case," brought by the American Civil Liberties Union, the ACLU, to test "gag laws" that enjoined a certain orthodoxy on teachers. Tennessee's 1925 "Butler Act" was a prime example. "BE IT ENACTED BY THE GENERAL ASSEMBLY OF THE STATE OF TENNESSEE [it declared], That it shall be unlawful for any teacher in any of the Universities, Normals and all other public schools of the State which are supported in whole or in part by the public school funds of the State, to teach any theory that denies the story of the Divine Creation of man as taught in the Bible, and to teach instead that man has descended from a lower order of animals."[10] Scopes—the "Bert Cates" of *Inherit the Wind*—had volunteered to test the statute, at the urging of a neighbor, George Rappelyea (a New York engineer, married to a local woman and living in the community) who was hostile to fundamentalist Christianity. Scopes was not, that is, an innocent, a martyr, a revolutionary, or a patsy. He was 24 years old and he didn't know much biology. He was hired principally as an athletic coach, responsible for the football, basketball, and baseball teams. Reporter H.L. Mencken, in town to cover the trial, observed that "even in his shirtsleeves" Scopes "would fit into any college campus in America save Harvard alone."[11]

As it turned out, in an ironic twist revealed after the conclusion of the trial, Scopes had in fact skipped the lesson on evolution he was supposed to teach that day, giving the time over instead to working out some vital team plays. Guiltily he confessed as much to a news service reporter, swearing him to silence till after the Tennessee Supreme Court got the case on appeal. His biggest fear had been that his students, who (coached by defense lawyers) testified eloquently about the teaching of evolution in the classroom, would remember that it had never happened. "You know I pleaded 'not guilty,'" Scopes told the reporter.[12] This was another way in which, ironically, the students, and the nation, would "hear no evil." The "evil" doctrine had never been taught in the targeted classroom. And Scopes was determined that that absence of hearing, that failure of evolution in fact to get a hearing, would never itself be heard.

Nonetheless, Scopes was found guilty and fined $100 by the judge. The fact that the judge himself (rather than the jury) set the fine became grounds for appeal. The defense had sought to quash the indictment, and, failing that, sought to present the constitutional issue to the jury, proposing to present expert testimony on evolution from a group of distinguished scholars in various academic specialities, from paleography to comparative anatomy. Judge Raulston ruled that such testimony from "foreigners" (hailing from towns like New York and universities like Harvard) was inadmissible. This precluded any trying of the case on the merits of evolution and the rights of fundamentalists (who paid the local taxes and hired the local teachers) to decide what should be taught in school. These issues would have, perforce, to be debated in the court of appeals. Clarence Darrow therefore cleverly chose to forego a closing argument, thus depriving the eager Bryan of the last word and the national soapbox he craved, and the case went on to a higher court.

The celebrity status of the lawyers had guaranteed the crowd: for the defense, the legendary Clarence Darrow; for the prosecution, William Jennings Bryan, the famous Democratic orator and populist, known throughout the land for his "Cross of Gold" speech at the 1896 Democratic National Convention, since then a perennial presidential candidate, Woodrow Wilson's former secretary of state, and now a sought-after speaker at Chautauqua gatherings, where he often delivered a speech called "The Menace of Darwinism."[13]

Darrow, the Chicago lawyer who appeared for the defense, had come direct from his victory as the defending attorney in the Leopold and Loeb case in New York—a case which, as we'll see, was mentioned pointedly within the Scopes trial, as evidence that Darrow himself believed in the possibility of corruption through the teaching of dangerous ideas. Drawn together in the 1880s in their support of the downtrodden, Darrow and Bryan had split over evolution, and urged by his friend H.L. Mencken, Darrow volunteered for the defense. This classic confrontation thus pitted a criminal trial lawyer of tremendous reputation—Darrow had defended labor leaders, radicals, anarchists, Communists, and socialists—against a public figure, Bryan—who hadn't tried a case in 36 years.

What were the issues under dispute? One was local option. Bryan had famously and repeatedly declared in his speeches and writings that "the hand that writes the paycheck rules the school."[14] Another issue,

still relevant today, was that almost oxymoronic concept, "academic freedom." John Randolph Neal, Scopes's Tennessee lawyer, had put his understanding of the case clearly: "The question is not whether evolution is true or untrue, but involves the freedom of teaching, or what is more important, the freedom of learning."[15] But the defense strategy finally adopted, with Darrow in control, was to reverse the roles of plaintiff and defendant, and to put fundamentalism itself on trial. "My object, and my only object," said Darrow, "was to focus the attention of the country on the programme of Mr. Bryan and the other fundamentalists in America."[16] This he did spectacularly by actually calling Bryan to the stand as a witness on the truth of the Bible.

But which Bible?

One thing that religious fundamentalism has in common with certain kinds of law, and indeed with certain kinds of literary criticism, is an emphasis upon the literal, upon what is sometimes called "the letter of the law." Here the opposite of "fundamentalism" is, in religious jargon, "modernism," a term that connotes, in fundamentalist Protestant churches, those movements that attempt to define church teachings in the light of modern revolutions in science and philosophy.

How can Christian fundamentalists believe in the literal truth of a Bible they can read only in translation?

In the Scopes trial, which purported to test the competing "truths" of various ways of reading the Bible and human history, William Jennings Bryan was called as an expert witness, and was deposed (devastatingly) by Darrow on the literal truth of Genesis. Did God really make the world in six days? Six days of twenty-four hours? Where did Cain get his wife, since no extra woman is mentioned in the Bible? Did Joshua really make the sun stand still? Bryan's answers put him into immediate disfavor with his supporters. Darrow: "You think those were not literal days?" Bryan: "I do not think they were twenty-four-hour days." "My impression is they were periods, but I would not attempt to argue as against anybody who wanted to believe in literal days." Darrow: "Now, if you call those periods, they may have been a very long time." Bryan: "They may have been." Darrow: "The creation may have been going on for a very long time?" Bryan: "It might have continued for millions of years."[17] Consternation in the court.

In 1924 Bryan had written, "Give the modernist three words, 'allegorical,' 'poetical,' and 'symbolical,' and he can suck the meaning out of every vital doctrine of the Christian Church and every passage in the

Bible to which he objects."[18] But as disconcerting as these admissions of figure were (we are talking, it is well to remember, about reading practices, about allegory and interpretation) even more disconcerting was what might be regarded as a more "fundamental" question. What was the Bible?

When the prosecution sought to enter "the Bible" into evidence, defense attorney Arthur Garfield Hays registered an objection: "What is the Bible?" he asked, rhetorically.

> Different sects of Christians disagree in their answers to this question. . . . The various Protestant sects of Christians use the King James version, published in London in 1611, while Catholics use the Douay version, of which the Old Testament was published by the English college at Douay, in France, in 1609 and the New Testament by the English college at Rheims in 1582, and these two versions are often called, respectively, the Protestant Bible and the Catholic Bible. The original manuscripts, containing the inspired word of God, written in Hebrew, in Aramaic and in Greek, have all been lost for many hundreds of years, and each of the Bibles mentioned is a translation, not of those manuscripts, but of translations thereof into the Greek and Latin. The earliest copy of the Old Testament in Hebrew now in existence was made as late as the eleventh century, though there are partial copies made in the nine and tenth centuries. The oldest known Greek manuscripts of the Bible, except a few fragments, belong to the fourth and fifth centuries. Each party claims for its own version the most accurate presentation of the inspired word as delivered to mankind and contained in the original scriptures.

"Which version does the Tennessee statute call for?" Hays wanted to know. "Does it intend to distinguish between the different religious sects in passing this law?"

> There is nothing in the statute that shows they should be controlled in their teaching by the St. James [sic] version. The statute might have said that, but it did not. And yet, with an unaccountable confidence they have presented a book to your honor, and attempt to put that book in evidence with the confidence of a man not learned in religion, because any man learned in religion knows it is no more the version of the Bible than a dozen or half a dozen other books. Therefore, your honor, we object to the Bible going in evidence, or that book going in evidence, but insist that the prosecution prove what the Bible is before they put it in evidence.[19]

John Washington Butler, the author of the Butler Law, was flabbergasted: what did they mean, more than one Bible? The idea was news to him, was (to use one of Judge Raulston's favorite words) "foreign" to him. The Bible was God's word. It never occurred to Butler that that "word" might be a translation, much less (or, therefore) an interpretation.[20] As Butler had said, in explaining why he wrote the statute, "The Bible is the foundation upon which our American government is built.... The evolutionist who denies the Biblical story of creation, as well as other Biblical accounts, cannot be a Christian.... It goes hand in hand with Modernism, makes Jesus Christ a fakir, robs the Christian of his hope and undermines the foundation of our Government...."[21]

Judge Raulston asked whether defense attorney Hays would raise the same objection if they attempted to file any other Bible, and then quickly overruled him: "Let your objection be overruled. Let it be introduced as the Bible."[22]

Here fundamentalism as a reading practice encounters what seem like insuperable difficulties: how can you believe in the literal truth of a document whose language you cannot read? And here the answer is, all too often, a version of Judge Raulston's: "Let your objection be overruled." Evidence on this point was further complicated by the expert testimony of a rabbi. Darrow had brought an entire gaggle of "foreigners" down to Tennessee to support his case: university scholars with expertise in anthropology, geology, paleontology, genetics, comparative anatomy, and religion. None of these experts was permitted to testify before the jury ("Hear No Evil"), but their views were read into the record. On the question of translation, Rabbi Herman Rosenwasser of San Francisco testified as follows:

> In the Bible there are four distinct terms for man: Adam, Enoch, Gever and Ish. Some of these are used as meaning animals.... In the first chapter of Genesis, the word "Adam" is used. The word Adam means a living organism containing blood. If we are descended from Adam we are descended from a lower order—a living, purely [sic] organism containing blood. If that is a lower order of animal, then Genesis itself teaches that man is descended from a lower order of animals.

Translation might thus reveal that the Bible supports, rather than contradicts, the theory of evolution. Yet we will soon see that the theory of evolution itself is subject to antithetical senses.

In a little paper on "The Antithetical Sense of Primal Words," first published in German in 1910, revised and translated into English in 1925, the same year as the Scopes Trial, Sigmund Freud (having come upon a pamphlet published in 1884 that described the capacity of some words in "the Egyptian language" to mean both a thing and its opposite— "strong" and "weak," for example) notes that this accords with his observations on the way dreams work, by bringing a category of thought to the surface without evaluating it. English language examples exist in terms like "cleave" (both to cling to and to cut apart), and in the modern slang term "bad" meaning "good," which in fact Freud and his philological expert both trace to Old Saxon "*bat*," which means good.

Could "evolution" itself be such a word?

Consider Raymond Williams's definition in his useful anatomy of culture, *Keywords: A Vocabulary of Culture and Society.* "Evolution" was singled out by Williams himself in his introduction as a "spectacular example"[23] of a word that has undergone a profound change. It turns out that "evolution" has its roots in theology—deriving from a word meaning to roll out. "It was soon applied, metaphorically, both to the divine creation and to the working out, the developing formation, of Ideas or Ideal Principles." According to Williams, it was only after the promulgation of the theory of the origin of species, from Charles Darwin and Herbert Spencer, that "evolution lost, in biology, its sense of inherent design, and became a process of natural historical development." To make things both more complicated and more interesting, *ev*olution began to be contrasted with *rev*olution, slow change with fast, violent change— even though some kinds of "evolutionary" change, like Social Darwinism, could be ruthless or damaging, the evolution/revolution dyad protected the concept of "evolution"—revolution by contrast was the bad twin, unnatural and radical. But "the overlap and confusion between evolution as (1) inherent development, (2) unplanned natural history, and (3) slow and conditioned change became matter for constant scrutiny.

The relationship between evolution and revolution, as it happens, was a crux for Adamists (as they called themselves) in post-Scopes Tennessee, where in December 1927, a high school teacher was asked by a student, "What was the difference between evolution and revolution?" J.H. Tate, a teacher at Farragut High School, replied by asking the student to look up "evolution" in the dictionary, where she found the definition, "A process of development." Tate, a good teacher, supplemented

this answer with what he must have regarded as benign examples: the electric light and the breeding of animals. Another student disagreed, however, maintaining that "Evolution means to come from a monkey." Tate replied cautiously—he was himself a fundamentalist—that Darwin had written about such a theory, "but no man ever said the theory was true."[24] The next day, irate parents demanded (and got) his ouster for mentioning evolution in the school. As for the meaning of "evolution," one parent told the principal he didn't know what it meant, and he didn't want his children to know, either.

II

See No Evil: The Evolution of Evolution

I am a camera with its shutter open, quite passive, recording, not thinking.... Some day, all this will have to be developed, carefully printed, fixed. —Christopher Isherwood, *Goodbye to Berlin*

There's a possibility that even an invisible man has a socially responsible role to play. —Ralph Ellison, *Invisible Man*

Films, like plays and novels, exist in multiple time: the time in which they are set, the time in which they are made, and the time in which they are seen or read. Thus, to take a very common example, Shakespeare's *Henry V* depicts the historical battle of Agincourt between the French and the English in 1415, in the middle of the Hundred Years' War: it was written by Shakespeare and performed by his company in 1599, celebrating the majesty of the English state and its Queen, among the most powerful in Europe; when it was filmed by Laurence Olivier in 1944, in the middle of World War II, it again celebrated English pluck and English ascendancy in the dark days of a war (Olivier's declamation of the Crispin Crispian speech on a Manchester patriotic radio program was a cause for national pride); and when Kenneth Branagh, an English-based Irish actor and director, filmed *Henry V* in 1989, the vivid sense of a post-Falklands, post-Vietnam anomie suffused the production, making it quite a different play, quite a different story, despite the fact that it contained the same characters, the same plot, and the same language.

The Stanley Kramer film of *Inherit the Wind* occupies similarly multiple sites in time. When we watch it some seventy years after the Scopes trial, forty years after the stage play on which it was based, thirty-five years after Kramer's film starring Spencer Tracy, Fredric March, and Gene Kelly was first seen in American theaters, we see history as a palimpsest, or a set of nested boxes.

Which film do we see?

A friend of mine who was a trial lawyer for a number of years and now teaches literature commented on the rather smug tone of the film—its air of self-congratulation, almost of self-righteousness. As a movie of the late fifties and earliest sixties, coinciding with the election of John F. Kennedy, *Inherit the Wind* is apparently unreflectively liberal. Is it smug, or is it anxious? As we will see in a few moments (and as your own experience of human nature may already have taught you) it is not always so easy to distinguish between these two positions.

Inherit the Wind is a film set in the American South in 1925. It was adapted from a hit Broadway play of the same name, written by Jerome Lawrence and Robert E. Lee and starring Paul Muni—a play which was produced in 1955 and was thus presumably developed for the stage in the same year as the landmark school integration case, *Brown v. Board of Education* (1954). Kramer's film was released in 1960, in the early years of the civil rights movement. It features numerous scenes of picketing and marching, with virulent expressions of hatred on the part of some of the townspeople. Yet it contains not a single black character, not even an extra in the crowd scenes. Viewed from the race-conscious nineties, the film seems astonishingly "white."

Why should this be? Is it that this particular film director was simply not interested in the question of race? Manifestly not. Stanley Kramer's films are frequently, indeed insistently, concerned with racial tensions as a principal "American" category. His early film *Home of the Brave* (1949) was adapted from a stage play by Arthur Laurents, in which the main character was a Jew who encountered anti-Semitism in the military. Kramer, himself Jewish, changed the plot to make the hero a black man, experiencing racial prejudice in the army in Japan in World War II. (The displacement and erasure of Jewishness here, a typical "liberal" move of the time, would come back to haunt the left in its later confrontations with Christian fundamentalism.) Kramer's *Member of the Wedding* (1952) was a film version of Carson McCullers's play, starring the redoubtable Ethel Waters in a major screen role. In *The Defiant Ones*

(1958), Tony Curtis and Sidney Poitier star as escaped convicts chained together: an American allegory transparent enough for its own, or any, time. *Inherit the Wind* (1960) was followed by *Pressure Point* (1962) a film about a black prison psychiatrist (Poitier again) and a bigoted white prisoner (Bobby Darin). Ultimately, *Guess Who's Coming to Dinner* (1967) brought director Kramer and actor Poitier together once more in a film often ridiculed as the high- (or low-) water mark of white liberalism, "the last of the 1960s explicitly integrationist message pictures."[25] (Critic Anthony Appiah mildly and devastatingly describes it as "quaint.")[26] The elegant and unexceptionable Poitier is cast as a doctor, "good-looking, educated, mannerly, and downright brilliant." As Donald Bogle notes with gentle irony, "How could anyone refuse him for a son-in-law?"[27]

Why does Kramer—a liberal, a man apparently deeply concerned with issues of black and white, and indeed of education and tolerance, leave race out?

In his study of the antithetical sense of primal words Sigmund Freud cites a statement from his *Interpretation of Dreams* that comments on a related phenomenon:

> The way in which dreams treat the category of contraries and contradictions is highly remarkable. It is simply disregarded. "No" seems not to exist so far as dreams are concerned. They show a particular preference for combining contraries into a unity or for representing them as the same thing. Dreams feel themselves at liberty, moreover, to represent any element by its wishful contrary; so that there is no way of deciding at a first glance whether any element that admits of a contrary is present in the dream-thoughts or as a negative.

If we posit, just for convenience's sake here, the analogy that many film critics have made between film and the unconscious, the "screen" and the "screen memory," the dark, dimly lit movie theater and the sleeping or dreaming mind, we can, perhaps, begin to see how contraries work in a film like Stanley Kramer's *Inherit the Wind*. Is the film talking about race and rights by leaving them out? Is there no "no" in the cinema?

Not for the first time, a blind spot marks the spot; where there is resistance, there is meaning; and what seems to be left out or coded negatively may turn out to carry a whole collection of meanings, some of them quite antithetical to one another.

There are no black actors in Kramer's *Inherit the Wind*, but there *is*, nonetheless, a lone and symptomatic black voice: the voice of Leslie Uggams on the soundtrack, singing "Give Me That Old Time Religion" during the opening titles, and, during the closing credits, "The Battle Hymn of the Republic."

Leslie Uggams was a black child star of the fifties and sixties—"discovered" by Mitch Miller after a 1958 appearance on "Name That Tune." From 1961–66 she was a regular on his weekly TV show, "Sing Along with Mitch." One critic called her, in a phrase meant to indicate high praise, "a sepia-toned Shirley Temple."[28] Ultimately, Uggams disappeared from television, reappearing almost 20 years later with star parts in "Roots" (1977) and "Backstairs at the White House" (1979), as well as a few movie roles. But in those early years Leslie Uggams was herself produced as an anodyne cultural cliché. Though drawn to the Motown sound and other black music styles of the mid-sixties, she says she felt trapped in the persona television and Mitch Miller had crafted for her. The public, said Uggams, "didn't want to see me grow up." (This was of course also true of Shirley Temple.)

At the time the film was made, Leslie Uggams was white America's idea of a good black girl: no rebel. She was, in effect, the absolute counterpart of those clean-scrubbed white youths who wait outside the Mansion House for lawyer Henry Drummond (the Clarence Darrow character) in *Inherit the Wind*. But, we might remember that Drummond and reporter Hornbeck (Gene Kelly, playing a figure closely modeled on Darrow's friend Mencken) at first found those silent, respectful young men menacing.

I want to suggest that the film of 1960, *Inherit the Wind*, may be smug about creation and evolution, but it is deeply anxious about race. This is the dangerous "inheritance" that is not acknowledged, the offscreen crisis ("See no evil") that is everywhere to be glimpsed. We might contrast it with the too overt symbolism in the film of Hornbeck as Satan, eating an apple, an over-the-top allegorical reading which is deliberately brought to the surface and which he himself dismisses.

Although there are no blacks in the little Southern town of the Kramer film, not even among the crowds or as servants in the houses, there is repeated mention of lynching, and of the Ku Klux Klan. The cynical reporter Hornbeck tells Cates (the Scopes character), "The *Baltimore Herald* is with you—right up to the lynching." Later, when Cates chivalrously insists that his fiancée be allowed to leave the witness stand unchallenged after testifying about his religious doubts, Hornbeck

hands him a sketch of a lynched stick-figure hanging from a tree. In the
streets of the film's fictional town of "heavenly" Hillsboro, there are
burning effigies. A crowd sings "We'll hang Bert Cates to a sour apple
tree." It's at this point that Hornbeck knocks on Drummond's door
wearing a white hood with holes for eyes. ("See no evil.")

The Ku Klux Klan was founded in Pulaski, a small town 120 miles west
of Dayton, Tennessee, in 1865. And in the namesake town of Dayton,
Ohio, right after William Jennings Bryan's death, the KKK burned a
cross in Bryan's memory, calling him "the greatest Klansman of our
time."[29] Historian Larry Levine describes Bryan's "attitude toward the
Southern Negro" as "worthy of any Klan member," though Bryan rarely
made his views public. In 1922 he gave it as his opinion that the passage
of an anti-lynching bill then before the House of Representatives would
be "a grave mistake." A year later he defended white supremacy as "a
doctrine absolutely essential to the welfare of the south," contending
that "The black people in the south have the advantage of living under
a government that the white people make for themselves. The laws
apply to everyone and are better laws than the black man would make
for himself."[30]

Clarence Darrow was as well known for his defense of disadvantaged
black clients as he was for his resistance to fundamentalism. When the
Scopes case was appealed to the Supreme Court in Tennessee a year
later, he arrived to offer closing arguments fresh from defending a
group of black men accused of murder in Detroit (the Sweet case).[31]
Darrow withdrew from the Scottsboro case when he concluded that the
Communist Party was using five black men accused of rape for political
purposes.[32] A member of the NAACP since its beginning, Darrow wrote
articles for the black press, defended poor blacks in court, attended
black churches, lectured at Howard Law School and to organizations of
black laborers, tradesmen, and educators. W.E.B. Du Bois said he was
"drawn to Clarence Darrow" because "he was one of the few white folk
with whom I felt quite free to discuss matters of race and class."[33] "All
his life he fought for the rights of the Negro," one of his biographers
observed.[34]

Leslie Uggams. The white hood and the Klan. The overdetermined
jokes about lynching. The known and contrasting views of Bryan and
Darrow on race. All these are symptoms of a cultural anxiety about
Darwinism and race conflict that the film declines or refuses to name.

And there is one other very disturbing marker of racialism in *Inherit the Wind,* however briefly glimpsed and relatively glossed over by the film-maker, and that is the scene at the fair stall in the town square, in the carnival atmosphere surrounding the trial. In this scene a satiric exhibit of the wonders of "devolution" is accompanied by exhibit A: a chimpanzee dressed like a man, in overalls, a hat, a plaid shirt—the obverse —or is he?—of the biological chart displayed in Bertram Cates's classroom, the anatomical drawing of the musculature of a male gorilla, his arm menacingly upraised. In a trial that became derisively known as the "monkey trial" what does this monkey signify?[35]

Was "monkey" in Dayton, Tennessee, a racialized code word for "negro" or "African"? It's disturbing to think so. Many of Dayton's citizens were descended from men who had fought on the Union side in the Civil War. Catholicism was as much, or more, a perceived threat as race struggle: the local Anti-Evolution League, which rented an entire storefront for the display and sale of its books, included works like *Romanism versus Americanism* on the shelf with *Evolution or Christ, Hell in the High Schools,* and *God—or Gorilla?*[36] But 37 anti-evolution bills were introduced into 20 state legislatures between 1921 and 1929, though only one (in Mississippi) was passed.[37] And as these so-called "monkey bills" were introduced into the legislatures—12 of them in the two years after Scopes, the height of anti-evolution sentiment in this country— the Arkansas-based American Anti-Evolution Association declared itself open to membership to all except "Negroes and persons of African descent, Atheists, Infidels, Agnostics, such persons as hold to the theory of Evolution, habitual drunkards, gamblers, profane swearers, despoilers of the domestic life of others, desecrators of the Lord's Day and those who would depreciate feminine virtue by vulgarly discussing [the] sex relationship."[38] As Frederick Douglass had long ago testified, blacks so often saw themselves "described and painted as monkeys" that, in Douglass's words, they "think it a great piece of fortune to find an exception to this general rule."[39]

The potential for justifying racism has always already been present in the development of evolutionary theory. Describing the racial discourse of the 18th-century French naturalist Buffon, a precursor of Lamarck and Darwin, Sander Gilman quotes Buffon's apparently untroubled observation, "the interval which separates the monkey from the Negro is hard to understand."[40] Black psychiatrist and anti-colonial

theorist Frantz Fanon, educated in Buffon's France two centuries later, would write in *Black Skin, White Masks,* "A Negro behaves differently with a white man and with another Negro. That this self-division is a direct result of colonialist subjugation is beyond question. . . . No one would dream of doubting that its major artery is fed from the heart of those various theories that have tried to prove that the Negro is a stage in the slow evolution of monkey into man."[41] And again, "It has been said that the Negro is the link between monkey and man—meaning, of course, white man."[42] For Fanon, "evolution" was a key—and contesta-tory—term. The French language refers to blacks who want to assimi-late to European culture as "evolués." "In response to a profound desire they sought to change, to 'evolve.' This right was denied them. At any rate, it was challenged."[43] As he wrote with bitter irony, "Black magic, primitive mentality, animism, animal eroticism, it all floods over me. All of it is typical of peoples that have not kept pace with the evolution of the human race."[44]

"In the history of the life sciences," notes biologist and cultural ana-lyst Donna Haraway, "the great chain of being leading from 'lower' to 'higher' life forms has played a crucial part in the discursive construc-tion of race as an object of knowledge and of racism as a living force. After World War II and the partial removal of explicit racism from evo-lutionary biology and physical anthropology, a good deal of racist and colonial discourse remained projected onto the screen of 'man's closest relatives,' the anthropoid apes."[45]

Black Skin, White Masks was published in 1952. In 1951, four years before the stage play of *Inherit the Wind* and nine years prior to the film version, another Hollywood film took on the tangled question of genetics, heredity, and environment with specific reference to Darwin's evolu-tionary theory. The film could, indeed, have itself been called "The Monkey Trial," since it centers on an experiment performed by a psy-chology professor on a chimpanzee. In the event, it was given a differ-ent title: *Bedtime for Bonzo. Bonzo* uses a Darwinian frame to make a counter-Darwinian argument. Its plot involves the attempt of a young professor of psychology, played by Ronald Reagan, to demonstrate the importance of environment over heredity. The professor, Peter Boyd, has a personal stake in the matter: his father (also known—to the police —as "The Professor") had been a habitual criminal who died behind bars, and the Dean of the Faculty of Sheridan College, learning of this

family taint, demands that Boyd break off his engagement to the Dean's daughter. "You forget that I was a professor of genetics myself," says the Dean, repressively. But Boyd, the author of a work called *The Power of Environment*, is determined to prove his case, with the aid of Bonzo, a chimpanzee acquired by the psychology department, and Jane, a young woman who answers his ad for a housekeeper.

Soon Peter and Jane are calling each other Poppa and Momma for the benefit of the impressionable young Bonzo, and simulating family values: a peck on the cheek before departing for work, a hot meal on the table at night (Bonzo, fully dressed, eats decorously with a cup and spoon), and lessons in "moral reasoning." Predictable events ensue: Bonzo runs away, is recovered, and is threatened with a fate worse than death in the Yale University Animal Research lab; Boyd's snobbish, highborn fiancée (herself a Ph.D.—*not* an asset for a woman in this fifties family saga) suspects hanky-panky, and the simulated family values of low-born Jane and Peter, ultimately captured in a series of Bonzo-centered home movies shown on screen, begin to take hold for real. The (faux?) naiveté of the film's race-consciousness is such that when Boyd needs to use a code phrase to describe the missing chimpanzee to his colleague he calls him "The young man who's visiting here from Africa." Bonzo's environmentally developed moral sense leads him to return a stolen necklace to a jewelry store as the amazed police look on (exonerating Boyd of the suspicion that he has followed in his father's footsteps as a criminal), the Dean realizes that "Operation Bonzo" has been good publicity for the college, and the bumbling Boyd finally notices that Jane has fallen in love with him. As they drive away for their honeymoon in his convertible, Bonzo riding in the back seat, they are the perfect American family. Environment counts for everything, as Peter Boyd had vowed to prove; genetics counts for nothing.

Yet in some ways, despite its comic tone and its aura of innocence, *Bedtime for Bonzo* is the *same* film as *Inherit the Wind*. In both a censorious blocking father intervenes between the feckless young academic and his fiancée. (Scopes in fact was not engaged to anyone at the time of the trial, and was regarded in Dayton as a bit of a playboy. The faithful fiancée is dramatic license, emotional punctuation.) Both films depict coming of age fables in which the monkey is at once catalyst and match-maker, for both of these films are about family values. The perky Reagan and the blonde, vapid Diana Lynn as Poppa and Momma need Bonzo to construct the family unit backward. In this case, the child is

father to the man, or at least to the father, reconfiguring a personal
genealogy or family tree backward from the chimp-as-child, himself
briefly up a tree in the film's most comic sequence, luring his frantic
"parents" there in quest of him. In *Inherit the Wind,* the nuclear family
discourse is also firmly in place, but in a significantly different place.
There "Mother" is Bryan's wife, Sarah, and he is, explicitly and fre-
quently, her whining and dependent (and beloved) "Baby." "Mother,
they laughed at me," Fredric March-as-Bryan wails, and she comforts
him: "It's all right, baby . . . baby . . . baby." This is the patriarch as help-
less and narcissistic infant, Freud's "His Majesty the Baby."

The exposure of Bryan's human weaknesses also played into another
story detectable beneath the surface of *Inherit the Wind,* another politi-
cal allegory readily apprehensible to contemporary viewers. For the
play, and later the film, were produced at the crossroads of not one but
two key cultural events in American history, both of them made into
media spectacles: the civil rights movement and the Army-McCarthy
hearings.

In the twenties, the time of the Scopes trial, the Red Scare and
Darwinism were linked in the popular imagination. The North had its
Red hunts and Palmer raids, the South had the demon Darwin. A writer
in the journal *Christian Fundamentals* claimed that almost the only
believers in evolution were "the university crowd and the social Reds."[46]
(Huey Long found it good politics to declare on the floor of the Senate
that he was ignorant.)[47] Thirty years later, the Red Scare was back again
with a vengeance. Not only back, but back on national TV.

The Army-McCarthy hearings of 1954, televised at the express desire
of Senator Joseph McCarthy, proved—in a way almost Shakespearean—
to be his undoing. The unraveling of the heretofore impervious dema-
gogue, self-righteous and bullying by turns, proved an irresistible draw
to at least a segment of the nascent television audience. Balding,
paunchy, jowly, and prolix, McCarthy was not the revered figure Bryan
had been at the end of *his* career, and the resounding *mot juste* of attor-
ney Joseph N. Welch, "Have you no sense of decency, sir, at long last?
Have you left no sense of decency?," fit the scoundrel in a way that it
could never touch the fundamentalist saint. But what the two scenes
had indelibly in common was the stage effect of cultural *Schadenfreude,*
the modern twist on tragedy: a great man goes too far in the public
eye, he overreaches himself, and he falls. Thus McCarthy, trying to
exert patronage control over the U.S. armed services; thus also Bryan,

seeking to outwit and out-grandstand Clarence Darrow, assuming that his encyclopedic grasp of Scripture would suffice to make a monkey of his interlocutor. Anyone who remembers the Army-McCarthy hearings or who has seen Emile de Antonio's documentary *Point of Order* (1961), compiled from the television footage, will recognize in the weakly grinning figure of the discomfited Bryan in Kramer's film the long-awaited public humiliation of Joseph McCarthy.[48] It is symptomatic both of the intrinsically theatrical nature of the Army-McCarthy hearings, and of the constant crossover between the purportedly fictive and the purportedly real, that Joseph Welch went on to become a movie star in his own right, starring as the judge in the 1959 courtroom thriller, *Anatomy of a Murder.*

Inherit the Wind, which came to Broadway just two years after Arthur Miller's *The Crucible*, might, like that play, be understood as an allegory of McCarthyism. Its plot drew attention to the stifling of intellectual freedom under political pressure, and in the spectacle of the disoriented Bryan it restaged McCarthyism's self-subversion through narcissistic excess. But between the writing of the play and the making of the film public attention began to be drawn to another developing political crisis: the rise of the civil rights movement in the American South. Nineteen-sixty, the date of the film's release, was a year of sit-down strikes; in subsequent years the visibility of the movement gathered strength nationwide. The tensions highlighted by *Brown v. Board* and the order to desegregate schools in 17 states and the District of Columbia generated resistance, lawsuits, and violence. The Montgomery bus boycott of 1955–56 was followed by other challenges to segregation. Northern lawyers and others committed to changing the old ways descended on Southern cities and towns.

And here too *Inherit the Wind* would offer resonances with current events, resonances both familiar and disquieting. The arrival of Henry Drummond and his panel of experts from Northern universities, the generational conflict between the idealistic young teacher and the insult-hurling townspeople of "heavenly Hillsboro," might well strike an audience as similar to what was going on in some Southern communities. The picket-wielding, hymn-singing marchers depicting their struggle as one of preserving traditional values against the incursions of outsiders bent on troublemaking fit the scenario of the early sixties as well as the twenties. My argument here, it is important to say, is not one of directorial "intention" but rather of interpretative adjacency.

Entering a movie theater—or *any* theater, for that matter—an audience brings its own world to match with the screen's fictions. The question I want to pose, again, is "which film do we see?"

To an audience watching Kramer's film more than forty years after its release, moreover, the associations with current events might be even more uncanny. The scenes of protesters with contorted faces, intemperate signs, and Biblical quotations borne on high could call to mind another crusade: that of the anti-abortion demonstrators who proclaim themselves "pro-life," and whose tactics include "blocking access to the clinics, thrusting disgusting posters, shouting threats and hounding clinic employees." As columnist A.M. Rosenthal wrote scathingly in the *New York Times*, "Have we forgotten when blockage, vilification and harassment were the weapons of the left, particularly in the universities? They brought the same result the pro-lifers now bestow upon the country—contempt for law, hatred as a substitute for civil discourse and ugliness, mean indelible ugliness."[49]

Rosenthal associates such tactics with the bad left rather than with the bad right. He is not thinking of the civil rights struggle of the fifties and early sixties but rather of the Vietnam War protest later in the decade. His analogy is between the anti-abortion movement of the nineties and the student strikes of the sixties, the violent encounters between police and demonstrators on college campuses and in the streets of Chicago. But the grimacing faces of Kramer's anti-evolution picketers revisited today might well be snapshots of Florida or Brookline anti-abortion demonstrators, replete with signage: "Read Your Bible."

We have already asked "which Bible" was the infallible Word of the fundamentalists' God. We need now to ask "which evolution"—and "which Darwinism"—are at stake in the modern story of the Scopes trial. Kramer's film seemed to align the views of the right with a die-hard creationism, and the views of the left with the progressive belief in Darwin's theory of evolution. But like all binaries, this one is hardly clear-cut. For "social Darwinism" (the "survival of the fittest" in stark economic terms) emerged in late 19th-century culture as a justification for imperialism abroad and unbridled capitalism at home. The rich were rich because they deserved to be so. Thus scholars and politicians on the left have been attacking attempts to apply Darwinism to current human behavior for generations, while defending non-biblical accounts of human evolution and animal behavior against right-wing fundamentalist attacks. In a 1981 variation on the Scopes trial,

paleontologist Stephen Jay Gould was called to testify against the Arkansas state legislature's Act 590, "The Balanced Treatment for Creation-Science and Evolution-Science Act."[50]

But the persistence of "Darwinism" and an escalating debate about it is today being critiqued from *within* the ranks of evolutionists. Claims for the centrality of evolutionary theory in determining human traits and choices have raised new concerns for progressives about the implications of this view of "human nature." The debate is now often couched in moral rather than economic terms, but scientific proofs are now being brought forward by evolutionary biologists and psychologists to explain (though not necessarily to justify) certain gender and racial stereotypes. The manifest liberal bias of Stanley Kramer's film *Inherit the Wind* (1960) ridicules those who resist Darwin and the theory of evolution as "bigots" (to use reporter Hornbeck's term). But the label of "bigotry" has lately sometimes been applied to those who *cite* Darwin and Darwinism.

In *The Moral Animal: Evolutionary Psychology and Everyday Life,* Robert Wright described a "new, improved, Darwinian theory [applied] to the human species"—a theory that would, he said, avoid the excesses of so-called social Darwinism, and the "simplistic ideas about the hereditary basis of behavior" that "played into the hands of racists, fascists, and the most heartless sort of capitalists,"[51] but would nonetheless explain the "deeper unity within the species."[52] Wright argues, using Darwin as his authority, that both "many of our moral sentiments" and our gendered behavior, are based in biology.

A more overt claim about the "evolutionary" nature of gender roles is offered by evolutionary psychologist David Buss. "In evolutionary terms," asserts Buss, "the payoff for each sex in parental involvement differs: to produce a child a woman has an obligatory nine-month commitment, while for a man it's just one sexual act."[53] And again, "For men in evolutionary terms what pays is sexual access to a wide variety of women, who will commit time and resources to helping raise children."[54] When this kind of "knowledge" trickles down, or up, the evolutionary scale of public influence, the results can be both striking and risible, as for example when Speaker of the House Newt Gingrich observed that women were clearly not meant for military combat since "females have biological problems staying in a ditch for 30 days because they get infections," while "males are biologically driven to go out and hunt giraffes."[55]

Another, even more controversial symptom of this "evolutionary" thinking is the kind of "scientific reasoning" presented in a book like *The Bell Curve*, subtitled "Intelligence and Class Structure in American Life," which declares in the opening sentence of its Preface (and in bold print on the back of the dust jacket) "This book is about differences in intellectual capacity among people and groups, and what those differences mean for America's future." Notoriously, the "groups" turned out to be racial and ethnic. Phrases like "genetic cognitive differences between the races" and "racial differences in intelligence"[56] mark the bias toward what is called "heritability." (*"inherit* the wind.") And for this insight into the inherited intellectual capacity of the races, page one of the book, the first page of the Introduction, credits—or blames—Charles Darwin.

"Variations in intelligence," write the authors, "became the subject of productive scientific study in the last half of the nineteenth century, stimulated, like so many other intellectual developments of that era, by Charles Darwin's theory of evolution. Darwin had asserted that the transmission of inherited intelligence was a key step in human evolution, driving our simian ancestors apart from the apes."[57] When Charles Murray, one of the *Bell Curve* authors, appeared at a Harvard University forum to defend his book, Stephen Jay Gould (who had authored a devastating review in *The New Yorker*) offered a stinging rebuttal. "It's an old argument," Gould observed about the book's genetic intelligence thesis, "what was called social Darwinism in the 19th century."[58] Social Darwinism is, of course, something different from Darwinism; but then, as we have already seen, Darwinism appears to have become, increasingly, self-different, different from itself. If "Darwin" to Stanley Kramer meant a Darrow-like liberality of social, political, and religious views, "Darwin" to Murray seemed to mean something more like the inescapable determinism of genetic—and racial—inheritance.

The theory of evolution is represented in *Inherit the Wind* as manifestly progressive, not regressive. Writing in 1955, playwrights Lawrence and Lee could "assume that audiences share their Darwinism," making "much sport of attempts to defend the belief that the world was created at 9 A.M. on October 23, 4004 B.C."[59] Five years later, Stanley Kramer produced a confidently serious film in the clear expectation that audiences would cheer the freethinking Spencer Tracy and be irritated by the pious pomposities of Fredric March.

For much of the country, though indeed never for all of it, the idea

that evolution could *not* be taught in the public schools was as unthinkable as the idea that something called "creation science" or "creationism" *could* be taught there. How shortsighted that was, and, indeed, how presumptuous and parochial, has amply been demonstrated by a new tide of court cases and proposed legislation.

III
Speak No Evil: The Politics of Academic Freedom

> The star of the collection was undoubtedly a large bespectacled baboon, standing upright, dressed in wing-collar, morning-coat and tie, and carrying under its arm the manuscript of a lecture on *The Origin of Species.* . . . Labelled Professor Fiske after a prominent Darwinian academic, Madame Blavatsky's baboon signalled her own posture in this debate as an adamant anti-Darwinian.
>
> —Peter Washington, *Madame Blavatsky's Baboon*

> Oh, what's the use? Even if Bonzo gave a lecture on Darwin, it wouldn't do any good.
>
> —Ronald Reagan as psychology professor
> Peter Boyd in *Bedtime for Bonzo*, 1951

Seventy years after the Scopes trial, Vanderbilt University staged a symposium to commemorate the event. A few months later, in Vanderbilt's home city of Nashville, Tennessee, the State Legislature considered a bill that would allow school boards to dismiss teachers who present evolution as a fact, rather than just a theory. "Many teachers won't teach evolution at all because of the stigma and the controversy," reported a Nashville high school biology teacher, whose last class of 30 students included only three who had studied evolution.[60] "I see this as a political power play to insert Bible Belt beliefs into our educational system," said another teacher in the same city. "The other day I went into my classroom and I said, 'Evolution, evolution, evolution, evolution,' and then told my students that I was saying it now because I might not be able to say it anymore."[61]

In January 1995, the pastor of the Merrimack, New Hampshire, Baptist Temple appeared before the school board to urge that creationism

and evolution be treated equally in classrooms. "I can't prove my model, and they can't prove their model," declared the Rev. Paul Norwalt to the board. One of the two newly elected members of the school board explained that she supports his request "based on my belief in academic freedom."

"I've been sitting here listening to all these evolutionists speak and speak and they get up and tell us evolution is an absolute fact," said board member Virginia Twardowsky. "I'm more convinced than ever before that creation science has got to be taught in the schools."[62] "Creation science" is the new and preferred term: the chairman of the New Hampshire State Board of Education said he wouldn't object to a local district "teaching about creation science as an alternative to evolution," and that, in his opinion, the Bible could be used as "anecdotal evidence" to support the lesson.

The key points here seemed to be two: "academic freedom" (à la Twardowsky) and local control (New Hampshire's motto is "Live Free or Die"). Thus the governor, a Republican, weighed in with his own views ("There are worse things taught in our schools, and I will continue to support local control of education"), while a state senator who was chairman of the Education Committee confessed that there were "a lot of things I don't understand about both theories. Why, let's remember the creation theory says God made the world in six days and rested on the seventh. I accept that as a Bible-believing Christian. I say students should be taught both theories in school. If I was on the local school board, I would want it taught in school. I would vote for it. I say even Darwin himself would vote for it."

That "creationism" had (re)emerged as a tenet of some factions within the New Right was exemplified by a letter of protest published in the *Boston Globe*.

The recent "revival" of debate about creationism misses the mark and is a disservice to everyone on both sides of the issue. This is not about "truth" but about venue.

Creationism is not a scientific theory. Its foundation is faith, not scientific evidence. It is not subject to the kinds of tests and scrutiny that we apply to scientific theories.

As a nonscientific theory, creationism belongs in Sunday school. It has no place being discussed in science classes, which ought to limit themselves to science, not English literature, modern art or religious faith.

In contrast, evolution is a scientific theory. Like all good scientific theories, evolution itself has evolved over the years as information has become available. It is proper to teach it in science classes. I thought this was settled by the First Amendment and the Scopes trial. It would seem that the Christian right is trying to resurrect an old fossil.[63]

"I thought this was settled by the First Amendment and the Scopes trial." So, apparently, did the National Academy of Sciences, when it declared in 1981 that "Religion and science are separate and mutually exclusive realms of human thought whose presentation in the same context leads to a misunderstanding of both scientific and religious belief."[64] But this "misunderstanding" is increasingly widely held.

According to a 1993 Gallup Poll, 47 percent of Americans believe that God created human beings pretty much in their present form sometime during the past 10,000 years. Only 46 percent believe that humans evolved from less advanced forms of life over millions of years. Ten years ago the figures were reversed; believing creationists are now a majority. So reported the *Boston Globe*'s science reporter, Chet Raymo, in March 1995, responding to the story of the Merrimack school. "I grew up in the Bible Belt," writes Raymo, "not far from Dayton, Tenn., the site of the famous Scopes Monkey Trial. Early on I came to New England so that my children could be raised in the thoughtful tradition of the Adamses, Emerson, Thoreau, Agassiz and Gray. Now the Bible Belt has been loosened to encompass the expanding girth of fundamentalism, just in time for my grandchildren to hear in science class that the world is 10,000 years old." Lamenting the fact that "school boards are taken over by folks who learned their science from supermarket tabloids and radio talk shows," and that textbook publishers now "back away from teaching evolution and human pre-history for fear of losing sales," Raymo urges "enlightened communities" to "continue to fight the constitutional battle in the courts." If the battle is lost, he says, "all of America may become the Dayton, Tenn., of the 21st century."[65]

He may be right. Revisitations of the Scopes trial and the Anti-Evolution movement have been popping up all over. In 1996, one Georgia school district endorsed the teaching of creationism. In Alabama in the same year it was decided that biology textbooks were henceforth to contain a disclaimer, in which evolution was described as "a controversial theory some scientists present as a scientific explanation

for the origin of living things." The state's reasoning was empirical. "No one was present when life first appeared on earth. Therefore any statement about life's origins should be considered as theory, not fact."[66]

Despite this absence of an on-site observer, some creationists have come to a firm decision. At a meeting of 3,000 members of the Christian Coalition in Washington in September, 1994 a video booth sold a tape called "Evolution: Hoax of the Century?"[67] In August of the same year what was called a "latter-day Scopes trial" in Georgia pitted schoolteacher Brian Bown against the Georgia State legislature on the question of the "moment of silence" mandated for all students in Georgia's public schools. The *Palm Beach Post* drew attention to the analogy: "In another time, before television beseiged us with constant news from all over the globe, Brian Bown would have achieved the fame and notoriety of John Scopes. Mr. Bown, like John Scopes, is a schoolteacher. And like Mr. Scopes—who defied the neanderthals of Tennessee on the teaching of evolution—Mr. Bown is a man of principle and quiet courage."[68]

A 1988 revival of *Inherit the Wind* for a television movie starring Kirk Douglas (as Matthew Harrison Brady, the fictional Bryan), and Jason Robards (as Henry Drummond) was hailed by all participants as "timely." Douglas explained that he "fashioned [his] character after the televangelists of today . . . like Pat Robertson, charming and softspoken, like Jimmy Swaggart with more flair and drama."[69] When the cast went to the small Oregon town of Medford to film a schoolroom scene in which the young teacher is talking to his students about Darwin's theory of evolution, school officials gave them their money back and threw them out. "We don't teach that here," representatives of the school, a Catholic institution, explained.[70] "They don't teach evolution, they only teach the Bible." "In this day and age!" exclaimed Douglas with astonishment.

He need not have been so surprised. A Supreme Court ruling in 1987 striking down a Louisiana state law that mandated the teaching of creationism along with the teaching of evolution in the public schools met with a strong response from conservative Christian forces. The law, the Balanced Treatment for Creation-Science and Evolution-Science in Public School Instruction Act, did not require that either evolution or creationism be taught, but rather that if one was, the other should be given equal time. Both the majority and the dissenters, perhaps inevitably, cited Scopes.

Justice Antonin Scalia, in a long dissent joined by Chief Justice Rehnquist, termed the decision "repressive" and "illiberal." In what looks like a mirror-image of the Scopes defense, several experts— "whose academic credentials are rather impressive," according to Scalia —cast doubt on the science of evolution and alleged that creationism was a believable alternative. Scalia insisted in his dissent that the law (which had never been enacted) was intended to promote the "academic freedom" of schoolchildren who were being "indoctrinated" in the false belief that evolution was a proven fact. "The evidence for evolution is far less compelling than we have been led to believe," declared Scalia. "Teachers have been brainwashed by an entrenched scientific establishment."[71] The reversal seemed to him to be clear: "In this case," the Justice wrote, "it seems to me that the court's position is the repressive one." "That illiberal judgment, that Scopes-in-reverse, is ultimately the axis on which the court's facile rejection of the Louisiana legislature's purpose must rest."[72]

In their opinions in the case (*Edwards v. Aguillard*) two justices had disputed both the claims to science and the claims of academic freedom: "The tenets of creation science parallel the Genesis story of creation, and this is a religious belief," wrote Justice Lewis Powell, and the majority opinion by Justice William Brennan declared, "The preeminent purpose [of the Louisiana law] was clearly to advance the religious viewpoint that a supernatural being created humankind." It thus endorsed religion, in violation of the First Amendment.[73] The law, he said, "does not serve to protect academic freedom, but has the distinctly different purpose of discrediting evolution by requiring it to be counterbalanced at every turn with the teaching of creation science."[74]

Religious broadcaster and incipient presidential candidate Pat Robertson, predictably, announced himself "outraged." In fact he predicted that his outrage would become general. Here is Robertson's statement in response to the Supreme Court's ruling in the Louisiana case:

Everyone in America who believes that he or she has been created by God will be outraged by this decision. The interpretation by the Supreme Court of the establishment of religion clause is an intellectual scandal. By this decision the U.S. Supreme Court has effectively repudiated the Declaration of Independence, which declares that our rights as Americans are endowed by our creator. The Supreme Court has written into the Constitution a questionable scientific theory of the origin of life. This

decision will accelerate the exodus of the children of America into pri-
vate and parochial schools. This decision strengthens my resolve to be
elected president of the United States.[75]

No cloud, apparently, however dark, is without its silver lining.

The most striking result of the Supreme Court ruling in the Louisi-
ana case, however, beyond propelling Pat Robertson with even more
zeal into the presidential fray, was a shift in the strategy of the opposi-
tion forces. To counter the court's claim that teaching creationism was
teaching religion, The Institute for Creation Research in El Cajon,
California, produced a document that offered to distinguish "scientific
creationism" from "Biblical creationism" by omitting the names of the
principals. "Biblical creationism," says the ICR, holds that "The first
human beings, Adam and Eve, were specially created by God, and all
other men and women are their descendants." By contrast "scientific
creationism" teaches that "The first human beings did not evolve from
an animal ancestry but were specially created in fully human form from
the start," and that "the 'spiritual' nature of man (self-image, moral con-
sciousness, abstract reasoning, language, will, religious nature, etc.) is
itself a supernaturally created entity distinct from mere biological life."[76]

The chairman of the Midwest Creation Fellowship, an organization
based in suburban Wheaton, near Chicago, predicted that the result
would be a refocused emphasis on academic freedom: "We anticipate
that the evolutionary activists may feel free now to discriminate against
the creation position. So legislation to protect teachers and students
who may teach or espouse the scientific evidence that supports cre-
ationism could and should be quickly passed." Atlanta attorney Wendell
Bird suggested that the decision would be "interpreted to restrict stu-
dent rights, student academic freedom to hear all the information on
the subject."[77] Meantime in Louisiana, creation surfaced again as an
"alternative": "All we're saying," said one parent in Livingston Parish
who signed a petition, "is give them both sides of the story, and let [the
students] decide."[78] The "major defeat for religious fundamentalists"
trumpeted by the *Washington Post* in 1987 had turned into a live issue
once again.

When English professor Gerald Graff concluded in his book *Pro-
fessing Literature* that in the matter of the so-called "culture wars" com-
batants should "teach the debate," he might not have had creationism
in mind, but he was nonetheless prescient. As an article in the *Chapel*

Hill Herald of May 1994, would note, "In the 1920s, creationists in the United States tried to ban the teaching of evolution in the public schools. Now they're just trying to get equal time."[79]

Thus "creation science," having achieved with the stroke of an oxymoron the status of intellectual legitimacy, laid claim to exactly the space of academic freedom that evolution had previously asserted. Was this an evolution—or a revolution?

"Academic freedom" had originally been claimed by the *evolutionists*, the pro-Scopes forces in the "Monkey Trial," as justification for teaching the theory of evolution in the public schools. Indeed in the courtroom the question of academic freedom became quite heated when William Jennings Bryan attempted to use Darrow's own words in the Leopold and Loeb case against him in the Scopes trial—much as Darrow had used Bryan as a witness for *his* own argument about the interpretation of the Bible.

Nathan Leopold and Richard Loeb, two wealthy New York schoolboys, had been charged in the brutal "thrill-murder" of another boy, Bobby Franks. Bryan quoted Darrow's court argument, alleging that he had said that it was "Nietzsche's philosophy of the superman," studied in the classrooms of the University of Chicago, that was to blame for the notorious crime—that "the teachings of Nietzsche made Leopold a murderer."[80] "Your honor," Darrow had said, "it is hardly fair to hang a 19-year old boy for the philosophy that was taught him at the university." Darrow bitterly objected to this quotation out of context, reading into the court record his own subsequent words on that occasion: "[Y]ou cannot destroy thought because, forsooth, some brain may be deranged by thought. It is the duty of the university, as I conceive it, to be the great storehouse of the wisdom of the ages, and to let students go there, and learn, and choose."[81] But it was Bryan's intention—in that closing statement he never got to deliver—to return to Darrow's words, this time from Darrow's defense of Richard ("Dicky") Loeb:

> I know that one of two things happened to this boy; that this terrible crime was inherent in his organism, and came from some ancestor, or that it came through his education and his training after he was born.[82]

In the written text of his speech Bryan seizes on the first option, to condemn the theory of evolution. "Evolutionists say that back in the twilight of life a beast, name and nature unknown, planted a murderous

seed and that the impulse that originated in that seed throbs forever in the blood of the brute's descendants, inspiring killings innumerable, for which the murderers are not responsible because coerced by a fate fixed by the laws of heredity! It is an insult to reason and shocks the heart." Bryan urges "responsibility," accountability, and morality; he wants to be able to punish the murderer and not absolve him. But he sees it as an impediment to social progress, and to individual betterment. Evolution "discourages those who labor for the improvement of man's condition."

Bryan thus hoped to turn the tables on Darrow, who had used Bryan's own words on the stand to support his own case for the teaching of evolution. Which is the "conservative" position here and which the "liberal"? Which kind of "evolution" is evolving here?

Consider this personal anecdote from the autobiography of a scientist who, as it happened, found himself, in 1950, in graduate school at the University of Tennessee (in Knoxville):

> The academic challenge was not great at the University of Tennessee, and I grew restive. Out of boredom I also became a bit reckless. I was intrigued by the fact that a statute was still on the books forbidding the teaching of evolution in the state. In 1925 the Tennessee legislature had declared unlawful any doctrine that questioned the divine origin of man.

After telling the story of the Scopes trial, he resumes his narrative.

> The law stayed in place and was still untested in the higher courts when I came to Knoxville.
> In the fall of that year, while teaching laboratory sessions in the general biology course at the University of Tennessee, I learned about the extraordinary discovery of the first of the South African man-apes.... They were the key missing links between remote apelike ancestors and the most primitive humans of the genus Homo known at the time of the Scopes trial....
> Here, I thought, was one of the most important scientific discoveries of the century: Eden revealed in Africa by the lights of Darwin!

The young scientist, prompted by a "mischievous itch to shake things up" and by his conviction that "the evidence was so much more solid—

I felt sure—and the faculty would support me—I hoped," determined to give "a lecture on the subject to the elementary biology class. I told them the matter was settled: we did descend from apes, or a close approximation thereof. . . . Eden was no garden. The students, some my own age, were mostly Protestants, and many had been raised in fundamentalist families. Some, I am sure, had been taught that Darwin was the devil's parson, the spokesman of evil heresy. They scribbled notes; some glanced at the clock."

Finally the class was over, and the young teacher waited, nervously, for a reaction. One large blond boy did approach him, and looked him in the eye: "Will this be on the final exam?" he asked. No, said the teacher. "He seemed relieved; one less thing to memorize. Nothing more was heard of my lecture."

Seventeen years later, in 1967, the state legislature of Tennessee finally repealed the anti-evolution law. But the young teacher had learned, he said, "a lesson of my own in Tennessee: the greater problems of history are not solved; they are merely forgotten."[83] The teacher was E.O. Wilson, the father of sociobiology, and the mentor, as it happens, of many of the scientists and social scientists of the next generation who would invent, and defend, evolutionary psychology. "By early 1951 I had decided to move on to Harvard University. It was my destiny," he writes. And not only his.

Wilson thus uncannily fulfills and trumps the half-ironic fantasy of H.L. Mencken, who had seen in the shirt-sleeved John T. Scopes an academic who "would fit into any college campus in America save that of Harvard alone." Yet the genial "father of sociobiology" has found it not so easy to protect the reputation of his own intellectual family tree. "Sociobiology," notes Robert Wright, "drew so much fire, provoked so many charges of malign political intent, so much caricature of sociobiology's substance, that the word became tainted. Most practitioners of the field he defined now try to avoid his label . . . they go by different names: behavioral ecologists, Darwinian anthropologists, evolutionary psychologists, evolutionary psychiatrists. People sometimes ask: What ever happened to sociobiology? The answer is that it went underground, where it has been eating away at the foundations of academic orthodoxy."[84]

Academic freedom, local option, religion in the schools, prayer in the courtroom. The events of 1925 seem uncannily familiar to denizens of

the last decade of the 20th century. Are these "liberal" or "conservative" issues? What I want to stress is the fact that the political valence of an incident or an argument cannot be detached from its cultural context—that ideas and events are read differently in different cultural domains. What may seem an incontrovertibly "left" position in one moment may uncannily pop up fifty years later as a basic tenet of the right; what appears to be a conservative position, indeed one absolutely foundational to conservatism, may reappear as a recognizably liberal idea. This is a "knowledge" that many people would prefer not to know, since it creates crises of alliance and epistemology, especially that mode of auto-epistemology we have tended of late to call "identity politics." My argument, then, is neither about political correctness nor about political incorrectness, but rather about something that might perhaps be called political incorrigibility.

"Now it's the left that's trying to restrict free speech," wrote Stanford law professor Charles Lawrence III in an essay on campus regulation of racist hate speech. "Though the political labels have shifted, the rationale is the same: Our adversaries are dangerous and therefore should not be allowed to speak."[85] "Have we forgotten when blockage, vilification and harassment were the weapons of the left, particularly in the universities?" asked moderate columnist A.M. Rosenthal in a description of the anti-abortion movement we have already noted.

Or consider Bill Clinton's impassioned response to the Oklahoma City bombing. "Those who trouble their own house will inherit the wind," declared the President, pledging to ask Congress for broad new powers to combat terrorism.[86] Clinton's call for enhanced surveillance of potential terrorist groups was met by a cautious response from the ACLU and the *New York Times*, which reminded readers of a time when dissidents on the left were the targets: "Exploiting precisely the kind of enforcement latitude Mr. Clinton would re-establish, the F.B.I. and C.I.A. illegally harassed Americans who opposed the Vietnam War. The F.B.I. burglarized the offices of suspect groups, bugged Martin Luther King Jr. and used infiltrators to provoke illegal activities. Even noble goals, like the control of Ku Klux Klan violence, were tainted by needlessly excessive tactics."[87] The President's own history of war resistance, often thrown in his face by political opponents, was reconsidered by some columnists in the wake of former Secretary of Defense Robert McNamara's startling and belated apologia, *In Retrospect: The Tragedy and Lessons of Vietnam.*[88] One commentator suggested that if he had the

courage Clinton would now speak out in moral support of draft re-
sisters. The *Times*, in a stunning editorial, noted that "another set of
heroes—the thousands of students who returned the nation to sanity by
chanting, 'Hell, no, we won't go'—is under renewed attack from a band
of politicians who sat out the war on student or family deferments. In
that sense we are still living in the wreckage created by the Cabinet on
which Mr. McNamara served."[89]

In the days following the bombing in Oklahoma City, it was disclosed
that the architects who designed the federal building previously were
"asked to toss in some extra concrete to reinforce it against possible
terrorist attack"—which they did. "The perceived threat then," wrote
Boston Globe columnist David Nyhan, "was from the left: anarchistic Viet-
nam War protesters, who'd torched or bombed some lightly guarded
government installations and college ROTC buildings." As Nyhan
noted, "The worm has turned."[90]

Repetition and repression are the twin mechanisms by which a cul-
ture processes and comes to terms with its intolerable history. The
inevitability and linkage of these processes, repetition and repression,
makes it impossible to secure the historical moment politically or ideo-
logically in a single place. Neither the left nor the right can be securely
in possession of the sense of its own primal words: when the repressed
returns, it may well turn out to be on the other side.

Which is the left position, and which is the right? Which is the liberal
move, and which the conservative? What are the "weapons of the left"—
and of the right? Who pickets? Who prohibits? Who blocks? Who
bombs? We may think we know the answers to these questions. But his-
tory sometimes answers them differently. As the overdetermined exam-
ple of creationism and evolution suggests, there can be more than one
way to stage a primal scene.

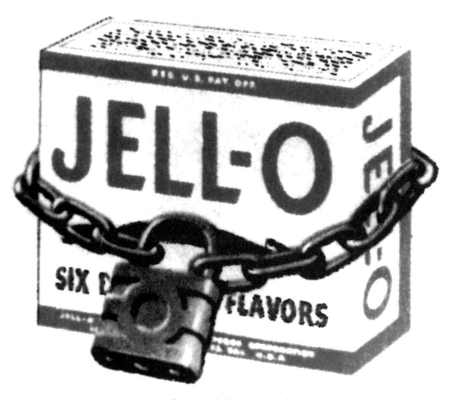

"Jell-O Announces Locked-In Flavor," from a 1940s magazine advertisement.

V

Jell-O

> this may help to thicken other proofs
> That do demonstrate thinly.
> —Shakespeare, *Othello* 3.3.431–32

The infamous "Jell-O box." In the trial of Julius and Ethel Rosenberg it would come to be regarded as the key piece of prosecution evidence, the "necessary link" tying the Rosenbergs to a purported conspiracy to steal the secret of the atomic bomb. As Judge Irving Kaufman put it in his charge to the jury, "the Government contends that you have a right to infer that there existed a link between Julius Rosenberg and Yakovlev [the Soviet agent] in that Julius Rosenberg in some way transmitted . . . the Jello box-side to Yakovlev."[1] And Irving Saypol, the prosecutor, claimed that Harry Gold's testimony about the Jell-O box "forged the necessary link in the chain that points indisputably to the guilt of the Rosenbergs."[2]

The Jell-O box, the government contended, was a sign, a password from one conspirator to another. Ruth Greenglass testified that in January 1945 her brother-in-law Julius took her into the kitchen of his apartment and cut the side of a Jell-O box into two odd-shaped pieces, giving one to Ruth and keeping the other for himself. "This half," she said he told her, "will be brought to you by another party and he will bear the greetings from me and you will know that I have sent him."[3]

With the Jell-O box, the government produced the damning code

phrase—"the greetings"—uttered by self-proclaimed courier Harry Gold. As the co-conspirators met and matched their Jell-O box halves, Gold (it was said) intoned the surprisingly uncryptic words, "I come from Julius." Without this primal scenario, the government had no evidence to present, nothing to link the Rosenbergs to David Greenglass and the atomic secrets.

Of course, the actual Jell-O box used in this transaction, as Roy Cohn and Myles Lane matter-of-factly admitted to the jury, had not been preserved. But since all Jell-O boxes look more or less alike (differing only as to which of the six delicious flavors then available—strawberry, raspberry, cherry, orange, lemon, or lime—had been favored on the crucial occasion) the prosecution helpfully produced, as an aide-memoir in the courtroom, a facsimile of the Jell-O box side in question, a simulacrum of the Jell-O box side that Harry Gold had, he said, presented to David Greenglass on that fateful morning in June 1945, in Albuquerque, New Mexico.

"The history of this Jello box side," said chief prosecutor Saypol in his summation to the jury, presumably holding up the object in question, "the history of this Jello box side, the greetings from Julius, and Greenglass's whereabouts in Albuquerque come to us not only from Ruth and David, but from Harry Gold . . . a man concerning whom there cannot be a suggestion of motive . . . [since] he has been sentenced to thirty years."[4] Much has been written about Harry Gold's active fantasy life, his spectacular history of untruthfulness: the wife and twin children he invented and described to his co-workers, his reasons for suddenly claiming to be Klaus Fuchs's courier, his opportunity, in the course of their adjacent incarceration in the Tombs, to concoct a story that concurred with David Greenglass's. "Recreating" in testimony an event that may never have occurred in life, Gold recalled an ambiguous, opaque transaction for which the Jell-O box was the chief clue, the clarifying agent. In a masterpiece of defamiliarization he described for the court the item he had received from Yakovlev as "a piece of cardboard, which appeared to have been cut from a packaged food of some sort. It was cut in an odd shape, and Yakovlev told me that the man Greenglass, whom I would meet in Albuquerque, would have the matching piece of cardboard."[5] On the witness stand he peered forward earnestly to examine the two cut halves of a Jell-O box and indicate for prosecutor Myles Lane which half more closely resembled that

he supposedly had received from Yakovlev and matched with the one possessed by David Greenglass.

Yet in pretrial testimony, as is frequently noted, Gold had been much less specific about the occurrence, and the signifying details, of this meeting. It was David Greenglass who first mentioned, in a statement to the FBI the day after his arrest on June 16, 1950, that his visitor carried "a torn or cut piece of card," not at that time identified as a Jell-O box. Greenglass supplemented this oral testimony with a memo to his attorney dated the following day.[6] Only belatedly did Gold "remember" Greenglass's name, and address, and the fact that he himself had been in Albuquerque at all.[7]

As for Gold's coded message, the disarmingly direct "I come from Julius," it had emerged, over the course of his depositions, from a welter of other possibilities. In a recorded interview on June 14, asked explicitly by his attorney John D.M. Hamilton whether the conspirators had some agreed-upon recognition sign, Gold replied: "Yes, we did, and while this is not the exact recognition sign I believe that it involved the name of a man and was something on the order of Bob sent me or Benny sent me or John sent me or something like that."[8] A phrase such as "Benny sent me" say Miriam and Walter Schneir in their book, *Invitation to an Inquest*;[9] Virginia Carmichael cites the phrase "Benny from New York sent me"[10] as one of Gold's versions of the message. In the documentary film *The Unquiet Death of Julius and Ethel Rosenberg*, former FBI agent Richard Brennan testified that when he first interrogated Harry Gold, "he used the expression Benny sent me, which was the best that he could recall at the time. Subsequently, when the trial of Greenglass led to Rosenberg, we asked him ... could it have been Julie sent me or Julius sent me. And immediately he brightened with a great light—yes, that is it. It wasn't Benny, it was Julius sent me."[11]

"Benny sent me." And then, "It wasn't Benny, it was Julius sent me." Like the elusive MacIntosh in Joyce's *Ulysses*, "Benny" here appears— and then disappears—out of nowhere, an apparent artifact. If we resist the suggestion that there was a real spymaster in New York and that it was he, the sinister Benny, and not the innocent (and framed) Julius Rosenberg who cut in pieces the mysterious Jell-O box, we are left with this supplement: "Benny sent me." What, if anything, does Benny— rather, than, say, Bob, or John, or Julius—have to do with the story Harry Gold told on the witness stand, the story, which evolved over the

period of his incarceration, of the Jell-O box, the coded password, and espionage?

Joyce's joke about "MacIntosh," as you will recall, is based upon a comic mechanism of association and slippage. Leopold Bloom has seen a man *in* a macintosh—a British term for raincoat, after Scottish inventor Charles Macintosh—and, through a series of aural misunderstandings, the man is hypostasized into someone *named* Macintosh, who then makes cameo appearances throughout the novel. Bloom is talking to a newspaper reporter:

> —And tell us, Hynes said, do you know that fellow in the, fellow was over there in the . . .
> He looked around.
> —Macintosh. Yes, I saw him, Mr Bloom said. Where is he now?
> —M'Intosh, Hynes said, scribbling. I don't know who he is. Is that his name?"[12]

"I don't know who he is—is that his name?" Consider now the case of Benny Kubelsky, better known as Jack Benny, Jewish comic, entertainer, and radio personality, the most popular radio host of his time. Jack Benny ruled the air waves in the early days of radio. And for seven years, from 1934 to 1941, each Sunday night, Jack Benny's immensely successful radio program was brought to you by General Foods, and was called "The Jell-O Program."[13]

"Jell-O again," Benny would salute his audience each evening. During the program, Benny's patter included a constant joking with announcer Don Wilson about the product, so that soon "even pre-school-age children could rattle off Jell-O's 'six delicious flavors.'"[14] Benny and his wife Mary Livingstone (born Sadie Marks) appeared (suitably refitted with WASP noses and profiles) in print Jell-O ads for magazines like *Country Gentleman*. So closely did American audiences link Benny and Jell-O that in a poll taken in 1973 of middle-aged listeners asked to name his radio sponsor, most answered "Jell-O," although in fact Benny was subsequently sponsored by Lucky Strike cigarettes for almost twice as long as he had been by Jell-O.[15]

"Benny sent me." When Harry Gold, fantasist and storyteller supreme, named to the FBI the supposititious man who gave him the Jell-O box half to deliver, he may well have been right the first time. It *was* in a way Benny who sent him, insofar as anyone did. "Benny" and "Jell-O"

were themselves two halves of a single code phrase for American popu-
lar culture of the thirties and forties, and, for many listeners, for at least
three decades after that. "Jell-O again."

Moreover, it is not, I think, insignificant that Jack Benny, born Benny
Kubelsky, was a *Jewish* comedian, and one whose most famous comic
turns came from an emphasis on his sterotypically "Jewish" signature
qualities (stinginess; the violin) despite the fact that he never used a
Jewish accent in his act. For as it happens gelatin as a product, and Jell-
O as a brand, was much in debate among Jewish leaders in the period
from 1933 to 1952.

Here is the opening sentence of a book entitled *Gelatin in Jewish Law*,
by Rabbi David I. Sheinkopf: "Can a substance of non-kosher origin
undergo physical transformations that render it permissible according
to Jewish Law?"[16] At issue was the question of gelatin's origin, from the
collageneous tissues of non-kosher animals. Some gelatin derives from
bones and cowhides, others from pigskins. An extended tradition of
rabbinic commentary from Maimonides down to the present day has
debated the kosher status of animal byproducts that at one time in the
course of their treatment are rendered inedible for canine consump-
tion and then are completely reconfigured, through chemical changes,
so that they become, in effect, new substances.

"Forbidden substances," as Rabbi Sheinkopf points out, can "lose
their prohibition once they become unsuitable for normal eating pur-
poses." Or, as a flyer sent out by Kraft General Foods in the Spring of
1993 under the heading "Jell-O Brand Gelatin Dessert" insists, "During
manufacture of gelatin, chemical changes take place so that, in the final
gelatin product, the composition and identity of the original material is
completely eliminated." "Because of this," the flyer continues, "gelatin
is not considered a meat food product by the United States govern-
ment. The plant is under supervision of the Federal Food and Drug
Administration. If the government considered gelatin a meat food
product, the plant would operate under the Meat Inspection Branch of
the Department of Agriculture.

"Jell-O Brand Gelatin is certified as Kosher by a recognized orthodox
Rabbi as per enclosed RESPONSUM."

And the Responsum, six pages in Hebrew, is indeed enclosed in the
same mailing.

I have to admit that as a young Jewish girl growing up on Long Island
in the fifties in a secularized family, and eating Jell-O brand gelatin

dessert on the average of three times a week, in all of its six delicious fla-
vors, it never occurred to me to worry about whether what I was eating
was Kosher, much less whether it was a highly disguised kind of meat.
But for the observant Orthodox community this was and is a real ques-
tion, made more crucial by the emergence in the thirties and forties of
commercial products like *Junket* (a dessert mix containing rennet from
the dried stomach lining of a calf) and, especially, of Jell-O. Two ortho-
dox rabbis, Samuel Baskin and Simeon Winograd, originally gave a
hekhsher, or kosher certification, to Jell-O brand gelatin, but were per-
suaded to withdraw their *hekhsher* in November 1951, because Jell-O's
manufacturers used pigskins as well as cowhides and cattle bones as a
gelatin source.[17] Since that time the disputes appear to have been
resolved, although a footnote in Sheinkopf's book alleges that Jell-O is
still made from pigskins, and expresses astonishment that supervising
rabbis from Atlantic Gelatin could possibly endorse Jell-O.[18] The mar-
keting of conspicuously kosher products like Kojel, a gelatin dessert
manufactured in Brooklyn and available in Jewish food stores since the
1930s, emphasizes the point: not every jel(lo) is ko(sher). In any case
the sheer amount of printed material that General Foods mails out
when asked about its Jell-O brand bespeaks a certain concern about
this question.

Nonetheless, the product is today clearly stamped and declared not
only Kosher but Kosher for Passover. The period of significant debate
about its status, from the first written decision of acceptance handed
down by Rabbi Hayyim Ozen Grodzienski of Vilna in 1935 to the con-
troversies of 1950–51,[19] coincides with the period from Jack Benny's first
identification with "The Jell-O Program" (in 1934–35) to the date of the
Rosenberg's trial and execution, in 1950–51—a trial that hinged directly
on the question of whether or not Julius Rosenberg cut a Jell-O box in
half in his New York kitchen and sent it as a sign and a password to his
brother-in-law. ("Benny from New York sent me.")

But if the hidden marketing anxieties of General Foods converged in
part around the kosher controversy, the public advertising campaign
had much more to do with patriotism. Jell-O, like Lucky Strike and a
host of other products, was eager to help America win the War. Print
ads from 1940 present Jack Benny and Mary Livingstone as WASP
Americans showing Farmer and Mrs. Gill how to make a Jell-O Plum
Pudding, a traditional Christmas dessert. By 1944, the company was urg-
ing its consumers to "Keep a Waste Chart Like the Army's," and offer-

ing a coupon which, together with six cents in stamps, would get you Jell-O's "Bright Spots for Wartime Meals." By 1944, Jell-O itself was apparently a scarce commodity, as several ads acknowledged, even patriotically foregoing a competitive edge to urge that, if grocers run out of Jell-O, consumers "Make these useful wartime dishes with some other brand of gelatin dessert."

In 1946, with the War over and jobs scarce, somber ads run in magazines like *Capper's Farmer* and *Country Gentleman* urged Americans to give up their nest eggs to make more jobs, identifying the product with the quintessential American spirit of free trade and business expansion, and concluding, in large type at the bottom of the page, "Jell-O is a Product of General Foods and American Enterprise." The word "America" or "American" appears seven times in the printed text, and the word "freedom" five times. No picture of the product, in its box or in its prepared form, appears anywhere in this broadsheet-like ad, which signals its own selflessness and generosity through this omission. By 1948, the crisis was apparently over, for the Jack Benny salutation, "Jell-O Again!" was triumphantly displayed above the Benny mantra of "six delicious flavors."

Considered in the frame of the Rosenberg case there is a certain inadvertent irony in some of these ads, like the one for Jell-O's "locked-in flavor," and the light-hearted query from 1944 run in *McCall's*, *Women's Home Companion*, and *Life* magazines, "Is there a Party hiding in your Ice-box?" But the keynote of all of the subsequent advertising campaigns has been to universalize Jell-O as a quintessentially American (and even Christian) food, closely tied to mainstream culture: voting, scouting, the Fourth of July, children, grandparents, weight-watching, and, again, plum-pudding. Nor did the cultural mystique of Jell-O as a metonymy for Norman-Rockwell America end at mid-century. A Jell-O museum opened in 1997 in the small town of Le Roy, New York, where the gelatin dessert was invented a century earlier and manufactured until 1964. Approached by way of a path officially called the Jello-Brick Road, the museum's nostalgic artifacts include a Gelometer, a contraption that measures Jell-O texture, as well as tie-in products from music boxes to suspenders. Jell-O, said a museum visitor from South Carolina, represented "old times, small towns, friendships, basic values."[20]

Considered in the context of the Rosenberg case, there is a sense in which the use of a Jell-O box as the supposed clue to a Communist conspiracy to deliver America and its free enterprise system into the hands

of the Soviet Union ranks as the ultimate, if trivial, outrage. A Communist Jewish man is in the kitchen, cutting up Jell-O boxes, while his neglected children listen to the radio ("Jell-O Again") and his wife, who *should* be in the kitchen making Kosher Jell-O molds, is masterminding the theft of atomic secrets. Is this any way to rebuild America?

Harry Gold, himself a Jew like virtually all the key players (on both sides) in the Rosenberg trial, artlessly reported to his attorneys in pretrial testimony that the chief topic in his initial conversations with the Greenglasses was the absence of familiar food products in the deserts of New Mexico:

> I think that their principal talk ... concerned the difficulty of getting Jewish food, delicatessen, in a place like Albuquerque and a mention by the man that his family or possibly her family regularly sent them packages including salami.[21]

As the Schneirs note, there is no mention in this recorded interview of the "Julius" password or the cut Jell-O box. The scene, real or fantasized, is familiar to any urban Jew who has spent time in "a place like Albuquerque," or even to fans of Calvin Trillin and his pilgrimages to Arthur Bryant's Kansas City barbecue. What does linger in the air here, however, stronger than the smell of salami or barbecue, is the question of what is kosher.

Kosher. From the Hebrew for "fit," "proper," "permissible." Now adopted into American slang, and present in most American dictionaries. Here are some of the things expert Leo Rosten, the author of *The Joys of Yinglish*, has to say today about the American usages of this common and complex word.

> —Legitimate, legal, lawful. "Is this deal kosher?" "Is this deal on the up-and-up?" "Everything is kosher" means "Everything is proper."

> —"The real McCoy," trustworthy, reliable. "Is he kosher?" which once meant, "Is he Jewish?" is now taken to mean, "Can I trust him?" or "Is he part of the group?" or (as I heard it used in the Pentagon) "Has he been cleared for classified information?"

> —Approved by a higher source; bearing the stamp of approval. "It's kosher," when uttered by a company V.P., can mean that his president has approved.[22]

Notice the degree to which "kosher," in America, has now become a political term. A person who is deemed "kosher" is "cleared for classified information," "part of the group," "approved by a higher source," and even, in a triumph of trans-ethnic transmogrification, "the real McCoy" (or, perhaps, the real MacIntosh). The new *American Heritage Dictionary* goes out of its way, or so it seems to me, to give a usage citation under "kosher" from the *Christian Science Monitor,* of all places.[23] Kosher, like lox and bagels, has gone mainstream (indeed, since lox is smoked salmon, I supposed we could say *up*stream).

But Rosten's book was published in 1989, and my dictionary is the 1992 Third Edition, with a usage panel that includes Harold Bloom, Justin Kaplan, Cynthia Ozick, Elaine Showalter, and numerous other Jewish intellectuals who have themselves been koshered by mainstream success. Forty years ago it was another story.

The place of Jell-O in the American Jewish mythology of the 1940s and 50s was both fascinating and complex. At a politically progressive summer camp held on the grounds of Kutsher's Catskill resort, campers were served an American flag made of Jell-O on the Fourth of July.[24] Philip Roth's brash autobiographical hero, Alex Portnoy (b. 1933), contrasts his childhood idealization of his mother (who referred to him as "Albert Einstein the Second") with the pity and contempt he felt for his father. "It was my mother who could accomplish anything," Portnoy tells his analyst. "She could make jello, for instance, with sliced peaches *hanging* in it, peaches just *suspended* there, in defiance of the law of gravity." And Portnoy's father? His son remembers him chiefly as a martyr to constipation: "I remember that when they announced over the radio the explosion of the first atom bomb, he said aloud, 'Maybe that would do the job.'"[25] Yet even Portnoy's father was proud of his wife's Jell-O, not least for its "real Jewish" character, as he explains to a gentile co-worker he has brought home to dinner: "that's right, Anne, the jello is kosher too, sure, of course, has to be."[26]

Like Benny Kubelsky, koshered by General Foods into Jack Benny, with a seemly nose and an appetite for Jell-O plum pudding, Jell-O itself both marked and crossed the borderline between Jewish and Christian, American and foreign, kosher and traif. As such, and embodied in the split or bifurcated box, it was the perfect sign for the politics of the Rosenberg case.

I return then to my epigraph, spoken of course by Iago, the master-plotter and master opportunist, the man who seized upon another overdetermined domestic object, a woman's handkerchief, and made it the sign of calumny. "This may help to thicken other proofs/ That do demonstrate thinly." The Jell-O box is not a random signifier, however it made its way into the evidence submitted in the trial of Julius and Ethel Rosenberg. Overdetermined by both its relationship to the Jewish community and its much more highly visible status as the quintessentially American, middle-class, and patriotic food, America's just dessert, the Jell-O box was already a culturally loaded term, "the necessary link," when Roy Cohn or one of his colleagues cut a fascimile into pieces and displayed it to the court.

Part II

Classic Signs

Anita Hill.

Clarence Thomas.

VI

Character Assassination:
Shakespeare, Anita Hill, and *JFK*

Great men are more distinguished by range and extent than by
originality. —Ralph Waldo Emerson, "Shakespeare"

1st VOICE: Oh no!
2nd VOICE: Can't be!
3rd VOICE: They've shot the President!
5th VOICE: Oh, piteous sight!
1st VOICE: Oh, noble Ken O'Dunc!
2nd VOICE: Oh, woeful scene!
6th VOICE: Oh, traitorous villainy!
2nd VOICE: They shot from there.
1st VOICE: No, that way.
3rd VOICE: Did you see?
4th VOICE: Let's get the facts. Let's go and watch TV.
 —Barbara Garson, *Macbird* (1966)

In the Fall of 1991, the televised Senate hearings on the confirmation of
Clarence Thomas as Justice of the U.S. Supreme Court yielded an unex-
pected and fascinating benefit for the student of literature and culture:
the voice of Shakespeare ventriloquized, speaking through our nation's
lawmakers and those called to testify before them.

Senator Alan Simpson of Wyoming, one of Judge Thomas's most
ardent supporters, declared roundly as he addressed the assembled

gathering that "Shakespeare would love this. This is all Shakespeare. This is about love and hate and cheating and distrust and kindness and disgust and avarice and jealousy and envy." To reinforce his point, that the Bard had a word for it, he then went on to cite in defense of Clarence Thomas what he felt was a particularly apposite and telling passage:

> Good name in man and woman, dear my lord,
> Is the immediate jewel of their souls.
> Who steals my purse, steals trash; 'tis something, nothing;
> 'Twas mine, 'tis his, and has been slave to thousands;
> But he that filches from me my good name
> Robs me of that which not enriches him,
> And makes me poor indeed.

To underscore the depth of his feeling, Senator Simpson added "What a tragedy! What a disgusting tragedy!"—a remark I take to be a comment on the Thomas-Hill events, and not on the play from which he had just quoted.[1]

Let us pause for a moment to consider what any psychoanalytic critic would recognize as the overdetermined nature of this choice of text. For the quotation, as Simpson noted to his learned colleagues, comes of course from *Othello*, a play about a black man whose love for a white woman, Desdemona, leads his detractors to describe his passion—or rather, their fantasies about his passion—in the most graphic and vivid terms. It is not, that is to say, only a telling passage about sexual jealousy, but also a passage chosen from a play with a peculiar pertinence—or impertinence—to the events narrated in the Senate chamber.

Whether Senator Simpson had, in fact, the thematic relevance of *Othello* firmly in mind when he quoted from it, however, must remain a little in doubt. For the passage that he quoted, in ringing tones, is not the voice of the injured Othello, but rather that of his Machiavellian manipulator, Iago, the very man who sets in motion the plot against him, the man whose own "hate . . . and distrust . . . and jealousy and envy"— to quote the Senator's eloquent peroration—leads him to falsify evidence and to twist the facts. Needless to say, Iago has no use at all for "good name," nor for the quality he calls, in an equally famous interchange with another victim of his innuendo, "reputation."

The whole speech (*Othello* 3.3. 155–61), as any student knows, is an

example of the most blatant *hypocrisy*. The audacity of Iago in taking what he pretends to be the high road while secretly manipulating his dupes (Othello and the unsuspecting, gullible Venetians) is, in dramatic context, breathtaking. In his next lines, Iago will invoke—and invent—the "green ey'd monster," "jealousy," which is the very quality that typifies *his*, and not Othello's, behavior throughout.

What is it that Senator Simpson thought he perceived in this dollop of the classics, this soupçon of Shakespeare, that somehow would make his point? Perhaps it is no accident that the Venetian deliberative body are themselves called Senators—"most grave senators" (*Oth*.1.3.229). Yet Iago's audience, like that of Senator Simpson, is a wider one. By citing Shakespeare this "most grave Senator" was in effect giving moral weight to his own position. Shakespeare said it: therefore it must be true. True, somehow, to human nature, whatever that is. Universally, transhistorically true.

This penchant for quoting Shakespeare out of context, as a testimony simultaneously to the quoter's own erudition and the truth of the sentiment being uttered, is itself a time-honored trick of American public oratory. In some quarters, although not on the fundamentalist right, it has come to replace the Bible, since Shakespeare is regarded as both less sectarian and less sanctimonious. For many years one of the most quoted passages of Shakespeare in the *Congressional Record* was a set piece equally wrenched out of context, Polonius's advice to his son in *Hamlet*: "This above all: to thine own self be true,/And it must follow, as the night the day,/Thou canst not then be false to any man" (*Ham.* 1.3.78). That this is the same passage that begins "Neither a borrower nor a lender be" may testify to the Congress's ability to disregard, as well as to regard, the timeless "wisdom" of Shakespeare.

For Polonius, like Iago, is being presented in an ironic context. His utterances on this occasion are bromides, sententiae, used wisdom, the *Bartlett's Quotations* of his day, spilled forth helter-skelter in a speech that many in Shakespeare's audience would have recognized as the mark of a puffed-up public man delighted with the sound of his own voice.

But let us return to Senator Simpson. For Senator Simpson emerged in the course of the hearings as in some sense the voice, and the guardian, of Shakespeare. When the Chairman of the Judiciary Committee, Senator Joseph Biden, mis-attributed another quote to Shakespeare, Simpson quickly corrected him: "One of the things that has been

indicated here," as Biden summarized the proceedings for his colleagues, "is this notion of maybe that the witness, Professor Hill, really was basically the woman scorned . . . and that after being spurned she took up the role in the way that Shakespeare used the phrase, 'Hell hath no fury like' and that's what's being implied here."[2]

But the ever-vigilant Senator Simpson was on hand to set the record straight. "My friend from Wyoming," Biden reported genially, "in an attempt to save me from myself, has suggested to me that it was not William Shakespeare who said 'Hell hath no fury. . . .' I still think Shakespeare may have said it as well, but he says, William Congreve said it and the phrase was, 'Heaven has no rage like love to hatred turned,/ Nor hell a fury like a woman scorned.' I want the record to show that."

Biden was good-natured enough to add a further self-deprecating quip: "I must tell you—I have my staff researching Shakespeare to discern if he said [anything like that]. Not that I think Mr. Congreve would ever plagiarize Shakespeare."[3] This last reference is to his own history of quotation without citation from the political speeches of British politician Neil Kinnock. But then, as Emerson reminds us in his essay on "Shakespeare," "Great men are more distinguished by range and extent than by originality." And though "a certain awkwardness marks the use of borrowed thoughts," "as soon as we know what to do with them they become our own."[4]

The Congreve passage comes from a play called *The Mourning Bride*, not necessarily standard American curricular fare even in Wyoming, which is why I am guessing that *Bartlett's Familiar Quotations*, not Congreve, was Senator Simpson's source.[5] And *Bartlett's Quotations*, that *disjecta membra* of famous, disembodied voices, is the repository of conventional wisdom, of what we, and our Senators, purport to know about "human nature." This use of quotation from the literary classics—quotation, especially, from Shakespeare—had, then, bipartisan appeal. Why did Biden think that "hell hath no fury like a woman scorned" was by Shakespeare? Because it was famous—and because he thought it was true. Indeed, many if not all of the most grave Senators seemed to think it was true, was a given, was a foregone conclusion. If Anita Hill *was*, or could be said to be, a scorned woman, then it would be clear that she was animated and motivated by fury, had become, in effect, one of the Furies, who were themselves regarded by the wise ancients as female. A "scorned" woman or a "spurned" woman? The Senators seemed unsure as to the exact quotation—how many of them had read *The Mourning Bride* recently?—but the phrase echoed, ghost-

like, thoughout the hearings. Hell had no fury like one of them; Shakespeare had—almost—said so.

Why Shakespeare? Well, for one thing Shakespeare is "safe"; neither too high nor too low. He is not an author whom Lynne Cheney or her colleagues then at the National Endowment for the Humanities could have accused of being the property of narrow specialists,[6] but rather the abiding, ventriloquized voice of us all, of disembodied wisdom. Emerson wrote in 1850 about the way in which Shakespeare's works underlay political and moral thought in America and Europe: "literature, philosophy, and thought," said Emerson, "are Shakspearized. His mind is the horizon beyond which, at present, we do not see. Our ears are educated to music by his rhythm."[7]

Emerson's Shakespeare is enhanced rather than diminished by the fact that so little is known about his life. Like some of George Bush's political and judicial appointments, whose past opinions are nonexistent, retracted, or under erasure, he is therefore free to be everything, to know everything, to tell us what we want to know, or what we already think we know. "The wise Shakespeare and his book of life," "inconceivably wise," a "poet and philosopher" who teaches the king, the lover, the sage, and the gentleman—this is the Shakespeare whom Emerson calls a "genius" and a representative man.[8] This is the Shakespeare whom Thomas Carlyle, in a book written a few years earlier, called a "Hero," an object of "Hero-Worship." "A thousand years hence," Carlyle wrote in 1840, "From Paramatta, from New York, wherever English men and women are, they will say to one another, "Yes, this Shakespeare is ours; we produced him, we speak and think by him; we are of one blood and kind with him.""[9]

We speak and think by him.

The power of this kind of disembodied, free-floating quotation is considerable. Sometimes the quotation itself can perform an implicit act of commentary, less overt than Senator Simpson's grumpy (and un-Shakespearean) off-stage (but on-mike) complaint that people were afraid to tell the supposed "truth" about Anita Hill because of "all this sexual harassment crap."[10] (The shift in tonal register in the learned Senator's language from the earlier heights of "Good name in man and woman . . . is the immediate jewel of their souls" was, perhaps, not wholly lost upon a discerning audience.) The faxes supposedly hanging out of his pockets were another kind of *disjecta membra*, foul papers that had come in over the transom.

Yet the Thomas hearings provided all-too-glaring evidence of how

the Shakespeare quote, lifted out of context, could be like a double-edged sword, turning back upon the wielder. During the floor debate on the day of the Senate vote, Patrick Leahy, Senator from Vermont, attempting to reclaim the high ground from the Republicans, noted that "Senator Simpson quoted Shakespeare the other day," and added, "let me paraphrase from *Hamlet*, 'Judge Thomas doth protest too much.'"[11] Leahy thus inadvertently cast himself as Queen Gertrude and Clarence Thomas as the Player-Queen whose over-fervent claims of innocence and fidelity were—or so Hamlet remarks to the audience— themselves grounds for suspicion. Notice the gender roles implicit in this allusion. Thomas, Senator Leahy's reference seemed subliminally to suggest, had appropriated to himself the "female" role, the role of impossible virtuousness and chastity. If he were in a locker room or a sports bar his language among men, Thomas asserted, would be as pure as tea party conversation with a roomful of Republican ladies. But the *Hamlet* context, of course, is doubled. The spectator who sees through this language of protesting too much is the very person whose own innocence the play-within-the-play is set up to question. Was Senator Leahy, among the most staunch and, to my mind, admirable, of Anita Hill's supporters, subconsciously offering a comment on the Senate's own holier-than-thou position—on, for example, Orrin Hatch's horri-fied claim that any man who watched pornography or talked about his own body was a psychopathic monster?

But this may be, to cite the Bard once more, to consider too curi-ously. My favorite of all the Shakespeare citations in the Thomas hear-ings, however, has, apparently, very little of the subconscious or inadvertent about it. I refer to the accusation leveled by Thomas char-acter witness J.C. Alvarez, who had worked with him in the office of Education, at Anita Hill, whom Alvarez characterized directly as aggres-sive, aloof, and, above all, *ambitious*. Alvarez, whom right-wing columnist Peggy Noonan unforgettably described as "the straight-shooting May-bellined J.C. Alvarez," "the voice of the real, as opposed to the abstract, America," sneered self-righteously,

> What is this country coming to when an innocent man can be ambushed like this, jumped by a gang whose ringleader is one of his own protégées, Anita Hill. Like Julius Caesar, he must want to turn to her and say "Et tu, Brutus? You too, Anita?"[12]

Thus the voice of the real America spoke, not entirely surprisingly, in and through the voice of Shakespeare. Can it be a total accident that her cryptic initials, J.C., are the initials of the Shakespearean figure she is quoting, Julius Caesar? Caesar who became the most famous case of literal character assassination in ancient history, or, indeed, in Shakespeare's plays?

The phrase "Et tu, Brute"—you too, Brutus—is, as I pointed out in another context a few years ago, "a quotation of a quotation, a quotation which has *always* been 'in quotation,' ultimately a quotation of nothing."[13] It has no source in ancient texts, and though it is set off in Shakespeare's play as apparently "authentic" by the fact that the dying Caesar speaks it in Latin, it is in fact not a sign of authenticity but its opposite, what I called "a back-formation from Elizabethan literary culture, a 'genuine antique reproduction.'"

"Et tu, Brute"—or, to quote the voice of America, J.C. Alvarez, more exactly, "Et tu, Brutus." That Ms. Alvarez has small Latin (and, I think it is fair to assume, perhaps even less Greek) makes her appropriation of Shakespeare, and Shakespeare's cultural power, even more striking. "You too, Anita." The bathos, as with Senator Simpson's rhetorical tumble into "sexual harrassment crap," is imperceptible to the speaker. For she is speaking "Shakespeare"—never mind that the Shakespeare she speaks is, to a large extent, made-up. (Peggy Noonan, you may recall, contrasted J.C. Alvarez favorably with "the professional, movement-y, and intellectualish [Judge] Susan Hoerchner," who, said Noonan disparagingly, wore no makeup.) Alvarez is speaking "Shakespeare," as "Shakespeare" has come to be spoken in the public sphere of American politics. Out of context, de-professionalized, timeless, transcendent, and empty, the literary version of the American flag, to be waved at the public in an apparently apolitical gesture toward universal wisdom.

Indeed, had Anita Hill wished to reply in kind, she too could have found prescient authorization and authority in the disembodied voice of Shakespeare. Turning to *Richard III*, his play of Machiavellian statecraft, she might have quoted a familiar passage from the episode known as Clarence's dream: "Clarence is come, false, fleeting, perjur'd Clarence,/That stabb'd me in the field by Tewksbury" (*Richard III* 1.4.56). The dreamer, and the speaker, in this case is in fact the Duke of Clarence himself, recalling a moment in his earlier career.

The saving remnant for the reader of Shakespeare is that the context

is, in fact, so often telling, that the play's language does, so often, to
quote Brutus on the spirit of Caesar, walk abroad, and "turn our
swords/In our own proper entrails," stabbing or undercutting the
speaker. Senator Simpson as Iago will long linger in my mind as one of
the most revealing moments of the hearings. Honest, honest, honest
Iago. The play's the thing.

Emerson himself was not immune to the nicking of this two-edged
sword. Both his chapter on "Shakespeare: Or the Poet" and the more
general introductory essay on the "Uses of Great Men" in *Representative
Men* reproduce the same pattern of quotation undercutting—we used
to say subverting—the apparent argument of the text. The overtly pre-
siding spirit of Emerson's essay is that of Hamlet. His observation that
literature, philosophy, and thought are "now" "Shakspearized" is pre-
sented in the context of a praise of German Romantic Shakespeare crit-
icism: "It was not until the nineteenth century, whose speculative genius
is a sort of living Hamlet, that the tragedy of Hamlet could find such
wondering readers."[14]

This privileging of *Hamlet* as the key text of the age is as expectable
for Emerson as it is common to writers of the period. The same semi-
autobiographical impulse that led him to claim that great geniuses all
plagiarize from one another (a teaching that might have been some
comfort to Senator Biden, had one of his staffers, or the staffers of the
indefatigably learned Senator Simpson, called it to his attention)—that
same impulse to write *himself* into his praise of Shakespeare surfaces
again in the "identification" with Hamlet and his problems.

Emerson tacitly casts himself as Hamlet when he tells the story of his
visit to the theater to see a great tragedian play the part, "and all I now
remember of the tragedian was that in which the tragedian had no part;
simply Hamlet's question to the ghost":

What may this mean,
That thou, dead corse, again in complete steel
Revisit'st thus the glimpses of the moon?[15]

It needs no ghost come from the grave to tell us that the "dead corse"
here is Shakespeare, or the avid questioner, Emerson; the "great" trage-
dian, a mere transitional object, is conveniently erased and forgotten,
remains nameless in the essay, and will not be numbered among the
"great men."

Hero-worship, and character assassination.

The question of "character assassination" and the phrase itself did, needless to say, come up in the course of the Thomas hearings. Thomas's protest against what he viewed as racial stereotyping of black male sexuality, his suggestion that he was undergoing a "high-tech lynching," was reinforced by this declaration: "I would have preferred an assassin's bullet to this kind of living hell that they have put me and my family through."[16] And Senator Edward Kennedy spoke out sharply against the "dirt and innuendo" that had been cast upon Anita Hill: "We heard a good deal about character assassination yesterday, and I hope we're going to be sensitive to the attempts of character assassination on Professor Hill. They're unworthy. They're unworthy."[17]

For Kennedy, the image of the assassin's bullet had, undoubtedly, a special and painful relevance. The difference (and the relationship) between assassination and character assassination, between the bullets that had killed his brothers and the innuendo aimed at him by the press, was doubly clear in his case, since his own "character" (and, indeed, the "question of character" raised by Thomas C. Reeves's moralizing JFK biography of that name) was tacitly on trial, or at least on view.[18] And ironically, the chief defense counsel for Judge Thomas, the point man for innuendo against Anita Hill, was also a key figure in the story of the Kennedy assassination and its aftermath.

To make the irony more precise, and to introduce what will be, inevitably, a strong and ghostly Shakespearean subtext to *that* story of character and assassination, we may note that the name of the counsel, the hardnosed senior Senator from Pennsylvania, was "Specter": Arlen Specter.

> What may this mean,
> That thou, dead corse, again in complete steel
> Revisit'st thus the glimpses of the moon?

Uncannily, this same Arlen Specter was the aggressive and ambitious junior counsel for the Warren Commission, the man who proposed the famous "magic bullet" theory that enabled the Warren Commission to claim that Lee Harvey Oswald had acted alone. In doing so he warded off any implications of the sort that Oliver Stone brings forward in his 1991 blockbuster film, *JFK:* that "spooks" from the C.I.A. had foreknowledge of, much less any hand in, the assassination. Is this specter

an "honest ghost"? or a "damned ghost"? Or just "an affable familiar ghost"—the return of the repressed?

It will probably not surprise you at this point to learn that Stone's film contains not one or two but five Shakespeare quotations, all performing cultural work of a kind which should now be familiar. *Hamlet*, inevitably, is the play of choice for this dramatization of the moral musings of a man who regards himself as the conscience of the nation— whether that part is being played by Jim Garrison (Kevin Costner) or Oliver Stone. "One may smile and smile and be a villain," Garrison/ Costner reflects, as he ushers the urbane and elusive Clay Shaw (Tommy Lee Jones) out of his office, shortly to charge him with conspiracy in the murder of JFK, whom he will characterize as a "slain king." In a long and (mostly) moving speech to the jury at the end of the film he tells them "we are all Hamlets, children of a slain father-leader whose killers still possess the throne." Since considerations of spurious "national security" have allowed the government to classify the relevant documents for a conspiracy trial, he tells the jury he himself will have "shuffled off this mortal coil" before they are unsealed, but he will urge his son to examine them when they are opened in fifty years. *Julius Caesar*, too, is, perhaps inevitably, invoked and cited, as Garrison asks a staff member whether he's read it; this is how a conspiracy works, he says, Brutus and Cassius and all the others united in a plot against the innocent leader. "Do you read Shakespeare?"

But the oddest and most piquant Shakespearean touch, as you will remember if you've seen the film, is the final epigraph, starkly lettered in white against a field of black: "What is past is prologue," it says. Not "what's past is prologue" (*Tempest* 2.1.253): "what is past is prologue." Is it that Shakespeare is not, on so solemn an occasion, to seem colloquial? Does mis-quotation here seem more authentic, more like a real quotation? Does it seem more like what Shakespeare—our Shakespeare —would have, should have, said?

The citation from *The Tempest*, itself a play of revenge, is spoken in the voice of the usurping Duke of Milan, Prospero's brother. The context is his suggestion to Sebastian that he kill his own brother, the king, and rule Naples in his stead, appropriate enough, we might think, in a film that paints a dark picture of the motivations of Lyndon Johnson. But Stone preempts this scenario, disembodies the text, to make the line an ominous pledge: like Garrison he will continue to fight the good fight, seek the truth, uncover the character assassination of the

single "patsy," Oswald, that is hiding the real story of the assassination of JFK by a mega-conspiracy of agencies, generals, and politicians. What is past is prologue.

A very similar set of concerns was brought forward in Barbara Garson's 1966 play *Macbird*, the source of the stichomythic dialogue I have cited at the beginning of this essay. ("Oh, no!"/"Can't be."/"They've shot the President," etc.) *Macbird*, a pastiche of parodied Shakespearean passages from plays like *Richard II, Henry V, Hamlet, Julius Caesar,* and *Othello,* as well as *Macbeth,* was written, as is doubtless clear from this excerpt, in the chaotic time after the Kennedy assassination, and was published in Berkeley, California in 1966, by an outfit calling itself the Grassy Knoll Press. It tells the story of the murder of Ken O' Dunc by the ambitious Macbird and Lady Macbird, who then escalate the war in Vietland and are finally defeated by Ken O'Dunc's surviving brothers Robert and Teddy "when burning wood doth come to Washington."[19]

But the role played by Shakespeare in Stone's *JFK* is a slightly different one from the one he plays in *Macbird.* Stone's Shakespeare is present not overtly as analogue and pretext but covertly as a glancing subtext, as 1) a sign that educated discourse in this country is Shakespeare-literate, and 2) a ghostly evocation of Shakespeare as the cultural voice of revenge and retribution, of values and of conscience; and 3) as yet further evidence that Shakespeare quotation can be an uncanny, double-edged sword—if not a magic bullet.

Furthermore, as is perhaps needless to say, Garson's *Macbird* was a coterie production of the antiwar movement, while Stone's *JFK* is a $40 million film bankrolled by Time Warner and ballyhooed on the pages of mass circulation magazines and newspapers from *Esquire* to *Newsweek* to the *New York Times.* And the question raised in journal after journal has been: is Stone, like Shakespeare's comic and self-important vicar, an "Oliver Mar-text"?[20] What right does he have to make so public and political a statement of his own interpretation of historical events, and to buttress that opinion with manufactured footage, cross-cuts, grainy color, and black-and-white reenactments of "historical events"—meetings between conspirators, the planting of Oswald's hand-print on the rifle, admirals intervening at the autopsy of JFK—"events" that may never have occurred?

Here is Oliver's Stone's defense, or explanation: "I consider myself a person who's taking history and shaping it in a certain way. Like Shakespeare shaped *Henry V.*" "Like Hamlet we have to try and look

back and correct the inaccuracies."[21] D.A. Jim Garrison may have suffered from hubris and made serious mistakes, but that "only makes him more like King Lear." This is indeed the official story from Stone headquarters, that Stone is today's Shakespeare. Here is entertainment lawyer Bert Fields, whose firm represents the director: "If you are doing what purports to be a book or film about history, it's hardly rare for an author or film maker to take a position. Look at *Richard III*. There was a violent controversy between those who believed Richard was a tyrant who murdered his two nephews. And those who think he was a wonderful king. Shakespeare represented one view, the view that was acceptable to his Queen. Nobody faulted Shakespeare."[22]

Leaving aside this last observation ("nobody faulted Shakespeare"), the argument seems fairly joined. *Newsweek*'s cover story decried "The Twisted Truth of 'JFK': Why Oliver Stone's new Movie Can't Be Trusted."[23] Headlines like "When Everything Amounts to Nothing,"[24] "Oliver Stone's Patsy,"[25] and Stone's Op-Ed page challenge, "Who is Rewriting History?"[26] (all printed on the same day in the same newspaper) are obviously good publicity for the film, but they are also something more. A *New York Times* reporter named Michael Specter—no relation, presumably, to the Senator from Pennsylvania—noted skeptically that many filmgoers seem to have "succumbed to Mr. Stone's Grand Unified Conspiracy Theory, a gaudy, frenetic fiction."[27] These ghosts are all around us.

"Stone has always required a hero to worship," wrote *Newsweek*'s arts columnist, David Ansen. "He turns the D.A. into his own alter ego, a true believer tenaciously seeking higher truth. He equally idealizes Kennedy, seen as a shining symbol of hope and change, dedicated to pulling out of Vietnam and to ending the cold war."[28] A hero to worship. Stone's heroes are not two but three: Jim Garrison, John F. Kennedy, and Shakespeare. And here he is in formidable company. Consider again the view of Shakespeare put forward by the man who popularized the term "hero-worship" (a term invented, it would seem, by David Hume)[29] more than one hundred and fifty years ago, Thomas Carlyle. "How could a man delineate a Hamlet, a Coriolanus, a Macbeth, so many suffering heroic hearts, if his own heroic heart had never suffered?"[30]

Of Shakespeare's "Historical Plays," Carlyle asserts that "there are really, if we look to it, few as memorable Histories. The great salient points are admirably seized; all rounds itself off into a kind of rhythmic

coherence; it is, as Schlegel says, *epic.*" Art, not history, is thus the measure of hero-worship; to Carlyle, Shakespeare's "veracity" lies in his "universality."[31]

For Carlyle—as for Emerson—Shakespeare was cramped, even demeaned, by the material circumstances of cultural production in his time: "Alas, Shakespeare had to write for the Globe Playhouse; his great soul had to crush itself, as it could, into that and no other mould. It was with him, then, as it is with us all. No man works save under conditions. . . . *Disjecta membra* are all that we find of any Poet, or of any man."

Disjecta membra. Familar quotations. Disembodied voices. In the Thomas-Hill hearings, in Oliver Stone's *JFK,* in *Bartlett's Familiar Quotations,* everywhere in the corridors of power, Shakespeare authorizes a rhetoric of hero-worship and character assassination based upon this Orphic dismemberment of the text. "Et tu, Brutus." "What is past is prologue." Perhaps it is well for us to remember in these times how uncannily the "familiar" can be de-familiarized—and that a "familiar" can also be a demon, a spirit, a Specter, a "spook," or a ghost.

Laurence Olivier as Hamlet.

VII

Shakespeare as Fetish

Why is Shakespeare fetishized in Western popular—as well as Western high—culture? Who does the fetishizing, and what work does that fetishization do? What is the relationship of Shakespeare as fetish to current debates about Shakespeare in the academy, including the role of Shakespeare as the anchor of the canon, the Bloomingdales or Neiman Marcus (or, as we'll see shortly, the Wanamakers) of the upscale shopping mall which is the present-day English department? What has the fetishization of Shakespeare to do with recent critical emphases on colonialism, imperialism, undecidability, feminism, and the discourse of subjectivity?

I want to address these questions by briefly considering the phenomenon of fetishizing Shakespeare in one case involving a literary critic, one case involving a theatrical (and cultural) audience, and one case involving a government bureaucrat. But let me start by posing a simple question, which will be familiar to all who have been engaged with teaching and writing about Shakespeare and poststructuralism in the wake of the explosion of new work on Shakespeare in the last several decades. Why is it that parents who would be appalled to find their college-age children studying the same chemistry textbooks, or economic theorems, that they themselves were taught 20 years ago, fully expect that those children will learn the same things about Shakespeare that they learned when they themselves were in college? What is it about the humanities in general, and Shakespeare in particular, that calls up this nostalgia for the certainties of truth and beauty—a nostalgia which, like (I would contend) *all* nostalgias, is really a nostalgia for something that

167

never was? Here I mean something as trivial as imagery and thematics ("What about the animal images in *King Lear*?" one alumnus asked me after a public talk. By not mentioning them I had, inadvertently to be sure, taken away something of his treasured childhood, or rather, his treasured memories of that childhood), or as loaded as politics: Caliban as the hero of *The Tempest*? cried an academic traditionalist. "Then I wouldn't know what the play would *mean*." By definition, the fetish and the circumstances of its narrative or enactment must always be the same.

That Shakespeare *is* the dream-space of nostalgia for the aging undergraduate (that is to say, for just about everyone) seems self-evidently true, and, to tell the truth, not all bad. He is—whoever he is, or was—the fantasy of originary cultural wholeness, the last vestige of universalism: *unser Shakespeare*. From the vantage point of a hard-won cultural relativism, a self-centered de-centering that directs attention, as it should and must, to subject positions, object relations, abjects, race-class-and-gender, there is still this tug of nostalgia, the determinedly secularized but not yet fully agnosticized desire to believe. To believe in something, in someone, all-knowing and immutable. If not God, then Shakespeare, who amounts to a version of the same thing.

Here is one of the most intelligent and influential of contemporary Shakespeareans, Stephen Greenblatt, fantasizing this wholeness-through-humanism.

> I began with the desire to speak with the dead.
>
> ... If I never believed that the dead could hear me, and if I knew that the dead could not speak, I was nonetheless certain that I could re-create a conversation with them ... conventional in my tastes, I found the most satisfying intensity of all in Shakespeare.
>
> I wanted to know how Shakespeare managed to achieve such intensity, for I thought that the more I understood this achievement, the more I could hear and understand the speech of the dead.[1]

By the end of this moving, almost incantatory introduction, itself a return to the rhetoric of high humanism despite (or because of) its emphasis on social energy and modes of production, Greenblatt has "corrected" his "dream": "the mistake," he says, "was to imagine that I would hear a single voice, the voice of the other. If I wanted to hear one, I had to hear the many voices of the dead. And if I wanted to hear

the voice of the other, I had to hear my own voice."[2] But the voice he dreams of is still the voice of Shakespeare: Shakespeare the fetish.

There are two things I'd like to say about this barely secular invocation. The first thing to say is that Greenblatt picks up, in this confessional beginning ("I began with the desire to speak with the dead"), a narrative that he let drop at the end of his previous book, *Renaissance Self-Fashioning*, the anecdote about the man whose son—whose grown son—was in the hospital with an incapacitating illness which made it impossible for him to articulate words. The man therefore asked the Greenblatt of the Epilogue (a Greenblatt who was planning, with professional detachment, to "finish rereading Geertz's *Interpretation of Cultures*") to "mime a few sentences so that he could practice reading my lips? Would I say, soundlessly, 'I want to die. I want to die'?" But Greenblatt found that he could not say these words, even soundlessly. "Couldn't I say, 'I want to live'?" Better still, he suggested that the man might "go into the bathroom, and practice on himself in front of a mirror." "It's not the same," the man replied. And clearly it wasn't.[3]

From the unvoiced, taboo pronouncement (who would say it when a plane was taking off?) "I want to die, I want to die," to the professed desire to speak with the dead (and to acknowledge that to do so he had to hear his own voice) is not, after all, so far to go. It is, if you like, to go from the Hamlet of Act 1 scene 2 to the Hamlet of Act 1 scene 5. It is still a long distance to the enunciation of what Derrida has called "the impossible sentence," Hamlet's declaration, "I am dead, Horatio" (*Hamlet* 5.2.337). But the movement from the secular text (Geertz's *Interpretation of Cultures*) back to the fetishized universal Shakespeare is striking. "Conventional in my tastes, I found the most satisfying intensity of all in Shakespeare."

Remember—and this is my second and last point about Greenblatt as re-fetishizer of Shakespeare—that it is he who, in the last essay of *Shakespearean Negotiations*, tells the story of H.M. Stanley's canny burning of a copy of Shakespeare's plays. Stanley substituted this handy volume, easily replaceable in an English bookstore, for his irreplaceable field-notebook, to palliate the members of an African tribe who regarded his note-taking as taboo. "We will not touch it. It is fetish. You must burn it."[4] And so—if Stanley is to be believed—his field research was saved by Shakespeare.

Greenblatt puts a lot of distance between himself and this anecdote, once he has told it. "For our purposes, it doesn't matter very much if

the story 'really' happened. What matters is the role Shakespeare plays in it." That role is described, characteristically, as two-edged; on the one hand, the field-notes were more powerful than Shakespeare's plays, and the plays had to be sacrificed for them; on the other hand, "Shakespeare *is* the discourse of power," whose agency in fact intervened to save Stanley's notes. In a footnote, which credits the finding of the anecdote to Walter Michaels, and the printing of it to William James, Greenblatt speculates on "the actual fetishism of the book" which he is willing to see in Stanley, "the attribution of power and value and companionship to the dead letter."[5] Thus Greenblatt is able to preserve, once again, his own divided subjectivity; he is at once the rational observer of discourses of power and the genial admirer of the numinousness of that power, both the desperate man on the plane and his dismayed, abashed, and finally unwilling Horatio. Yet "the attribution of power and value and companionship to the dead letter" is clearly what Greenblatt's opening gambit is all about. "I began with the desire to speak with the dead."

What has happened here, it seems to me, is that the dead metaphor of commodity fetishism has come back to life through the commodification of Shakespeare *as* a fetishized commodity. But what of the psychoanalytic understanding of the fetish, that the fetish is a substitute for the mother's penis (or phallus)? Here is Freud's description:

> the boy refused to take cognizance of the fact of his having perceived that a woman does not possess a penis. No, that could not be true: for if a woman has been castrated, then his own possession of a penis was in danger; and against that there rose in rebellion the portion of his narcissism which Nature has, as a precaution, attached to that particular organ. In later life a grown man may perhaps experience a similar panic when the cry goes up that Throne and Altar are in danger.[6]

The fetishist, says Freud, at once disavows and affirms the castration of women. To quote the famous little boy cited by Octave Mannoni, "Je sais bien, mais quand même" ("I know, but still. . . ."). "When the cry goes up that Throne and Altar are in danger"—so says Freud, writing in the Austria of 1927. We may hear, from a time and place when neither Throne nor Altar hold sway, the academic's (and the alumnus') cry, "then I wouldn't know what the play would *mean*." Shakespeare is the phallus of the mother, the guarantor of (impossible) originary wholeness.

And the phallic mother is England. Not any old merrie olde England, but the fantasy space of "early modern" England, the England of Elizabeth and James, in which we are busily discovering all kinds of behaviors and social practices, from colonialism to imperialism to transvestism to sodomy, that make it the mirror of today. Elizabethan England as phallic mother—"this sceptered isle," in John of Gaunt's famous speech about just such a nostalgia for originary wholeness (*Richard II* 2.1.40)—the place of "the balm, the sceptre, and the ball" (*Henry V* 4.21.260) as signatures of office. Elizabeth herself as a man, perhaps physiologically a blurred gender, certainly appearing as that famous androgynous martial maiden before the troops at Tilbury, Elizabeth as Amazon, as Prince, as—precisely the phallic mother who is *the* fetish object, the object of fetishism.

Let us consider, briefly, some material evidence for the fetishizing of Shakespeare through the body of the phallic mother, on our way back to that quandary I noted a few moments ago. Consider, for example, the recently completed project to rebuild the Globe Theatre on the Bankside, a slick, professional campaign spearheaded by an expatriate American character actor, Sam Wanamaker, who put together a dynamite coalition of Hollywood celebrities, wealthy socialites, and bemused British (and Anglophilic) academics, with the goal of exactly reproducing, with surveyor's plans from period engravings, the dimensions, orientation, and furnishings of the old Globe. Naturally it would have been an American who longed for this, who made it his dream: to wrest the territory from a commercial brewery which owned the rights to the land, and rebuild, not just a building, but Shakespeare himself. Like the Rockefellers rebuilding colonial Williamsburg, or Disney reconstituting the psychic realms of Fantasyland, Frontierland, and Tomorrowland in the conservative suburbs of Los Angeles, this plan longed for origins, for the moment when the dream began, for the navel of the dream.

The desire to return to a place one has never been, this very particular return of the repressed, animated the Wanamaker project of rebuilding the Globe. But the claim to return through reconstruction, the origin as located in and through representations of what the Globe once was, gave way for the moment to a claim of return through archaeology, the excavation of the site of the Rose Theatre, yet another brouhaha in a London attuned to Prince Charles's obsession with traditional architecture. "Dig Unearthing the Bard's World," trumpeted an early *Boston Globe* article on the excavation. The name of Shakespeare was repeatedly invoked to explain the importance of the project. "At

the Rose, Shakespeare's *Titus Andronicus* was first performed.... It's fairly certain, scholars say, that Shakespeare himself acted minor roles in Ben Jonson plays at the Rose before turning to writing plays full-time."[7] On the night of May 14, 1989, 500 people, including "many prominent actors," camped out on the Rose site "listening to the likes of Dame Peggy Ashcroft and Ian McKellen" recite Shakespearean exhortations to hold firm. McKellen wore a shirt that said, "Will Power." Now, the Rose is not exactly *Shakespeare's* theater. The name (and fledgling acting career) of Shakespeare is here invoked to sanctify the site against incursion. "No other nation on the face of the Earth would allow the destruction of the theatrical home of the world's greatest playwright," declared Dame Peggy Ashcroft "as she trod the ruins with Hollywood's Dustin Hoffman, who was in London to appear in *The Merchant of Venice*." Even if it is not the Globe, it is still, somehow, "the world of the Bard."

I want to tie this kind of fetishizing of Shakespeare as maternal phallus in with the other major Shakespearean event in the London news during that period, the death of Lord Olivier. Now Olivier's death, quite simply, was celebrated, or mourned, or commemorated, as if it were the death of Shakespeare himself—only this time, much more satisfyingly, *with* a body. At a memorial service in Westminster Abbey, where, famously, Shakespeare is *not* buried, although a portrait bust represents him, "the casket," according to the *Boston Globe*, "was surmounted with a floral crown ... studded with flowers and herbs mentioned in Shakespeare's works: from lavender and savory to rue and daisies."[8] The parade of dignitaries who moved up the aisle to the fanfare from Sir William Walton's music to "Hamlet," included Douglas Fairbanks, Jr., carrying the Order of Merit on a gold-fringed, blue velvet pillow, Michael Caine, carrying Olivier's Oscar (awarded not for any single role, but for "lifetime achievement"), and a host of other actors and actresses (Maggie Smith, Paul Scofield, Derek Jacobi, Peter O'Toole, etc. etc.) bearing such relics as the crown used in the film of *Richard III*, the script of the film *Hamlet*, the laurel wreath in the stage production of *Coriolanus*, and the crown used in the television production of *King Lear*, as well as silver models of the Royal National Theatre and the Chichester Festival Theatre. That impossible event in literary history, a state funeral for the poet-playwright who defines Western culture, doing him appropriate homage—an event long-thwarted by the galling absence of certainty about his identity and whereabouts—has now at last taken place.

Through a mechanism of displacement, the memorial service for Olivier became a memorial service for Shakespeare.

What I would like to argue here, riding my own hobbyhorse for a moment, is that under these cultural circumstances it is no accident that the Olivier eulogized (even before his death in commemorative essays) is a transvestite Olivier.

At first it might seem surprising that in both print and television obituaries for Olivier he was repeatedly pictured in drag, and described as "girlish." A photo of Olivier as Katherina in a school production of *The Taming of the Shrew* appeared on the NBC Evening News to mark the actor's passing. *Time* magazine commented that "From a list of his acting credits at school (Maria in *Twelfth Night*, Kate in *The Taming of the Shrew*), one imagines that his teachers had already spotted what director Elia Kazan would later cite as Olivier's 'girlish' quality. Throughout his career . . . Olivier would bat his eyes at the audience, soliciting its surrender. But belying those feminine eyes were the cruel, pliant lips, and on them the smile of a tiger too fastidious to lick his chops in anticipation of a tasty meal."[9]

"I may be rather feminine but I'm not effeminate," Olivier once declared, and critic Michael Billington remarks that "he can be masculine and feminine but never neuter."[10] He has been compared to Garbo and Dietrich in his sexual ambiguity—a quality, it is claimed, of great actors, though what this asserts it does not explain. Nor is Olivier as woman merely an artifact of the tranvestite theater of his same-sex public school. The "definitive" biography by Anthony Holden ("author of *Prince Charles*," says the dustjacket) devotes a page of photographs to the great actor in drag, including a full-length photo of a serious-face middle-aged Olivier in a girdle, high heels, stockings, and padded bra.[11] Olivier's Malvolio at Stratford in 1955 is said to have been marked by a "dainty, fairy-footed progress across the stage and a skittish, faintly epicene lightness," like that of Jack Benny.[12] (Jewish and working class, this Malvolio, with his crinkly hair and his uncertainty about pronunciation, invoked stereotypes about Jewish effeminacy that are part of the stage heritage of category crisis in ethnic- and gender-crossover, an essential element in what I call the "transvestite effect.") Kenneth Tynan described Olivier's Richard III, admiringly, as "a bustling spinster" in his dealings with Clarence,[13] and one critic aptly recalled Neil Simon's lampoon of a flamboyantly gay Richard III in *The Goodbye Girl* as the obverse of Olivier's "sinister amalgam of male-power-hunger and

female seductiveness."[14] The mechanism of displacement in category crisis deployed in and by transvestism is never more acutely emblematized than in Olivier's *Othello*; as Billington notes, "[e]ven at his butchest Olivier slips in hints of a dandified vanity: one remembers that astonishing first entrance in *Othello* with a red rose held gently between thumb and forefinger and with the hips rotating slightly in a manner half way between Dorothy Dandridge and Gary Sobers."[15]

This odd emphasis on the feminine and girlish Olivier comes despite —or, perhaps, because of—the fact that Olivier is frequently described as an exceptionally "athletic" Shakespearean actor, and his three marriages are extensively chronicled, as is his career as a movie heartthrob modeled after John Barrymore. As Billington in the same proto-posthumous appreciation recalls, "Olivier's fops leave you in no doubt as to their ultimate masculinity. . . . It is a modern fallacy that fops are homosexual. Olivier's two Restoration performances reminded us that in the seventeenth-century finery of apparel and frivolity of manner were compatible with balls."[16]

It is not, then, that Olivier is revealed in these representations as effeminate or gay (although biographer Donald Spoto would later publish disclosures about Olivier's sexual relationships with Danny Kaye and Peter Finch, and perhaps also with Noel Coward and critic Kenneth Tynan)[17] but rather that he becomes the portrait of triumphant transvestism—no closet queen, but the Queen Elizabeth of his age, and thus a figure for (who else) Shakespeare himself. If it is the case—and I believe it is—that the transvestite makes culture possible, that there can be no culture without the transvestite because the transvestite marks the entrance into the Symbolic, then the eulogizing of Olivier as on the one hand a matinee idol who began his career as a girl (or a "boy actress"), and on the other hand as Shakespeare makes a compelling, if at first counterintuitive, cultural sense.[18]

The nature and the point of that sense can perhaps best be seen by looking—briefly—at my last example of the fetishizing of Shakespeare, which comes from a report issued at about the same time to "the President, the Congress, and the American People" of the then-chairman of the National Endowment for the Humanities, Lynne Cheney. Cheney's 1988 report, *Humanities in America*, was at pains to point out that every cultural custodian *except* the university was doing its job right. High schools, libraries, museums, theater companies all came in for praise, but colleges and universities were letting America down by

politicizing literature, opening up the canon, and teaching third world and ethnic studies rather than "the ideals and practices of our [which is to say, Western] civilization." [19]

"The humanities," declared Cheney, "are about more than politics, about more than social power. What gives them their abiding worth are truths that pass beyond time and circumstances; truths that, transcending accidents of class, race, and gender, speak to us all."[20] This paean to timeless and transcendent truths was guaranteed, it is almost needless to say, by a reference to Shakespeare, and in this case a very clever one, an apparent preemptive strike at the race-class-and-gender crowd: a quotation from a speech given in 1985 by a black woman writer, Maya Angelou, in which she declared that Shakespeare was a black woman.

In this address (entitled, doubtless to Cheney's gratification, "Journey to the Heartland"), Angelou told her audience in Cedar Rapids, Iowa, that when she was growing up in Stamps, Arkansas, she announced to her grandmother her intention to read "Portia's speech from *The Merchant of Venice*" to her church congregation. Her grandmother admonished her not to read the works of a white author, but rather one from her own tradition, like Langston Hughes, Countee Cullen, or Paul Laurence Dunbar. But years afterward, Angelou recalled, "I found myself and still find myself, whenever I like, stepping back into Shakespeare. . . . He wrote it for me. 'When in disgrace with fortune and men's eyes,/I all alone beweep my outcast state. . . .' Of course he wrote it for me: that is a condition of the black woman. Of course, he was a black woman. I understand that. Nobody else understands it, but I *know* that William Shakespeare was a black woman. That is the role of art in life."[21]

Now, let us pass over the ironic fact that Angelou's original choice of presentation piece, "Portia's speech in *The Merchant of Venice*," is spoken by one of the few Shakespearean characters to openly disparage a black man for his race and color, in ways that even sympathetic editors have not been able to explain away. ("Let all of his complexion choose me so," Portia remarks with satisfaction, when the Prince of Morocco chooses the wrong casket and fails to win her hand [*Merch.* 2.7.79].) Let us concentrate, instead, on Angelou's humanistic claim that "William Shakespeare was a black woman," and the ways in which that assertion is offered by Cheney as a validation of her own claim that "the humanities are about more than politics . . . [and] social power," that they are about truths transcending time, circumstance, and "accidents" of race, class, and gender.

What makes Angelou's appropriation of Shakespeare as a black woman acceptable—and a fitting climax to Cheney's indictment of ideologues in the academy—is the same thing that makes the figure of Olivier as a woman acceptable: the fact that this is *only* a figure, an allegory, a "transcendent" "truth." Shakespeare's identity is shrouded in mystery, and rival factions have warred for centuries over the competing claims of Oxford, Bacon, Queen Elizabeth, Christopher Marlowe, and the mysterious "William Shakespeare of Stratford." What would happen if it were *in fact* discovered that Shakespeare was a black woman, not through a ventriloquizing voice lamenting an archetypal "outcast state," but through some diligent feat of archival research? Just the same thing, I would suggest, that would happen if it were *in fact* discovered that Laurence Olivier was a woman. If morticians had revealed to the world days after his death that Olivier had actually, anatomically and biologically, been a woman, what would have happened, of course, would have been a massive campaign of disavowal. The man, after all, had wives, and children, and, to recall the Secretary of State's word, *cojones.*

Shakespeare as fetish *is* Shakespeare as phallus. The mother's phallus, to be sure—the imagined phallus of the child's universalizing vision of the world. But what makes Shakespeare fetishized and fetishizing, a scenario of desire that has to be repeated with exactitude for every generation, is the way in which he has come to stand for a kind of "humanness" which, purporting to be inclusive of race, class, and gender, is in fact the neutralizing (or neutering) of those potent discourses by appropriation and by a metaphysical move to the figure.

Race, class, and gender. If Maya Angelou can be convinced that Shakespeare speaks for her, at the cost of acknowledging vestiges of racism, sexism, and classism in his own works (that is, if she can be persuaded to believe that he speaks for her even—or precisely when—he is in fact speaking against her) then the ideological danger of fetishizing Shakespeare becomes clear and present. If Olivier's voice, recorded on tape, can again be heard echoing through Westminster Abbey in the most blatantly nationalistic and chauvinistic of English calls to arms, the Crispin Crispian speech from *Henry V* with which a living Olivier exhorted his fellow citizens to arms during World War II from that same Abbey—a call to arms that came, not coincidentally, on the eve of Britain's loss of most of its colonies— it is worth stopping to think what the political implications are of this kind of speaking with the dead. If Stephen Greenblatt can conclude that "the open secret of identity—

that within differentiated individuals is a single structure, identifiably male—is presented literally in the all-male cast" of a Shakespearean play[22]—that, in effect, women are an artifact of male culture—then the danger of a critical refetishizing of Shakespeare is overt, and disturbing. What is much less clear is how we can get beyond this particular ideology. For Shakespeare as fetish has, in this time of perceived crisis in the humanities, become the ideology of our age.

Harold Lloyd in *Safety Last.*

VIII

Roman Numerals

I love not only you yourself. I love your name. And your
numeral. —Jenny Cavilleri to Oliver Barrett, IV,
 in Erich Segal's *Love Story*

Menace II Society —title of a 1993 film

I

In late September 1985, during the height of Hurricane Gloria, the
purchaser of a New England house built in 1790 went up to the rafters
to check for leaks in the roof. Shining his flashlight above his head, he
discovered a "large Roman numeral six" carved near the end of one of
the rafters. Nearby rafters were similarly marked with Roman numerals
"not by Romans, of course," he assures us, "but by people from long
ago."[1]

The timbers for a post-and-girt house might be hewn by its 18th-cen-
tury builder over the period of many months. To keep track of the
pieces, the incised Roman numerals would indicate where in the fin-
ished structure this particular beam or post would go. "In the attic of a
log cabin built in Illinois near Lake Michigan a hundred years ago,"
another observer reported, he discovered on the roof beams "carpen-
ter's marks, I II III and so on, cut with mallet and chisel, as a guide for
their order of placing."[2] I have myself seen similar markings in the wide-
board pine floors of a house in Nantucket—boards that were taken

from the attic of one building and recently re-laid as a floor in another, using the colonial-era numerals as a guide.

"The scratched lines from which Roman numerals supposedly arose, require only primitive tools and skill," notes a historian of typography. "Arabic numerals predicate a brush and a hand trained in calligraphy. Nevertheless. they are casual and demotic, while the Roman are formal, inscriptional, hieroglyphic."[3] A French account of the "universal history of numbers" commented in 1981 that "the Roman numerals we sometimes still use today . . . now seem old-fashioned and quaint."[4]

Old-fashioned and quaint. Formal, inscriptional, hieroglyphic. What are the implications of Roman numerals today?

This inquiry began as an exploration of the relationship between anachronism and nostalgia—specifically, my own nostalgia for the days when act and scene numbers to Shakespeare's plays were written in Roman numerals. For me, these glyptic capital letters and curly minuscules once conveyed the very spirit of canonicity—an effect, of course, not of "authentic" or "original" 16th- or 17th-century notation, but rather of subsequent scholarship and editorial practice. Act III, scene iv, seemed quite different from plain old Act three, Scene four.

For the record, the First Folio gives act and scene numbers in Latin words (*Actus Secondus, Scena Tertia*), marks the date of publication in Arabic numbers (or, more properly, Hindu-Arabic numbers) (*1623*), paginates the leaves in Arabic numbers, and spells out the names of Kings in English words, using ordinals ("King Henry the Fourth," "Fift," "Sixt," and so on).[5] Francis Meres's famous praise of Shakespeare in *Palladis Tamia* (1598) uses Arabic numbers: "for Tragedy his *Richard the 2.*, *Richard the 3.*,[and] *Henry the 4.*"[6] So—as we might by now expect about virtually any object of nostalgia—the original is absent. This is a nostalgia, like all nostalgias, for something that never was. The only Roman numerals *per se* in the First Folio are to be found in the tavern bill Prince Hal discovers in Falstaff's pocket, for ii.s, ii.d. for a capon, and v.s, viii.d for two gallons of sack (*1 Henry IV* 2.4.535ff.).

But by the time of Nicholas Rowe's edition of 1709, based largely on the Fourth Folio, many key elements have already been converted to Roman numerals, which are used for Act and Scene numbers (which Rowe attempted to systematize), for the title pages of the plays, and in some references to dramatis personae ("Richard II," "Henry V"). So also with the editions of Pope (1723) and Theobald (1733), who even

give the year of publication in Roman numerals (Rowe used Roman numerals for the title pages of volumes, and Arabic numerals on the title pages of plays). Thus begins a textual and cultural practice that has over the years become naturalized as the very sign of Shakespearean reference until the advent of computers, and computerized concordances, in the present day.[7]

For it is largely, I think, computers that we have to thank (or blame) for the recent changes in notation. Marvin Spevack's *Harvard Concordance to Shakespeare*, which has rendered so much formerly painstaking literary detective work now into a matter of instant (and consequently devalued) knowledge, boasts in its 1973 Preface that it is "based on the most advanced Shakespeare scholarship and produced by means of computer technology." Spevack's Preface, of course, like most modern Prefaces, is paginated in minuscule or lower-case Roman numerals. And his multi-volume *Complete and Systematic Concordance to the Works of Shakespeare*, published in Germany, uses majuscule or upper-case Romans to number the volumes. But the concordance entries themselves, as all latter-day Shakespeare scholars know, are given in Arabic numbers, as are the abbreviations to the play titles.

Spevack's concordance, which promised in those optimistic days to "exemplif[y] the latest thinking on what may be called the 'true text' of Shakespeare" based on the newly published modern-spelling Riverside Shakespeare of 1973, inevitably revolutionized notation in Shakespearean publishing practice. For though the Riverside itself used Roman numerals to mark Act and Scene numbers (as well as in the running titles of the English history plays and the names of the English kings), scholars working with that edition, and with the Ardens and other Shakespearean texts of record, began increasingly post-Spevack to give Act, Scene, and line references in Arabic numbers.

The first book of Shakespeare criticism I remember noticing with this distinctively "modern" touch (this is sheer anecdotal memory, not any point of origin) was Janet Adelman's *The Common Liar: An Essay on Antony and Cleopatra*, itself published (like Spevack's concordance and the Riverside Shakespeare) in 1973. Adelman did not use the Riverside as her text (she could hardly have done so even if she had wanted to, since her book was published in the same year), but rather cited M.R. Ridley's Arden edition of *Antony* from 1954, which, like all the other "new Ardens"—it is perhaps needless to say—used Roman numerals to mark the Acts and Scenes, with the notation at Act I. Scene I (given in

Roman numerals) that "*Acts and scenes [were] not marked, save here, in F.*"
(As we have noticed, in the First Folio the initial designation was in Latin
words, not numbers: "Actus Primus. Scena Prima.") But today the new
"new Ardens" of the third series have replaced the Roman numerals with
Arabic ones without comment on the change, noting only that "Act and
scene divisions (seldom present in the early editions and often the prod-
uct of eighteenth-century or later scholarship) have been retained for
ease of reference, but have been given less prominence than in the pre-
vious series."[8] (We may note that this information from the "General
Editors' Preface" can be found in the new new Arden *Antony and
Cleopatra* on page xi. Some conventions are more enduring than others.)

The Arden is not the only recent edition to convert to Arabic num-
bers for acts and scenes; the popular paperback Bantam, made the
switch in 1988. On the other hand, the new (1996) edition of the River-
side retains Roman numerals, which the editors have deemed more
attractive and "official"-looking—and which would have cost a great deal
to change.

Economics, aesthetics, and cultural authority thus—as usual, we
might think—reinforce one another to produce anachronism as tradi-
tion. But why should a Roman numeral look either more attractive or
more "official"? And to whom? Let me offer a hint in the form of an
unscientific observation: it's scholars, today, who use the Hindu-Arabic
notations in their citations. Journalists, politicans, and students—at least
my students—hanker (like my younger self) after the iconic Roman
numerals, the sign of otherness. The sign (to them) of the real
Shakespeare. These Roman numerals are the equivalent of "genuine
antique reproductions"—the kind of classy notations Shakespeare *would*
have used if he had only thought to do so.

II

There's a lot I never knew about Roman numerals. Like the fact that in
the medieval period and the Renaissance, they are often described not
as Roman but as German. And the fact that, despite all appearances,
"Roman numerals" do not derive from letters. C and M were not, that is
to say, originally abbreviations for *centum* and *mille,* no matter what you
were taught at school.

The Roman number symbols seem to have developed over time, in
fits and starts, probably from tally sticks, groups of notches, much as we

put a cross stroke through four 1s on the blackboard to count 5. (Thus an I for a 1, not an I for a "I.")

Comparative anthropological research suggests that in Switzerland and in parts of India, as well as in ancient Rome, "a crossing of straight-line symbols means 10."[9] V is pictographically the top half of an X. (Ancient coins show that the Romans used the *top* half to signify 5; the Etruscans, the *bottom* half.) Alternatively (this is the theory of Theodore Mommsen and others), V is a kind of hierography representing the open hand with its five fingers. Two such V's combined produced an X, the sign for ten.[10]

The pictographic view based on anatomical gesture has been dismissed recently as both "banal" and "stretch[ing] visual credibility" (how likely is it that two open-hand V's would be used to make an X? Try it yourself and see.)[11] Alphabet historian Johanna Drucker, commending the Romans for "the adaptation of letter forms to represent number values," argues that "the conventions which brought these forms into conformity with letters within the Latin alphabet were the effect of convenience, rather than necessity, and other signs would have functioned equally well—even better since they would have stood less chance of confusion."[12] But of course the confusion became part of the process—became, in fact, one of its most valued attributes.

The Romans never wrote M for 1000; instead they used a single vertical stroke enclosed in what look to modern eyes like parentheses. M (for *mille*) was a medieval contribution. An alternative notation for 1000 was a horizontal stroke above the number, a mark known as the *titulus* in the Middle Ages and as *vinculum* in classical Latin.[13] This horizontal stroke was different from the stroke that served to distinguish numbers from letters, and does appear in classical times: that stroke is the origin of our present-day practice of enclosing Roman numerals within horizontal strokes, above and below.

German authors of the 16th century, and others in Europe as well, called these "German numbers," not "Roman numerals." An arithmetic book of 1514, for example, gives its fractions in Roman numerals (I over IIII, VI over VIII, and so on), with the genial notation, "To make this little book of computations agreeable and useful to its reader, who will find numerals hard to learn at first, I have used the common German numbers throughout."[14]

But what about those letters and numbers? An early Etruscan figure for 1000 was a circle with an oblique cross in it, which gradually became

an upright cross and then dropped its horizontal bar, leaving something that looked like a circle cut in half by a straight vertical line. (Some historians theorize that this figure may have been derived from the Greek *phi*, which it resembles.) The Roman numeral C, for 100, has been traced to the left half of this old form for 1000, and the Roman numeral D, for 500 (half of 1000), to the right half. To indicate larger numbers, like 5,000 or 100,000, additional hoops or curves were added, in effect multiplying the numbers by ten or a hundred, and producing, as we've noted, an image like a capital I enclosed in several sets of parentheses. The central point here, though, is that the pictograph that looks like C, and, indeed, the pictograph that looks like M, were both derived, scholars believe, from symbols that had, originally, nothing to do with the words *centum* and *mille*, Latin for one hundred and one thousand. The verbal equivalence, the verbal match between symbol and word, between C and a hundred, M and a thousand, is, historically speaking, a back-formation. (An analogous modern instance is the American slang word "sawbuck" for ten-dollar bill, from the resemblance of the Roman numeral X—found on pre-Federal Reserve Bank currency—to the ends of a sawhorse. And "sawbuck," in turn, seems to be unrelated, etymologically speaking, to the word "buck" for a single dollar, which comes, say the dictionary-makers, from "buckskin." Go figure.) Likewise, the Roman numeral that looks like the letter L "coincidentally resembles" it but "has nothing to do with the letter L," according to mathematician Karl Menninger.[15]

Nothing to do with it *historically*, that is to say. Nothing to do with it developmentally. Nothing to do with it etymologically, in terms of origins and intentions. But in other registers we might want to claim that it has *everything* to do with it.

The very fact that numbers and letters *could* be confused or interchanged would lead to a kind of visual punning or riddling, a cryptography that would have its uses even in the modern day. Thus the "chronograms" or "date riddles" that used capital L's, V's (for U's), M's and D's to spell out a second message. *LVtetIa Mater natos sVos DeVoraVIt*, "Mother Lutetia has devoured her own children," encoded the date 1572 in Roman numerals to commemorate the Massacre of St. Bartholomew's Night, when Huguenots were slaughtered in Paris."[16] A rhyme memorializing the Council of Constance in 1416 declared,

The council was held
In Costnitz; that happened when we counted
a ring, 4 horseshoes too,
a ploughshare, a hook, and an egg.

The ring is a buckle (a circle with a line through it, looking like the let-
ter M), the horseshoes are C's (open at one end), the ploughshare is
the iron tip of the plough, shaped like an X, the hook is a V, and the egg
(despite its rounded shape) a time-honored symbol for "one." Thus
1416.

Nor is letter-and-number magic using Roman numerals exclusively a
thing of the past. A recent Internet contribution, headed "Barney is
Satan," took the phrase "Cute Purple Dinosaur," converted all the U's
to Roman-equivalent V's, extracted the Roman numerals CV, V, L, DI,
and V, added up their decimal equivalents (100 5 5 50 500 1 and 5) and
revealed that the total was 666, the notorious Biblical "number of the
Beast" (Revelation 13: 16–18) Voila! Barney is Satan.[17]

Just as Roman numerals were sometimes read as, taken for, or
thought to be derived from letters in the medieval and early modern
periods, so letters could be, after a fashion, derived from numbers. In
1463, a scholar-printer felicitously named Felice Feliciano wrote a man-
uscript setting forth rules governing the construction of a Roman capi-
tal alphabet by geometrical means. In 1509, the mathematician Luca
Pacioli, said to be the inventor of double entry bookkeeping, printed
his own set of rules, and several other scholars, mathematicians and
artists (including Albrecht Dürer) did the same.[18] It seems that Ren-
aissance geometricians, designing capitals or majuscules, rather than
copying "the forms which at that mid-15th century period existed about
them in great numbers on the classical monuments scattered through-
out Western Europe,"[19] instead imagined, quite falsely, that the Roman
forms derived from the harmonious proportions of the circle and the
square, and developed, in consequence, elaborate theoretical models
based on this mistaken historical notion. The revival of the classical let-
ters, both in stone inscriptions and medals and in manuscripts, drew
energy from these elaborate systems, whether or not they were ever
fully put in practice.

This change came on the cusp of the shift from manuscript to print,
and from Roman to Hindu-Arabic numerals. As Elizabeth Eisenstein

observes, "The way letters, numbers, and figures were pulled and pushed into new alignments by early printers and engravers is worth further thought. Human proportions were made to conform with letters once inscribed on ancient Roman arches, even while Roman numerals were being replaced by Arabic ones."[20] As we will see, the volatility of the cultural moment led to both over- and under-valuation of the Roman forms. Number and letter magic, familiar in necromancy, in ciphers and in the process of Biblical decoding known as gematria, found another way into Elizabethan culture through the overdetermined site of the Roman numeral.

Consider now a little complex of charts from the pages of a late 16th-century manuscript.

A	T	G	C	L	V	Li	SCO	SA	CAP
.1.2	345	678	9.10	11.12.13	14.15	16.17	18.19.20	21.22	23.24

Aq	P
25.26.27	28.29

take the name of Chilld m or wom & the name of the

.m	A thowsan	mother her owne naturall name & the chylldes name
.C	A hundred	& then youe moste take owt all the m & c & l & x &
.d	v hundred	& d & v & n & J [the take] & owt of & m & owt of
.l	for fifte	

& l & a n & J & JJ owt of 100 owt of 40 4 owt of 30 owt

.x for tenne $_2$ $_2$ $_1$ $_2$ $_{2[4]}$ $_4$ $_6$

.v for five of 20 owt of 500 owt o$^{(2)}$ 800 owt of 700 owt of 400 owt of 200 owt of

n for two 8 8 8 4 4 8
 160 owt of 140 owt of 80 owt of 50

.J for one $_4$ $_8$ $_8$ $_2$

JJ for two

Across the top of the page are abbreviations for the signs of the zodiac. Below to the left, running vertically down the side of the leaf, is a chart of Roman numeral equivalences: ".m A thowsan," ".C A hundred," ".d v hundred," and so on. And to the right of this listing is an instruction for what looks like the casting of a nativity. "take the name of Chilld m or wom & the name of the mother her owne naturall name & the chylldes name & then you moste take owt all the m & c & l & x & & d & v ... " and so on. This is one of several sets of instructions or recipes clustered together in this part of the manuscript: those that follow on the next two pages include charms "to drive away a grievous ague," "for a great ache or strain in the back," "to make a bird fall

down," "to know wher a thing is stolen," and so on.

What's so striking to me here, in the instructions for casting the nativity, is the way in which the letters listed on the left—the letters corresponding to Roman numerals—are the ones to be subtracted or taken from the letters in the names of the child and its mother. I'm reminded of the telltale elixirs in Middleton and Rowley's 17th-century play *The Changeling*, one in glass C (to detect whether a woman is with child or not) and the other in glass M (to detect whether she is a maid). That C=child and M=maid once seemed a sufficiently revealing if serio-comic code. But clearly these letters that are also numbers carry with them, potentially, an even greater kind of power.

What is the 16th-century manuscript from which this nativity spell is taken? It is not, as it happens, one of the works of mathematical sages like John Dee or John de Sacrobosco. It is a page of Philip Henslowe's *Diary*, more properly described as a book of accounts and memoranda kept by Henslowe (and by his predecessor, the book's first owner, John Henslowe) from 1579 to 1609. Philip Henslowe, theater manager, pawnbroker, moneylender, and entrepreneur, kept accounts of the daily receipts of performances in the several theatres, together with records of loans made on behalf of the theater company, payments made in connection with the building and repair of the Rose and the Fortune theaters, and lists of costumes, properties, and other items and transactions. He was not a magus; he was a bookkeeper.

During the course of Henslowe's record-keeping, the mathematical notations in his *Diary* change from lower case (minuscule) Roman numerals to pounds-shillings-and-pence. This was a period of transition in early modern accounting. It was not unusual for these two methods of notation to coexist or cross. In 1596, for example, Henslowe recorded a series of sums lent to his son-in-law, the actor Edward Alleyn. The sums are noted in a kind of demotic Roman numeral system, what could almost be described as pidgin numbers: xj (meaning "eleven") with a superscript li (short for Latin *librae*, "pounds"); xxxs meaning "thirty shillings," followed by xxxx with a superscript s, meaning "forty shillings." At the bottom of this set of "items lent" Henslowe reckons up the total, in Hindu or Arabic numbers: 21 pounds, 13 shillings, 04 pence. It's clear that Henslowe had no difficulty making the transition from one number system to another, any more than we have difficulty "translating" from Roman to Arabic numerals on the dial of a clock.

Throughout the *Diary* the same kind of casual multinumeracy obtains: items are recorded in Roman numerals and then the totals are given in pounds, shillings, and pence. Since "li" for pounds and "d" for pence are also Roman numeral notations, and since Roman numerals are retained throughout the *Diary* for operations like itemization (for example, the famous list of stage properties for the Lord Admiral's Men, "j rocke, j cage, j tombe, j Hell mought ... viij lances, j payer of stayers for Fayeton, ... iij marchepanes, & the sittie of Rome"),[21] what we have in the book known as *Henslowe's Diary* is a snapshot of a cultural practice, or set of cultural practices, in the process of being overwritten.

Far from being exclusively a "formal, inscriptional, hieroglyphic" mode, then, the Roman numerals of the medieval and Renaissance periods were, indeed, casual and demotic. They were used by bookkeepers and shopkeepers. So the Roman numerals of the middle ages and the Renaissance were "low" not "high," culture, the tools of "counter-casters," bookkeepers, debitors and creditors, at the same time they were enjoying a kind of double life as magical and mystical symbols, as notations for mathematicians, and (in some places) as ordinals after the names of monarchs.

In 1300, the use of Hindu-Arabic numerals was *forbidden* in commercial documents and in the banks of certain European cities, since it was thought that they could be more easily forged or changed (an 0 turned into a 6 or a 9 by a single stroke, for example). In fact, Roman numerals were commonly used in bookkeeping in European countries through to the 18th century, and Hindu-Arabic numbers were not generally accepted by the English public until the 17th.[22]

One reason bookkeepers preferred the Roman system—other than the conservatism inherent in any business practice—was that addition and subtraction were easier in it, though multiplication and division were more difficult. (Two C's plus one C was CCC; XXV minus X was XV, and so on.)[23] For multiplication and division, the ancient Romans used the abacus—as did early modern (human) calculators.

Brian Rotman points out that "the Roman way of notating numbers, like those languages that express the plural by repeating the singular, did not detach itself from the iconic mode," but "introduced an order into the syntax through the subtractive principle," so that three Is in a row could make a three, while an I before an X indicated the operation of subtraction. But as he is also careful to note, this complex syntax produced "an overcomplicated grammar," so that calculations with Roman numerals were "laborious, byzantine, impractical," and, in fact,

apparently seldom attempted, since "throughout its history there is no evidence that the system of Roman numerals was used or ever intended to be used for calculation."[24] Instead, those who wrote in Roman numerals calculated on an abacus.

The abacus appears in Shakespeare as a "counter"—thus Iago, who scorns Cassio as a "great arithmetician" (a book-soldier or armchair warrior) also calls him a bookkeeper (this "debitor and creditor—this counter-caster" [*Othello* 1.1.19;31]). The Clown in *The Winter's Tale* can't calculate his profit "without compters" (4.4.36), and Posthumus's jailer entertains him with some hangman's wit: "your neck, sir, is pen, book, and counters" (*Cymbeline* 5.4.169–70). (Arithmetic books, we might notice, were not apparently held in universally high regard in early modern England. The dying Mercutio sneers at Tybalt as "a villain, that fights by the book of arithmetic" [*Romeo and Juliet* 3.1.102], and Hamlet out-Osric's Osric with a riddling remark about "dozy[ing] the arithemetic of memory" [*Ham.* 5.2.114]. Arithmetic in these usages means something abstract and useless, like "theory," as well as something practical and useful, like bookkeeping.)

But, despite their popularity, Roman numerals are actually not very good for mathematics, though they are excellent for literature. "When considering views of antiquity," suggests Elizabeth Eisenstein, "the discarding of Roman numerals, or of Galen's anatomy or of Aristotle's physics, deserves at least as much emphasis as does the survival of theorems established by Pythagoras, Euclid, or Archimedes." And she notes, crucially, that "this discarding had not occurred until after a century of printing."[25] And again, "The discarding of Roman numerals . . . represented changes that cut across town-gown divisions and penetrated college halls. These changes are well reflected in the new printed materials turned out by applied mathematicians."[26]

Roman numerals were still in general use at the time of the invention of printing—though the Hindu-Arabic numeral, which took up less space on the printed page, had begun to come into fashion. Manuscripts were generally cited by chapter and verse, as is still done with the Bible (since no two copies would necessarily have the same pages). Chapters were given Roman numerals, a practice that continues today. Manuscript books were foliated, the leaves were counted, and numbers (in Roman numerals) appeared only on the recto pages. Pagination, which numbered the pages, recto and verso, came in later, and tended to use Hindu-Arabic numbers, again, because they saved space and were less ponderous. But the pagination of prefaces in lower-case

Roman numerals, and the giving of chapter (and volume) titles in Roman capitals, is a practice that still persists today. We've seen this in the Roman-numeraled prefaces of learned books and editions of Shakespeare. One of my favorite instances, again nicely overdetermined, is a page from a modern book called *The Development of Arabic Numerals in Europe* that contains 64 tables of examples culled from the 12th to the 16th centuries, with both the tables and the centuries meticulously numbered—in *Roman* numerals.[27]

The other obvious belated venue for Roman numerals is the clock or watch dial, where position rather than inscription allows the numbers to be "read" even by those who can't read. (Think of your driver-ed instructor telling you to "put your hands at ten of two" on the steering wheel.) This may be one reason why Roman numerals remained on clock faces long after Hindu-Arabic numbers replaced them in commercial use. Decorative, familiar, and iconic, the numerals on a clock did not need to be computed. It was only in the 19th century that Hindu-Arabic numbers began to appear with regularity upon clock dials—shortly to be followed, in this century, by the digital clock that did away with the notion of the dial altogether.[28] The striking clock in *Julius Caesar*, as editors never tire of pointing out, was always already an anachronism—what we might call an "original anachronism," in contradistinction to the modern use of Roman numerals as genuine antique reproductions, used to denote a spurious "originality."

One problem with the "German numbers" had been the absence of a zero; another, related problem was the increasingly inconsistent way in which place-value notation was given. The number 600 might be written, by authors in the medieval and early modern periods, as DC (500+100) or as vi.c (6 X 100). The English mathematician Robert Recorde, in the middle of the 16th century, wrote vj.C for 600 and CCC.M for 300,000.[29] What looked like abbreviations were actually evidences of a conceptually different mode of notation.

In the 16th and 17th centuries, therefore, enormous interest arose in developing a system of mathematical symbols as a kind of common language. François Viète used vowels for unknown quantities and consonants for known quantities. Descartes used letters from the beginning of the alphabet for known quantities and those from the end of the alphabet for unknown quantities. In England, Robert Recorde introduced the equals or equality sign, and William Oughtred experimented

with more than 150 symbols. In this intellectual climate, the Roman numeral, with all its limitations, was destined for anachronism. Its days, we might say, were numbered. But with change came—as always—resistance. And with resistance, overvaluation. And with overvaluation, iconicity.

"Uniform mathematical symbols," says Elizabeth Eisenstein, "brought professors closer to reckon-masters. They did not separate academicians from artisans, although they did move scientists away from poets. To the warfare between scholastics and humanists was added a new schism, between the party of number and the party of words. Print insured a victory of the 'algorists' over the 'abacists.'"[30] The abacists wrote Roman numerals and calculated with the abacus. The algorists recorded and calculated with Hindu numerals. Eisenstein is here describing a shift in the practice of writing and printing mathematics; but she could equally well be describing C.P. Snow's two cultures.

In short, the shift from Roman to Hindu numerals was a revolution. It produced the important possibility of *zero*, aptly described by Brian Rotman as "a sign about names, a meta-numeral."[31] It allowed the registration of the concept of an absence—unrecordable in Roman numerals. And it regularized the crucial idea of place-value, first described by the mathematician Thomas Harriot (1560–1621), the founder of the English school of algebra, rather curiously known to a generation of post-New Historicist critics chiefly as the author of *A Brief and True Report of the New Found Land of Virginia* (1588).[32]

But this change was not achieved all at once, or without effort. "At our present stage," writes Karl Menninger,"we can scarcely imagine the extreme difficulty of abandoning the highly satisfactory visual quality of the number groupings in order to adopt the more sophisticated principle of place-value." Charts and tables for comparing "the German numbers and the cipher numerals" appeared in countless arithmetic texts, while verbal comparisons of the two systems also circulated widely. ("Cipher" originally meant "zero," and then came to refer to the entire number system. "Zero," short for the Latinized *zepharino* ["cipher"], thus came to denote 0.)[33] Polixenes in *The Winter's Tale* has learned the lesson perfectly: "And therefore, like a cipher/(Yet standing in rich place), I multiply/With one 'We thank you' many thousands moe/That go before it" (*Winter's Tale* 1.2.6–9). He himself, of course, was shortly to become an absence, to take his hasty leave of the "rich place."

An elementary lesson in cultural capital was also about to be learned.

For as the practical prestige of the Roman numerals fell, their iconic and esthetic value rose. They were now excess value rather than use. For some time they retained their customary utility among that most conservative of classes, the shopkeepers, whose ledgers continued to blossom with cursive l's, v's, i's, and j's. But in a development that will seem quite familiar to observers of culture, the Roman numerals became, correspondingly (and as if in consequence of their loss of utility), emblems of monumentality and authority. Always "iconic" in a mathematical sense, they now became icons of a somewhat different sort. Their prestige as bearers of high culture increased as their arithmetical function decreased. They became, like the "Rome" whose borrowed name they bore, self-referential indices of their own defunct and therefore unassailable greatness. In their comparative uselessness they acquired a new and enduring use.

The Roman numeral—especially but not exclusively the capital Roman numeral—was now the perfect sign of anachronism and nostalgia, the perfect vehicle of what might be termed "the greatness effect."

III

The architects of the French Revolution renamed not only the months but also the years, starting over with the year I—in Roman numerals. The "great campaign of de-Christianization"[34] no longer dated the modern era from the birth of Christ, but rather from the fact of the Revolution. Thus in the Autumn and Winter of Year II, peoples' festivals abounded; the Constitution of Year III was approved on what we would call August 22, 1795; and the Directory government began after the elections of Year IV, in what we would call October of 1795.[35] At once monumentalizing and classicizing, this use of the Roman numeral recalled —as the Revolution did so often—the fantasmatic model of ancient Rome. "In the revolutionary view of history," as historian Lynn Hunt notes, "the republicans of Greece and Rome had invented liberty, and the mission of France was to bring that good news to all men."[36] But the choice of Roman numerals also struck a pose, historically speaking, instantiating what Hunt calls a "mythic present."[37] Perhaps unsurprisingly, the Statue of Liberty that stands in New York harbor, a gift of the people of France in 1886, bears the cast-iron date JULY IV MDCCLXXVI (July 4, 1776). In these cases, I would like to suggest, the Roman numeral becomes a sign of myth. Its iconicity is primary: an icon rather

than an index, displaying itself rather than pointing to a referent, the Roman numeral is a sign of a sign.

In his charming essay on "The Romans in Films" Roland Barthes reads the little bangs worn by all the characters in Joseph Mankiewicz's 1953 *Julius Caesar* as "simply the label of Roman-ness." These "insistent fringes," as he delights in calling them, are transhistorical signs of historicity: "cross the ocean and the centuries, and merge into the Yankee mugs of Hollywood extras," these "Romans are Romans thanks to the most legible of signs: hair on the forehead."[38] Barthes hasn't much respect for this kind of sign, which is neither "openly intellectual," a kind of "algebra," nor "deeply rooted" (note the mathematical language here). The "fringe of Roman-ness" is an "intermediate sign," a "degraded spectacle," a hypocritical hybrid characteristic of bourgeois art, "at once elliptical and pretentious."

What would Barthes think, I wonder, of the *typographical* "fringe of Roman-ness" which is the Roman numeral today? What are the fringe benefits of the Roman numeral as monument to monumentality? Let us count the ways.

Perhaps the most visible worldwide use of Roman numerals to designate rulers today is that of the Popes of the Roman Catholic Church. (Another overdetermined relationship, since they are styled the Vicars of Rome.) Julius II, Innocent IX, Pius XII, and John XXIII are familiar designations, indicating a tradition that is ages old. Some observers were taken aback when, in 1978, Albino Cardinal Luciani chose the name of John Paul I, indicating his reverence for his two predecessors, but also his expectation that there would be successors of that name. (Popes, of course, have no heirs of the body, at least officially.) Vatican loudspeakers boomed the announcement: "He . . . has taken the name of John Paul the First (Joannes Paulus Primus)."[39] This was the first double-name ever for a Pope, and the first new name in a thousand years. But *Newsweek* speculated that "the Roman numeral 'I' in his chosen name may turn out to be more significant than his decision to be called John Paul." The newsmagazine saw this as a sign "that he intends to govern the church in a fresh manner." Within 34 days he was dead. (And in due course succeeded by John Paul II.)

Before John Paul I, the last pope to select an "original" name was Lando (913–14), who did not call himself "Lando I." Actually, the custom of appending an ordinal number to the Pope's name dates only to

the 8th century (with Gregory III [731–41]), and became common practice only in the 10th. Since Leo IX (1049–54), the lead seal of the papacy has borne the ordinal number. Earlier popes who chose the same names as their predecessors were—you will be interested to know—known as *junior*, or, for the third in line, *secundus junior*.[40]

In America, lacking (and perhaps secretly longing for) a hereditary elite, the Roman numeral after the name has been secularized into a version of American aristocracy: John D. Rockefeller III and IV, Henry Ford II (never a "junior," since he was the grandson of the original Henry), the novelist Lucian K. Truscott IV, an army officer who is the son and grandson of army officers. The British, who have their hereditary kings and queens, can be more cheeky about them; thus the sixties hit song from Herman's Hermits, "I'm Henry VIII," told the story of a man whose wife had married seven previous 'Eneries, making him "'Enery the Eighth."

But the real "hereditary" lineage in American culture is found in the spectacles of popular culture, in film and in sport. The greatness effect, the signifying function of the capital Roman numeral as spectacle, is evidenced in public entertainments from the Rocky films to the Super Bowl. *Rocky I*, *Rocky II*, *Rocky III*, *Rocky IV* and *Rocky V* are the *Richard II*, *Henry IV*, and *Henry V* of today.[41] In fact, the Roman-numeraled sequel, from *Airplane II* to *The Godfather, Part III* and *Friday the 13th, Part VIII* has become so much of a cultural convention that when Alan Bennett's 1991 London hit *The Madness of George III* was adapted for the screen in 1994, the "people at Goldwyn" thought the play's title sounded like a sequel. They changed the title of the film to "The Madness of King George."[42] Even the *dates* of Hollywood films are given in Roman numerals: an on-screen equivalent of the architectural cornerstone, and another sign of grandeur (or at least, *delusions* of grandeur). In all of these contexts a Roman numeral means "greatness," historicity, cultural endurance, and authority. No matter that they can often not be read. Like celebrities, they are there to be seen.

As with Hollywood, so—quintessentially—with the Super Bowl. Under the apt headline, "Supernumerary," a Russell Baker column in the *New York Times* for January 1988, Baker jokingly lamented the advent of "Roman numerology" in an era when no one any longer remembers what Roman numerals are, or how they work.[43]

The titles of the early Super Bowls were satisfactorily macho, he thought. "Those great numerals V, X and I looked so absolutely football. They looked like numerals a coach could use to diagram a rock 'em, sock 'em play on the blackboard," or a quarterback could use to call a play. But in the assumed persona of a public relations meister of the future, Baker speculated about the unfortunate Super Bowl XLIX, which would look "like a name for a laxative," and Super Bowl LI, which would remind viewers of "a Chinese general." The point of his little spoof was that the "youthful moneybags" who now owned all the professional sporting teams knew nothing about Roman numerals as numerals, regarding these weird combinations of X's, V's, I's and L's instead as a peculiar semiotic of sports discourse.

Another newspaper's treatment of Super Bowl XXX took a similar—and similarly facetious—view. "Those three X's should convey to you the bigness here. Roman numerals are big. They were first used by the Romans, who were very big for a while until they collapsed. Now Roman numerals are used exclusively for very big things like Super Bowls, World Wars, Olympic Games, King Georges, King Henrys, Queen Elizabeths, popes, 'Death Wish' movies, and Wrestlemanias."[44] Facetious—and true. We live in a desperate cult of greatness, in which even olives are "Colossal."

The Roman numerals of today can be encountered in unexpected places, sometimes still as a result of the confusion, or conflation, of letters and numbers. That magic, and those portents, remain uncannily vivid. (I'm sure I'm not the only Shakespearean to do a double-take when confronted, these days, with the standard abbreviation for *Henry the Fourth*: HIV.) The Roman numeral II in the title of the 1993 film *Menace II Society* is a manifestly postmodern Roman numeral, "readable" as a word, demotic and iconic at once, a defiant sign of greatness on its own terms. And in the aftermath of a wave of celebrity trials and retrials the news media began to refer to them with Roman numerals. One columnist made casual mention of "the Simpson II trial" and the "verdict in Simpson I."[45] "Last year brought Menendez II and Goetz II," reported the *New York Times*. "1997 is off to a fast start with O.J. II, and Crown Heights II. . . . Probably coming to newsstands this spring: Alex Kelly II."[46] Such show trials, it might be said without too much exaggeration, are the public theater of our day, the "abstract and [not so] brief chronicles" of our time.

Surely the putative "Romanness" of the numerals is itself part of the greatness effect; "German numbers," however correctly described, would not carry the same monumental weight. But "Romanness" is also, these days, part of the wistful joke—like the postmodern quotation of architectures of the past. Thus the contemporary Roman numeral can present itself as a witticism that monumentalizes even as it seems to undercut itself, like the advertisement for *A Funny Thing Happened on the Way to the Forum* that cautioned potential Broadway theatergoers that tickets were only available till February IX. Or,—my favorite example— the 1941 Chon Day cartoon in which a placid Roman skater noncha- lantly finishes off tracing a figure VIII. That the standard "figure eight" is a sign for infinity, proposed as such by the English mathematician John Wallis in 1655, but already in use in Rome as another numeral for 1000,[47] adds something piquant (I can't help thinking) to the scene.

What is fascinating, as we have observed, is the way in which the use of Roman numerals *increased* in literary and cultural contexts as they decreased in arithmetical or mathematical contexts. They have become,

that is to say, iconic signs of *something else*. Something desired, and something lost.

"Some are born great, some achieve greatness, and some have greatness thrust upon 'em." Fans of Shakespeare's Malvolio are already predisposed to find rebuses everywhere, magical combinations of letters and numbers that conjure a monumental identity. ("What should that alphabetical position portend?.... M, why that begins my name" [*Twelfth Night* 2.5.118–26].) "Greatness" is an effect of dislocation and decontextualization. The decontextualizing of the sign produces an anxious fantasy of originary wholeness—of great heroes and great texts. Produces, that is to say, greatness as an effect of nostalgia and anachronism. Thus the attractive and "official" Shakespeare with its Roman numeraled acts and scenes is the Great Book to end all Great Books. No wonder it is only scholars who have made the democratizing cultural shift to the more "demotic" Hindu-Arabic act and scene citations, the ordinals of ordinary language, the numerals of everyday life. Everyone else has too much to lose.

The Lincoln Bedroom.

IX

Second-Best Bed

^Itm I gyve vnto my wief my second best bed wth the furniture Itm
I gyve & bequeath to my saied daughter Iudith my broad silver gilt
bole All the Rest of my goodes Chattels Leases plate Iewels &
househod stuffe whatosoever after my dettes and Legassies paied &
my funerall expences discharged I gyve devise & bequeath to my
Sonne in Lawe Iohn Hall gent & my daughter Susanna his wief

—Shakespeare's will

If others have their will Ann hath a way.　　　—James Joyce, *Ulysses*

During a meal at a Chinese restaurant, critic Terry Castle once taught
me an invaluable lesson about what might be called situational gram-
mar. Any fortune-cookie fortune could be immeasurably altered, and
enriched, she pointed out, by simply adding to it the phrase "in bed."
(Try this yourself and you will see.)

When Shakespeare left his "second-best bed" to his wife Anne
Hathaway in his will, he left, as well, a seductive historical conundrum.
Is the phrase "second-best" a sign of his estrangement from the
marriage, or was the "best" bed in the house given to guests, so that the
"second-best" was the connubial couch—the one, as Shakespeare biog-
rapher Sam Schoenbaum remarks with deadpan wit, "rich in tender
matrimonial associations?"[1]

Jane Cox, a specialist in old legal documents at the Public Records
Office in London recently described the second-best bed forthrightly as
a "miserable souvenir." "This was no 'affectionate little bequest,'" she

remarked, "neither was it usual for a seventeenth-century man, of any rank, to make no overt provision for his wife in his will. Of [a] sample of 150 wills proved in the same year ... about one third of the testators appointed their wives as executrixes and residuary legatees. None left his wife anything as paltry as a second-best bed. Bedsteads and bedding were without doubt valuable and prized items and they were normally carefully bequeathed, best beds going to wives and eldest sons."[2]

But Shakespeareans are an ingenious lot, and much ingenuity has been expended in explaining, or explaining away, the problem of second-bestness in bed—or in beds. First there is the matter of "dower right," the provision of English common law that automatically entitled a widow to a life interest in her husband's estate. Since this was the law, and known to be the law, there was no reason for Shakespeare to make a specific bequest to his wife at all. The diary of the Reverend John Ward, vicar of Stratford-upon-Avon during the lifetime of Shakespeare's daughter Judith, poses and answers the question to at least his own satisfaction:

> But why, it has been asked, leave the wife of his youth "his second best bed," and not his first best bed? It will not, I think, be difficult to give a most satisfactory answer to this query. Shakspeare had expressly left to his daughter, Susanna, and her husband, Dr. John Hall, "all the rest of his goods, chattels, leases, plate, and household stuffe whatsoever;" and supposing, as is most probable, Mrs. Shakspeare to have resided with them after her husband's death at New Place, she would there have the use and benefit of every article, as in her husband's lifetime. There is, I presume, a special reason why the second best bed was deemed by him so precious a bequest "to his wief"; few, if any, either in London or in the country, are themselves in the habit of sleeping on the first best bed;—this was probably by Shakspeare reserved for the use of Jonson, Southampton, the aristocratic Drayton, or for other of those distinguished persons with whom he is known to have been in habits of intimacy. The second best bed was, doubtless, the poet's ordinary place of repose,—the birthplace of his children; and on these and many other grounds it must have been, to Mrs. Shakspeare, of more value than all the rest of his wealth.[3]

Still, some modern commentators have privately—and not so privately—mused, he might have spared her a tender word. "Most of the wills of this period are personal and affectionate," writes biographer Marchette Chute, but "Shakespeare was one member of [his acting] company whose will does not show a flicker of personal feeling."[4]

G.E. Bentley complained that the will's single and possibly slighting proviso for Anne Hathaway had "given rise to many romantic or lurid tales."[5] E.K. Chambers, the great historian of the Elizabethan stage, declared that "A good deal of sheer nonsense has been written about this." Chambers and others, taking recourse (or refuge) in historical fact, suggest that "Mrs. Shakespeare would have been entitled by common law to her dower of a life interest in one-third of any of the testator's heritable estates in which dower had not, as in the case of the Blackfriars property, been legally barred"[6]—thus raising the inconvenient fact that the Blackfriars house *had* been left away from Shakespeare's wife, and by legal means.

And there was the undeniable and unhappy fact that the bequest of the bed was not even part of the original text, but was instead interlineated, inserted (perhaps, with Hamlet, we could say "popped in") after the fact. Like the wedding itself, it was, apparently, an afterthought.

"It is observable," noted the 18th-century Shakespeare editor Edmond Malone in a famous commentary, "that his daughter, and not his wife, is his executor; and in his Will, he bequeaths the latter only an old piece of furniture; nor did he even think of her till the whole was finished, the clause relating to her being an interlineation. What provision was made for her by settlement, does not appear."[7]

The context of Malone's remark is a reading of Sonnet 93, and Malone's contention is that the poet is writing "from the heart" about sexual jealousy. "That our poet was jealous of the lady," rejoins rival editor George Steevens with some asperity, is "an unwarrantable conjecture. Having, in times of health and prosperity, provided for her by settlement, (Or knowing that her father had already done so) he bequeathed to her at his death, not merely *an old piece of furniture*, but perhaps, as a mark of peculiar tenderness,

> the very bed that on his bridal night
> Receive'd him to the arms of Belvedira.

And why did Shakespeare initially omit to leave her anything? "His momentary forgetfulness as to this matter, must be imputed to disease."

Malone, of course, will have none of this. His riposte is meant to be withering; it is clear to him that Shakespeare felt, and exhibited, nothing but contempt.

> His wife had not wholly escaped his memory; he had forgot her—he had recollected her—but so recollected her, as more strongly to mark how

little he esteemed her; he had already (as it is vulgarly expressed) cut her
off, not indeed with a shilling, but with an old bed.

"However," Malone goes on to remark, astringently, "I acknowledge, it
does not necessarily follow, that because he was inattentive to her in his
Will, he was therefore jealous of her. He might not have loved her; and
perhaps she might not have deserved his affection."

Scholars and sentimentalists of the following centuries struggled to
resist or overturn this uncharitable assessment. The author of *Shake-
speare's True Life* (1890), once again citing dower right as the reason why
the playwright made no express provision for his wife's maintenance,
observes that "The bequest which he makes to her in his will, of his 'sec-
ond-best bed,'—doubtless that in which as husband and wife they had
slept together, the so-called 'best' being reserved for visitors—is intelli-
gible enough, and needs none of the disquisitions of the would-be
wise."[8] In *Shakespeare's Marriage* (1905), Joseph William Gray is similarly
confident: "It is difficult to believe that the bequest of the 'second-best
bed' was intended for a slight, as is sometimes asserted. Even if feelings
of dislike had been rankling in his mind, it is questionable whether he
would have adopted such a contemptible method of expressing them."[9]
We could hardly call this a "psychoanalytic" approach to the problem,
but it does struggle toward the psychological, though here too it uses
"history" (or "lore") to shore up its claims: "The only tradition which
indicates Anne Shakespeare's opinion of or regard for her husband is
that she 'greatly desired to be buried with him.'" (The "tradition" dates
from Dowdall's *Traditional Anecdotes of Shakespeare, Collected in Warwick-
shire in the Year 1693*.)[10] The *grave* thus becomes the first-best bed, to
which all others are second.

In 1918, Charlotte Stopes offered an argument based on sentiment
and the humbleness of Anne Hathaway Shakespeare's origins, assuring
her readers that "There is nothing derogatory in the legacy of the sec-
ond-best bed; it was evidently her own last request. She was sure of her
widow's *third*; she was sure of her daughters' love and care, but she
wanted the bed she has been accustomed to, before the grandeur at
New Place came to her."[11]

The authors of *Shakespeare's Town and Times* give a halcyon picture of
the final years in Stratford: "At the time of the poet's death, we may
imagine his wife, then over sixty years of age, as a brisk and kindly
dame, her hair shot with silver and her step less firm than when she was
wooed in Shottery fields, but with eyes still bright and cheeks still

ruddy."[12] And Shakespeare biographer A.L. Rowse, a hundred years later, offers an equally benevolent view: "Most of his Will is concerned with the disposition of property among his family, most of it going to his heir, his elder daughter Susanna. She and her husband, Dr. John Hall, would naturally have the best double bed, so it was characteristically considerate of Shakespeare to specify that his widow, Anne, should have the next best bed for herself."[13]

From Malone's time to our own, then, we have moved from a characteristically cruel Shakespeare motivated by sexual jealousy to a characteristically considerate one motivated by fine family feeling, both predicated on the evidence of that second-best bed.

These explanations, or excuses, or explainings-away, had become so notorious by the beginning of this century that James Joyce could not resist mocking them in *Ulysses*: Stephen Daedalus and his friends are discussing Shakespeare and the neglected, patient "Mrs S." "He was a rich country gentleman, Stephen said, with a coat of arms and a landed estate at Stratford and a house in Ireland yard, a capitalist shareholder, a bill promoter, a tithefarmer. Why did he not leave her his best bed if he wished her to snore away the rest of her nights in peace?" Stephen's friend, the Englishman John Eglinton, is inclined to defend the playwright, and Joyce has him do so in Shakespearean blank verse:

> You mean the will.
> But that has been explained, I believe, by jurists.
> She was entitled to her widow's dower
> At common law. His legal knowledge was great
> Our judges tell us. . . .

But Stephen, whose sympathies are with the wife, will have none of this. His mordant reply picks up the rhythms of Eglinton's verse and then breaks into mocking pseudo-Elizabethan song:

> And therefore he left out her name
> From the first draft but he did not leave out
> The presents for her granddaughter, for his daughters,
> For his sister, for his old cronies in Stratford
> And in London. And therefore when he was urged,
> As I believe, to name her
> He left her his
> Secondbest
> Bed.

Punkt.
> Leftherhis
> Secondbest
> Leftherhis
> Bestabed
> Secabest
> Leftabed.
Woa!

Eglinton has recourse to the other stock answer: beds were valuable, "pretty countryfolk had few chattels then," but again Stephen's curiosity is piqued by Anne Hathaway: "She lies laid out in stark stiffness in that secondbest bed, the mobled queen, even though you prove that a bed in those days was as rare as a motorcar is now and that its carvings were the wonder of seven parishes."[14]

There have been other skeptics, enough to generate an entire philosophy of Shakespearean furniture. Samuel Neil's 1847 guide to *The Home of Shakespeare* describes the appointments of Anne Hathaway's cottage, including "Shakespeare's courting chair," so-called by Shakespeare enthusiast Samuel Ireland (the father of William Henry Ireland, shortly to become famous for his forgeries). The chair, the author admits, is not the same one that was there in the 16th century—the latter having been bought for a stiff price by a central European princess—but it is "a very old chair," nonetheless, and the "absence of the genuine chair was not long felt." "It is but fair to add, that those who are sceptical are not met by bold assertions of its genuineness, although there be no denial of its possible claim to that quality; but all credulous and believing persons are allowed the full benefit of their faith."

And there was "an old carved bedstead, certainly as old as the Shakesperian era," which "has been handed down as an heirloom with the house.... Whether there in Anne's time, or brought there since, it is ancient enough for her and her family to have slept in, and adds interest to the quaint bed-room in the roof."[15] Any bed that Shakespeare—or his wife—or both—might have slept in had become a vital accessory after the fact.

But it was the famous "second-best bed" that had the first claim on the public's, and the scholars', attentions. The bed—that elusive and phantasmatic bed—has often seemed, in fact, something that could be fixed by history, by scouring the archives and the annals. Much energy has been expended on a search for other similar bequests to normalize

THE .ROOM
IN WHICH SHAKSPEARE WAS BORN.
Published by E. Adams.

or contextualize the apparent oddity of Shakespeare's interlineation.
Thus, for example, scholars have located a number of other "second-
best beds" in legal documents, including wills. In 1573, one William
Palmer of Leamington left his wife Elizabeth his "second-best fetherbed
for hir selfe furnished, And one other meaner fetherbed for her
mayde. . . . And that I wolde have hir to live as one that were and had
bien my wife."[16] So the second-best bed could be not only an affection-
ate bequest but, apparently, a status symbol. Palmer's will was seen by
Schoenbaum as a knife that cut both ways, since by contrast the
Shakespeare bequest "is unaccompanied by any expression of testamen-
tary emotion, as in the Palmer will"; Schoenbaum promptly speculates
that "perhaps his lawyer did not encourage, or permit, such embellish-
ments."[17] Like Steevens's earlier conjecture that Shakespeare was too far
gone with illness to think up any pretty thoughts for the occasion, this
exculpatory speculation raises as many questions as it answers.

The best bed would technically qualify as an heirloom, an article of
personal property handed down with the estate. Richard Marley in 1521
left his son his "best fetherbed," and, as historian Frederick Emmison
suggests, "it is the eldest son, and not the widow, who gets the best

bed."[18] In a will dated December 22, 1608, Thomas Combe left all bed-
steads to his wife "except the best," which was bequeathed, "with the
best Bedd and best furniture thereunto belonging" (that is, the sheets,
pillows, linens, and so forth) to his son.[19] John Harris, a notary residing
in Lincoln, left his wife two beds: "the standing bedstead in the little
chaumber, with the second-best featherbed I have, with a whole furni-
ture therto belonging and allso a trundle-bedsted with a featherbed,
and the furniture therto belonging."[20]

 "A second time I kill my husband dead/When second husband kisses
me in bed," intones the Player Queen in *Hamlet* (3.2.184–85), echoing
the advice of Sir Walter Raleigh to his son: "leave thy wife more than of
necessity thou must, but only during her widowhood, for if she love
again, let her not enjoy her second love in the same bed wherein she
loved thee."[21] Here the problem is that of the second *becoming* the first:
the second love threatens to render the first husband's bed retroactively
(and posthumously) second-best.

 Scholar Joyce Rogers concludes from her own examination of
medieval and Renaissance legal documents that many items other than
beds are described in wills as "best" or "second-best," and makes a per-
suasive argument that this practice is linked to the medieval legal tradi-
tions of heriot and mortuary: the "best" things were given to the lord as
a kind of tithe; after this the "second-best," or next-best, chattel was
reserved to the church as a "mortuary," or reparation for the soul. Thus
the jurist Sir William Blackstone, lamenting the passing of "the old com-
mon law," saw among those rights disappearing both the dower law or
dower right and the "custom of many places ... to remember his lord
and his church, by leaving them his two best chattels."[22] "After the lord's
heriot or best good was taken out, the second best chattel was reserved
to the church as a mortuary."[23] Here, as Rogers points out, is quite a dif-
ferent valuation for "second-best." Instead of connoting something like
"second-rate," or "second-hand"—something, that is, near the notional
bottom of the heap, it instead repositions the "second-best" close to the
top. "Thus the infamous phrase, 'second-best,' so often taken as an inten-
tionally malicious slur, may be understood in ancient context as a part-
ing tribute of profound meaning."[24]

 Does this recourse to history "resolve" the problem of the "second-
best bed"? On the one hand, we have learned that the surviving son—
or, in Shakespeare's case, daughter—often got the best bed. On the
other, we have seen that "second-best" (especially "with the furniture")
is actually pretty good, and that its standing in law was traditional and

honored. This would seem to be a "solution," of sorts, to the "problem" of Shakespeare's misogyny, or jealousy, or licentiousness, or homosexuality, or—at the very least—flight from the marriage and from Stratford, of which the "second-best bed" has been such a potentially tantalizing clue. In fact, there is no problem.

Or is there? The fact is that these "facts" will not make the problem go away, because Shakespeareans, professional and amateur alike, do not wish it to go away, however much they may protest to the contrary. We prefer the problem to any answer. The second-best bed, that perfect tester for the intersection and mutual embeddedness of historicism and psychoanalysis, is an overdetermined site for critical curiosity. The bed functions eroto-historically as the equivalent, in material culture, of the navel of the dream. Locus at once of procreation, legitimate and illegitimate (born on which side of the blanket?), inheritance and sexual fantasy, the scene of the primal scene. It is not an accident—as psychoanalytic critics like to say—that of all the elements in the Shakespeare story, and the Shakespeare will, the "second-best bed" has excited so much interest and controversy—interest and controversy that will not be quieted, or subdued, by a simple "answer" from history. For we do not want just the history—we want the story.

One evidence for this is the frequency with which the second-best bed has figured *in* a story. A 1993 novel by Robert Nye, *Mrs. Shakespeare, The Complete Works*, discloses that the "first best bed" was in fact the playwright's bed in London, where he engaged in sexual relations with Southampton (whom we may recall the Rev. Mr. Ward to have imagined visiting New Place and sleeping there in the household's "first best bed") and also with his wife when she came to visit. Initiated into sodomy ("what men do") by her husband, the delighted Mrs. Shakespeare finds a newly erotic pleasure in their marriage (as indeed does Mr. Shakespeare). The bequest of the "second best bed," she understands, is not "an insult" but a tribute to the memory of "that other bed, in every sense the best one,"[25] in which she had the best sex of her life. This queer narrative of female eroticism is a Shakespeare bedtime story for the 1990s. But it also—and this is perhaps more pertinent—conjures the scenario that lies behind the cultural fascination of the bequest: the spectacle of Shakespeare—our Shakespeare, *unser Shakespeare*—in bed. (Remember Castle's law of the prurient prepositional suffix: what was Shakespeare really like—in bed? What *did* Shakespeare really like—in bed?)

An earlier attempt at fiction offers a wry "historicist" approach. *No*

Bed for Bacon, a 1941 comic novel by Caryl Brahms and S.J. Simon, evokes an Elizabethan England in which Raleigh longs chronically for a new cloak, Shakespeare for a perfect play (*Love's Labour's Won*), and Bacon for a bed. Sixteenth-century monarchs and great landowners took their own beds with them on their progresses, and Elizabeth, according to the novel's plot, is in the habit of presenting her favorites with "country bedsteads slept on by the Queen."[26] The comic conceit of *No Bed for Bacon* is that Bacon wants an Elizabethan trophy bed. But Bacon's longing is destined, of course, to go unsatisfied. The elusive bed is periodically glimpsed offstage: reports suggest that it has been delivered to Anne Hathaway's cottage; Shakespeare changes the subject whenever Bacon brings it up. The second-best bed is the *objet petit a* for both Bacon and the Shakespeare scholars gently satirized in the text.

No Bed for Bacon takes a creative approach to history, beginning with a "Warning to Scholars" that "This Book is Fundamentally Unsound," and a prefatory page that cites the great American pragmatist Henry Ford:

> It was Henry Ford who is said to have remarked that "History is Bunk." The authors of this book have in a number of works set out to prove the point.

But if "History is Bunk," in the context of our inquiry we may be moved to ask whether it might also be said that "History is Bunk Beds." Indeed, a little reflection suggests that it is not only the "*bunk* bed" but the "*queen* bed," the "*king* bed," the "*California* king bed" (suitable for watching Kenneth Branagh's and Al Pacino's Shakespeare movies?), and perhaps especially, in light of Shakespeare's family, the "*twin* bed" that have some relevance for Shakespearean clinophiles.

"Shakespeare's will would not have been thought funny if his second-best bed had been a singleton," observes Reginald Reynolds in a 1952 book on the social history of the bed.[27] But if the bed had been a twin? The decade of the fifties, the decade of *Pillow Talk,*[28] was the modern heyday of the twin bed (a cultural innovation that dates, in point of fact, to a Sheraton design in the late 18th century, when they were invented "to keep lovers cool during the hot summer months").[29] Here are some striking statistics: the percentage of twin beds relative to all beds purchased in the U.S. in the pre-war period was 25 percent; by 1950—according to a number of studies—they had risen to 68 percent. And

the scuttlebutt on twin beds was that—far from producing twins, as Shakespeare's bed had done (with some help from its tenants), twin beds produced divorce. Or so said the Director of the [American] Family Relations Institute in 1947: "This movement towards twin beds must stop.... The change from a double bed to twin beds is often the prelude to a divorce."[30]

"Twin Beds for Divorce," read the title of an article published in the previous year. But a British judge, called upon to rule in a 1950 divorce case as to whether a married couple sleeping in twin beds were sharing "the matrimonial bed" or occupying "separate sleeping accommodation" decided emphatically that the former was the case. Are twin beds one "bed" or two? Identical—or fraternal? It depends upon the nature of the (legal) case. If they slept in twin beds, neither could be said, for legal purposes, to have left the other's "bed and board." "I cannot," declared the judge, "regard twin divan beds in a married couple's bedroom as being otherwise than the matrimonial bed."[31] "The bed," in the terms of this ruling, henceforth could mean "the beds": when there were two in the same room, neither, presumably, was second-best.

Here we may seek further corroboration from an important and neglected work on beds by the early Marx—the early *Groucho* Marx. In a 1930 volume called *Beds* (described on the back cover as "the sleeper of the year!"), Groucho notes that "couples often become confused and get into the same twin bed by mistake, which explains why one bed is worn out more quickly than the other." [32] But if in life twin beds could cause divorce, in the Hollywood of the 1950s they were the very sign of marriage. "Twin bed marriages," writes Parker Tyler, a historian of sex in films, "actually mark a whole Hollywood epoch of bedroom customs." One of the ironclad rules was that, though a man and a woman could be shown alone together in a bedroom, even in their nightclothes, "there couldn't be a double bed waiting to accommodate their conjugal embraces; rather, there had to be *twin beds*."[33]

Hollywood, the "California king bed," and Groucho Marx may lead us to a consideration of a more recent manifestation of the second-best bed in public culture, the controversy about President Bill Clinton's use of the Lincoln bedroom. This hallowed White House chamber, where Lincoln never slept (but in which he was autopsied and embalmed, and where some say his spirit still walks abroad) has become the centerpiece in an American political scandal. ("Hark! Who lies i' th' second chamber?")

"Ready to start overnights right away," wrote Clinton in a memo to his staff. It turned out that some 938 supporters and friends had availed themselves of the opportunity to stretch out on the long and lumpy mattress of the Lincoln bed. *Newsweek*, unable to resist the obvious witticism, headlined its article on the Presidental bed-trick "Strange Bedfellows."[34]

Best bed? or second-best? For the guests of the Clintons—like, presumably, the guests of the Lincolns—the best was not good enough.

Some denizens of the Lincoln bedroom had more spectral expectations. Though Lincoln never slept there, it was an office in his lifetime and he is asserted to have visited, post mortem, when the fancy took him. Winston Churchill is said to have encountered the Great Emancipator's ghost, and Queen Wilhelmina of the Netherlands once saw "an ectoplasm in a stovepipe hat."[35] The most numinous encounter with Lincoln was imagined, perhaps not surprisingly, by Ronald Reagan, who confided his excitement to a group of junior high school students. "If he is still there, I don't have any fear at all! I think it would be very wonderful to have a little meeting with him, and probably very helpful."[36] It seems that Hillary Clinton's chats with Eleanor Roosevelt may have had Republican—and Presidential—precedent.

The seemingly inconsequential saga of the Lincoln bedroom, then, engages not only history but also, and even more crucially, psychoanalysis: narratives of the ghost, the revenant, the father, the family romance, the unattainable object of desire—and, perhaps even more crucially, the undecidable question of how we can tell first-best from second-best. Is the first-best bed the bed slept in by the First Family, or the bed that has come to signify—though, as we have seen, it never cradled—the most beloved President of them all?

On the key question, the question of how to distinguish the "first-best" from the "second-best" bed and what is at stake in that distinction, we may get some assistance from Plato. Let us turn for a moment to that controversial section of the *Republic* in which he speaks of the role of the poet and artist. For the object that Socrates holds up to Glaucon as an exemplary "thing" is the *bed*. And what we discover if we do so is that there are for our consideration not two beds, but three:

> Here we find three beds; one existing in nature, which is made by God, as I think that we may say—for no one else can be the maker?
>
> No one, I think.
>
> There is another which is the work of the carpenter?

Yes.

And the work of the painter is a third?

Yes.

Beds, then, are of three kinds, and there are three artists who superin-
tend them: God, the maker of the bed, and the painter?

Yes, there are three of them.

God, whether from choice or from necessity, made one bed in nature
and one only; two or more such beds neither ever have been made nor
ever will be made by God.

Why is that?

Because even if He had made but two, a third would still appear
behind them of which they again both possessed the form, and that
would be the real bed and not the two others.[37]

"Very true," says Glaucon, obediently, and so we may perhaps say,
as well. The third bed, the spectral bed—the bed, we may say, of
Goldilocks, the bed that is (but only in fantasy) "just right"—appears
"behind."

Plato's "third" bed is the *form* of the bed: "that would be the real bed
and not the two others." But the thirdness of the bed disrupts, in what is
by now a familiar fashion, the unsatisfactory binary of the carpenter's
bed and the painter's bed, the material object-in-history and the object-
in-representation. And it is the third which, according to Plato, is the
"real" one.

The carpenter is a maker and the painter an imitator. Of their two
beds, which is the "second-best"? That of the artist, the "imitator of that
which others make"? Or is it in fact the case that the "third bed" is—by its
very nature—the "best bed," so that the artifacts of both carpenter and
painter are—again, by their very nature—only "second-best"? The "real"
is the one that we *cannot* see. "The essential object which isn't an object
any longer, but this something faced with which all words cease and all
categories fail."[38] And this, needless to say, is not Plato's real but Lacan's.

Furthermore, this central passage from the *Republic* that we have
been considering, about the three beds, comes from Benjamin Jowett's
translation of Plato. But this is not the only way to construe the passage,
or its key word. The Greek word here is *kline*, from *klinein*, to slope or
lean—the word from which we get "recline," "incline," and "decline."
And in Paul Shorey's translation of Plato for the Bollingen Series the
word (or concept) is translated as not *bed* but *couch*.

The resulting rhetorical questions have a special resonance for a
20th-century reader.

What of the cabinetmaker? Were you not just now saying that he does not make the idea or form which we say is the real couch, the couch in itself, but only some particular couch?[39]

"Some particular couch." With this we arrive at the scene of psycho-analysis, ground zero for Freudians, that celebrated piece of furniture that Freud historian Peter Gay repeatedly calls "the famous couch."

Freud's couch, the centerpiece of the doctor's office, the gift of a grateful patient,[40] was draped with Persian carpets, one of which hung behind the couch like an Elizabethan arras. Biographer Gay pictures the expansive founder of psychoanalysis "look[ing] around his consult-ing room from his comfortable upholstered armchair behind the couch."[41] When Freud became virtually deaf in his right ear as a result of operations on his oral cavity "the couch was moved from one wall to another so that he could listen with his left."[42] (Shakespeareans will recall that Julius Caesar had a complementary infirmity, being deaf in his left ear rather than his right.) The couch was moved once again near the end of Freud's life when the family was forced to leave Vienna and to resettle in London. "The possessions he had had to ransom from the Nazis—his books, his antiquities, his famous couch—were placed in the new house at 20 Maresfield Gardens so that the two downstairs rooms resembled, as closely as possible, the original consulting room and study in Berggasse 19."[43] In a fascinating essay on the architecture and symbolism of Freud's office, Diana Fuss and Joel Sanders suggest that "the sexual overtones of the famous couch—the sofa as bed . . . dis-comforted Freud's critics and, if Freud himself is to be believed, no small number of his patients."[44] Once, in its earliest history, Freud's couch had been used for hypnosis, a technique he abandoned, but the couch itself remained as a relic or "remnant" of "psychoanalysis in its infancy."[45] Fuss and Sanders aptly describe the office as "the birthplace of psychoanalysis."[46]

Here we might think of that other Birthplace, now held in trust for the nation: "The Holy of Holies of the Birthplace was the low, the sub-lime Chamber of Birth," writes Henry James.[47] "It was as empty as a shell of which the kernel had withered. . . . It contained only the Fact—the Fact itself." The Fact is the fact of the unnamed Shakespeare's birth, though to give it a name is to destroy the wicked subtlety of James's parlor-trick prose. In guidebooks of the period—to which James may well have had recourse—words like "relic" regularly appear,[48] and even the most current 20th-century guidebook calls the house and the birth-

room a "shrine." Though the room James visited was empty and evocative, today's Shakespeare birthroom, outfitted for our more literal age, contains, not only a period bedstead standing in for the Fact of his conception, but also a cradle.

The relations between Freud and Shakespeare are complicated, and in fact revolve around two versions of the second bed: the second marital bed of Hamlet's mother, and the marital bed (indeed, the identity) of Shakespeare himself.

Freud's take on *Hamlet* (like that of his disciple, Stephen Daedalus) had placed the mother's bed squarely front-and-center. As Gary Taylor notes, what had been "the closet scene" now became, in Dover Wilson's *What Happens in "Hamlet"* "the bedroom scene." By the 1940s the bed had become a standard prop, and in 1948 Laurence Olivier brought the Sigmund Freud-Ernst Jones *Hamlet*—and the maternal bedroom—to the world screen.[49] "Let not the royal bed of Denmark be/A couch for luxury and damned incest" (1.5.82), enjoins the Ghost-King in *Hamlet* to the conflicted son. In this parental prohibition, bed and couch, those two Freudian props, again function as not-quite synonyms. But exactly whose incest is being prohibited—the Uncle's, or the son's?

In classic Freudian readings the eavesdropping scene in Gertrude's closet or bedroom is another thinly disguised wish appearing as a projection: Polonius ("that great baby" [*Ham.* 2.2.382]) takes the place of the child in the primal scene, who wants to spy on his parents' lovemaking in bed—and perhaps even, in fantasy, to witness his own conception.[50] Takes the place, that is, of Hamlet. Or of Freud.[51] Freud had famously written to his friend Fliess that he had found, "in my own case, too, [the phenomenon of] being in love with my mother and jealous of my father," and his conviction that this was "a universal event in early childhood" was tied, once again, to his reading of *Hamlet* as a confessional text. So, for Freud, the story of Hamlet was overtly and self-evidently the story of Shakespeare. "It can of course only be the poet's own mind which confronts us in Hamlet."[52]

By 1919, about twenty years later, Freud was referring readers, in a footnote, to Jones's fuller psychoanalytic account of Hamlet and Oedipus, where we are told in a chapter called "The Hamlet in Shakespeare," that "the poet himself . . . had been hastily married, against his will. . . . —an act for which he never forgave his wife, and to which we may ascribe some part of his misogyny."[53] But by 1930, in another footnote (his favorite mode of self-interrogation), Freud quietly disavowed

his entire biographical reading: "Incidentally, I have in the meantime ceased to believe that the author of Shakespeare's works was the man from Stratford."[54] "Shakespeare wrote *Hamlet* very soon after his own father's death," he had asserted in his *Autobiographical Study* (1925). But in 1935 he inserted a footnote that caused great consternation to his English translator: it read, "This is a construction which I should like explicitly to withdraw."[55] Shakespeare was not the author of the plays.

And here we have a good theoretical instance of what might be called the logic of the second-best bed. This disavowal of Shakespeare's authorship (about which I have commented at some length elsewhere)[56] may be usefully compared to that other famous Freudian disavowal, the disavowal of the seduction theory. In the latter, Freud revised his early view that the origins of neurosis lay in "infantile sexual scenes" or "sexual intercourse in childhood." But now Freud claimed that the "seduction theory" was not grounded in historical fact—that is, that his patient's intimations of "sexual intercourse in childhood" had not really taken place. Rather, these "seductions" were fantasies: "I was at last obliged to recognize that these scenes of seduction had never taken place, and that they were only fantasies which my patients had made up."[57] The "real" bed of incest or seduction was second best to the fantasy—indeed, it was now only the fantasy that was "real."

With the concept of the primal scene Freud had a similar problem: were these mental images of parental coitus memories or fantasies? "Real" or "imagined"? Psychoanalysis or history? The question was, he thought, undecidable in the general case: his account of the Wolf Man story emphasizes the degree to which the reality of the primal scene is only grasped by the child after the fact, by "deferred action"; on the other hand, retrospective fantasies are triggered by some real-world clues or symptoms, like familiar noises or the sexual encounters of animals.[58]

That the primal scene itself should be poised between—or overlap across—the boundaries of so-called reality and so-called fantasy is, for the terms of my argument, crucial. For what I propose is not just that the bequest of the second-best bed inserted, belatedly, into Shakespeare's will is a good example of the interpretative tensions between psychoanalysis and historicism, but rather that it embeds those tensions in a cultural icon—Will's will, "what he hath left us"—that is the primal scene of poesis, the primal scene of our literature. In other words, the second-best bed as cultural legacy is an overdetermined instance of primal rivalry between psychoanalysis and history. This is what accounts for its fascination. Psychoanalysis, as we can see from the examples of

the seduction theory and the primal scene, is itself about, precisely, the relationship between history and psychoanalysis.

In revising his "seduction theory" Freud decides in favor of fantasy over history, and thus, as many have remarked, through this very act of disavowal creates the discipline of psychoanalysis. What I am suggesting here is that in revising his identificatory relationship with "Shakespeare" Freud performs a very similar act of disavowal, though apparently in the opposite direction (seeming, that is, to choose "history" over "fantasy").

When he accepted the Goethe Prize from the City of Frankfurt, Freud directly addressed the rival claims of history and psychoanalysis, acknowledging both the limits of biographical knowledge and the psychoanalytic reasons that lay behind the quest for historical details. Biographers, even the best of them, cannot explain either the artist or his work. "And yet there is no doubt that such a biography does satisfy a powerful need in us. We feel this very distinctly if the legacy of history unkindly refuses the satisfaction of this need—for example, in the case of Shakespeare."

Was "the author of the Comedies, Tragedies and Sonnets" the "untutored son of the provincial citizen of Stratford" or the "nobly-born and highly cultivated" aristocrat, Edward de Vere? How can we justify "a need of this kind to obtain knowledge of the circumstances of a man's life when his works have become so important to us?" Freud's answer is that we are in quest of father figures, teachers, and exemplars—and also that we need to think them finer than ourselves. Biographical research often produces unwelcome bits of information that tends toward the "degradation" of the same great man we so wish to admire.[59] "The man of Stratford," wrote Freud in a fan letter to the most vigorous proponent of the Oxford theory, "seems to have nothing at all to justify his claim, whereas Oxford has almost everything."[60] History is the phantasmatic sign of the family romance Freud elects to believe as truth.

So where we saw, a moment ago, that psychoanalysis was itself founded on the borderline between history and psychoanalysis, we can see now that the same is the case with history. The family romance of Oxford as the better Shakespeare reverses the pattern of fantasy as the better seduction. History itself is about the relationship between history and psychoanalysis.

Neither historicism nor psychoanalysis, in short, will benefit from a Procrustean view. What becomes most evident is the difficulty of making a bed while lying in it—a task, perhaps, beyond even the talents of Procrustes.

Meg Ryan and Billy Crystal in *When Harry Met Sally.*

X

I'll Have What She's Having

Reflect on the whole history of women: do they not *have* to be first of all and above all else actresses? Listen to physicians who have hypnotized women; finally, love them—let yourself be "hypnotized by them"! What is always the end result? That they "put on something" even when they take off everything.

Woman is so artistic. —Nietzsche, *The Gay Science*

Imagine the scene.

Rummaging in her new husband's closet, Beatrice-Joanna, the headstrong heroine of Middleton and Rowley's Jacobean tragedy *The Changeling*, is desperate about the impending wedding night. She has yielded her virginity under duress to the aptly named DeFlores, and now she fears discovery and disgrace.

DeFlores, at her bidding, had secretly murdered Alonzo de Piraquo, her father's choice, the man to whom she was first engaged, rendering her free to marry Alsemero. To confirm the deed, DeFlores had cut off his victim's finger with its ring, and brandished it before her in triumph. Welcome to the "other scene." This is not a play that will hide castration under a bushel.

Thinking to buy him off with gold, Beatrice-Joanna had been dumbfounded to learn that DeFlores expected instead a sexual reward. "Y'are the deed's creature," he told her. The "deed" here was, prospectively, both sex and murder. He was implacable in his demand: "Can you weep fate from its determin'd purpose?/So soon may you weep me." And he

217

was coolly knowing. He anticipated, in fact, that she would enjoy herself, despite her demurrals. "'Las, how the turtle pants," he grinned at her, "Thou'lt love anon/ What thou so fear'st and faint'st to venture on."

So here now is our heroine on the night of the wedding, convinced that her husband will detect her deflowered condition and denounce her. What remedy? Luckily for her, Alsemero has gone for a walk in the park, leaving the key in the closet door. It is only a moment's work to open it. And what does she see?

Alsemero's pharmacy. "A right physician's closet," as she describes it, "set round with vials," and a book of experiments called "Secrets in Nature" open upon the table. Her worst fears are confirmed by the table of contents.

> "How to know whether a woman be with child or no."
> I hope I am not yet; if he should try though!
> Let me see: "folio forty-five." Here 'tis;
> The leaf tuck'd down upon't, the place suspicious.
> "If you would know whether a woman be with child or
> not, give her two spoonfuls of the white water in glass C—"
> Where's that glass C? O, yonder, I see't now—
> "and if she be with child, she sleeps full twelve hours after, if not, not."
> None of that water comes into my belly:
> I'll know you from a hundred. (4.1.26–36)[1]

This pregnancy test, as one edition of the play notes, bears some resemblance to a test contained in Thomas Lupton's *A Thousand Notable Things of Sundry Sorts* of 1579: "If you would know whether a Woman be conceived with Child or not, give her two spoonfuls of Water and one spoonful of Clarified Honey, mingled together, to drink when she goes to sleep; and if she feels Gripings and Pains in the Belly in the night, she is with child; if she feel none, she is not."[2]

But for Beatrice-Joanna, the worst is yet to come—"ten times worse," as she declares. For the next experiment offers advice on "How to know whether a woman be a maid or not."

> If that should be applied, what would become of me?
> Belike he has a strong faith in my purity,
> That never yet made proof; but this he calls
> "A merry sleight, but true experiment, the author
> Antonius Mizaldus. Give the party you suspect the quantity of a spoonful

of the water in the glass M, which upon her that is a maid makes three
several effects: 'twill make her incontinently gape, then fall into a sudden
sneezing, last into a violent laughing; else dull, heavy, and lumpish."
(40–49)

The Revels editor informs the reader that, although Alsemero is
apparently consulting *De Arcanis Naturae* (*Secrets of Nature*) by Mizaldus,
a 16th-century French scholar and compiler of scientific knowledge,
"there are no passages in it resembling those quoted by Beatrice." Such
tests are, however, very common in the scientific literature of the
period, he observes, ultimately deriving perhaps from Pliny's *Natural
History*,[3] virginity and pregnancy tests are given, two of which involve
the ingestion of liquids by the woman being tested, "though in none of
them are her reactions those described" in Middleton and Rowley's
play. "The fantastic nature of the virginity test," N.W. Bawcutt con-
cludes, in language that is worth our noting, "makes it seem very prob-
able that Middleton devised it himself and then fathered it upon
Mizaldus."

"Fathered it upon Mizaldus." The editor's note here makes explicit
the implicit link between glass M and glass C. For what would be the
economic and political usefulness of "scientific" tests for virginity and
pregnancy? Manifestly, to ensure the legitimacy of offspring. A wise
father—and the bridegroom Alsemero is described by Beatrice-Joanna,
despairingly, as a "wise man" who will detect her secret—a wise father
will want to know his own child. Thus a materialist reading of the con-
tents and effect of "glass M" in *The Changeling* will take the agency of the
letter—M for maid—at its word. The test is a test for virginity, the com-
modification of the well-born bride and her expected children, part of
a nobleman's marriage bargain. In the next moments Beatrice—and
the audience—will witness a graphic demonstration of the efficacy of
that test, as in desperation she hits upon a plan to employ a changeling,
sending her waiting-woman Diaphanta in her place to Alsemero's bed.

First, however, she must be sure that Diaphanta is herself a "maid"—
an identification the waiting-woman puts in doubt by volunteering with
alacrity to take her mistress's place. "Y'are too quick, I fear, to be a
maid," observes Beatrice pointedly, and proposes an "easy trial." Both
of them will drink from glass M. The results are just what she fears—and
hopes. She herself feels no effect, but Diaphanta produces all the
appropriate symptoms, and in the prescribed sequence. She gapes
("there's the first symptom. And what haste it makes/To fall into the

second,") then sneezes, then laughs ("Ha, ha, ha! I am so—so light/At heart! Ha, ha, ha!—so pleasurable!/But one swig more, sweet madam,") and finally grows "sad again." "Just in all things and in order," observes Beatrice ruefully, "As if 'twere circumscribed; one accident/Gives way unto another." The bargain between them is struck: Diaphanta, convinced that her mistress is afraid of sex and wants someone else to describe it to her before she tries it, is to have "the bride's place,/ And . . . a thousand ducats," while Beatrice-Joanna prepares to slip into the bed at midnight, after the supposed defloration has occurred.

Glass M, then, would seem to be as aptly and transparently named as the deflowerer DeFlores. If we ask Malvolio's question, "M?" "What should that alphabetical position portend?," we may if we like rest content with a version of Malvolio's answer—"why this is evident to any formal capacity. There is no obstruction in this."[4] M stands for "maid," and "maidenhead." Drinking its contents reveals, to the skilled scientific eye, the unmistakable symptoms of virginity.

But does it? Alsemero clearly thinks so, but then Alsemero, while no Malvolio, is a somewhat hapless and inattentive observer, for all of his vaunted experience and knowledge. He is an investigator with an answer already in mind as he conducts his experiment, and, like many such investigators, he finds his desired result.

We may recall that the Revels editor, who found precedents in the scientific literature for the pregnancy test of glass C, regarded the "virginity test" of glass M as "fantastic" in nature, and noted that "in none of the tests" in Mizaldus's works—including tests "Mulierem corruptam ab incorruptam discernere" (how to tell a fallen woman from a pure one) and "Noscendi ratio an mulier sit virgo integra & intacta an non" (ways of knowing whether a woman is a virgin or not)—"are her reactions those described in 11.48–50": that is, first gaping, then sneezing, then laughing, then falling into a fit of melancholy.

What if we were to ask, then, not "what is the agency of the letter M?" but rather, of what are these things symptoms? Or, even, of what are they *supposed to be* symptoms? In other words, what is being tested here? And what is being displayed?

Let us consult some putative experts, some latter-day Mizalduses.

I maintained years ago that the dyspnoea and palpitations that occur in hysteria and anxiety neurosis are only detached fragments of the act of copulation.

This is Freud, describing the patient known as Dora, one of whose chief symptoms was "dyspnoea," or shortness of breath. He notes

> [Dora's] concern whether *she* might not have over-exerted herself in mas-turbating—an act which, like [her father's copulation with her mother], led to a sexual orgasm accompanied by slight dyspnoea—and finally came a return of the dyspnoea in an intensified form as a symptom.[5]

Dyspnoea; shortness of breath. Not always, perhaps, with open mouth—but to "gape" is also to gasp, with pain or pleasure. "'Twill make her *incontinently* gape," says the symptom book describing the effects of glass M. This is stage one.

And now to stage two, the telltale sneeze.

Sneezing had been associated with omens and the supernatural at least since Aristotle.[6] In the early 17th century, the physician William Harvey took special note of the sneeze reflex as an involuntary reflex *in women*, and compared it to labor pains: "the throes of childbirth, just as sneezing, proceed from the motion and agitation of the whole body."

Harvey tells the story of a young woman patient who fell into a coma during labor and could not be roused. "Finding that injections and other ordinary remedies has been employed in vain" to rouse her, he "dipped a feather in a powerful sternutatory [that is, a substance, like pepper, that induces sneezing] and passed it up the nostrils. Although the stupor was so profound that she could not sneeze, or be roused in any way, the effect was to excite convulsions throughout the body, beginning at the shoulders, and gradually descending to the lower extremities."[7] The impulse to sneeze is deflected or displaced physio-logically into convulsions, which here facilitate a healthy completion of labor. In Harvey's description, these convulsions, "roused" by the ster-nutatory, appear to mimic the involuntary spasms of sexual orgasm. Notice, however, that the woman feels nothing, neither pain nor plea-sure. It is the (male) doctor who produces these effects, without her conscious participation, or even her knowledge.[8]

In the early days of psychoanalysis, with its emphasis upon hysteria and the body that unconsciously speaks its symptoms, the sneeze again figured memorably as a sign. Here is Freud's collaborator Joseph Breuer: "Sexuality at puberty appears," he writes, "as a vague, indeterminate, purposeless heightening of excitation. As development proceeds, this endogenous heightening of excitation, determined by the functioning

of the sex-glands, becomes firmly linked (in the normal course of things) with the perception or idea of the other sex."[9]

To explain the ways in which repressed sexual feelings are acted out in "hysterical" symptoms, Breuer instances a particular physiological event:

> I will select an extremely trivial example—the sneezing reflex. If a stimulus of the mucous membrane of the nose fails for any reason to release this preformed reflex, a feeling of excitation and tension arises, as we all know.... This everyday example gives us the pattern of what happens when a psychical reflex, even the most complicated one, fails to occur.[10]

But for Freud sneezing and sexual energy are not merely analogous. Freud had, he said, "begun to suspect" his patient Dora of masturbating when he heard her complain of gastric pains, since, according to his friend Wilhelm Fliess, "it is precisely gastralgias of this character which can be interrupted by an application of cocaine to the 'gastric spot' discovered by him in the nose."[11] The famous "gastric spot"—we could call it a G spot—was, Fliess thought, a seat of sexual passion, and he and Freud corresponded avidly about "the therapy of the neurasthenic nasal neurosis." Freud referred to Fliess for surgery patients, both male and female, who evidenced "a suspicious shape to [the] nose" or other symptoms indicative of masturbation.[12] So sex, desire, is seated in the nose. (The recurrent popularity of both cocaine and snuff as pleasurable stimulants attests to the enduring autoerotic *jouissance* of the sneeze.)

Furthermore, it is worth noting that at about the same time that the sneeze was being regarded by Freud and Breuer as suspiciously sexual, sexy sneezes were also occurring in literature and film. *Studies on Hysteria* was published in 1893. In 1891, Thomas Hardy described, in *Tess of the d'Urbervilles*, the effect of Tess's beauty on Angel Clare:

> Clare had studied the curves of those lips so many times that he could reproduce them mentally with ease; and now, as they again confronted him, clothed with colour and life, they sent an *aura* over his flesh, a breeze through his nerves, which wellnigh produced a qualm; and actually produced, by some mysterious physiological process, a prosaic sneeze.[13]

The juxtaposition here of the lips, the "*aura*," and the sneeze, however the latter is dismissed as "prosaic," tells its own story. The body—here the body of the neurasthenic male Angel—speaks.

Meantime, the pioneers of film technology were likewise recording the sneeze as a visual document of involuntary pleasure.

Fred Ott's Sneeze was one of the earliest test films made by the Edison Laboratory in 1893–94. The short film record (eighty-one frames) of a man in the act of sneezing has been celebrated by film historians as Edison's first film, the first film to use an actor, and the first cinematic close-up.

But, in fact, the initial impetus to film a sneeze specified a *female* subject. The idea for the film came from a journalist for *Harper's Weekly* bored with the dull topics of previous experiments in film, who wrote to Edison suggesting the possibility of a "nice looking young person to perform a sneeze," explicitly a woman "in the act of sneezing."[14] Ott, a young laboratory technician with a flowing moustache, was chosen by Edison as a substitute, for reasons of convenience.

The original idea of a "pretty young woman who would have lent prurient interest to the involuntary comic action of a sneeze," as Linda Williams notes, indicates the way in which "technicians of pleasure" "from Charcot to Muybridge, from Freud to Edison" solicit for their science "further confessions of the hidden secrets of female pleasure."[15]

"The animating male fantasy of hard-core cinema," maintains Williams, might be described as "the (impossible) attempt to capture visually this frenzy of the visible in a female body whose orgasmic excitement can never be objectively measured. . . . the woman's sexual pleasure is elicited involuntarily, often against her will." And when *Fred Ott's Sneeze* appeared as a series of photographs in *Harper's Weekly*, it was accompanied by a text that analyzed in detail the ten stages of "this curious gamut of grimace"—a sequence that seems cognate in some ways to Alsemero's—or Mizaldus's—four-stage sequence of female involuntary pleasure.

Freud and Breuer's observations about panting and sneezing are taken from some of their earliest work. Interestingly, however, it was to very similar questions about sexual pleasure and displaced physiological response that Freud recurred in his last years, and, indeed, in his journal jottings just before his death.

"The ultimate ground of all intellectual inhibitions and all inhibitions of work," he wrote on August 3, 1938, "seems to be the inhibition of masturbation in childhood."

But perhaps it goes deeper; perhaps it is not its inhibition by external influences but its unsatisfying nature in itself. There is always something

lacking for complete discharge and satisfaction—en attendant toujours quelque chose qui ne venait point—and this missing part, the reaction of orgasm, manifests itself in equivalents in other spheres, in *absences*, outbreaks of laughing and weeping . . . , and perhaps other ways. Once again infantile sexuality has fixed a model in this. (emphasis in original) [16]

Gaping, sneezing, laughing—and finally melancholy sadness. For this last symptom, perhaps, we do not need the testimony of psychoanalysts to augment that of the poets: *Post coitum omni animal triste est.* But in fact the relationship between orgasm and sadness, hypnosis, and sleep is repeatedly noted in the psychoanalytic literature. Thus Breuer insists that "the sexual orgasm itself, with its wealth of affect and its restriction of consciousness, is closely akin to hypnoid states"; "in orgasm thought is almost completely extinguished."

In a letter to Fliess Freud finds "Instructive!" (the ejaculatory punctuation is his own) the story of a young woman who—according to her wealthy lover—had "from four to six orgasms during one coitus. But—at the very first approach she is seized with a tremor and immediately afterwards falls into a pathological sleep; while she is in this she talks as though she was in hypnosis, carries out post-hypnotic suggestions and has complete amnesia for the whole condition."[17] Later Freud would write in his "Three Essays on Sexuality" that in infants "sensual sucking involves a complete absorption of the attention and leads either to sleep or even to a motor reaction in the nature of an orgasm."[18]

Of what, then, might this sequence of diagnostic symptoms in *The Changeling* be indicative?—a list of symptoms, detailed from Mizaldus's "The Book of Experiments, Call'd Secrets in Nature," that Bawcutt found "fantastic," and that seem, indeed, to have more than a little to do with fantasy? They are not, in fact, the telltale signs of virginity, but rather of *orgasm*. Not the commodification and ownership of women, as virgins, as mothers, but rather the intangibility of desire.

Here again is Sigmund Freud, writing to Fliess in the early days of psychoanalysis about the case of one "Frau P.J.," aged 27, who was suffering from feelings of oppression, anxiety, and abdominal discomfort. The tone in this letter, as in many of Freud's communications with Fliess, is man-to-man, self-congratulatory, much—to strain the comparison a little—like Alsemero's confident assertions to his friend Jasperino.

What I expected to find was this. She had had a longing for her hus-
band—that is, for sexual relations with him; she had thus come upon an
idea which had excited sexual affect and afterwards defence against the
idea; she had then taken fright and made a false connection or substitu-
tion.[19]

And from the same account:

> I then asserted that before the attack there had been thoughts present to
> her which she might not remember. In fact she remembered nothing,
> but pressure [on her forehead] produced "husband" and "longing." The
> latter was further specified, on my insistence, as longing for sexual
> caresses. . . . "There was certainly something besides this: a feeling in the
> lower part of the body, a convulsive desire to urinate." She now con-
> firmed this. The insincerity of women starts from their omitting the char-
> acteristic sexual symptoms in describing their states. So it had really been
> an *orgasm*. (emphasis in original)

Notice the astonishing scientific "detachment" of this last pair of asser-
tions. "The insincerity of women starts from their omitting the charac-
teristic sexual symptoms in describing their states. So it had really been
an *orgasm*."

The male doctor here detects—and shares with his male friend—the
woman's secret, and thus her power. "Insincerity" seems a harsh word
for the concealment of symptoms; Freud's response in fact appears
overdetermined, both by his own agency in producing this result (the
pressure of his hands on her forehead, an early aspect of the treatment
of his neurotic patients, later discontinued) and by his desire to *know*
what he cannot know except through her confession and confirmation.
"So it had really been an *orgasm*."

Freud and Alsemero, in fact, are fellow physicians in this quest for
certainty and power over the stories told by women's symptoms. One
curious paradox of Alsemero's glass M is the fact that it produces, or is
expected to produce, orgasmic effects in *virgins*, and not in women of
sexual experience. Should we not expect the opposite to be the case?
Furthermore, contemporary physiology held that female orgasm was
necessary for conception.[20] Why then are the orgasmic symptoms in
Middleton and Rowley's play not elicited by Glass *C* (for "child") rather

than by glass M? The answer to both questions, I think, is that glass M—the detection of a virgin—represents the fruits of a male fantasy, the fantasy of the male doctor/lover as at once the inventor and the scientific investigator of female pleasure. Glass M, like the whole pharmacopia so carefully locked away by Alsemero for his private use, is in fact a fantasy projection of the lover's power. He will elicit signs of sexual pleasure in their most manifest form from a woman who knows sexuality, and physical love, only through him. Just as Freud knows better than Dora (or even the married Frau P.J.) what pleasures their bodies betray, so Alsemero's drugs test his power, not, or not only, their response.

Let us now consider what happens in *The Changeling* once Beatrice-Joanna learns, by precept (Mizaldus's book) and example (Diaphanta's display of "symptoms") how to respond to the contents of glass M.

The plot has reached a crucial juncture. It is still the night of the wedding, and Alsemero is at this point advised first of Piraquo's murder and then of a private conversation between Beatrice-Joanna and DeFlores. "The very sight of him is poison to her," Alsemero protests (4.2.98), but once again the borderline between "poison" and "remedy" appears to have been breached. Beatrice-Joanna has pleaded her "fears" as a "timorous virgin" (117–18) and has asked to come to her husband's bed modestly in the dark. Can she be lying? Has she betrayed him with DeFlores? Discovery, exposure, and denunciation lie apparently just around the corner. Is DeFlores a *pharmakeus* (magician, sorcerer) or a *pharmakos* (scapegoat)?

Good empiricist that he is, determined to find the truth, Alsemero sends immediately to his closet for "A glass inscrib'd there with the letter M" (114), and offers it to his bride. Her response, aside, has all the horror of classic melodrama ("The glass, upon my life! I see the letter"; "I am suspected."[130]). Yet forced to drink, she produces all the appropriate symptoms, in the right order—gaping, sneezing, laughing, melancholy. As she confides to the audience, "th'effects I know,/If I can now but feign 'em handsomely" (137–38). Alsemero is completely won over, convinced that she is "Chaste as the breath of heaven, or morning's womb" (149–50). His faith in her is tied to his faith in science, and, indeed, to his own sexual expertise—for, as he notes confidently to a male friend, glass M "ne'er missed, sir,/Upon a virgin."

> I'm put now to my cunning; th'effects I know,
> If I can now but feign 'em handsomely. (4.2.137–38)

What Beatrice-Joanna learns in Alsemero's pharmacy, and turns immediately to her own use, is "what every woman knows": how to fake it. She produces the symptoms, the simulacra of orgiastic response, that delight her husband and confirm his apparent mastery of her. When she does so, Alsemero clasps her to him; "thus my love encloses thee" (150).

The Changeling is a play about the pleasure and danger of woman's desire. In the complex dynamics of its heterosexual power relations, the power to withhold becomes the power to control. Beatrice-Joanna romanticizes her feelings about the dashing Alsemero ("This was the man meant me!" [1.1.84]) but she finds in DeFlores the frisson of involuntary response: "I never see this fellow but I think/ Of some harm towards me; danger's in my mind still,/I scarce leave trembling of an hour after" (2.1.89–91). Her ruse to employ him to dispatch her inconvenient fiancé ("men of art make much of poison. Keep one to expel another. Where was my art?" [2.2.46–47]; "Why, put case I loathed him. . . ./Must I needs show it? Cannot I keep the secret/And serve the turn upon him?" [2.2.66–69]) leads inexorably to a relationship in which loathing and desire are intertwined and finally beyond her control. "I have kissed poison" for your love, she tells Alsemero (5.3.66), but it is never finally clear whether for Beatrice-Joanna there is any real difference between "danger," "trembling," "loathing," and desire.

With Alsemero, however—the idealized lover, the longed-for husband, the handsome romantic lead, Ashley Wilkes to DeFlores's sinister Rhett Butler—she is, paradoxically, in control, once she learns, from his own "pharmacy," how to simulate the throes of passion.

Here, then, is our question: is there any difference between centering a play on woman's desire and centering it on woman's ability to fake it? Which is more threatening?

Recall once more Freud's apparently unfeeling judgment on Frau P.J. (her name itself, to a modern reader, so evocative of bedtime). "The insincerity of women starts from their omitting the characteristic sexual symptoms in describing their states. So it had really been an *orgasm.*"

Hollywood mogul Sam Goldwyn is said to have offered this famous advice to aspiring actresses: "The most important thing about acting is sincerity. If you can fake that you've got it made." From the analyst's couch to the casting couch, from the "insincerity" of concealing sexual responsiveness to the "sincerity" of faking it, the fear, and the excitement, is of a woman's sexual pleasure. Woman's orgasm is Freud's "dark

continent," as well as Mizaldus's "secret of nature." Female pleasure is the unknown and unknowable, the other, less masterable and controllable answer to the question Freud poses over and over again, in different forms, throughout his work: "What does a woman want?"

It is hardly a new question.

Ovid's famous story about Tiresias, who was asked whether men or women had greater pleasure in sex, is part of the same obsessive inquiry. How could a man ever know? Tiresias was drawn into the dispute between Juno and Jove because he had been both woman and man. Once, having seen snakes coupling, he struck them apart, and was instantly turned into a woman. Seven years later he saw them again, struck them again, and was changed back into a man. His answer, that women had more pleasure than men, pleased Jove and displeased Juno, who struck him blind; Jove then, since he could not undo this curse, gave to Tiresias second sight, power to know the future. Thomas Laqueur points out that "Ovid's account would become a regular anecdote in the professorial repertory, told to generations of medieval and Renaissance students to spice up medical lectures," and comments trenchantly that "One might translate the question more specifically as 'which sex had the better orgasm.'"[21]

Why does Tiresias's answer anger Juno? Because female pleasure is shameful? Or because a woman's pleasure is her secret—and her power?

Can she fake it? And thereby deny her partner the pleasure of her pleasure? How can her partner ever know? For orgasm, *jouissance*, is—as Jacqueline Rose deftly describes it—"what escapes in sexuality."[22] Thus Lacan recurred to Freud's unanswered question, "What does a woman want?" by evoking Bernini's St. Teresa as a model for *jouissance*. "What is her *jouissance*, her *coming* from?" he asks.[23] Thus, too, in discussing Mallarmé's *Mimique*, Jacques Derrida identifies the "supreme spasm," the orgasm of Columbine as mimed by her husband, Pierrot as a double miming. "I'm going to tickle my wife to death," he declares, and for Derrida the "spasm" is also the "hymen," that word that paradoxically incorporates virginity and marriage.[24]

Feminist theorist Gayatri Spivak saw clearly that this was for Derrida a scene of faked orgasm, in which the male actor appropriates the language of a woman's desire. "The faked orgasm now takes center stage. The Pierrot of the pantomime 'acts' as the woman 'is' ('Pierrot is [plays] Columbine') by faking a faked orgasm which is also a faked

crime."[25] Is it worth noting that the boy actor playing Beatrice-Joanna likewise "fakes[s] a fake orgasm" from the ambivalent double position of transvestite theater, a man playing a woman playing a trick on a man? So perhaps we are dealing not—or not only—with the "insincerity of women," but also with the intrinsic and instrumental insincerity of theater. With the mimesis of mimesis itself.

Female orgasm as mimesis, as an act or an acting out, poses a special problem. How can a lover tell the difference between origin and imitation, between the "fake" and the "real"? And, once again, which is more threatening?

Aristotle as a scientist was not interested in female pleasure, or in female orgasm; it did not fit into his theories.[26] Debates about the role, if any, of the clitoris, and about the necessity of pleasure for procreation appear from time to time in the writings of medieval and Renaissance physicians.[27] Aphrodisiacs for women were seldom mentioned in the herbals, and then they were recommended for use by unsatisfied husbands with recalcitrant wives.[28] Laqueur suggests that in the 18th century and after, "the routine orgasmic culmination of intercourse became a major topic of debate.

> The assertion that women were passionless, or alternatively the proposition that, as biologically defined beings, they possessed to an extraordinary degree, far more than men, the capacity to control the bestial, irrational, and potentially destructive fury of sexual pleasure; and indeed the novel inquiry into the nature and quality of female pleasure and sexual allurement—all were part of a grand effort to discover the anatomical and physiological characteristics that distinguished men from women. Orgasm became a player in the game of new sexual differences.[29]

The histories of medicine and sexual sociology appear to offer an either/or choice, between the fantasy of women possessing no desire, and the fantasy of women as eros embodied. But more disconcerting remains a third possibility: that women are somehow in control of the sexual rhetoric of desire. Women may lack desire—and therefore stand aloof and untouched by the circuit of courtship, blandishment, arousal, and possession which is the economy of sexual mastery. Or they may act in pursuit of their own desire. Or they can fake it. With no one the wiser but themselves.

Here, for example, is the sage counsel of a 19th-century French

physician, Auguste Debay, whose manual on the physiology of marriage went through an astonishing 153 editions from its original publication in 1849 to 1880.

> O wives! Follow this advice. Submit to the demands of your husband in order to attach him to you all the more. Despite the momentary aversion for the pleasures he seeks, force yourself to satisfy him, put on an act and simulate the spasm of pleasure: this innocent trickery is permitted when it is a question of keeping a husband.[30]

If the Victorian Englishwoman had been exhorted to close her eyes and think of England, her Gallic counterpart, with the future of her marriage rather than the Empire in mind, was to keep her eyes open for theatrical opportunity, for simulation and innocent trickery. All this ostensibly in the service of "keeping a husband," preserving the basis of her own social legitimation and economic dependency. Marital truth here depends upon theatrical falsehood, "permitted"—once again—by an authorizing doctor. In Debay's formulation, the satisfaction is imagined as entirely the husband's. The woman's pleasure is in her status, not in her bed.

Twentieth-century sex manuals, especially those from the "free to be me" seventies and eighties, stress the usefulness of rehearsal. Here, for example, with theatrical coaching and stage directions included, is a passage from an American self-help book entitled *Becoming Orgasmic: A Sexual and Personal Growth Program for Women.*

> We call this exercise Role-Playing Orgasm. What we'd like you to do is to fantasize about a wild orgasm and act it out.
>
> Set aside thirty minutes to one hour. Begin one of your self-pleasuring sessions in the usual way. The first time, begin role-playing orgasm after you've pleasured yourself for a while but *before* you become extremely aroused. Move around, tense your muscles, lie very rigid, do some pelvic rocking, make noises—do whatever seems really extreme to you. Moan, scratch, pummel the bed, cry—the more exaggerated the better. Stop pleasuring yourself if you want, or continue while you have your "orgasm." You will probably feel awkward doing this the first few times, but it will become easier with practice. Remember the way you act is not really the way you would or should act. For this exercise, pretend to be the star in your own orgasmic fantasy![31]

In a chapter called "Orgasm—Yours, Not His," "J," the author of *The Sensuous Woman*, notes that she's "never met a woman yet who didn't occasionally fake it," and stresses the theatricality of faked orgasm, which she calls "The Sarah Bernhardt" maneuver. "J," also, emphasizes the importance of rehearsal.

> To become a fabulous fake, study again every contortion, muscle spasm, and body response that lead to and make up the orgasm and rehearse the process privately until you can duplicate it.

"Women have been faking since time began," she informs us, cautioning against "ham[ming] it up too much" ("then he really will suspect you're acting") and, above all, against "telling the truth."

> You must *never, never* reveal to him that you have acted sometimes in bed.
> You will betray a trust shared by every other female in the world if you do.[32]

In this case the presumed homosocial compact among women enforces the "success" of heterosexual relations.

Dr. Ruth Westheimer, "author, psychologist, and media personality," has a different concern about "The Perils of Faking It," since to pretend to be satisfied is to forego real satisfaction. Yet she too sees the congruence between theater and sexual fakery. In a "typical case" of a "lady [who] had never experienced orgasm" although she had been impressed by women thrashing about on the movie screen in the throes of ecstasy, Dr. Ruth's client was manifestly "a good actress," because her husband "never had an inkling that she was faking it." In this case the cure, facilitated through the intervention of a sex therapist, was the one proposed by the authors of *Becoming Orgasmic*, a variant of Beatrice-Joanna's observation and imitation of Diaphanta. The woman learned to masturbate, thus discovering for herself the sensations of pleasure that she could then reproduce by guiding her husband's hand over her body.[33]

The desire to control a woman's orgasm, and to know when it occurs, has mobilized the agency of the letter. Beyond Middleton's (or Alsemero's) glass M and glass C lie, for example, the elusive G spot, or Grafenberg spot, as well as the erotic advice of "J," the author of *The Sensuous Woman*, and "M," author of *The Sensuous Man*. Sexologists

from Kinsey to Masters and Johnson to Ladas, Whipple, and Perry have sought to describe, delimit, and pin down the female orgasm. Was it clitoral? Vaginal? "Blended"? How could you tell when a woman had one? Consider the case of sex researcher John D. Perry, who attempted to replicate the research of Masters and Johnson on women's muscle contractions. Perry asked a number of male college students who the sexiest women on campus were, and then invited them—without explaining how he got their names—to become research subjects. One agreed.

She passed with flying colors a written test of sexual interest, and demonstrated good control over her sexual musculature. They then put her to the test in the lab.

> At first, during masturbation, her PC [urinary] muscle showed normal, expected increases in tension. But as she became more aroused, suddenly PC muscle activity ceased. The laboratory technicians assumed that their research subject was taking a break—until the remote signal light flashed that the woman was having an orgasm.[34]

This unexpected datum, together with "subjective reports from many women" who claimed that they had experienced more than one kind of orgasm, "our own laboratory evidence that some women achieved what they claimed were satisfying orgasms *without* the characteristic contractions of the orgasmic platform," and "the undeniable fact of female ejaculation, especially in reponse to G spot stimulation" led the sex researchers to revise their understanding of female sexuality completely. Notice here the conjunction of "subjective reports," women's "claims," and "undeniable fact." Despite all the data, it was upon claims and reports that these scientific findings had, necessarily, to be based.

Is this experiment another example of the "insincerity" of women? How much pleasure does a woman get, and how?

"While the mechanics of an orgasm may be known, it is still a sensation, and like all sensations it's subjective," writes the author of an article called "Evolution of the Big O," in the popular science journal *Discover*.

> As a result, its existence can't be demonstrated or disproved by empirical measures. That unhappy truth becomes especially clear when evolutionary biologists turn their attention to the female orgasm—which they do

with unseemly fascination. Even human lovers have to take their lady's word for it. How much more ineffable, then, must be the coital consciousness of Madame Marmoset.[35]

The Big O. When something hits the Renaissance G spot, what is often told is a story of "O." Thus in the final discovery scene of *The Changeling* an incensed Alsemero has dispatched DeFlores after the woman he labels, in fury, a "crying crocodile."

> —Get you into her, sir.
> I'll be your pander now; rehearse again
> Your scene of lust, that you may be perfect. (5.3.113–15)

From the "closet," behind the stage, there now issue ambiguous cries.

> Beatrice (within). O! O! O!
> Alsemero. Hark! 'Tis coming to you.
> DeFlores (within). Nay, I'll along for company.
> Beatrice (within). O, O!
> Vermandero [Beatrice-Joanna's father]. What horrid sounds are these?
> (5.3.139–41)

The nonplussed father, Vermandero, hearing his daughter's cries, finds them mysterious, unrecognizable. "What horrid sounds are these?" "O, O, O!" Are these the sounds of enforced sexuality, of rape and injury? Or the voice of the woman moved beyond control? The omnipresent Renaissance "die" pun, the simultaneity of sex and death, is in this episode more than usually literal and vivid, not an implication but an enactment, a passionate outcry. Remember Alsemero's scathing epithet "crocodile," his brusque instruction to "rehearse" the "scene" of sexual passion. Even here it is not possible to tell what Beatrice-Joanna feigns, and what she feels.

We might usefully compare this final moment, embedded in a Jacobean tragedy, with what is perhaps the locus classicus of hystrionic "faking it" for the eighties: Rob Reiner's 1989 film *When Harry Met Sally . . .* , with a witty, streetwise screenplay by Nora Ephron. In the climactic scene, set in a New York deli, Sally (Meg Ryan) takes Harry (Billy Crystal) to task for his casual ways with women.

Harry. I don't hear anyone complaining. I think they have an okay time.

Sally. Because they. . . . (rotating hand gesture signifying orgasm)?

Harry (truculently). Yes, because they. . . . (rotating hand gesture signifying orgasm)

Sally. How do you know they really. . . . (rotating hand gesture)

Harry (indignantly). What are you saying, that they fake orgasm?

Sally. Most women at one time or another have faked it.

Harry. Well they haven't faked it with me.

Sally. How do you know?

Harry. Because I know.

Sally. I forgot, you're a man. All men are sure it hasn't happened to them and most women at one time or another have done it, so you do the math.

Harry. You don't think I could tell the difference?

Sally (faking orgasm, as all heads in the restaurant turn). Mmmmm . . . Yes . . . right there . . . Yes, yes yes yes YES!!!

A pause. She lifts one corner of her mouth and grins at him, then casually picks up her fork and resumes stabbing at her salad. Harry looks at her steadily, while everyone around them draws a deep breath. Everyone, that is, except a middle-aged woman—played by Rob Reiner's mother Estelle—seated a few tables away, who beckons to the waiter and tells him, deadpan: "I'll have what she's having."

"I'll have what she's having." But what she's having is a fake orgasm.

In Middleton and Rowley's play, the father, who has attempted to control his daughter's marriage and thus her desires, finds the sounds of a woman's passion indecipherable and "horrid." In Reiner's film, the mother—and we might note that practically everyone who has seen the film has somehow learned the "real" identity of the customer in the deli—listens, recognizes, and desires the woman's "passion," even (or especially?) if that "passion" is only a pretense. "I'll have what she's having." But what if she's having us on?

The potions and philtres in Alsemero's pharmacy, like the book of recipes he follows, are designed to decipher, and thus to control, women's bodies and women's pleasure. By learning to fake the responses of pleasure, Beatrice-Joanna, like Sally Albright in the film, retakes control of the relationship, and of the scene. Yet, as all the self-help manuals suggest, to fake pleasure may be the first step in attaining it. Or—and this is more to the point—it may become a pleasure in itself.

When Beatrice-Joanna shifts her mimetic attention from Alsemero's book to Diaphanta's symptoms she shifts from text to theatricalization,

from script to stage. In both the written and the acted models she finds, and takes, the cues for passion.

And the particular case of orgasm only serves to epitomize the power that actors derive more generally from this "female" capacity to withhold, to dissimulate, to test the boundaries of the real.

Furthermore, these scenes in which instead of faking an orgasm characters fake the faking of an orgasm exhibit something intrinsic to the nature of theater. Isn't the frisson an audience feels both in *The Changeling* and in *When Harry Met Sally* . . . related to this intrinsic paradox of performance, that in acting only the fake is real?

Nor (is it needless to say?), are women the only ones who fake it on or off the stage, when the occasion arises. Martin Sherman's 1979 play *Bent*, with its central scene of two homosexual men in a Nazi prison camp, unable to touch or even look at each other, brought to simultaneous orgasm by language as they stand facing the audience, is a theatrical tour de force. Compare this onstage fake realness to the commercial phenomenon of telephone sex, its erotic power dynamic linked, fiber-optically, to questions of "authenticity," "sincerity," and arousal, offering an example of the disparate pleasures of faking it in the real world.

In a rather different performance register, how does the cliché "money shot" of pornographic film, with its evidence of "real" ejaculation by men, put in question protocols of imitation and sincerity? If the ejaculation is "real" and the "passion" is faked, is the actor, male or female, in the position of Beatrice-Joanna?

As we have seen, there is a special theatrical "insincerity" in orgasm enacted on the stage, in precisely the space where grounded scientific knowledge and secure anatomical reference are by the nature of the genre put in question. What is "female orgasm" when mimed by a boy player? "Female," in the context of drama and performance, reveals itself, once again, as a position in a structure rather than an aspect of anatomical—or even cultural—destiny.

From Dr. Freud to Dr. Ruth, the "insincerity of women" has been seen as an ambivalent asset, a poison needed to effect a remedy. It turns out, though, that the poison is its own remedy, the remedy its own poison. The representation of female pleasure is itself a changeling. The existence of the possibility of fakeness protects the privacy and control of pleasure. Perhaps this was the secret that Juno was so angry at Tiresias for disclosing.

Notes

Symptoms of Culture: An Introduction

1. Richard A. Knox, "Pleasing the Palate: Scientists Find a Three-Star Addiction." *The Boston Globe,* May 22, 1997, p. A19.

2. "All the Rage in Massachusetts." Editorial, *The Boston Globe,* July 23, 1997, p. A14.

3. Auden, "In Memory of W.B. Yeats," *The Collected Poetry of W.H. Auden* (New York: Random House, 1945), p. 48–51.

4. Jane Austen, *Mansfield Park* 1814 (London and New York: Penguin Books, 1985), p. 361.

5. Jane Austen, *Pride and Prejudice* 1813 (London and New York: Penguin Books, 1985), p. 302.

6. Ibid., p. 228.

7. Ibid., p. 209.

8. Jacques Lacan, "The Function and Field of Speech and Language in Psychoanalysis," in *Ecrits,* trans. Alan Sheridan (New York and London: W.W. Norton, 1977), p. 59.

9. Slavoj Žižek, *Enjoy Your Symptom!* (New York and London: Routledge, 1992).

10. S.T. Coleridge, *The Statesman's Manual,* W.G.T. Shedd, ed. (New York: Harper and Brothers, 1875), pp. 437–38, quoted in Angus Fletcher, *Allegory: The Theory of a Symbolic Mode* (Ithaca, NY: Cornell University Press, 1964), p. 16, n. 29.

11. Wilson quoted in Kevin Sack, "Symbols of Old South Feed a New Bitterness." *The New York Times,* February 8, 1997, p. 8. State Senator Glenn F. McConnell, quoted in Ibid., p.8.

12. Ibid.

13. Thomas Mann, *An Exchange of Letters,* trans. H.T. Lowe-Porter (New York: Knopf, 1937), p. 8.

14. Freud, *Interpretation of Dreams,* in *The Standard Edition of the Complete Psychological Works of Sigmund Freud* (London: The Hogarth Press and the Institute of Psycho-Analysis, 1953), vol. 4, pp. 175–76.

15. Ibid., pp. 277–78.

16. A.S. Byatt, *Angels and Insects* (New York: Vintage, 1992), pp. 174–75.

17. E.B. White, *Charlotte's Web* (New York: Harper Collins, 1952), p. 80.

Chapter I: Greatness

1. Seth Mydans, "A Great Wall, Alas, of T-Shirts and Baseball Caps," *The New York Times,* July 9, 1997, p. A4. See also, Arthur N. Waldron, *The Great Wall of China: From History to Myth* (Cambridge: Cambridge University Press, 1990).

2. B. Drummond Ayres, Jr. "Millions of Elvis Sightings Certain in '93." *The New York Times,* January 11, 1992, p. 6.

3. Shakespeare, *Love's Labour's Lost,* 5.2.545–46; 55. *The Arden Shakespeare,* ed. Richard David (London: Methuen, 1968).

4. Shakespeare, *Measure for Measure* 3.1.214–16. *The Arden Shakespeare,* ed. J.W. Lever (London and New York: Methuen, 1987).

5. Shakespeare, *Hamlet* 3.1.190. *The Arden Shakespeare,* ed. Harold Jenkins (London and New York: Routledge, 1982).

6. *Hamlet* 4.4.52–56.

7. Shakespeare, *Twelfth Night* 2.5.145–46. *The Arden Shakespeare,* ed. J.M. Lothian and T.W. Craik (London: Methuen, 1975).

8. Shakespeare, *The Winter's Tale* 4.4.740–2. (The Clown is here describing the rogue Autolycus dressed in Prince Florizel's clothes.)

9. Jane Austen, *Pride and Prejudice* (London and New York: Penguin Books, 1985; orig. pub. 1813), 96. The phrase is Elizabeth Bennet's; she is wondering, early in the novel, "how to suppose that she could be an object of admiration to so great a man." p. 96.

10. Ibid., p. 278.

11. Ibid., p. 194.

12. Ralph Waldo Emerson, "Uses of Great Men," in *Representative Men* (Boston: Houghton Mifflin, 1903).

13. L. Frank Baum, *The Wonderful Wizard of Oz* (New York: Dover Publications, 1960), p. 127.

14. Jacques Lacan, "The Signification of the Phallus," in *Ecrits,* trans. Alan Sheridan (New York and London: W.W. Norton, 1977), p. 288.

15. Jean Genet, *The Balcony,* trans. Bernard Frechtman (New York: Grove Press, 1958), p. 92.

16. Ibid., p. 94.

17. Ibid., p. 92.

18. Ibid., p. 96.

19. Baum, p. 184.

20. James Reston, Jr., *Collision at Home Plate: The Lives of Pete Rose and Bart Giamatti* (New York: HarperCollins, 1991), p. 308.

21. Ibid., p. 312.

22. Dave Anderson, "Pardon Rose, and Put Him in Hall." Reprinted in *The Miami Herald,* January 5, 1992, p. 3C. The "Hall of Fame" whose members are often nominated by special interest or chosen by vote is another distinctive institution of this century (though the Pageant of the Nine Worthies, like Raphael's School of Athens, attests to a much earlier interest in the canonization of great men). Since the founding of the original Hall of Fame at the Bronx campus of New York University in 1900, the concept has proliferated. The marble portico of the Bronx Hall celebrates great Americans in politics, invention, and the arts from Washington and Franklin to Emerson and Hawthorne to Audubon and Samuel F.B. Morse. Subsequent Halls have included the following, all

with edifices to commemorate the honorands: the International Boxing Hall of Fame, Teddy Bear Hall of Fame (Teddy Bear Museum, Stratford-Upon-Avon), Accounting Hall of Fame (Ohio State University, Columbus), Pro Football Hall of Fame, Hockey Hall of Fame, Basketball Hall of Fame, Women of Nebraska Hall of Fame, National Cowboy Hall of Fame (Oklahoma City), International Jewish Sports Hall of Fame, International Space Hall of Fame (Alamogordo, N.M.) and numerous other Halls, including several more devoted to sports heroes and to the dignitaries, especially, of the Southern states.

23. A. Bartlett Giamatti, *Take Time for Paradise: Americans and Their Games* (New York: Summit Books, 1989), p. 101.

24. Ibid., p. 51.

25. Ibid., p. 83.

26. Ibid., p. 30.

27. Ibid., p. 87.

28. Ibid., p. 92.

29. Ibid., p. 93.

30. Ibid.

31. Ibid.

32. Ibid., p. 95.

33. Ibid., p. 92.

34. Ibid., p. 27.

35. Erich Auerbach, *Mimesis: The Representation of Reality in Western Literature*, trans. Willard Trask (Garden City, NY: Doubleday Anchor, 1957), p. 492.

36. Erich Auerbach, "*Philology and Weltliteratur*," trans. M. and E.W. Said, *Centennial Review*, 13 (Winter 1969), p. 17. "Culture often has to do with an aggressive sense of nation, home, community, and belonging." Edward Said, *The World, the Text, and the Critic*, (Cambridge, MA: Harvard University Press, 1983), p. 12.

37. Auerbach, *Mimesis*, p. 491.

38. Said, *The World, the Text, and the Critic*, p. 8.

39. Robert Maynard Hutchins, *The Great Conversation*, in *Great Books of the Western World*, ed. Robert Maynard Hutchins and Mortimer J. Adler, 54 volumes (Chicago: Encyclopedia Britannica), p. xvii.

40. Ibid., p. xvi.

41. Ibid., p. xiii.

42. Ibid.

43. Ibid., p. xxv.

44. E.B. White, *Charlotte's Web* (New York: HarperCollins, 1952), p. 49.

45. Ibid., p. 80.

46. Ibid., pp. 81–82.

47. Ibid., p. 101.

48. Jacques Derrida, "Plato's Pharmacy," in *Dissemination*, trans. Barbara Johnson (Chicago: University of Chicago Press, 1981), p. 63.

49. White, *Charlotte's Web*, p. 114.

50. Ibid., pp. 157–58.

51. Ibid., p. 55.

52. Joseph Campbell, *The Hero With a Thousand Faces* (Princeton: Bollingen, 1949; 1968), p. 71. Campbell's reading of the place of "woman" in the heroic scheme of things can be deduced from the listing under that heading in the index: "symbolism in hero's adventures; as goddess; as temptress; Cosmic Woman; as hero's prize; *see also* mother."

53. Mary Daly, *Gyn/Ecology: The Metaethics of Radical Feminism* (Boston: Beacon Press, 1978), p. 399.

54. Ibid., p. 400.

55. Abbie Hoffman, *Soon to be a Major Motion Picture* (New York: Perigee Books, 1980), p. 144.

56. Joe McGinniss, *The Selling of the President* (New York: Penguin Books, 1988 [orig. pub. 1969]), pp. 193–94. Italics in the original.

57. Ibid., pp. xiv–xv.

58. Ibid., pp. 73–75.

59. Ibid., p. 72.

60. Ibid., pp. 218–19.

61. Mortimer J. Adler, *Reforming Education: The Opening of the American Mind*, ed. Geraldine Van Doren (New York: Collier Books, 1988), p. 350.

Chapter II: Two-Point Conversion

1. Nick Cafardo, "Parcells Plays to Audience." *The Boston Globe*, January 7, 1997, p. C5.

2. Gerald Eskenazi, "Jaguars and Patriots Put It On the Line: Expect a Shootout." *The New York Times*, January 12, 1997, p. H3.

3. Michael Vega, "Jaguars' Leap of Faith." *The Boston Globe*, January 9, 1997, p. C7.

4. When reporter Michael Vega asked players for their favorite Bible verses, they had them ready, as if they were plays to be audibled from the huddle.

"Philippians 4:13," said guard Rich Tylski. "That's been my favorite Scripture ever since I became a Christian in high school." "Colossians 3:23," said tight end Rich Griffith. "It has to do with 'Everything you do, do with all your heart as for the Lord and not for men.' So everything I do, I try to do it for God. I don't do it for Coach Coughlin or for anyone else. I try to do it for a superior person." As for Brunell's favorite, it was Jeremiah 29:11: "For I know the plans I have for you, declares the Lord, plans to prosper you and not to harm you, but to give you hope for the future."

Said Jaguars' team chaplain Don Walker, "When Coach Coughlin put this team together, he didn't just stop with excellent athletes, he went looking for young men with values and character . . . some good guys." "What he ended up getting were good guys who are walking and looking after God." "From the very beginning," the chaplain observed, "I think there was a very strong core group, spiritually, within this team, and it has grown and progressed. There's a very, very positive atmosphere spiritually in this team and there's almost positive peer pressure to consider walking in faith. There's just a tremendous sense of prayer on this team." (Notice the interesting qualification, "*almost positive peer pressure.*" Is that "almost pressure"—or "almost positive"?)

5. Adam Nossiter, "North Carolina's Faith in Football." *The New York Times*, January 11, 1997, p. 6.

6. Don Beebe, quoted in Mark Blaudschun, "No Doubt White Is on a Mission." *The Boston Globe*, January 22, 1997, p. F5.

7. Timothy W. Smith, "White Wants Pulpit Between Hash Marks." *The New York Times*, January 23, 1997, pp. B13, B14.

8. "Some Packers Say They Plan to Pray Publicly." *The New York Times*, January 24, 1997, p. B13.

9. Rick Romell, "Packer Pride: Jubilant Hordes Jam Homecoming." *Milwaukee Journal Sentinel,* January 28, 1997, p. 5A.

10. "Having a Prayer: Christians Are Making a Statement in the NFL." *San Francisco Chronicle,* January 22, 1997, p. D1.

11. Cited by Lester Kinsolving, "Exploiting Athletes in Religion Questioned." *The Johnson City Press,* January 12, 1971, p. 10. Quoted in Robert J. Higgs, *God in the Stadium: Sports and Religion in America* (Lexington, KY: The University Press of Kentucky, 1995), p. 10.

12. Bill Heyen, "Until Next Time." Quoted in Higgs, pp. 12–13.

13. Higgs, p. 12, citing Gary Swan, "Religion's a Hit in Baseball Clubhouses." *The Greenville Sun,* August 25, 1990, p. B1 (AP story).

14. Described by W. Brown Patterson, Dean of the College at the University of the South. Quoted in Higgs, p. 238.

15. Joe D. Willis and Richard G. Wettan, "Religion and Sport in America: The Case for the Sports Bay in the Cathedral Church of Saint John the Divine." *Journal of Sport History,* vol. 4, no. 2 (Summer 1977), pp. 189–207. Cited in Higgs, p. 236. The chapel's racing runners would seem to illustrate St. Paul's instruction to the Corinthians, "Know yet not that they which run in a race run all, but one receiveth the prize? So run, that ye may obtain" (1 Cor. 9:24)—rather than Ecclesiastes, "the race is not to the swift" (Ecc. 9:11) or even Paul's more temperate—or marathon-like—"let us run with patience the race which is set before us" (Heb. 12:1).

16. Cited in Higgs, p. 325. See John T. McNeille, "The Christian Athlete in Philippians 3:7–14." *Christianity in Crisis: A Christian Journal of Opinion,* (August 2, 1948), pp. 106–7.

17. Quoted in William Martin, *A Prophet With Honor: The Billy Graham Story* (New York: William Morrow, 1992), p. 347. Cited in Higgs, p. 289.

18. Frank Deford, "Endorsing Jesus." *Sports Illustrated* (April 26, 1976), pp. 54–69.

19. James A. Mathisen, "From Muscular Christians to Jocks for Jesus." *Christian Century* (January 1–8, 1992), pp. 11–15. Quoted in Higgs, p. 15.

20. Matt Harvey, "Super Bowl Sunday Stokes Creative Fires of Clergy Nationwide." *Johnson City Press,* January 28, 1995, p. 7. Cited in Higgs, p. 15.

21. Rajiv Chandrasekaran, "A Reverse in the End Zone: After Liberty's Challenge, NCAA Clarifies Rule, Allows Praying After Touchdowns." *The Washington Post,* September 2, 1995, p. C1. "N.C.A.A. Clarifies Rule to Permit Prayers." *The New York Times,* September 2, 1995, p. A26. Arthur Hoppe, "Football Prayers." *San Francisco Chronicle,* September 6, 1995, p. A15.

22. Wendy Kaminer, "The Last Taboo." *The New Republic* (October 14, 1996), pp. 28, 32.

23. Herrmann, "A Legal Leg to Stand On." *Chicago Sun-Times,* March 14, 1996, p. 8. Roscoe Nance, "Abdul-Rauf to Stand, Pray During Anthem." *USA Today,* March 15, 1996, p. 1C.

24. Peter Steinfels, "Beliefs." *The New York Times,* June 22, 1991, p. A10.

25. Rick Reilly, "Save Your Prayers, Please." *Sports Illustrated* (February 4, 1991), p. 86.

26. Grantland Rice, "Alumnus Football." *Only the Braves: and Other Poems* (New York: A.S. Barnes, 1941), pp. 142–44.

27. Steinfels, "Beliefs."

28. Skip Bayless, "God's Playbook." *The New York Times,* December 1, 1996, p. E7.

29. Peter Monaghan, "Religion in a State-College Locker Room: Coach's Fervor Raises Church-State Issue." *The Chronicle of Higher Education* vol. 32, no. 3 (1985), pp. 37–8, and

Peter Monaghan, "U. of Colorado Football Coach Accused of Using His Position to Promote His Religious Views." *The Chronicle of Higher Education* vol. 32, no. 12, (1992), pp. A35, A37. For this and subsequent references, see also Gil Fried and Lisa Bradley, "Applying the First Amendment to Prayer in a Public University Locker Room: An Athlete's and Coach's Perspective." *Marquette Sports Law Journal* 301 (Spring 1994).

30. Charles R. Farrell, "Memphis State Coach is Accused of Imposing Religious Beliefs on Players." *The Chronicle of Higher Education* vol. 29, no. 6 (1984), p. 26.

31. Harry M. Cross, "The College Athlete and the Institution." *Law and Contemporary Problems,* vol. 38 (1973), pp. 150, 168–69. Cited in Fried and Bradley, footnote 57.

32. "Not a Prayer." *The Boston Globe,* October 16, 1992. From wire services.

33. *Menora, et al., v. Illinois High School Association, et al.* 527 F. Supp. 637.

34. Ibid., 642.

35. Ibid.

36. Ibid., 646.

37. Sigmund Freud, "Group Psychology and the Analysis of the Ego" (1920), in James Strachey, ed. and trans., *The Standard Edition of the Complete Psychological Works of Sigmund Freud* (London: The Hogarth Press and the Institute of Psycho-Analysis, 1955), vol. 18, p. 95.

38. Higgs, *God in the Stadium,* pp. 225, 227.

39. Freud, "Group Psychology," p. 103.

40. Diana Fuss, *Identification Papers* (New York: Routledge, 1996), p. 45.

41. Freud, "Group Psychology," p. 141.

42. Brian Pronger, *The Arena of Masculinity: Sports, Homosexuality and the Meaning of Sex* (New York: St. Martin's Press, 1980), p. 197.

43. Lionel Tiger, *Men in Groups* (New York: Random House, 1969), p. 91.

44. Mariah Burton Nelson, *The Stronger Women Get, the More Men Love Football* (New York: Harcourt Brace, 1994), p. 116.

45. Freud, "Group Psychology," p. 91.

46. Alan Dundes, "Into the Endzone for a Touchdown: A Psychoanalytic Consideration of American Football." In Dundes, *Interpreting Folklore* (Bloomington: Indiana University Press, 1980), p. 209.

47. Barbara Moon, "For the Sake of Argument," *Maclean's Magazine* (October 5, 1963). Cited in Tiger, p. 122.

48. Tiger, p. 122.

49. Frank Rich, "'Thank God I'm a Man.'" *The New York Times,* September 25, 1996, p. A21.

50. Gustav Niebuhr, "Men Crowd Stadiums to Fulfill Their Souls." *The New York Times,* August 6, 1995, p. A1.

51. Ibid., p. A30.

52. "New Men for Jesus." *The Economist* (June 3, 1995), p. 21.

53. Freud, "Group Psychology," p. 120.

54. Michael Janofsky, "At Mass Events, Americans Looking to One Another." *The New York Times,* October 27, 1997, p. A21.

55. Sigmund Freud, "The Psychogenesis of a Case of Homosexuality in a Woman," in *Standard Edition,* vol. 18, p. 151.

56. Lewis Way, *Jewish Repository I* (London, 1813), pp. 279–80. Quoted in Michael Ragussis, *Figures of Conversion: "The Jewish Question" and English National Identity* (Durham and London: Duke University Press, 1995), p. 6.

57. Gustav Niebuhr, "Baptists Censure Disney for Gay-Spouse Benefits." *The New York Times,* June 13, 1996, p. A14.

58. Leonard Garment, "Christian Soldiers." *The New York Times,* June 27, 1996, p. A23.

59. M. Jastrowitz, "Muskeljuden und Nervenjuden," *Jüdische Turnzeitung* 9 (1908), pp. 33–36. Cited in Sander Gilman, *The Jew's Body* (New York and London: Routledge, 1991), pp. 53–54.

60. Benjamin Ward Richardson, *Diseases of Modern Life* (New York: Bermingham and Co., 1882), p. 98. Cited in Gilman, p. 52.

61. Larry Lewis, former president of the Home Mission Board that supervises the Southern Baptist Convention's United States-based missionaries. Quoted in Jeffrey Goldberg, "Some of Their Best Friends are Jews." *The New York Times Magazine,* March 16, 1997, p. 43.

62. James Carroll, "Critics of Albright's Conversion Ignore the Essence of Judaism." *The Boston Globe,* February 18, 1997, p. A11.

63. Freud, *Civilization and Its Discontents,* in *The Standard Edition,* vol. 21, p. 114.

64. Ronald Smothers, "For Mississippi's Governor, Another Fight Over Power." *The New York Times,* July 10, 1996, p. A10.

65. James A. Aho, *The Politics of Righteousness: Idaho Christian Patriotism* (Seattle and London: University of Washington Press, 1990), p. 15. Since, according to the logic of these groups, only the Anglo-Saxon peoples have fulfilled all of God's promises in the Bible, they alone are His chosen people. Thus Gordon "Jack" Mohr, the co-founder of a group called the Christian Patriot Defense League and a member of the Christian Identity movement, can claim that Talmudism is Satan worship, that Jews are born evil, and that the real Israelites, the ones to whom God promised a chosen future, are white Aryans. Mohr's book on this topic is called *Exploding the 'Chosen People' Myth.* In it he suggests, among other things, that Jews *cannot* be converted, because the "Jewish character" is inherited from "2,500 years of legacy." "Judah," in fact, say some Christian Identity believers, was the homeland of the Aryan people known as the Jutes, who lived in northern Germany. Under the headline "Adolf Hitler was Elijah," a brochure distributed by the Socialist Nationalist Aryan Peoples Party declared that the "message of Identity" was that Aryans are, "to the exclusion of all others, representative of the only Covenant agreeable to our God." Jews are "vipers," "murderous," "mongrelizing" international bankers, rightly opposed by the prophet Hitler. A brochure from Mythos Makers, Aryan Nations (reproduced in Aho's Appendix), advertises—among other items—a Mythos baseball jersey (50% cotton 50% polyester) bearing the logo, "White Pride World Wide." Such extremist groups, often overtly and proudly anti-Semitic, "Aryan," and racialist, are far from the mainstream of American Christian opinion. But whether Jews and homosexuals are cast out forever, or capable of being "saved" and "converted" to the majority's faith makes less difference than the fact that self-appointed experts have determined their right to coax and coach them into conformity.

66. Francis Fukuyama, *The End of History and the Last Man* (New York: Maxwell Macmillan International, 1992).

67. Jacques Derrida, *Specters of Marx* (New York and London: Routledge, 1994), p. 60.

68. Tom Elliff, President of the Southern Baptist Convention. In Art Toalston, "SBC Challenges Disney, Church Arsons, Moves Ahead with 21st Century Thrust." *Baptist Press News Service,* June 13, 1996.

69. The Rev. Phil Roberts, quoted in Goldberg, "Some of Their Best Friends are Jews," p. 43.
70. Kenneth L. Woodward and Sheery Keene-Osborn, "The Gospel of Guyhood." *Newsweek* (August 29, 1994), p. 60.
71. Ralph Hickok, *The Pro Football Fan's Companion* (New York: Macmillan, 1995), pp. 42–44.

Chapter III: Gentility

1. "Preface to Understanding," *Jews in a Gentile World: The Problem of Anti-Semitism*, ed. Isacque Graeber and Steuart Henderson Britt (New York: Macmillan, 1942), n.p.
2. Talcott Parsons, "The Sociology of Modern Anti-Semitism," in Graeber and Britt, *Jews in a Gentile World*, pp. 115, 116, emphasis added.
3. Parsons, p. 120.
4. Ibid., p. 117.
5. Slavoj Žižek, *The Sublime Object of Ideology* (London and New York: Verso, 1989), p. 127.
6. Parsons, p. 116.
7. Žižek, p. 49.
8. "The bulk of persisting anti-Semitism in the United States," wrote sociologist Melvin A. Tumin in the sixties, "is practiced not by loud-mouthed agitators and crackpots, not by neo-Nazis, but by the so-called 'gentle people of prejudice,' the polite bigots—those who would hardly, if ever, insult a Jew to his face or discriminate against him openly and candidly." Cited in *"Privacy" and Prejudice: A Survey of Religious Discrimination in Private Clubs* (New York: Anti-Defamation League, 1963), p. 22.
9. This is how the word is spelled throughout Hobson's novel.
10. Laura Z. Hobson, *Gentleman's Agreement* (New York: Simon and Schuster, 1947), p. 142.
11. Ibid., p. 155.
12. *Too Jewish: Challenging Traditional Identities*, ed. Norman L. Kleeblatt (New Brunswick, NJ: The Jewish Museum, New York and Rutgers University Press, 1996).
13. Hobson, *Gentleman's Agreement*, p. 232.
14. Lee Wright to Laura Z. Hobson. In Laura Z. Hobson, *Laura Z: A Life* (New York: Arbor House, 1983), pp. 350–51.
15. Hobson, *Gentleman's Agreement*, p. 232.
16. Ibid., p. 84.
17. A telephone operator once told Theodor Adorno in the 1940s, "You get so you always know a Jewish voice." Cited in Theodor Adorno, Else Frenkel-Brunswik, Daniel J. Levinson, and R. Nevitt Sanford, *The Authoritarian Personality* (New York: Harper, 1950), p. 643.
18. Hobson, *Gentleman's Agreement*, p. 64.
19. Neal Gabler, *An Empire of Their Own: How the Jews Invented Hollywood* (New York: Doubleday, 1988), p. 301.
20. Hobson, *Gentleman's Agreement*, p. 131.
21. See, for example, Joseph Jacobs, *Studies in Jewish Statistics* (London: D. Nutt, 1891), p. xxxii, and Eden Warwick (Georges Jabet), *Notes on Noses* (1848; London: Richard Bentley, 1864), p. 11. Cited in Sander Gilman, *The Jew's Body* (New York and London: Routledge, 1991), chapter 7, "The Jewish Nose."

22. Jean-Paul Sartre, *Anti-Semite and Jew*, trans. George Becker (New York: Schocken Books, 1948; 2nd edition, 1995), p. 144.

23. When in 1997 the Los Angeles Film Critics Association and the American Film Institute declined to give Kazan career achievement awards, the cry went up from some quarters that he was being "blacklisted." (Bernard Weinraub, "A McCarthy Era Memory That Can Still Chill." *The New York Times*, January 16, 1997, p. C15.) In a number of strong letters responding to a *New York Times* editorial on the question ("Hollywood's Long Memory." January 19, 1997, p. 14), members of the entertainment industry noted that "blacklisting" meant being prevented from working because of one's political beliefs. "That is what Mr. Kazan helped to do by informing on his colleagues to the House Committee on Un-American Activities in 1952," wrote Joseph McBride, vice-president of the Film Critics' Association. "Would you support a career achievement award to Leni Riefenstahl, the talented German director whose career was founded upon her willingness to make the Nazi propaganda film *Triumph of the Will?*" (*The New York Times*, January 13, 1997, p. A22.)

24. Gabler, p. 372. From HUAC transcripts.

25. Statement of Samuel Ornitz, prepared for presentation to HUAC, October 1947. Gabler, *An Empire*, p. 370.

26. Sartre, *Anti-Semite and Jew*, p. 144.

27. Gabler, p. 370. From HUAC testimony.

28. Hobson, *Gentleman's Agreement*, p. 152.

29. Ibid., p. 114.

30. Gabler, p. 349.

31. George F. Custen, "Over Fifty Years, a Landmark Loses Some of Its Luster." *The New York Times*, November 16, 1997, Section 2, p. 19.

32. Patrick Dennis, *Auntie Mame* (New York: Vanguard Press, 1955), p. 205.

33. God's "covenant with Abraham" (Genesis 17), the giving of the Mosaic law (Exodus 24:7, 8), and phrases like "book of the covenant," "ark of the covenant," and "land of the covenant" are all cited, by Jews, as signs of the fact that they have been chosen by God. Christians refer to the Old Covenant and the New Covenant (or the Old Law and the New Law, or the Old Testament and the New Testament), and equate "covenant" with "dispensation."

34. Leonard S. Berkowitz, letter to the editor. *The New York Times*, February 9, 1997, p. D14.

35. *The American Heritage Dictionary of the English Language*, ed. William Morris (New York: American Heritage Publishing Co., 1973), p. 372.

36. Quoted in Steven Erlanger, "Albright Grateful for Her Parents' Painful Choices." *The New York Times*, February 5, 1997, p. A8.

37. Anne Bernays, letter to the editor. *The New York Times*, February 13, 1997, p. A32.

38. Letters to the editor from Harriet Brickman, Laura-Lee Tolliver, Beryl Satter, Emanuel Tanay, and Brenda Sansom-Moorey. *The New York Times*, February 13, 1997, p. A32.

39. Steven Erlanger, "Albright Grateful," p. A8.

40. Ibid.

41. Philip Taubman, "The Albright Syndrome." *The New York Times*, February 9, 1997, p. 14.

42. Frank Rich, "The Albright Question." *The New York Times*, February 19, 1997, p. A27.

43. "Many Jews Must Grapple With a Hidden Heritage." *The Washington Post*, February 6, 1997, p. A16.

44. Erlanger, p. A8.
45. Carl Lohmann to Frederick Wiggin, quoted in Dan A. Oren, *Joining the Club: A History of Jews and Yale* (New Haven and London: Yale University Press, 1985), pp. 176–77.
46. Edward S. Noyes, "Report of the Board of Admissions," *Yale Reports to the President, 1944–45*, p. 3. Cited in Oren, *Joining*, p. 177.
47. Robert Corwin, "Memorandum on the Problems Arising from the Increase in the Enrollment of Students of Jewish Birth in the University," May 12, 1922. Cited in Oren, p. 44.
48. Oren, p. 178.
49. Ibid., p. 180. Nonetheless, at Yale the number of Jews admitted to the liberal arts college continued at 10 percent in the post–World War II years, while at Harvard and Cornell it jumped to around 25 percent.
50. Cited in Rich, "The Albright Question," p. A27.
51. Cited in Stephen L. Slavin and Mary A. Pradt, *The Einstein Syndrome: Corporate Anti-Semitism in America Today* (Washington, D.C.: University Press of America, 1982), p. 102.
52. In a 1962 survey of social clubs in the United States the Anti-Defamation League found that of 1,152 clubs investigated—with a membership of about 700,000 persons—781 (67%) discriminated on religious grounds. Of the 781 discriminatory clubs, 691 were "Christian" clubs, excluding or limiting the membership of Jews, and 90 were "Jewish" clubs, excluding or limiting the membership of Christians. Ninety percent of the discriminatory clubs maintained their religious restrictions unofficially—through unwritten agreement rather than by constitution. *"Privacy" and Prejudice: A Survey of Religious Discrimination in Social Clubs* (pamphlet published by the Anti-Defamation League of B'nai Brith, New York, 1962).
53. A. Bernard Ackerman, letter to *The New York Times*, February 19, 1997, p. A26.
54. Monica J. Strauss, letter to the editor. *The New York Times*, February 19, 1997, p. A26.
55. "Is Madeleine Albright Jewish?" *Moment*, vol. 22, no. 2 (April 1997), p. 62.
56. Editorial, February 6, 1997. Adam Chernichaw, letter to the editor, *The New York Times*, February 9, 1997, p. 14.
57. John Daniszewski, "Arab World Gets Personal in Press Attacks on Albright." *The Los Angeles Times*, December 11, 1996, p. A1. The article cited the Saudi-owned international Arabic daily *Al Hayat*, December 7, 1996.
58. Cited in Daniszewski, "Arab World."
59. Cited in Frank Rich, "Albright Comes Home." *The New York Times*, February 26, 1997, p. A29.
60. Sartre, *Anti-Semite and Jew*, p. 84.
61. Walzer, "Preface" to Sartre, *Anti-Semite*, 2nd ed., p. xxiv, emphasis added.
62. Walzer, "Preface," p. xxv.
63. Quoted in Frank Rich, "Albright Comes Home," p. A29.
64. Sartre, p. 80.
65. David L. Marcus, "Albright, in Texas, Urges Larger U.S. Role Worldwide." *The Boston Globe*, February 8, 1997, p. 1.
66. Kenneth Jacobson, *Embattled Selves: An Investigation into the Nature of Identity Through Oral Histories of Holocaust Survivors* (New York: Atlantic Monthly Press, 1994), pp. 7, 10–11.
67. Kenneth Jacobson, quoted in Michael Dobbs, "Many Jews Must Grapple with a Hidden Heritage." *The Washington Post*, February 6, 1997, p. A16.
68. Slavin and Pradt, pp. 3–4.

69. Ibid., p. 28. Yet a "Jewish" name could be misleading: In the 1960s, Rabbi Richard J. Israel, director of Yale's Hillel Foundation, challenged Yale's way of counting "Jewish" students. The dean of admissions had suggested that perhaps as many as a quarter of the admitted students were Jewish, but Israel's figures, based on the religious preference cards then routinely filled out by entering students, were smaller. The dean, he concluded, had counted every student with a German name as Jewish, as well as every student with a Jewish ancestor somewhere in his background. Oren, pp. 190–91.

70. Elaine K. Ginsberg, "Introduction" to Ginsberg, ed., *Passing and the Fictions of Identity* (Durham and London: Duke University Press, 1996), p. 3, emphasis added.

71. Gayle Wald, "White Identity in *Black Like Me*," in Ginsberg, *Passing and the Fictions of Identity*, p. 155.

72. Carleton Stevens Coon, "Have the Jews a Racial Identity?," in Graeber and Britt, *Jews in a Gentile World*, pp. 20–37.

73. Coon, "Final Comment" to this section of *Jews in a Gentile World*, p. 56; Coon's essay, Jacobs's essay, and Coon's "Final Comment" together constitute a section of the volume called "The Problem of Race."

74. Melville Jacobs, "Jewish Blood and Culture," in Graeber and Britt, Ibid., pp. 53–54.

75. Sartre, *Anti-Semite and Jew*, pp. 78, 105, 135, 143.

76. Jacques Derrida, *Specters of Marx*, (New York and London: Routledge, 1994), pp. 39, 58, 63.

77. For the clearest explanation of Derrida's concept of the *supplément*, see Barbara Johnson, "Writing," in Frank Lentricchia and Thomas McLaughlin, eds., *Critical Terms for Literary Study* (Chicago and London: University of Chicago Press, 1990; 1995), p. 45.

78. Hobson, *Gentleman's Agreement*, p. 270.

79. Diana Fuss, *Identification Papers* (New York: Routledge, 1996), pp. 218; 2.

80. Hobson, *Gentleman's Agreement*, p. 106.

81. Laura Z. Hobson, *Laura Z., A Life: Years of Fulfillment* (New York: Donald L. Fine, 1986), pp. 226–27.

82. Laura Z. Hobson, *Over and Above* (New York: Doubleday, 1979). Cited in Christopher Z. Hobson, "Afterword" to *Laura Z., A Life: Years of Fulfillment*, p. 301.

83. "As I Listened to Archie Say, 'Hebe' … " *The New York Times*, September 12, 1971. Cited in Hobson, *Years of Fulfillment*, p. 275.

84. Hobson, *Years of Fulfillment*, pp. 313–14.

85. Christopher Z. Hobson, "Afterword," in Laura Z. Hobson, *Years of Fulfillment*, p. 307.

86. Laura Z. Hobson, *Over and Above*, cited in Christopher Z. Hobson, "Afterword," p. 301.

87. Laura Z. Hobson, *Consenting Adult* (Garden City, NY: Doubleday & Company, 1975), p. 256.

Chapter IV: Cinema Scopes

1. "In the examination of the jury panel, one venireman after another testified that he had never heard any discussion of evolution until after Scopes was indicted and that, while there had been a 'right smart' of it since that time, he himself had not paid much attention to it. Eleven of the 19 veniremen had stated this general fact. Ten of the 11 were taken onto the jury." Ray Ginger, *Six Days or Forever? Tennessee vs. John Thomas Scopes* (London: Oxford University Press, 1958; rpt. 1981), p. 99.

2. Ray Ginger, *Six Days or Forever?* pp. 99, 103.

3. "Although Judge Raulston prevented the defense from presenting its case to the jury in Dayton, he did not prevent them from submitting it to the American people: the statements by the expert witnesses were presented verbatim by newspapers in all parts of the United States, including the South." Ginger, Ibid., p. 164.

4. *The World's Most Famous Court Trial* (Cincinnati: National Book Company, 1925; rpt. Birmingham, AL: Legal Classics Library, 1984).

5. November 2–3, 1995. The Robert Penn Warren Center for the Humanities at Vanderbilt University, Nashville, TN.

6. Maureen Dowd, "Media Martyr." *The New York Times,* March 3, 1996, p. 15.

7. Peter Applebome, "Creationism Fight Returns to Nation's Classrooms." *The New York Times,* March 10, 1996, pp. A1, A22.

8. Trial transcript in *The World's Most Famous Court Trial,* p. 316.

9. Ibid.

10. House Bill 185, Public Acts of Tennessee for 1925. L. Sprague de Camp, *The Great Monkey Trial* (Garden City, NY: Doubleday and Co., 1968), p. 2.

11. H.L. Mencken, *The Baltimore Sun,* July 10, 1925, p. 1f.

12. de Camp, p. 432.

13. Ibid., p. 42.

14. William Jennings Bryan, *The Commoner,* (January 1923), pp. 1–2.

15. Ginger, p. 45.

16. Clarence Darrow, *The Story of My Life* (New York: C. Scribner's Sons, 1932), p. 249.

17. Trial transcript, in *World's Most Famous Court Trial,* pp. 302–3.

18. *Seven Questions in Dispute* (Philadelphia: The Sunday School Times Co., c. 1924), p. 106.

19. Trial transcript, in *World's Most Famous Court Trial,* pp. 121–22.

20. Ginger, p. 122; de Camp, p. 294.

21. Ginger, p. 4.

22. Trial transcript, in *World's Most Famous Court Trial,* p. 123.

23. Raymond Williams, *Keywords: A Vocabulary of Culture and Soceity* (New York: Oxford University Press, 1976), p. 21.

24. Maynard Shipley, *The War on Modern Science: (A Short History of the Fundamentalist Attacks on Evolution and Modernism)* (New York: Knopf, 1927), p. 160. Norman F. Furniss, *The Fundamentalism Controversy 1918–1931* (New Haven: Yale University Press, 1954), pp. 95–96.

25. Donald Bogle, *Blacks in American Film and Television: An Illustrated Encyclopedia* (New York: Simon & Schuster, 1988), p. 101.

26. K. Anthony Appiah, "'No Bad Nigger': Blacks as the Ethical Principle in the Movies." *Media Spectacles,* ed. Marjorie Garber, Jann Matlock, and Rebecca L. Walkowitz (New York: Routledge, 1993), p. 84. As one video guide properly notes, however, the film was considered "quite daring at the time of its original release." Mick Martin and Marsha Porter, *Video Movie Guide 1998* (New York: Ballantine, 1997), p. 442.

27. Bogle, p. 101.

28. Ibid., pp. 473–74.

29. Cited in *The World's Most Famous Court Trial,* p. 5. In 1926—the year after the Scopes trial—the Imperial Wizard and Emperor of the Klan made an impassioned speech that could, alas, have been written by an "angry white male" of today, railing about affirmative action:

... Nordic Americans for the last generation have found themselves increasingly uncomfortable and finally deeply distressed. There appeared first confusion in thought and opinion, a groping hesitancy about national affairs and private life alike, in sharp contrast to the clear, straightforward purposes of our earlier years. There was futility in religion, too, which was in many ways even more distressing.... Finally there came the moral breakdown that has been going on for two decades.... The sacredness of our Sabbath, of our homes, of chastity, and finally even of our right to teach our children in our own schools fundamental facts and truths were torn away from us (Ginger, p. 9).

30. Lawrence W. Levine, *Defender of the Faith: William Jennings Bryan, The Last Decade, 1915–1925.* (New York: Oxford University Press, 1965), p. 257.

31. de Camp, p. 463.

32. Ibid., p. 76.

33. Quoted in Irving Stone, *Clarence Darrow for the Defense* (Garden City, NY: Garden City Publishing Co., 1943), p. 471.

34. Ibid., p. 89.

35. "The ironic reversal of a received racist image of the black as simianlike, the Signifying Monkey, he who dwells at the margins of discourse, ever punning, ever troping, ever embodying the ambiguities of language," notes Henry Louis Gates, Jr., "is our trope for repetition and revision, indeed our trope of chiasmus, repeating and reversing simultaneously as he does in one deft discursive act." Henry Louis Gates, Jr., *The Signifying Monkey* (New York: Oxford University Press, 1988), p. 52.

36. T.T. Martin, *Evolution or Christ* and *Hell in the High Schools*; Alfred McCann, *God—or Gorilla?* (New York: Devin-Adair Co., 1922).

37. Willard H. Smith, *The Social and Religious Thought of William Jennings Bryan* (Lawrence, KS: Coronado Press, 1975), p. 174.

38. R. Halliburton, Jr., "The Adoption of Arkansas' Anti-Evolution Law," in *Arkansas Historical Quarterly* (Autumn 1964), p. 280.

39. Frederick Douglass, cited in Dinitia Smith, "Reconstruction's Deep Imprint," review of an exhibit, "America's Reconstruction: People and Politics After the Civil War," at the Schomburg Center for Research in Black Culture, New York City. *The New York Times,* June 18, 1997, p. B2.

40. Sander Gilman, *Sexuality: An Illustrated History: Representing the Sexual in Medicine and Culture from the Middle Ages to the Age of AIDS* (New York: John Wiley, 1989), pp.101–2.

41. Frantz Fanon, *Black Skin, White Masks,* trans. Charles Lam Markmann (New York: Grove Weidenfeld, 1967), p. 17. Originally published as *Peau Noire, Masques Blancs* (Paris: Editions du Seuil, 1952).

42. Ibid., p. 30.

43. Ibid., p. 59.

44. Ibid., p. 126.

45. Donna Haraway, "The Promise of Monsters: A Regenerative Politics for Inappropriate/d Others," in Lawrence Grossberg, Cary Nelson, and Paula Triecher, *Cultural Studies* (New York and London: Routledge, 1992), p. 308.

46. Ginger, p. 15.

47. Ibid., p. 15. Mencken, as we have already noted, excoriated the Fundamentalist Christian colleges for their resistance to learning: "Certainly Fundamentalism should not be hard to understand when its sources are inspected. How can the teacher teach

when his own head is empty?. . . . Of the arts he knows absolutely nothing; of the sciences he has never so much as heard. No good book ever penetrates to those remote 'colleges,' nor does any graduate ever take away a desire to read one. He has been warned, indeed, against their blandishments." H.L. Mencken, editorial in *The American Mercury* (November, 1925), p. 287.

48. The analogy between Red-hunting and religious fundamentalism or anti-evolution sentiment is far from far-fetched, historically speaking. T.T. Martin, the author of *Hell in the High Schools*, one of the books prominently on display at the Anti-Evolution bookstall in Dayton, who had attended the Scopes trial, offered this exhortation to the Mississippi legislature when it was considering an anti-evolution bill a year later, in 1926: "Go back to the fathers and mothers of Mississippi and tell them because you could not face the ridicule and scorn and abuse of Bolsheviks and Anarchists and Atheists and Agnostics and their co-workers, you turned over their children to a teaching that God's Word is a tissue of lies and that the Saviour who said it was God's word was only the illegitimate son of a Jewish fallen woman." (T.T. Martin, quoted in Norman F. Furniss, *The Fundamentalist Controversy, 1918–1931* [New Haven: Yale University Press, 1954], p. 34.) The journal *Christian Fundamentals* asserted that virtually the only believers in evolution were "the university crowd and the social Reds" (Ginger, p. 15). In 1925, the year of the Scopes trial, a writer for the British *Observer* took cognizance of the American tendency to cultural paranoia: "America since the War," he wrote, "has been the prey of multiple terrors: fear of the European alien, the Negro, the Asiatic; of Radicalism, Labor, Bolshevism. Harassed by the prophets of woe, scared by the hundred-headed demon of Propaganda, the good American conceives a dread of every sort of modernism. And in Tennessee, particularly, he is at the moment taking it out of an English avatar of Anti-christ— Charles Darwin." As a commentator on the "Monkey trial" noted in 1968, "the same practice [of labeling any unwelcome change as Red] featured the McCarthy agitation of the late 1940s and early 50s and features the 'radical right' agitation of today" (de Camp p. 17). "Today" then was thirty years ago—but it is still, or again, true "today."

49. A.M. Rosenthal, "On My Mind." *The New York Times,* February 14, 1995, p. A19.

50. Langdon Gilkey, *Creationism on Trial: Evolution and God at Little Rock* (San Francisco: Harper & Row, 1985), p. 149.

51. Robert Wright, *The Moral Animal: Evolutionary Psychology and Everyday* Life (New York: Pantheon Books, 1994), p. 7.

52. Ibid., p. 9.

53. David Buss, *The Evolution of Desire* (New York: Basic Books, 1994).

54. David Buss, quoted in Daniel Goleman, "For Man and Beast, Language of Love Shares Many Traits." *The New York Times,* February 14 [Valentine's Day], 1995, p. C9.

55. Gingrich, lecture on "Renewing American Civilization" at Reinhardt College in Georgia. Reported in *The Chicago Tribune,* January 19, 1995; Pat Schroeder's remarks on this in the House of Representatives, reported in *The New York Times,* January 19, 1995, p. A20.

56. Richard J. Herrnstein and Charles Murray, *The Bell Curve: Intelligence and Class Structure in American Life* (New York: The Free Press, 1994), p. 297.

57. Ibid., p. 1. *The Bell Curve*'s other citation of Darwin by name tells us "Darwin himself had noted that, even within the lower classes, the smaller families had the brighter, the more 'prudent,' people in them." p. 343.

58. Cited in Anthony Flint, "'Bell Curve' Book on Race and Intelligence Debated." *The Boston Globe,* February 15, 1995, p. 23.

59. Vincent Canby, "Of Monkeys, Reason and the Creation" (review of a production of *Inherit the Wind* at the National Actors Theatre in Manhattan). *The New York Times*, April 5, 1996, p. C21.

60. Wesley Roberts, quoted in Applebome, "Creationism Fight," p. 22.

61. Pamela Messick, quoted in Ibid., p. 22.

62. "Town Divided Over Whether to Teach Creationism in Schools." *The New York Times*, February 13, 1995, p. A13.

63. Letter from Daniel Kurtz Winthrop, "Creationism doesn't belong in classroom." *The Boston Globe*, March 31, 1995, p. 18.

64. Cited in Peter Steinfels, "Beliefs." *The New York Times*, December 2, 1995, p. 12.

65. Chet Raymo, "The Real Battle Over Creationism." *The Boston Globe*, March 6, 1995, p. 26.

66. Applebome, "Creationism," pp. 1, 22.

67. Kim Masters, *The Washington Post*, September 19, 1994, p. D1.

68. George McEvoy, "Georgia's Latter-Day Scopes Trial." *The Palm Beach Post*, August 29, 1994, p. A9.

69. Merrill Schindler, "Kirk Douglas Inherits a Role Still Valid Today." *The Chicago Tribune*, March 20, 1988, TV Week section, p. A3.

70. *The Los Angeles Times*, March 18, 1988.

71. Stuart Taylor, Jr. "High Court Voids Curb on Teaching Evolution Theory." *The New York Times*, June 20, 1987, p. A1.

72. Al Kamen, "Supreme Court Voids Creationism Law; 7–2 Ruling Deals Blow to Fundamentalists." *The Washington Post*, June 20, 1987, p. A1.

73. Bruce Buursma, "New Creationist Strategy May Evolve From Ruling." *The Chicago Tribune*, June 21, 1987, p. 1.

74. Kamen, p A1.

75. PR (Pat Robertson) Newswire, "Robertson Responds to Supreme Court Decision on Creation Science." June 19, 1987.

76. Institute for Creation Research, El Cajon, California. As quoted in *The New York Times*, March 10, 1996, p. 22.

77. Buursma, p. 1.

78. Mary Broussard, "Livingston Eyes Creationism as School Course." *State-Times/Morning Advocate*, Baton Rouge, March 25, 1995, pp. B3–4.

79. Karen Lange, "Advocate Showing Resilence." *Chapel Hill Herald*, May 1, 1994, p. 1.

80. Trial transcript, in *The World's Most Famous Court Trial*, pp. 178–79.

81. Ibid., p. 182.

82. *The World's Most Famous Court Trial*, p. 332.

83. Edward O. Wilson, *Naturalist* (Washington, DC: Island Press, 1994), pp. 130–32.

84. Wright, pp. 6–7.

85. Charles R. Lawrence III, "If He Hollers, Let Him Go: Regulating Racist Speech on Campus," in Mari J. Matsuda, Charles R. Lawrence III, Richard Delgado, and Kimberlè Williams Crenshaw, *Words That Wound: Critical Race Theory, Assaultive Speech, and the First Amendment* (Boulder, Colorado: Westview Press, 1993), p. 55.

86. Todd S. Purdum, "Clinton Seeks Broad Powers in Battle Against Terrorism." *The New York Times*, April 24, 1995, p. A1.

87. "Don't Legislate in Haste." *The New York Times* editorial, April 25, 1995, p. A22.

88. Robert S. McNamara with Brian VanDeMark, *In Retrospect: The Tragedy and Lessons of Vietnam* (New York: Times Books, 1995).

89. "Mr. McNamara's War." *The New York Times* editorial, April 12, 1995, p. A24.

90. David Nyhan, "Assessing the Threat Within." *The Boston Globe,* April 28, 1995, p. 10.

Chapter V: Jell-O

1. Walter and Miriam Schneir, *Invitation to an Inquest: A New Look at the Rosenberg-Sobell Case* (New York: Dell, 1968), p. 374.

2. Ibid., p. 401.

3. Ibid., pp. 372–73.

4. Ibid., p. 155.

5. Ibid., p. 402.

6. Ibid., p. 418.

7. Ibid., pp. 368, 423.

8. Ibid., pp. 401–2.

9. Ibid., p. 418.

10. Virginia Carmichael, *Framing History: The Rosenberg Story and the Cold War* (Minneapolis: University of Minnesota Press, 1993), p. 79.

11. Alvin H. Goldstein (producer). *The Unquiet Death of Julius and Ethel Rosenberg* (Chicago: Facets Multimedia, 1989), script version (New York: Lawrence Hill, 1975).

12. James Joyce, *Ulysses* (New York: Vintage, 1962), p. 112.

13. Mary Livingstone Benny and Hilliard Marks, with Marcia Borie, *Jack Benny* (Garden City, NY: Doubleday, 1978), p. 61.

14. Milt Josefsberg, *The Jack Benny Show* (New Rochelle: Arlington House, 1977), p. 470.

15. Ibid., p. 360.

16. David I. Sheinkopf, *Gelatin in Jewish Law* (New York: Bloch, 1982), p. 7.

17. Ibid., pp. 12–13.

18. Ibid., p. 13n.

19. Ibid., pp. 10, 95–96.

20. William Glaberson, "Celebrating a Jiggly Dessert's Place in History." *The New York Times,* July 27, 1997, pp. 1, 26.

21. Schneir, p. 401.

22. Leo Rosten, *The Joys of Yinglish: An Exuberant Dictionary of Yiddish Words, Phrases, and Locutions. . . .* (New York: McGraw-Hill, 1989), pp. 304–5.

23. *The American Heritage Dictionary of the English Language,* 3rd ed. (Boston: Houghton Mifflin, 1992). **kosher**, 2a. "Legitimate; permissible: *consolidating noneditorial functions of the papers, which is kosher* (*Christian Science Monitor*).

24. This is the recollection of historian Ellen Schrecker, who attended the camp.

25. Philip Roth, *Portnoy's Complaint* (New York: Bantam Books, 1970), pp. 2, 3, 10.

26. Ibid., p. 93.

Chapter VI: Character Assassination

1. Senator Alan Simpson. Hearing of the Senate Judiciary Committee on the Thomas Supreme Court Nomination, Saturday, October 12, 1991 (Washington: Federal News Service, Federal Information Systems Corporation [computer disc record]). On the subject of the Senate Committee deliberations, see a witty one-page commentary in *The New Republic* by Barry G. Edelstein that also notes the incongruity of the Shakespeare quotations used in the hearing ("Macbluff," November 11, 1991, p. 13). I am sure that many others at the time likewise noted these references with mingled amusement and dismay.

2. Senator Joseph Biden. Hearing of the Senate Judiciary Committee on the Thomas Supreme Court Nomination, Sunday, October 13, 1991.

3. Biden, October 13, 1991.

4. "Great genial power, one would almost say, consists in not being original at all." The great man "steals by this apology—that what he takes has no worth where he finds it, and the greatest where he leaves it. It has come to be practically a sort of rule in literature, that a man having once shown himself capable of original writing, is entitled thenceforth to steal from the writings of others at discretion. Thought is the property of him who can entertain it and of him who can adequately place it. A certain awkwardness marks the use of borrowed thoughts; but as soon as we have learned what to do with them they become our own. Thus all originality is relative."

Ralph Waldo Emerson, "Shakespeare," in *Representative Men* (Boston: Houghton, Mifflin, 1903), pp. 191, 198.

5. William Congreve, *The Mourning Bride*, 3.1.457–58. *The Complete Plays of William Congreve*, ed. Herbert Davis (Chicago: University of Chicago Press, 1967).

6. Lynne V. Cheney, *Humanities in America: A Report to the President, the Congress, and the American People* (Washington, DC: National Endowment for the Humanities, 1988).

7. Emerson, p. 204.

8. Ibid., pp. 210–11.

9. Thomas Carlyle, *On Heroes, Hero-Worship, and the Heroic in History* (1840), ed. Carl Niemeyer (Lincoln, Nebraska: University of Nebraska Press, 1966), p. 114.

10. Senator Alan Simpson. Hearing of the Senate Judiciary Committee, October 12, 1991. For an acute media analysis of Simpson on "this sexual harassment crap," see Anna Quindlen, "The Perfect Victim." *The New York Times*, October 16, 1991, p. A25.

11. Senator Patrick Leahy. *Congressional Record*: Proceedings and Debates of the 102nd Congress, First Session. Washington. Tuesday, October 15, 1991. Vol. 137, No. 147, p. S14650.

12. J.C. Alvarez. Hearing of the Senate Judiciary Committee on the Thomas Supreme Court Nomination, October 13, 1991.

13. Marjorie Garber, "A Rome of One's Own," *Shakespeare's Ghost Writers* (London and New York: Routledge, 1987), p. 55.

14. Emerson p. 204.

15. Ibid., p. 207.

16. "Excerpt from Senate's hearings in the Thomas Nomination." *The New York Times*, October 13, 1991, p. 31.

17. "Excerpt from a Statement by Senator Kennedy." *The New York Times*, October 14, 1991, p. A13.

18. Thomas C. Reeves, *A Question of Character: A Life of John F. Kennedy* (New York: The Free Press, 1991).

19. Barbara Garson, *MacBird* (Berkeley: Grassy Knoll Press, 1966).

20. Shakespeare, *As You Like It*, 3.3.

21. Robert Sam Anson, "The Shooting of JFK." *Esquire* (November 1991), p. 102.

22. Quoted by Bernard Weinraub, "Hollywood Wonders if Warner Brothers let 'J.F.K.' Go Too Far." *The New York Times*, December 24, 1991, p. C12.

23. *Newsweek* (December 23, 1991).

24. Vincent Canby, *The New York Times*, December 20, 1991.

25. *The New York Times* editorial notebook, December 20, 1991.

26. *The New York Times*, December 20, 1991.

27. *The New York Times,* December 23, 1991, p. 1.

28. "A Troublemaker for Our Times, *Newsweek* (December 23, 1991), p. 50.

29. David Hume, *The Natural History of Religion* (1757), Section VI, "Various Forms of Polytheism: Allegory, Hero-Worship," in *The Philosophical Works,* ed. T.H. Green and T.H. Grose (London, 1882), vol. 4, p. 328. "The same principles [on which human beings create divinities] naturally deify mortals, superior in power, courage, or understanding, and produce hero-worship, in all its wild and unaccountable forms."

30. Carlyle, pp. 108–9.

31. Ibid., p. 112.

Chapter VII: Shakespeare as Fetish

1. Stephen Greenblatt, *Shakespearean Negotiations* (Berkeley: University of California Press, 1988), pp. 1–2.

2. Ibid., p. 20.

3. Stephen Greenblatt, *Renaissance Self-Fashioning: From More to Shakespeare* (Chicago: University of Chicago Press, 1980), p. 255.

4. Henry M. Stanley, *Through the Dark Continent,* 2 vols. (New York: Harper and Brothers, 1878), vol. 2, pp. 384–86. Cited in Greenblatt, *Shakespearean Negotiations,* p. 162.

5. Ibid., p. 198n.

6. Sigmund Freud, "Fetishism," trans. Joan Riviere, in *The Standard Edition of the Complete Psychological Works of Sigmund Freud,* ed. James Strachey (London: The Hogarth Press and The Institute of Psycho-Analysis, 1961), vol. 21, p. 153.

7. *The Boston Globe,* May 29, 1989, p. 25.

8. *The Boston Globe,* July 15, 1989, p. 17.

9. *Time* (July 24, 1989), p. 52.

10. Michael Billington, "Lasciviously Pleasing," in Garry O'Connor, *Olivier: In Celebration* (New York: Dodd, Mead, 1987), p. 71.

11. Anthony Holden, *Laurence Olivier* (New York: Atheneum, 1988), pp. 234–35. "Definitive" is the verdict of Hugo Vickers, *The Times* (London), cited on the dustjacket.

12. Billington, p. 72.

13. Ibid., p. 73.

14. Ibid.

15. Ibid., p. 75.

16. Ibid.

17. Donald Spoto, *Laurence Olivier: A Biography* (New York: HarperCollins, 1992). For a more extended discussion of Olivier's bisexuality, see Marjorie Garber, *Vice Versa: Bisexuality and the Eroticism of Everyday Life* (New York: Simon and Schuster, 1995), pp. 136–37.

18. On the subject of transvestism and culture, see Marjorie Garber, *Vested Interests: Cross-Dressing and Cultural Anxiety* (New York: Routledge, 1992).

19. Cheney, *Humanities in America,* p. 14.

20. Ibid.

21. Maya Angelou, "Journey to the Heartland" (Address delivered at the 1985 National Assembly of Local Arts Agencies, Cedar Rapids, Iowa, June 12, 1985). Cited in Cheney, p. 15.

22. Greenblatt, *Shakespearean Negotiations,* p. 93.

Chapter VIII: Roman Numerals

1. David Owen, *The Walls Around Us: The Thinking Person's Guide to How a House Works* (New York: Vintage, 1992), p. 85.

2. Paul McPharlin, *Roman Numerals, Typographical Leaves and Pointing Hands: Some Notes on Their Origin, History and Contemporary Use* (New York: The Typhphiles, Mcmxlii [1942]), pp. 3–5.

3. Ibid.

4. Georges Ifrah, *From One to Zero: A Universal History of Numbers*, trans. Lowell Bair (New York: Viking, 1985), p. 131. Originally published as *Historie Universelle des Chiffres* (Paris: Editions Seghers, Paris, 1981).

5. Except in one case in the list of Actors Names for *The Life of Henry the Fift* where the King's title, appearing at the end of a line, is abbreviated as *Henry 5*, with an Arabic numeral (not, please note, a Roman numeral) instead of the word "Fift."

6. Francis Meres, *Palladis Tamia* (New York: Scholars' Facsimile Edition, 1938), ed. Don Cameron Allen, p. 282. Reproduced in S. Schoenbaum, *William Shakespeare: A Documentary Life* (New York: Oxford University Press, 1975), p. 140. Bacon's *Essays* likewise use the ordinal: "K. Henry the 7. of England, K. Henry the 4. of France" (Essay LVm "Of Honour and Reputation." Michael Kiernan, *Sir Francis Bacon: The Essaies or Counsels, Civill and Morall* (Cambridge, MA: Harvard University Press, 1985), p. 164.

7. Helge Kokeritz's 1954 facsimile of the First Folio included a "reference number to the last line of each right-hand column" in Arabic numerals at the foot of the page, so that—for example—the notation on the bottom of the first page of the first play, *The Tempest*, reads 1.2.6 for "Act I, Sc. 2, line 6." But Charlton Hinman's 1968 facsimile marked the pages in Roman numerals (the same page in Hinman is labeled I.i.1–I.ii.6).

8. "General Editors' Preface" to the third series of the Arden Shakespeare. In John Wilders, ed., *Antony and Cleopatra* (London and New York: Routledge, 1995), p. x.

9. Karl Menninger, *Number Words and Number Symbols: A Cultural History of Numbers*, trans. Paul Broneer (Cambridge, MA: The M.I.T. Press, 1969), p. 241.

10. See not only Menninger, but also, for example, Melius de Villiers, *The Numeral-Words: Their Origin, Meaning, History and Lesson* (London: H.F. & G. Witherby, 1923), p. 61.

11. Johanna Drucker, *The Alphabetic Labyrinth* (London: Thames and Hudson, 1995), p. 71.

12. Ibid., pp. 70–71.

13. Menninger, p. 281.

14. Jacob Kobel, *Short Book of Arithmetic* (1514), cited in Menninger, p. 286.

15. Menninger, p. 242.

16. Ibid., pp. 281–83.

17. "Barney is Satan." http://www.io.com/-hitchker/barney.satan.html.

18. James Hayes, *The Roman Letter* (Chicago: R.R. Donnelly and Sons, 1951), pp. 37–38.

19. Drucker, p. 162.

20. Elizabeth L. Eisenstein, *The Printing Press as an Agent of Change,* 2 vols. (Cambridge: Cambridge University Press, 1979), vol. 2, p. 532.

21. R.A. Foakes and R. T. Rickert, *Henslowe's Diary* (Cambridge: Cambridge University Press, 1961), p. 319.

22. McPharlin, p. 21.

23. David Eugene Smith and Jekuthiel Ginsburg, *Numbers and Numerals* (New York: Columbia Teachers College Bureau of Publications, 1937), pp. 17–18.

24. Brian Rotman, *Signifying Nothing: The Semiotics of Zero* (Stanford: Stanford University Press, 1987), pp. 9–10.

25. Eisenstein, vol. 1, p. 193.

26. Eisenstein, vol. 2, p. 531.

27. G.F. Hill, *The Development of Arabic Numerals in Europe* (Oxford: Clarendon Press, 1915).

28. "Four" on clock faces is almost always IIII, not IV—a preference ascribed variously to aesthetic symmetry (the IIII balances VIII on the other side) or to a whim of Louis XIV. See Willis Milhamn, *Time and Timekeepers* (New York: Macmillan, 1923), pp. 195–96.

Today's quartz clocks, which have no works, weights, or pendulum, also often have no dial, in the traditional sense, but rather a cathode-ray tube screen. The famous "Movado" watch has no numerals at all. In short, as "analogue" has been replaced by "digital" in the world of computers and clocks, we have moved, or returned, to the world of numbers theorized by Leibniz, who invented the binary code, and for whom 1 symbolized God, and 0 the void.

The weight-driven clock arrived in England from Italy in "about 1368" (Kenneth Ullyett, *British Clocks and Clockmakers* [London: Collins, MCMXLVII]). Clocks and watches were valued by Renaissance royals: Henry VIII, "a pioneer among English chamber clock owners" had a Bavarian "deviser of the King's horologues," and an Englishman, Bartholomew Newsam, to make his table clocks. (He gave one to Anne Boleyn as a token of his timeless love.) Domestic clocks were a prized new item, and Newsam became clockmaker to Queen Elizabeth at the behest of Sir Philip Sidney (Ullyett, p. 16). Portable timepieces—British pocket "horologues" or watches" were obtainable for £20 (upwards of £500 today) in 1600, and when James I came to the throne he sent for the Scotsman David Ramsay, then in France, to be Keeper of his Majesty's Clocks and Watches (Ullyett, p. 17). In 1612 the Keeper of the Privy Purse recorded "Watches, three, bought of Mr. Ramsay the Clockmaker lx li [i.e., £60]." The notation of this transaction is itself of some small interest, because it is a sign of how confusing the use of the letters used for Roman numerals could be for the uninitiate. "lx" is sixty, and "li" a standard abbreviation for "pound" (from Latin *libra*, "pound," balance).

Theodore Komisarjefsky's famous production of *The Comedy of Errors* at Stratford in 1938 was dominated by a large onstage clock whose hands moved, underscoring the passage of time toward the fateful hour of five. The numbers on the clock were Roman numerals, which might at first be presumed to mark and underscore the "classical" locale. But photographs of the production show no attempt at Roman costume. The effect is rather a hodgepodge of "museum Shakespeare" and Keystone cops. This "Roman" clock, then, is not—except very elusively—a sign of Rome.

29. If we turn from Henslowe to his 20th-century editors, we can see another set of practices in flux. W.W. Greg's edition (1904–8) of *Henslowe's Diary* is in two (Roman numeraled) volumes, and contains an Introduction paginated in minuscule Roman numerals. The second volume has five Roman numeraled chapters, several of which are broken down into sections, each also indicated by a majuscule or capital Roman numeral. Foakes and Rickert's edition, more than fifty years later (1961), still uses minuscule Roman numerals for the Preface and Introduction, but marks its chapters and the page numbers of the book proper in Hindu-Arabic numerals and its Plates in Roman majuscules.

30. Eisenstein, vol. 2, p. 532.

31. Rotman, p. 14.

32. Since Harriot did not publish his findings, the credit for the positional number system has tended to go to the philosopher Gottfried Leibniz (1646–1716), who developed the same ideas independently.

33. Robert K. Logan, *The Alphabet Effect* (New York: William Morrow, 1986), p. 157.

34. Mona Ozouf, *Festivals and the French Revolution*, trans. Alan Sheridan. (Cambridge, MA: Harvard University Press, 1988), p. 93.

35. Ibid., p. xvii.

36. Lynn Hunt, *Politics, Culture, and Class in the French Revolution* (London: Methuen, 1986), p. 28. Originally published in 1984 by the University of California Press.

37. Ibid., p. 27.

38. Roland Barthes, *Mythologies*, trans. Annette Lavers (New York: Hill and Wang, 1972), p. 26; French edition (Paris: Editions de Seuil, 1957).

39. *Time* (September 4, 1978), p. 60.

40. *The New Catholic Encyclopedia*, 18 vols. (New York: Catholic University of America and McGraw-Hill, 1967), vol. 11, pp. 576–77.

41. In some cases, the numbering system is inconsistent: *Friday the 13th* had a Part 2 and a Part 3, a Final Chapter (which was not, as it turned out, final), and then, in a burst of classicizing fervor, a Part V, Part VI, Part VII, and Part VIII.

42, Anthony Lane, "Power Mad." *The New Yorker,* vol. 70, no. 45 (January 16, 1995), p. 86.

43. Russell Baker, "Supernumerary." *The New York Times,* January 31, 1988, Section 6, page 12 (or section VI, p. xii).

44. "Super Bowl is a roman numeral kind of event." Scripps Howard News Service, January 25, 1996. [National Football League Features Page/The National Football League Page/ The Football Server.]

45. Mary McGrory, "In a State of Distraction." *The Boston Globe,* February 8, 1997, p. A11.

46. Jan Hoffman, "Tried and Tried Again, With a Vengeance." *The New York Times,* February 9, 1997, p. D1.

47. Menninger, p. 245.

Chapter IX: Second-Best Bed

1. S. Schoenbaum, *William Shakespeare: A Documentary Life* (New York: Oxford University Press, 1975), p. 247.

2. Jane Cox, cited in a 1997 book supporting the claim that the Earl of Oxford wrote Shakespeare's plays. Joseph Sobran, *Alias Shakespeare: Solving the Greatest Literary Mystery of All Time* (New York: The Free Press, 1997), p. 27.

3. John Ward, *Diary of the Rev. John Ward,* arranged by Charles Severn (London: Colburn, 1839), pp. 56–58.

4. Marchette Chute, *Shakespeare of London* (New York: Dutton, 1949), p. 320.

5. Gerald Eades Bentley, *Shakespeare: A Biographical Handbook* (New Haven: Yale University Press, 1961), p. 63.

6. Sir Edmund K. Chambers, *William Shakespeare: A Study of Facts and Problems* (Oxford: Clarendon Press, 1930), vol. 2, p. 173.

7. Edmond Malone, ed., *Supplement to the Edition of Shakespeare's Plays Published in 1778 by Samuel Johnson and George Steevens* (1780), vol. 1, p. 653.

8. James Walter, *Shakespeare's True Life* (London: Longmans, Green, 1890), p. 386.

9. Joseph William Gray, *Shakespeare's Marriage: His Departure from Stratford and Other Incidents in His Life* (London: Chapman & Hall, 1905), pp. 140–41.

10. John Dowdall, *Traditional Anecdotes of Shakespeare, Collected in Warwickshire in the Year 1693* (London: Thomas Rodd, Great Newport Street, 1838).

11. C[harlotte]. C[armichael]. Stopes, *Shakespeare's Environment* (London: G. Bell, 1918), p. 6.

12. H. Snowden Ward and Catharine Weed Ward, *Shakespeare's Town and Times* (London: Dawbarn and Ward), p. 137.

13. A.L. Rowse and John Hedgecoe, *Shakespeare's Land: A Journey Through the Landscape of Elizabethan England* (San Francisco: Chronicle Books, 1987), p. 190.

14. James Joyce, *Ulysses*, ed. Hans Walter Gabler (New York: Vintage Books, 1986), pp. 166–69.

15. Samuel Neil and F.W. Fairholt, *The Home of Shakespeare* (London: Chapman & Hall, 1847), pp. 22–23.

16. Mark Eccles, *Shakespeare in Warwickshire* (Madison: University of Wisconsin Press, 1961), pp. 164–65.

17. Schoenbaum, p. 247.

18. Frederick George Emmison, *Elizabethan Life: Morals and the Church Courts* (Chelmsford: Essex County Council, 1973), p. 31.

19. E. Vine Hall, *Testamentary Papers II: Wills from Shakespeare's Town and Time* 2nd series (London: Mitchell Hughes and Clarke, 1933). Cited in Joyce Rogers, *The Second Best Bed: Shakespeare's Will in a New Light* (Westport, CT: Greenwood Press, 1993), p. 77.

20. James O. Halliwell-Phillipps, *Outlines of the Life of Shakespeare*, 10th ed. (London, New York, Bombay: Longmans, Green, 1898), vol. 1, p. 259. Cited in Rogers, p. 77.

21. Cited by Schoenbaum, pp. 302–3, who in turn cites G.R. Potter, "Shakespeare's Will and Raleigh's Instructions to his Son," *Notes and Queries* (1930), p. 364. The passage, as Schoenbaum notes, appears in Raleigh's posthumous "Remains."

22. Sir William Blackstone, *Commentaries on the Laws of England: A Facsimile of the First Edition of 1765–1769.* Vol. II: *Of the Rights of Things* (1766), Introd. by A.W. Brian Simpson (Chicago and London: University of Chicago Press, 1979), pp. 492–93.

23. Blackstone, p. 425.

24. Rogers, p. xvii.

25. Robert Nye, *Mrs. Shakespeare, The Complete Works* (London: Sinclair-Stevenson, 1993), p. 212.

26. Caryl Brahms and S.J. Simon, *No Bed for Bacon* (New York: Thomas Y. Crowell, 1941; 1950), p. 24.

27. Reginald Reynolds, *Beds* (London: Andre Deutsch, 1952), p. 142.

28. *Pillow Talk*, 1959. A film called *Twin Beds*, a comedy about a neighbor constantly interrupting a married couple, appeared in 1942.

29. Alecia Beldegreen, *The Bed* (New York: Stewart, Tabori & Chang, 1991), p. 36.

30. Paul Popenoe, cited in Reynolds, p. 139.

31. Reginald Sharpe, K.C. *Evening Standard*, December 13, 1950. Quoted in Reynolds, p. 141.

32. Groucho [Julius H.] Marx, *Beds* (Indianapolis and New York: Bobbs Merrill, 1930), p. 26.

33. Parker Tyler, *A Pictorial History of Sex in Films* (Secaucus, NJ: The Citadel Press, 1974), p. 61.

34. Howard Fineman and Michael Isikoff, "Strange Bedfellows." *Newsweek* (March 10, 1997), pp. 22–28.

35. Richard Lacayo, "Step Right Up." *Time* (March 1997), p. 34.

36. "Still Around: Ghosts of Lincoln and His Era." *The New York Times*, February 13, 1987, p. A18.

37. Plato, *Republic* X, trans. Benjamin Jowett, in David H. Richter, *The Critical Tradition: Classic Texts and Contemporary Trends* (New York: St. Martin's, 1989), pp. 22–23.

38. Jacques Lacan, *The Seminar. Book II. The Ego in Freud's Theory and in the Technique of Psychoanalysis, 1954–55*, trans. Sylvana Tomaselli, notes by John Forrester (New York: Norton; Cambridge: Cambridge University Press, 1988), p. 164.

39. *Republic*, trans. Paul Shorey, in *Plato, The Collected Dialogues*, ed. Edith Hamilton and Huntington Cairns (Princeton: Princeton University Press, Bollingen Series LXXI), p. 821.

40. From Marie Bonaparte's notes, cited by Peter Gay: "Madame Freud informed me that the analytic couch (which Freud would import to London) was given to him by a grateful patient, Madame Benvenisti, around 1890." Peter Gay, *Freud: A Life for Our Time* (New York and London: Norton, 1988), p. 103.

41. Gay, p. 171.

42. Ibid., p. 427.

43. Ibid., p. 635.

44. Diana Fuss and Joel Sanders, "Bergasse 19: Inside Freud's Office," in *Stud*, ed. Joel Sanders (Princeton: Princeton Architectural Press, 1996). See also Sigmund Freud, "Papers on Technique," in James Strachey, ed. *The Standard Edition of the Complete Psychological Works of Sigmund Freud* (London: The Hogarth Press and the Institute for Psycho-Analysis, 1953), vol. 12, p. 139.

45. Freud, "Papers," p. 133. Fuss and Sanders, p. 129.

46. Fuss and Sanders, book proposal for MIT Press: *Berggasse 19: Inside Freud's Office*.

47. Henry James, "The Birthplace," *The Jolly Corner and Other Tales* (London: Penguin, 1990), p. 122.

48. See, for example, Samuel Neil, *The Home of Shakespeare* (Warwick: Henry T. Cooke and Son, 1888), p. 19. Neil quotes Douglas Jerrold, from James O. Halliwell-Phillipps, *The Life of William Shakespeare* (London: J.R. Smith, 1848), p. 39.

49. Gary Taylor, *Reinventing Shakespeare* (New York: Weidenfeld and Nicolson, 1989), pp. 261–62. A 1927 Prague production had presented a "prominent bed" and Gertrude in her nightgown.

50. This view is put forward by Otto Rank, *Das Inzest-Motiv in Dichtung und Sage* (Leipzig, Wein: Franz Denticke, 1912).

51. Freud, *The Interpretation of Dreams*, in *Standard Edition*, vol. 4, p. 266.

52. Stephen Daedalus makes the same biographical assumptions: "Is it possible that the player Shakespeare, a ghost by absence, and in the vesture of buried Denmark, a ghost by death, speaking his own words to his own son's name (had Hamnet Shakespeare lived he would have been prince Hamlet's twin), is it possible, I want to know, or probable that he did not draw or foresee the logical conclusion of those premises: you are the dispossessed son: I am the murdered father: your mother is the guilty queen. Ann Shakespeare, born Hathaway?" *Ulysses*, p. 155.

53. Ernest Jones, *Hamlet and Oedipus*, 1910 (Rev. ed. New York and London: W.W. Norton, 1949), p. 121.

54. Freud, *Interpretation of Dreams*, p. 266n.

55. Sigmund Freud, *An Autobiographical Study* (1925), in *Standard Edition*, vol. 20, pp. 63–64n.

56. Garber, *Shakespeare's Ghost Writers* (London and New York: Routledge, 1987).

57. Freud, *Autobiographical Study*, p. 34.

58. "I was the first," Freud insists, asserting his own primacy over Adler and Jung, "to recognize both the part played by phantasies in symptom-formation and also the 'retrospective phantasying' of late impressions into childhood and their sexualization after the event." Sigmund Freud, "From the History of an Infantile Neurosis," *Standard Edition*, vol. 17, p. 103n.

59. Freud, "The Goethe Prize" (1930). Trans. Angela Richards, *Standard Edition* vol. 21, p. 211.

60. Letter from Freud to John Looney, June 1938, in J. Thomas Looney, *"Shakespeare" Identified as Edward de Vere the 27th Earl of Oxford*, 3rd rev. ed., ed. and augmented by Ruth Loyd Miller (Port Washington, NY: Kennikat Press, 1975), vol 2, p. 273.

Chapter X: I'll Have What She's Having

1. Thomas Middleton and William Rowley, *The Changeling*, ed. N.W. Bawcutt (Revels Plays; Cambridge: Harvard University Press, 1958). All subsequent citations in the text are to this edition.

2. Thomas Lupton, *A Thousand Notable Things of Sundry Sorts*, The Fifth Book, No. 56 (1579; rpt. 1814), p. 43. *The Changeling*, ed. N.W. Bawcutt (Revels Plays; Cambridge, MA: Harvard University Press, 1958), p. 69n.

3. Pliny, *Natural History*, xxxvi.19 (translated by Philemon Holland, [1601], II, 589). Antonius Mizaldus (1520–78), *Centuriae IX. Memorabiliam* (1566): Centuriae VI, 54, "Experiri an mulier sit grauida" (ed. Frankfurt, 1613, p. 127); Centuriae VII, 12 and 64, "Mulierem corruptam ab incorrupta discernere" (ed. Frankfurt, pp. 141–2, 154); "Appendix secretorum experimentorum antidororumque contra varios morbos," p. 253; "Noscendi ratio an mulier sit virgo integra & intacta an non." Robert Burton, as Bawcutt notes, is dismissive of the entire notion; "To what end are all those Astrological questions, *an sit virgo, an sit casta, an sit mulier*? and such strange absurd trials in *Albertus Magnus, Bap. Porta, Mag. lib. 2, cap.21*, in *Wecker, lib. 5, de secret.*, by stones, perfumes, to make them piss, and confess i know not what in their sleep; some jealous brain was the first founder of them." *Anatomy of Melancholy*, Pt. III, Sec. 3, Memb. 2; ed. A.R. Shilleto, 1983. III, 327.

4. William Shakespeare, *Twelfth Night*, 2.5.117–20. *The Arden Shakespeare*, ed. J.M. Lothian and T.W. Craik (London: Methuen, 1975).

5. "Fragment of an Analysis of a Case of Hysteria," *The Standard Edition of the Complete Psychological Works of Sigmund Freud* (London: The Hogarth Press and the Institute for Psycho-Analysis, 1953), vol. 7, p. 80.

6. "for a man inhales and exhales by this organ [the nose], and sneezing is effected by its means: which last is an outward rush of collected breath, and is the only mode of breath used as an omen and regarded as supernatural." Aristotle, *History of Animals* (*Historia animalium*), trans. D'Arcy Wentworth Thompson. In *The Works of Aristotle, II*, ed. W.D. Ross, reprinted in *Great Books of the Western World*, vol. 9, ed. Robert Maynard Hutchins (Chicago: Encyclopedia Brittanica, 1952), p. 14 (492b, 5).

7. *The Works of William Harvey*, ed. and trans. Robert Willis [*De generatione animalium*] (New York: Johnson Reprint Corp., 1965), p. 534.

8. Nasal stimulation as a test for fruitfulness was also recommended in the 18th century. The author of *Aristotle's Last Legacy* reports that "some make this experiment of a woman's fruitfulness.

"They take myrrh, red florax, and such odoriferous things, and make a perfume of it: which let the woman receive into the neck of the womb, thro' a funnel; if the woman feel the smoak ascend to her nose, then she is fruitful; otherwise barren.

"Others take garlick, and beat it, and let the woman lie on her back upon it, and if she feel the scent thereof to her nose, it is a sign of fruitfulness."

Aristotle's Last Legacy (London: 1776), p. 30, rpt. Garland Publishing (New York and London, 1986).

9. Josef Breuer and Sigmund Freud, *Studies on Hysteria, Standard Edition*, vol. 2, pp. 200, 206–7.

10. Ibid., pp. 206–7.

11. Freud, "Fragment," p. 78.

12. *The Complete Letters of Sigmund Freud to Wilhelm Fliess, 1887–1904*, trans. and ed. Jeffrey Moussaieff Masson (Cambridge, MA: Harvard University Press, 1985), pp. 45–48. The notorious case of Emma Eckstein, on whom Fliess operated with disastrous results, was the most dramatic of these surgical interventions on the nose. Eager to acquit his friend of culpability in the botched operation, Freud wrote to him a year after the surgery "I shall be able to prove to you that you were right, that her episodes of bleeding were hysterical, were occasioned by *longing*, and probably occurred at the sexually relevant times (the woman, out of resistance, has not yet supplied me with the dates)." *Freud-Fliess*, p. 183.

13. Thomas Hardy, *Tess of the d'Urbervilles* (New York: Bantam Books, 1981), p. 148.

14. Gordon Hendricks, *Origins of the American Film* (New York: Arno Press, 1972), p. 91.

15. Linda Williams, *Hard Core: Power, Pleasure, and the "Frenzy of the Visible"* (Berkeley: University of California Press, 1989), pp. 50, 53.

16. Sigmund Freud, "Findings, Ideas, Problems" (1941 [1938]), *Standard Edition*, vol. 23.

17. Breuer-Freud, *Studies on Hysteria*, pp. 200, 248. Sigmund Freud, Letter 102 (to Fliess), January 16, 1899, *Standard Edition*, vol. 1, p. 277.

18. Sigmund Freud, "Three Essays," *Standard Edition*, vol. 7, p. 180.

19. Sigmund Freud, "Extracts from the Fliess papers," Draft J (1950 [1892–99]), trans. Eric Mosbacher and James Strachey, *Standard Edition*, vol. 1, p. 217.

20. Thomas Laqueur, *Making Sex: Body and Gender from the Greeks to Freud* (Cambridge, MA: Harvard University Press, 1990), pp. 45–46, 49–52, 66–68.

21. Ibid., pp. 43, 257n. Ovid, *Metamorphoses* (3.323–31).

22. *Feminine Sexuality: Jacques Lacan and the Ecole Freudienne*, ed. Juliet Mitchell and Jacqueline Rose (New York: W.W. Norton, 1982), p. 52.

23. Jacques Lacan, *Encore: Le séminaire XX. 1972–73* (Paris: Seuil, 1975). Excerpted in *Feminine Sexuality*, p. 52.

24. Jacques Derrida, "The Double Session," in *Dissemination* (Chicago: University of Chicago Press, 1981), p. 201.

25. Gayatri Chakravorty Spivak, "Displacement and the Discourse of Woman," in *Displacement: Derrida and After*, ed. Mark Krupnick (Bloomington: Indiana University Press, 1983; 1987), p. 175.

26. Aristotle, *Generation of Animals*, Loeb Classical Library (Cambridge, MA: Harvard University Press, 1953), pp. 2.4.739a27–3. Cited in Laqueur, pp. 47–48.

27. Danielle Jacquar and Claude Thomasset, *Sexuality and Medicine in the Middle Ages*, trans. Matthew Adamson (Princeton: Princeton University Press, 1988), p. 46.

28. Thomas G. Benedek, "Beliefs about Human Sexual Function in the Middle Ages and Renaissance," in Douglas Radcliffe-Unstead, ed., *Human Sexuality in the Middle Ages and Renaissance* (Pittsburgh: University of Pittsburgh Press, 1978), p. 108.

29. Laqueur, p. 150.

30. Auguste Debay, *Hygiène et physiologie du mariage*, 153rd ed. (Paris, 1880). See esp. pp. 17–18, 92, 94–95, 105–9. Cited in *Victorian Women: A Documentary Account of Women's Lives in Nineteenth-Century England, France, and the United States*, ed. Erna Olafson Hellerstein, Leslie Parker Hume, and Karen M. Offen (Stanford: Stanford University Press, 1981).

31. Julia R. Heiman and Joseph LoPiccolo, *Becoming Orgasmic: A Sexual and Personal Growth Program for Women* (New York: Fireside, Simon & Schuster, 1976, 1988, and 1992), p. 91.

32. "J," *The Sensuous Woman* (New York: Dell Books, 1969), pp. 180–81.

33. Ruth Westheimer, *Dr. Ruth's Guide to Good Sex* (New York: Warner Books, 1983), pp. 45–46.

34. Alice Kahn Ladas, Beverly Whipple, and John D. Perry, eds., *The G Spot: And Other Recent Discoveries about Human Sexuality* (New York: Holt, Rinehart, and Wilson, 1982), p. 143.

35. Karen Wright, "Evolution of the Big O," *Discover* (June 1992), p. 56.

Permissions

Permission to reprint the following photographs and illustrations were obtained from: p. xii, *Fred Ott's Sneeze,* Museum of Modern Art Film Stills Archive; p. 16, Muhammad Ali, Archive Photos; p. 35, *Charlotte's Web,* HarperCollins; p. 44, *Promise Keepers,* Jean-Marc Giboux/Liaison; p. 74, *Gentleman's Agreement,* © 20th Century-Fox, courtesy of the Museum of Modern Art Film Stills Archive; p. 106, *Inherit the Wind,* © 1960, United Artists Corporation, courtesy of the Museum of Modern Art Film Stills Archive; p. 152, Anita Hill, Reuters/Rick Wilking/Archive Photos; p. 152, Clarence Thomas, Archive Photos/Consolidated News Pictures, photo by Arnie Sachs; p. 166, Laurence Olivier in *Hamlet,* Corbis Bettman; p. 178, *Safety Last,* Museum of Modern Art Film Stills Archive; p. 196, cartoon *Figure VIII,* Chon Day © 1941 from the New Yorker Collection, all rights reserved; p. 198, Lincoln Bedroom, AP/World Wide Photos; p. 216, *When Harry Met Sally,* Copyright 1989 Castle Rock Entertainment, all rights reserved, courtesy of the Museum of Modern Art Film Stills Archive.

An excerpt from "In Memory of W.B. Yeats," from *W.H. Auden: Collected Poems,* by W.H. Auden, ed., Edward Mendelson, is reprinted by permission of Random House, Inc., and Faber & Faber. Copyright © 1940 and renewed 1968 by W.H. Auden.

These essays first appeared as follows:
"Greatness" in *Feminism and Postmodernism,* a special issue of *boundary 2,* edited by Margaret Ferguson and Jennifer Wicke (Summer 1992); "Cinema Scopes" in *Law in the Domains of Culture,* edited by Austin Sarat and Thomas R. Kearns (Ann Arbor: University of Michigan Press, 1998); "Jell-O" in *Secret Agents: The Rosenberg Case, McCarthyism, and Fifties America,* edited by Marjorie Garber and Rebecca L. Walkowitz (New York and London: Routledge, 1995); "Character Assassination" in *Media Spectacles,* edited by Marjorie Garber, Jann Matlock, and Rebecca L. Walkowitz (New York and London: Routledge, 1993); "Shakespeare as Fetish" in *Shakespeare Quarterly* (Summer 1990); "I'll Have What She's Having," under the title "The Insincerity of Women" in *Desire in the Renaissance,* edited by Valerie Finucci and Regina Schwartz (Princeton, NJ: Princeton University Press, 1994).

Index

Cymbeline (Shakespeare), 189

Dallas Cowboys (football team), 52, 53, 73
Daly, Mary, 38–39
Dandridge, Dorothy, 174
Darin, Bobby, 118
Darrow, Clarence, 107–139 passim
Darwin, Charles, 39, 107–139 passim
Darwinism, 108–139 passim
Day, Chon, 196
de Antonio, Emile, 125
Debay, Auguste, 229–230
Dee, John, 187
Defiant Ones, The (film), 117
Deford, Frank, 50
Denver Nuggets (basketball team), 51
Derrida, Jacques, 37–38, 72, 100, 169, 228–229
de Sacrobosco, John, 187
Descartes, 190
de Vere, Edward, see Oxford, Earl of
Dietrich, Marlene, 173
Discover (magazine), 232
Disneyland, 68
Divine Comedy, The (Dante), 30
Dobbs, Michael, 89, 94
Dodds, Gil, 50
Doe v. Duncanville Independent School District, 55
Donaldson, Sam, 108
Dooley, Vince, 51
Douglas, Kirk, 85, 132
Douglas, Melvyn, 86
Douglass, Frederick, 121
Douglass, R. Bruce, 52
Dowdall, 202
Drucker, Johanna, 183
Du Bois, W.E.B., 120
Dunbar, Paul Laurence, 175
Dundes, Alan, 63
Dürer, Albrecht, 185
Durning, Charles, 108

Edwards v. Aguillard, 133
Einstein Syndrome, The, 97
Eisenstein, Elizabeth, 185–186, 189, 191
Ellison, Ralph, 116
Emerson, Ralph Waldo, 20, 153, 156, 157, 160, 165

Emmison, Frederick, 205
End of History and the Last Man, The (Fukuyama), 72
Ephron, Nora, 233
Episcopalian, 86, 88, 92, 93
Esquire (magazine), 163
evolution, 115–139 passim
Evolution of Desire, The (Buss), 127–128, 137

Fairbanks, Douglas Jr., 172
Falwell, Jerry, 45, 50, 51, 65
Fanon, Frantz, 122
Fascists, 88
Favre, Brett (Green Bay Packers), 48, 64
Feliciano, Felice, 185
Fellowship of Christian Athletes, 47, 50, 60
"Femininity" (Freud), 39
Ferris, William, 7
fetish, 167–177
Field of Dreams (film), 24
Fields, Bert, 164
Fields, W.C., 21
Finch, Peter, 174
Fliess, Wilhelm, 222, 224
football, 45–73, 194–195
Ford, Henry, 194, 208
Fordice, Kirk, 71
France, 95
Fred Ott's Sneeze (film), 223
French Revolution, 192
Freud, Sigmund, 5, 9–10, 23, 39, 60–62, 63, 65, 67, 70–71, 115, 118, 124, 170, 212–215, 220–225, 227–228, 235; see also titles of individual works
Friday the 13th Part VIII (film), 194
Frost, Robert, 71
Fuchs, Klaus, 142
Fukuyama, Francis, 72
Funny Thing Happened on the Way to the Forum, A, 196
Fuss, Diana, 61–62, 101, 212

Galen, 189
Garbo, Greta, 173
Garfield, John, 84–85, 86
Garland, Judy, 85
Garment, Leonard, 68